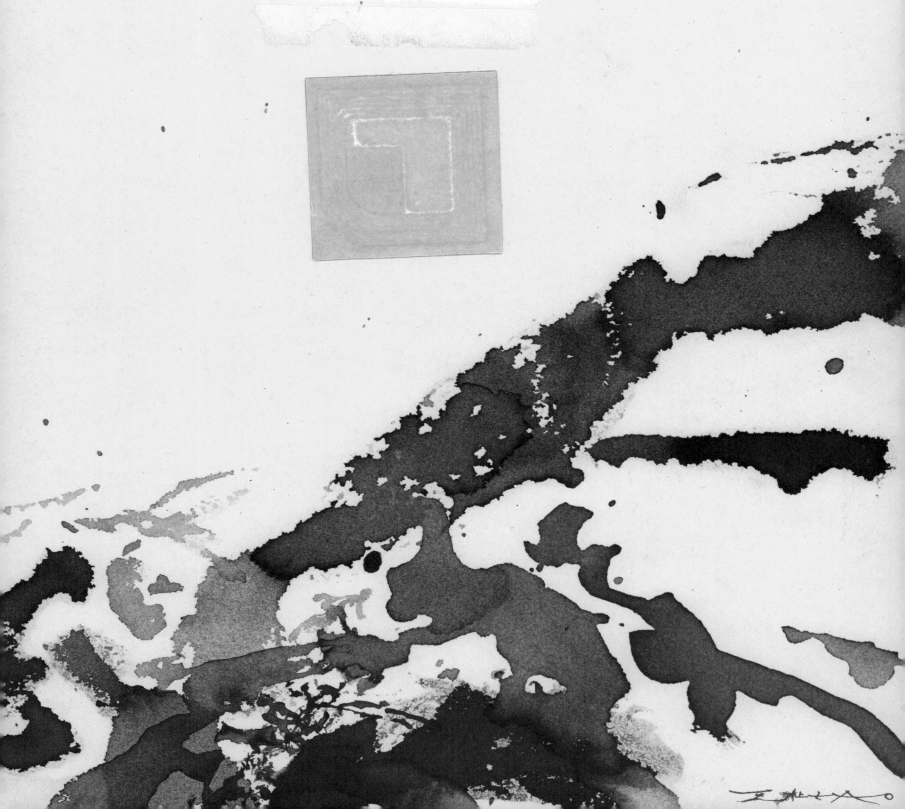

ZAO WOU-KI

ZAO

JEAN LEYMARIE

WOU-KI

Documentation: Françoise Marquet

Rizzoli NEW YORK

Published in the United States of America
in 1979 by:

RIZZOLI INTERNATIONAL PUBLICATIONS, INC.
712 Fifth Avenue/New York 10019

French-language edition:
© *1978 by Ediciones Polígrafa, S. A. - Barcelona (Spain)
and Éditions Hier et Demain - Paris*

Translated by Kenneth Lyons

Library of Congress Catalog Card Number: 78-57906
ISBN 0-8478-0180-2

CONTENTS

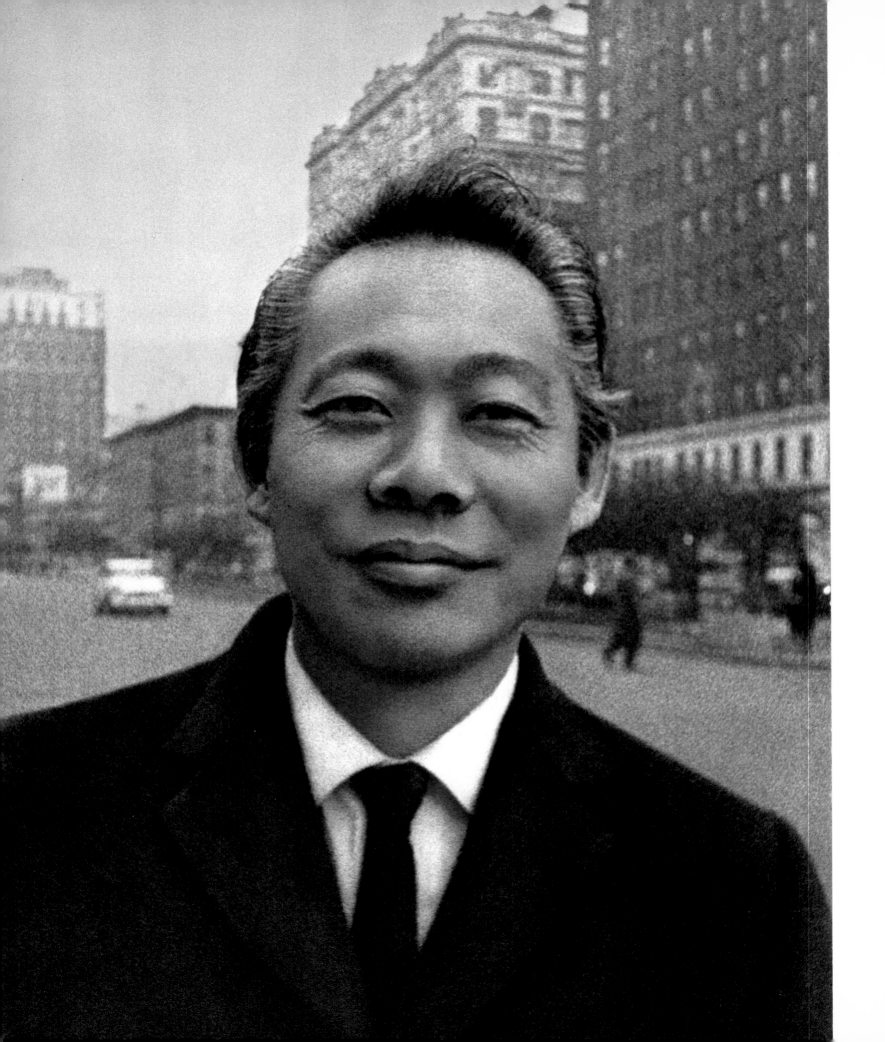

Chao Wu-chi, who was to become famous in France as Zao Wou-Ki (Zao being the patronymic and Wou-Ki the first name), was born in Peking on 13th February 1921, the eldest son of an old aristocratic family that can trace its ancestry back to a brother of the Emperor around the beginning of the Sung dynasty (960 A.D.). On this forefather's birthday every year, all the brothers and sisters were assembled in the temple and were shown the family treasure, a notable feature of which was one of the rare paintings of the great Chinese master Mi-Fei (1051-1107). When Zao Wou-Ki was only six months old, his parents moved to Nantung, a small town to the north of Shanghai. Four daughters and two more sons were born after him. They all eventually entered one or another of the liberal professions and (with the exceptions of Zao Wou-Ki himself and a brother who became an engineer in New York) remained in China. As a child — and this inclination tells us something about his temperament — Zao Wou-Ki dreamed of becoming a doctor, attracted by the humanitarian character and almost magical powers of that profession, which has had links with art since history began. His talent for painting, however, revealed itself in his early childhood, and his vocation found a favourable reception in his family and an atmosphere propitious to his development — despite some natural doubts as to the financial precariousness of painting as a profession. His father, a banker by profession but not really by choice, and a man of a very open, generous nature, had himself been an amateur painter and had even won a prize for painting in an international competition in Panama. To his son he passed on the vast heritage of knowledge and tradition that he had received himself and taught him at a very early age how to discern the beauty of the objects around him, how to appreciate not only the technical excellence of the calligraphies hanging on the walls of their home but also their aesthetic values. One of the artist's uncles was a poet and a professor of Chinese literature; another, the youngest, who had been a student in Paris, had brought home a great collection of postcard reproductions of the works of art he had seen in the museums and exhibitions of Europe. Among these were the allegories of Prudhon and Millet's *Angelus,* and for Zao Wou-Ki, then still at school, these were his first introduction to European art. When he began to learn the extremely difficult Chinese system of writing, his grandfather, who was a Taoist scholar and a really exceptional man (an ex-marine, among other things), used to sit with him telling him stories of his adventurous life and helping him with his task by drawing on the back of each of the ideograms the corresponding image: a duck, a teapot or whatever it was. Zao Wou-Ki's mother was rather less enthusiastic about her son's activities, especially when she found the white plates of her best dinner services daubed all over with colours.

At the age of fourteen Zao Wou-Ki, though an excellent scholar, decided not to go on to the University and took instead the entrance

New York, 1961. Photo: Hans Hartung.

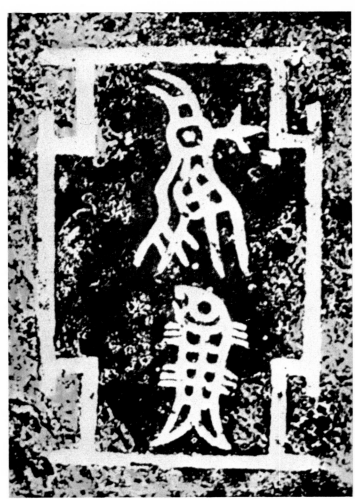

1. Sseu: character traced in ink on pottery, 25 mm² (1766-221 B.C.).
 Nan-Kang Academy, Taipeh.

2. Inscription on bronze, Chang period (1766-1122 B.C.).

examination for the National School of Fine Arts in Hangchow. Founded — or, rather, reorganized — in 1105 by the Emperor Hui-tsung, himself a painter and collector, besides enjoying great distinction in the study of flowers and birds, this august institution had reached the height of its splendour under the Southern Sung dynasty, which made Hangchow the imperial residence and a brilliant centre of the arts. Painters, poets and travellers have for centuries acclaimed the magnificence of the city and the charms of its surroundings, ringed by mountains between the great gulf of the river mouth and the celebrated Western Lake. "Nowhere in the world," wrote Marco Polo, who visited Hangchow towards the end of the 13th century and has left us a bedazzled description, "is there any city like it [...], nor one that offers so many delights of a sort to make you feel you are in Paradise." The atmosphere and unfailing charm of the lake, in all seasons and all weathers, is splendidly evoked by Su Shih, better known by his nickname of Su Tung-p'o (1035-1101), one of the most illustrious of

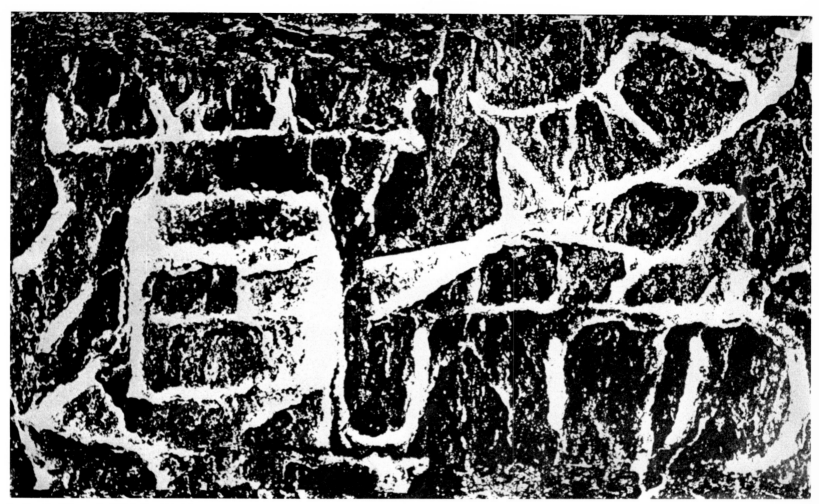

3. Detail of Han stele (209 B.C. - 200 A.D.).

painters, poets and calligraphers of the Northern Sung dynasty, who was also governor of the surrounding region:

> *Sun-shot fullness of the wave — the weather is fine...*
> *Dark blur of the mountains — the rain, too, has its charms....*

Standing between the two bridges that bear the names of the poets who had them built a thousand years ago, in Zao Wou-Ki's time the School was still housed in magnificent old buildings raised on piles as if to form a dream-island in the middle of the lake, from which there were marvellous views. The school also had a special boat for the students' outings. On the rolling hills round about, among willows and bamboos, perched the cottages of the painter-monks, their presence as distinctive of the region as was that of the Italian primitives among the olive trees and cypresses of Tuscany or Umbria. Seen as he saw it every day through the receptive years of adolescence, this noble landscape, with

its ever-changing aspects and infinite nuances, could not fail to leave a lasting impression on Zao Wou-Ki's consciousness. It was also in Hangchow, to which the imperial potteries had also been transferred, that that Sung porcelain that is almost unrivalled in the world reached the height of its perfection. So wherever he went in the old city, Zao Wou-Ki would find pieces of old china that offered its velvety texture to his caressing fingers, and later on he was to attempt to re-create in paint its fine smoothness and colour.

He spent six years at the Hangchow school, where the morning was devoted to western painting and the afternoon to the art of China — poles apart as regards both technique and spirit. There were also courses in English and art history. Chinese painting and calligraphy, which are really inseparable, were taught through the copying of models from the later years of the Ming and Ch'ing dynasties. The western art taught at the School consisted of classical — or, rather, academic — painting, rigorously subject to the rules of perspective and anatomy, and based on a progressive acquaintance with drawing, first from plaster casts and then from life. It was only in their final year that the students were introduced to oil painting, a medium hardly known in Asia, where the traditional forms of art are pen-and-ink drawing and watercolour. But Zao Wou-Ki, who had already studied the technique, took it up long before this at home, not bothering to go through the usual preliminary studies.

At the Hangchow school there were a few really good teachers, teachers who did not confine themselves to acting as mere correctors but endeavoured to arouse their pupils' visual sensibility — "the eyes", said one of them, Wu Ta-Yu, "are everywhere, but particularly in the heart". And there was a lively spirit of competition among the best of the pupils, some of whom reached a remarkable level of proficiency, but either were not fortunate enough to study abroad or did not wish to. On the whole, however, the level of teaching was not only mediocre but doubly artificial, for on the Chinese side it merely handed on the last glimmerings of an exhausted tradition, while in western art it stuck to the sterile shibboleths of the official Fine Arts Schools of Paris and Brussels, where most of the teachers had studied. Aware of the dangers inherent in this, Zao Wou-Ki rebelled against the routine and restrictions of a system he considered false, pedantic, concerned with trifles rather than unity and quite unrelated to real life. His way of reacting was to go back to the ancient sources of Chinese art — back beyond the 15th century, which was when in his opinion the decline had set in — and to abandon the official style that his masters tried to teach him for the truly independent masters of modern art, whose works he was gradually discovering through reproductions in such western books and magazines as fell into his hands: Renoir and the Impressionists, Cézanne, Matisse, Picasso. He was encouraged by the

4. Calligraphy by Mi-Fei (1051-1107).

5. Calligraphy by Wang-To (1592-1652).

principal of the School, Ling Feng-mien, a man who knew and loved France and whose respect Zao Wou-Ki earned by his enthusiasm and the quality of his work.

In 1941, at the age of twenty, Zao Wou-Ki graduated and was immediately appointed an assistant teacher at the Hangchow school itself, though since 1938 it had in fact been established in Chungking, on account of the war — or, rather, the wars, for apart from the long, cruel civil strife China was now partly occupied by the forces of the Japanese invader. Originally a fortified town built on a huge, imposing headland at the confluence of two rivers, Chungking had become the country's provisional inland capital and all the foreign embassies and consulates had been transferred there. And it was at the Sino-Soviet Society's headquarters in Chungking that Zao Wou-Ki had his first one-man show. To encourage his son, and to help him to pay the rent of the exhibition room, his father bought one of the pictures — pictures which were mostly fairly evident transpositions of Matisse and even more so,

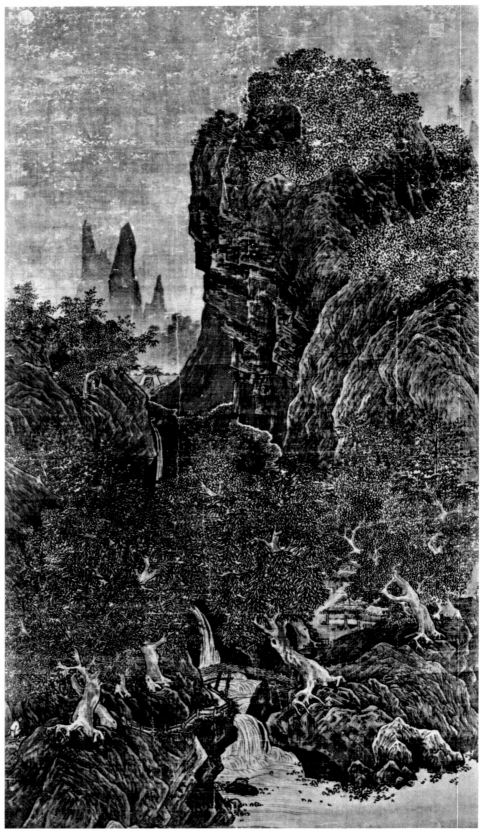

6. Fan K'uan (Early 10th century). Waterfall in a wood, autumn.
Painting on silk, 181 × 99,5 cm.
Imperial Palace, Taipeh.

in manner and subject, of Picasso. "My harlequins", he now admits, "recalled Picasso's blue period, my statue-women his Greek period." But at the age of twenty direct imitation is often a necessary phase; and the fascination of Picasso, that demiurge of modern art, at that time held the whole world in thrall.

In 1945, while still in Chungking, Zao Wou-Ki met the orientalist Vadime Elisseeff, now the curator of the Musée Cernuschi but at that time the cultural attaché at the French Embassy to China. Elisseeff was impressed by his talent, soon became a great friend of his and strongly urged him to go to Paris. In 1946, after the defeat of Japan and the liberation of China, the National School of Fine Arts returned to its old premises in Hangchow. But before leaving Chungking, Zao Wou-Ki organized an exhibition at the National Museum of History, at which he presented works by five Chinese painters with European leanings, among them Ling Feng-mien and himself. This first manifestation of contemporary artists freeing themselves from tradition and eagerly receptive of foreign trends caused quite a stir in intellectual circles. A few months later the young artist had a show of his latest works at the Ta-Sing department store in Shanghai. By then the western influence had been rather more fully digested and blended happily with that of the engravings of the Han period.

With whatever spare money he had, and an occasional contribution from his father, Zao Wou-Ki tried to buy all the western art books and reviews that were to be found in China. One of these, which he bought just after it was published, was Alfred Barr's indispensable work on Picasso, a book he has cherished ever since, with the roses he drew in the margin of the passages that most impressed him. At the Librairie Française in Shanghai he bought the little monographs on painters with black-and-white reproductions published by Braun, and he also used to cut out the full-page colour reproductions in such American magazines as *Life, Vogue* and *Harper's Bazaar,* and the albums he filled with these gradually built up his imaginary museum.

In the humanistic education that was traditional in his family, "art" meant not only painting and calligraphy but also music and poetry. For these are "the arts" *par excellence,* the only ones worthy of the name, the four truly liberal and independent arts, superior to mere professionalism and revealing of a person's character. Zao Wou-Ki, who had a sensitive ear and a fine voice, and who maintained that voice with regular singing practice, married his childhood sweetheart Lan-lan, a very gifted musician who also had a considerable talent for painting and for dancing. They both belonged to a generation which, though still brought up to have a thorough acquaintance with the enormous cultural heritage of China, were impelled by an intense curiosity and a new surge of universalism to discover foreign literature.

Zao Wou-Ki loved the English, American and, above all, Russian novelists; among French writers, he read Victor Hugo, Alphonse Daudet and André Gide, while Romain Rolland's *Jean-Christophe,* that humanist exaltation of art, friendship and love, soon became, as he says himself, his Bible.

Having at last obtained French visas, Zao Wou-Ki and Lan-lan sailed from Shanghai on 26th February 1948. After a voyage of about a month, calling at several ports on the way, they landed in Marseilles and were greeted by some friends of the family, who regaled them with coarse sausage and white wine. Later, from the train taking them to Paris, they could see the radiant Provence that Van Gogh had painted, with lilac trees in blossom on that early spring morning — the first lilacs they had ever seen. Arriving in Paris on April 1st, they left their luggage at their hotel and went straight off to the Louvre. Later that evening they went to a concert.

Most of the works Zao Wou-Ki painted in China have since been destroyed or lost. Some significant examples still survive, however, which help us to imagine those early days in his career, with the pressure of so many influences. The earliest of these extant paintings, done on a cotton canvas that he made himself, is the 1936 portrait of his young wife-to-be, Lan-lan. It is a head-and-shoulders study which shows her full-face, with her beautiful dark eyes looking straight at the viewer. Everything is concentrated in the sitter's gaze and its expressive power, and there is a feeling of frankness and animation that is surprising in a girl of fifteen. The conception owes much to Renoir, that great painter of the modern woman, and the technique is half-way between Impressionism and Fauvism. The figure is blended with its background by means of very supple brushwork, with the colours, whether dense or light, carefully nuanced and some vivid touches like the red ribbon in the black hair or the brightly-coloured scarf against the pale blouse. Zao Wou-Ki, who is still very fond of this charming and promising picture, in which painterly skill is intimately bound up with sincerity of emotion, has since explained the reasons that led the Chinese art students of his generation to accept Fauvism while rejecting Cubism. "Since the 15th century," he says, "colour had been lost to us; all we had left was atmosphere. We found Fauvism acceptable because the line plays such an important role. Cubism, on the contrary, seemed absolutely crippling — an art of decoding, when what we wanted was to feel and to project our feelings."

From Renoir the young artist went on to Matisse and Picasso — the non-Cubist Picasso of the Blue and Greek periods, in which drawing was all-important. Matisse, obsessed as he was by the art of Byzantium and Islam, by Persian ceramics and miniatures, had risen above the western dilemma between line and colour by simultaneously exalting

7. Mi-Fei (1051-1107).
Mountains and pines, spring. 35 × 44,10 cm.
Imperial Palace, Taipeh.

Pavilion, Hangchow.

Pavilion, Hangchow.

both of these opposites on the unity of the flat surface, "drawing", as he said himself, "within the colour". Zao Wou-Ki was also influenced by Modigliani, as might easily be expected of a young painter for whom line was traditionally paramount. He adopted the Italian painter's curvilinear system and his manneristic elongations. In 1941 he happened to see some drawings by his seven-year-old sister, Wou-hsi, and was enchanted by their freshness and freedom. "Where there are children," as Novalis says, "there you have the golden age." This moment of naive stylization and starry-eyed enchantment is beautifully caught in the little oil on wood, *The Bride,* with its simplified lines standing out in black segments against a background of light colours applied with a full brush. In another head-and-shoulders portrait of his wife, painted in 1942, her hair now in plaits framing her fine, pale face with its glowing eyes, he achieved a distillation of form and pictorial substance. The purity of the outlines and the transparency of the colour filter the image as it were through a limpid, vibrant mirror.

But we have not really enough evidence of that early period in the form of paintings, so we must make up for the deficiency with the drawings, the earlier ones being figure studies and the later works mostly landscapes. In his figure drawings Zao Wou-ki followed European models, but in landscape he fell back on the age-old traditions of his native land. Cézanne, universally recognized as the supreme exponent of the modern vision, and a painter who had noticeable affinities with the Chinese style of painting, makes it easier for the western eye to appreciate these works. "From Picasso," Zao Wou-Ki has said, "I had learnt to draw — like Picasso. But Cézanne taught me to look at the Chinese landscape properly. I already admired Modigliani, Renoir and Matisse, but it was Cézanne who helped me to find myself, to discover myself as a Chinese painter." A 1946 landscape shows how Zao Wou-Ki, with nothing to go on but a few reproductions, successfully depicted a Chinese scene — the trees and hills seen from the terrace of his house — using Cézanne's spectrum and colour modulation, in blues and greens tinged with violet. His understanding of the great painter of Aix-en-Provence is really remarkable, but it is also evidently selective, for he did not retain Cézanne's internal structure or density of construction but developed those elements that coincided with his own intentions: the vibration of the light, the careful spacing of the planes, the arrangement of the space by means of well-directed brushstrokes.

In its subject — a place of popular devotion— and its style — deriving from old prints — the next landscape, painted in 1947, marks a return to Chinese sources. It represents a corner in one of the parks of Hangchow, and in the upper part of the canvas we see the monument to General Yüeh Fei (1103-1141), revered as a national hero for his stout resistance to the Mongol invasion and his later unjust condemnation. The tomb of this brave soldier, which even under the Mongol dynasty

was the subject of a moving poem by Chao Meng-fu (1254-1322), a descendant of the imperial family of the Sung dynasty and an ancestor of Zao Wou-Ki, is depicted in tones of red and black on a little knoll between the dark green mass of the pines in the foreground and the golden tracery of bamboos on the horizon. The composition is based on this diagonal movement and even the rhythm of the light conveys emotion. In comparison with the preceding picture, the brushwork is more independent and expressive. Pines and bamboos, the symbols of wisdom and will-power respectively, are among the most characteristic trees of the Chinese landscape.

Lake Tai, Wu-Chi.

From the moment he arrived there, Zao Wou-Ki was captivated by the beauty of Paris and its hospitable character. "I have never felt such an immediate affection for any large city," he recalls. "In Paris one's fellow workers behave as though they were one's lifelong friends from the start." He stayed at his hotel for several months but in 1949 moved into a quiet studio with a little garden (where he was to remain for ten years) in the Rue du Moulin-Vert, a street between Montrouge and Montparnasse which still had much of the rural air suggested by its name. Among the famous artists of an older generation who lived in the neighbourhood were Braque, Léger, Laurens and Brancusi. Another artist neighbour (living almost next door) was Giacometti, whose insatiable curiosity made him a very frequent visitor, especially in the early days. Zao Wou-Ki's first months in Paris were devoted to learning French, exploring the city, attending concerts and visiting galleries, exhibitions, museums. Pierre Schneider has since told us of the young artist's reactions to the Louvre, to which at that time he was an almost daily pilgrim. Fascinated by the art of Egypt and pre-Hellenic Greece, he rejected anything in painting that seemed to him to be too "theatrical" — the Renaissance, Baroque, Romanticism (except, perhaps, Delacroix) — or too uniformly perfect — Fra Angelico, Botticelli, David, Ingres. He loved works that were spontaneous and transparent, with an air of freshness, or firmly outlined in a stiff texture: Cranach, Uccello, Mantegna. He stopped in front of Watteau, Chardin, Goya, Titian, Rembrandt, Vermeer — and in front of Poussin, exclaiming: "But he's a poet! How enchanting! Here is the joy of painting." A little canvas by Courbet, *Stags Fighting,* reminded him of "ancient bronzes" in its solidity without thickness. And before Corot's *Woman with a Pearl* he said: "One feels that this painting must have been brewing for millions of years. In China, you know, some herbs are simmered for years to bring out their essential flavour." But for him, as for all great painters, the ultimate masterpiece was Cimabue's *Madonna and Child with Angels.* "It is the most beautiful thing in the Louvre," he said. "What serenity! The whole of the picture is on almost the same plane, but the gold haloes create a strange perspective, a feeling of depth. It makes me think of the classical Chinese landscapes, with their planes separated by walls of mist."

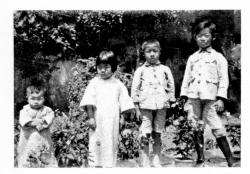

From left to right: Zao Wou-Ki's brother Wou-Chi (died five years old), his sister Wou-Hwa (died in 1939), his brother Wou-Wai and the painter himself at the age of six, in Nantung. 1927.

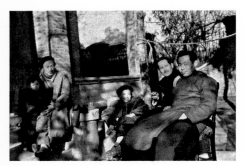

Zao Wou-Ki in the garden of his house in Hangchow, with his teacher, Ling Feng-mien, his poet friend Chu-Tzi and Lan-lan. 1946.

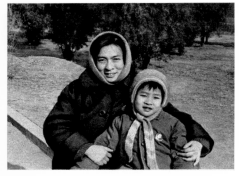

The painter's youngest sister, Wou-hsi, and her daughter. Peking, 1972.

In Paris he also renewed his friendship with Vadime Elisseeff, who had paved the way for the painter's arrival by bringing some of his canvases from China on his return in July 1946 and showing them at the Musée Cernuschi. He helped Zao Wou-Ki to find his feet in Paris and introduced him to many people in the art world, among them his colleague Bernard Dorival, curator of the National Museum of Modern Art, who presented the painter's first one-man show in Paris, at the Galerie Creuze, in May 1949. This show attracted the attention of the critics thanks to the novelty of its subtle combination of two traditions in painting. The critic of the "Daily Mail", for instance, used the expression "a Chinese Bonnard". One of the enthusiastic visitors to the gallery was the painter Jacques Villon, who gave Zao Wou-Ki a cordial welcome at his studio in Puteaux and got him an invitation to show at the Salon d'Automne. The works exhibited, numbering about thirty, had almost all been done before coming to Europe, for during this acclimatization period, which lasted until the end of 1949, Zao Wou-Ki did very little painting. He did produce some drawings and engravings, however, that reflected his instinctive inclinations. He attended classes under Othon-Friesz at the Académie de la Grande-Chaumière, applied himself to the study of the nude as an exercise in control and produced a few nude studies in red chalk with exquisitely delicate outlines.

Zao Wou-Ki soon found his way to the Desjobert printing house, where he made the marvellous discovery of lithography, a technique so eminently suited to the spontaneity of modern art. After some trial prints in black and white, he produced an astonishing series of eight colour lithographs, in two or three tones. When these were seen by Robert Godet, the publisher of Henri Michaux's *Exorcismes* and *Labyrinthes,* he hastened to show them to that great poet and eastern traveller, asking him to write a text to accompany them. "[Godet] brought me the lithographs," Michaux said later. "I knew neither the painter nor his works. The next day I wrote the following pages, more or less as they are now." Godet could hardly have made a happier choice. In China there is a very close interpenetration between painting and poetry, and Michaux's comments in verse were written in the same spirit as those Chinese poems that are inscribed directly on paintings the meaning of which they are intended to elucidate and develop. They give us a penetratingly true *reading* of these lithographs, with their gossamer line and magic colours — *Lecture,* indeed, was the title of the resultant book, exhibited at the La Hune bookshop in June 1950. These poems really make us see the fishes living "the dream of life complete" in their silent "watery abode", the lovers lying in the forest at night, overcome by the moon and "taken away from themselves", the trees rising up into the black sky "like blood-soaked masses of nerves", two wolves confronting each other in a storm of red, under a bruised blue moon.

But the moon will not abandon China;
Not yet.
She struggles to keep the land,
To keep it in her soul.

The green planet is ringed with snow and blood, the houses of men are transparent but empty, waiting, a hearse travels the wintry road, a great crippled bird drags itself over the ground and questions the tree that bends down to it:

It is better to seek counsel from a tree [...]
From a tree,
For whom
Simply sucking the soil and the hard gravel
Means an easy life.

It was only after writing these poems that Michaux met Zao Wou-Ki himself, who was greatly moved by this homage paid to his work by an older man of such celebrity, and a deep and lasting friendship sprang up almost immediately between the two men. Michaux at that time had just gone through some harrowing experiences and was turning once more to the Far East, which had influenced him so decisively when he first visited it, searching beyond words for some release in painting. And to that art he devoted himself more and more, carried away — *converted* — by Chinese painting. "The moment I saw it, I was subjugated once and for all by the world of signs and lines." His affection for Zao Wou-Ki was strengthened by their accord at an essential level. In the autumn of 1952 Michaux agreed to do something he had never, despite all entreaties, consented to do for any other living artist: to write the preface to the catalogue of Zao Wou-Ki's exhibitions at the Hanover Gallery in London and the Cadby-Birch Gallery in New York. With his permission I am transcribing this perceptive, concise essay here in its entirety:

While almost all peoples, as soon as they attain to some degree of civilization, however mediocre and poorly equipped, are unable to resist the temptation to assert themselves in forms that are hard, stark, brutal, massive, "impressive", the Chinese with all their wealth of resources are content to build themselves palaces that look like tents, their interiors seen through the dim light of woodland, not meant to last any longer than a plantation of saplings.

This lack of weight, mistrusted by other peoples, is something they prize most highly.

In painting even more so: on silk cloths and on translucid paper, to which the brush barely imparts the most fleeting touch of grey or black, nature is

The Su Tong-po Bridge, Hangchow.

in no way forced, circumscribed or subjugated, but rather invited to be present, without any ceremony, as one of the family. And, as though by magic, she is present.

Instead of writing with the wrong end of a hard wooden or metal instrument, students and scholars form their characters with a brush, so that the message is imbued with the lightness of the hand (the friend of nature), the impulses of the heart and the twists and turns of the imagination.

It would be quite misleading, therefore, to compare the lightness of Zao Wou-Ki to that of any of our own artists.

Even when we see in his work a technique that is close to that of a modern western artist, he does not thereby cease to follow his own Chinese way, which is similar to the murmur of his mother tongue, a way that exempts him from authority.

The fine zigzag strokes of his drawing, with its multiple blending of bushes, boats and men, seem to have been traced behind the uneven weft of a curtain.

Unfaithfully accurate, they render the landscape without following it, and with minute, twig-like intricacies give life to the distant figures.

If he happens to paint a vase, it is not roughly planted before us or definitively modelled, but seems rather to have been slowly and incompletely gone over with a beetle's claw and then reconstituted, not so much by the artist as by the collaboration of that diffident coleopteron.

To display while concealing, to break the straight line and make it waver, to depict in idle traceries the wanderings of a stroll and the spidery scrawl of a dreaming spirit: that is what Zao Wou-Ki loves to do. And then, quite suddenly, and with the same air of festivity that enlivens the Chinese countryside and villages, the picture appears, quivering with joy and just a little strange in an orchard of signs.

It would be impossible to improve on this text in the way it penetrates to the essence, the ethereal grace, of Chinese art, relating it to the evolution of this painter who has revived its heritage within his own development.

Zao Wou-Ki's was a basically graphic evolution, indeed, for at this time line was predominant in his work; painting and engraving went hand in hand and each was influenced by the other. After lithography the artist explored the different methods of copperplate engraving, under the guidance of such accredited specialists as Goetz and

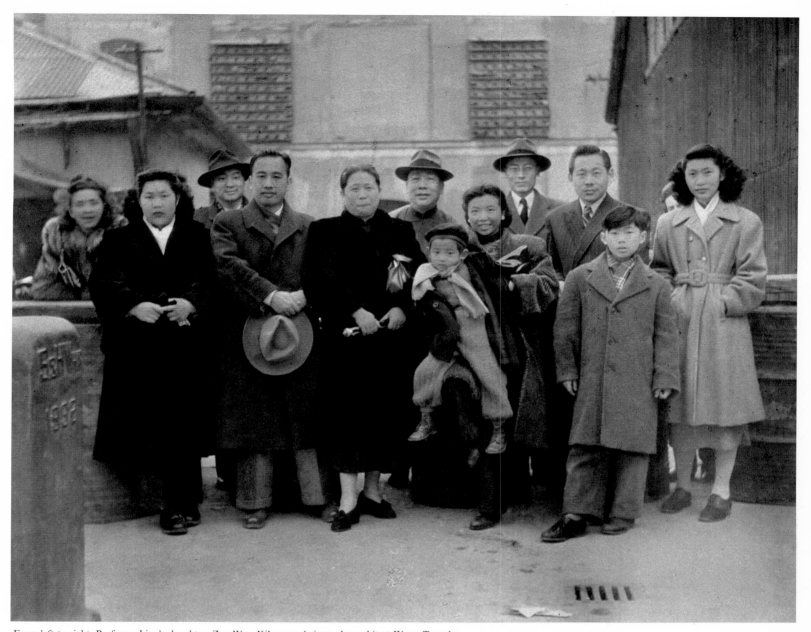

From left to right: Professor Ling's daughter, Zao Wou-Ki's second sister, the architect Wong-Ten, the painter's mother, his father, Lan-lan and their son, the painter himself, his younger brother (died in 1973) and his third sister.
Before sailing for France on the "André Lebon". 26th February 1948.

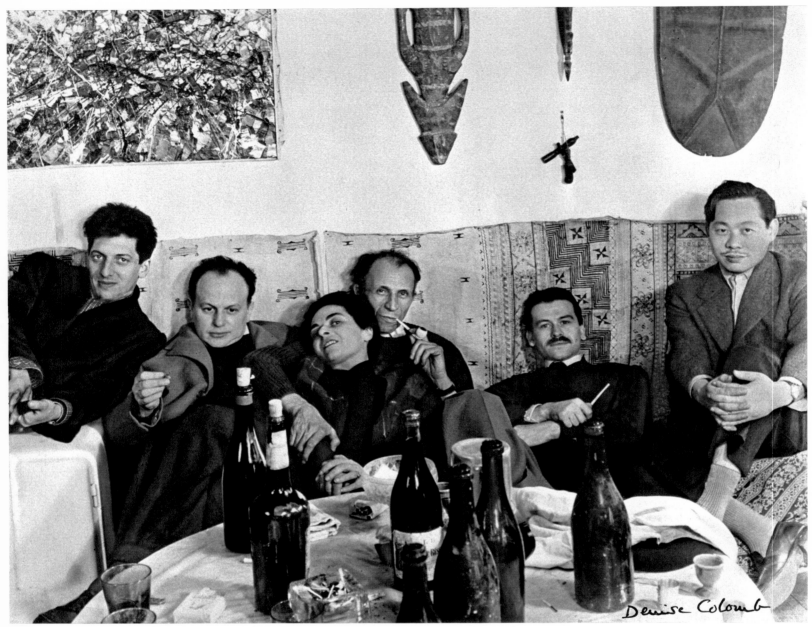

From left to right: Jean-Paul Riopelle, Germain, Vieira da Silva, Pierre Loeb, Georges Mathieu, Zao Wou-Ki, at the Galerie Pierre, 1952. Photo: Denise Colomb.

Friedländer, and produced quite a few works in this technique. Pierre Loeb, on Michaux's advice, came to his studio and offered him a contract in January 1950. A friend of poets and an enthusiastic collector of the sculpture of Africa and Oceania, this dealer has successfully maintained his personal style for forty years and has become almost a legend as the man who recognized and encouraged all the original artists when they were only starting. In his gallery — which had the air of a salon and, as one of the strongholds of Surrealism, was a discreet meeting-place for many distinguished visitors — Zao Wou-Ki found himself in friendly rivalry with Vieira da Silva, Georges Mathieu and Riopelle. Apart from Loeb's gallery and the Galerie René Drouin, which was then very important (Dubuffet, Fautrier and Wols had their first shows there), quite a few of the influential galleries in Paris were run by women: Colette Allendy, Lydia Conti (who was the first to show work by Hartung and Soulages), Denise René, Nina Dausset. In the effervescent postwar period these galleries were also places where artists could meet and where their work could be compared.

Thanks to his charm, his talent and his exotic background, Zao Wou-Ki made many friends in the various literary and artistic circles of Paris and soon became one of the best-known painters of his generation. Picasso, Miró and Giacometti encouraged him and followed his progress. Germaine Richier commissioned him (as she had commissioned Hartung and Vieira da Silva) to paint some screen-pictures for her sculptures. Léger, too, was flatteringly enthusiastic, though recognizing that the young Chinese painter's work and his own were poles apart. He said, in fact, that Zao Wou-Ki painted "in a mist", a succinct but apt description of the Chinese way of seeing things.

Zao Wou-Ki now began to broaden his range through travel. Following the example of the masters of classical Chinese painting, for whom travelling over their vast country and visiting the holy places of its different regions was as necessary a part of their training as the study of the great masterpieces, he now set out to visit France and the rest of Europe. In France he was anxious to visit, first of all, the Cézanne country around Aix-en-Provence and the museum of Grenoble with its collection of modern art, and after that the Roman monuments everywhere, the châteaux of the Loire (a river that reminded him a little of those of his own country) and the shores and offshore islands of the Atlantic coast. In the summer of 1950 he and Friedländer — who was later to partner him in many joint exhibitions of engravings — made a short stay in Saint-Jeoire-en-Faucigny, in the Alps of Haute Savoie. This picturesque village lies in the valley of the Giffre, not far from Geneva, and in the shadow of the Môle, an almost perfectly conical mountain which dominates the surrounding massif. Painted by Corot and sketched by Brueghel, the silhouette of the Môle had already

1954.

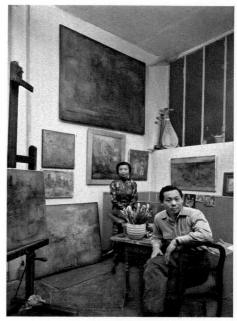

The studio at 51 bis, Rue du Moulin-Vert. 1953.
Photo: Dimitri Kessel.

1958. Photo: May Zao.

appeared in Conrad Witz's *Altar-piece of St Peter,* regarded as the first identifiable landscape in European painting. Western painters, with rare exceptions, always have difficulty in rendering mountain scenery, which is an integral part of Chinese landscape painting, the mountain-water *(shan-shui)* combination being a genre in itself. Zao Wou-Ki was enchanted to rediscover such familiar features as the overlapping voids and solids, rocks and mists, though bathed in another — rawer — light than that of his native land. He filled three sketch-books with splendid watercolours and wash drawings which, in their linear rhythm and luminous tones (light greens and blues with touches of red), their meticulous attention to detail and the animist feeling that pervaded the whole, are reminiscent of those European landscapes which came closest to the miraculous achievements of Chinese art: the watercolours Dürer painted during his sojourn in the Tyrol and the marvellous landscape drawings of the two masters of the Danube School, Altdorfer and Wolf Huber, which were also done in the Alps.

Later he made two extensive tours by car, during both of which he filled still more sketch-books (the last notes of this kind that he was to make). One was through Italy in 1951, the other round Spain in 1952. In Italy he visited, almost stone by stone, the principal centres of art — Rome, Florence, Venice, Naples, Ferrara — but also the territories of the Etruscans, the ancient ruins of Herculaneum and Pompeii, and the towns of Tuscany and Umbria: Siena, Arezzo, San Gimignano, Perugia, Assisi. In Spain he travelled through Catalonia, Castile and Andalusia. In Barcelona it was the Romanesque frescoes and the arts of the people that appealed most to him, in Madrid it was the Goya rooms in the Prado. He also admired the walls of Toledo and all the works of El Greco in that city, while as for Cordova, he loved it so much that he explored it to its last alleyway. In the same year he visited Holland, to see the Rembrandts there, and England, for the Turners; he was enchanted, too, by the Port of London and by the canals in Amsterdam. Exhibitions of his engravings (very successful exhibitions) took him to Switzerland in 1951 and to Germany in 1952. In Munich he wanted above all to see the Cranachs and the sketches by Rubens. In the museum in Bern he was finally able to study the Klee Foundation's vast collection of drawings and pictures by Klee himself, the contemporary painter to whom he then felt closest, and whose work he had been longing to know at first hand rather than through reproductions. He had arrived in Europe just a few weeks too late for the Klee exhibition held at the National Museum of Modern Art in Paris in February 1948, but he had heard all about it from the artists who had become friends of his, and for whom the discovery of Klee, when it came, had been no less decisive, Michaux and Vieira da Silva. Another of his friends and neighbours was Hans Reichel, a painter of German origin who had been very close to Klee from 1919 on, and who continued the great Swiss painter's teachings in a tender, dream-like fashion, with delicate watercolours which he called "my songs, my prayers, my little arias in

colour". Attracted, in his need for universality, by the literature and arts of the Far East (he dreamed of illustrating the Chinese poems he had read in Klabund's translation), Klee had succeeded in bringing about in his own work the interpenetration of painting, poetry and music, assigning (or restoring) to drawing its original function of writing, and capturing reality in its genesis and as a continuous flow. What he taught was not so much a way of painting as a way of looking. "Art," he maintained, "does not reproduce what is visible; it makes it visible."

Though he had arrived in Paris at the very moment when lyrical abstraction, or non-formal painting, was making its explosive entrance on the scene, and though he knew the leading figures in this genre and felt its influence, Zao Wou-Ki did not immediately or automatically join this movement. Faithful to what Kandinsky called "the inner need", which is the sole guarantee of any authentic adventure, it was not until some years later that he crossed this threshold. Appearances of the figurative persist until 1953 in the pictures, drawings and engravings that he produced alternately on subjects more often than not suggested by his travels or by his stay in Haute Savoie: mountain landscapes, town scenes, seascapes. In the paintings, still quite small and almost monochromatic, the essential feature is the line, which is incisive and sinuous, with accents that look as if they had been etched rather than drawn. All the treatises on Chinese painting (and calligraphy) emphasize the paramount importance of the line, the original and constituent value of a brushstroke that creates a form without imprisoning it in its own outlines. With the assurance of line that characterizes Chinese artists, Zao Wou-Ki proceeds according to a sort of pictographic condensation. The images, reduced to the barest framework, to their graphic nervous system, spread their spidery web over a surface as thinly coated as a watercolour, which reacts like a vibratory field rather than a plain, neutral background. Sandpapering or scraping effects sharpen the texture, with its varied nuances of a dominant tone: amber, emerald or turquoise.

Landscape has for centuries been the most important genre in Chinese art, with the scenery of the high mountains its constant theme. It has even been said that it plays the same role as the nude in European painting, and one could hardly find a better illustration of the aesthetic and mental difference between the two civilizations. In his mountain landscapes, Zao Wou-Ki goes back to certain ancestral conventions, such as views seen from above and from a distance, vertical arrangements and structures in parallel lines; but they are subordinated to the unity of the modern flat surface and its constructive tension. He draws the lines of the mountain ridges in all their geometrical magnificence without omitting the disc of the sun, articulates the areas of forest, houses and plants on their various levels, suggests the variable

Zao Wou-Ki, Nesto Jacometti, Nay, Otto Stangl.
Munich, 1952.

Playing Ku with Pierre Soulages. Tokyo, 1958.

1960. Photo: May Zao.

The studio in the Rue Jonquoy, 1964.
Photo: Weintrob.

density of the air and wittily places rather stiff human figures among the leaping deer, the supple-bending plants and the flying creatures of all sorts. Fauna and flora arouse all his verve. Insects and plants, flowers and birds, with their wealth of symbolism and the refinements of form and tone to which they so readily lend themselves, form one of the most solidly established and popular categories in Chinese art.

The paintings Zao Wou-Ki did inspired by the piazzas of old Italian cities like Siena, Arezzo and Venice, and their theatrically arranged monuments, belong, on the other hand, to a typically European genre (to which they make a singular contribution): the architectural picture or townscape, depicting squares of medieval, non-rectilinear shapes, at that time devoid of tourists. In these paintings topographical veracity yields place to the artist's wondering admiration, his foreign way of seeing things, the airy rhythm of his work. The proportions are elongated and the spindly human figures, stretched as taut as any of Giacometti's, fix the scale on curving, off-centre axes. Warm colours ranging from ochre to red, to suit the subject, have replaced the cold, bluish tones of the mountain landscapes. Zao Wou-Ki adores travelling, not only for the beauty of the discoveries to be made but also because each journey gives him a new charge of energy and modifies his perspectives in every sense of the term. Chinese space, which is that of the whole of nature rather than of man and his works, is a space of dreams and distant contemplation. Western space — which is anthropomorphic, adapted to the human scale and the rhythm of architecture — is a space that is close, realistic and inhabited.

Arezzo (Henri Michaux Collection, Paris), on its hill, marks the transition from the artist's landscapes of Haute Savoie to his Italian works. The figure standing over the central space acts as a landmark that gives us our bearings in the total space (in Chinese art the centre is regarded as a fifth cardinal point) and helps to situate the monuments at the end of the twisting streets. *Piazza Siena* (in the artist's own collection) spreads the scallop-shaped Piazza del Campo over a small, almost square canvas that is the colour of burning earth. Venice, of course, which has enchanted so many painters with its potpourri of styles, its inversion of voids and solids, its Byzantine domes that seem to be just as light as Chinese buildings, inevitably captivated Zao Wou-Ki too. His version of the *Piazza San Marco* (National Museum of Modern Art, Paris), in which a tumult of pigeons expands the space between the Basilica and the courting couple, recaptures to some extent the rather naive, oriental feeling of Bellini and Carpaccio, the first artist to record the Venetian scene, yet avoids the illusionistic concept of the classic *veduta,* the fidelity of which was based on strict adherence to the laws of perspective. Finally, in *Restoration of the Old Castle,* a picture he finished in December 1952 and exhibited at the Salon de Mai in 1953, the great fortress of Ferrara rises impressively against a reddish

background, with its drawbridges, its towers and the team of builder's labourers scurrying about their tasks.

Notre-Dame, depicting the historic complex of the great church and the Ile de la Cité, is one of Zao Wou-Ki's rare townscapes inspired by Paris and is closely related — both stylistically and chronologically — to his Italian series. On a rectangle of hessian thinly covered in grey or brown tones, the densely arrayed or slowly meandering lines create all the majesty of the buildings, follow the course of the river under the bridges and loiter with the strollers and anglers along the banks. A comparison might be made with the work Vieira da Silva was doing at that time — in which the town, with its stations, building sites and mazes of alleys, was also the pretext — on account of the similar role of the graphic system, of paramount importance in both. The discontinuous network of lines, with its thrusts and counterthrusts, its labyrinths and gaps, internalizes the space that opens and closes along its path.

In 1952, in addition to all these townscapes and seascapes, Zao Wou-Ki painted about ten still lifes. Reproduced in colour in this book is *Still life with grapes and walnuts,* which also contains a Ming vase chosen for its rustic air and its blue tones. The composition, owing something to Cézanne in style but wholly Chinese in its rhythm, is divided into three parallel horizontal sections, the top and bottom one — in ochre-pink — which are decorative in function, and the middle one in blue-green forming the top of the table and bearing the motif of the title. Still life, a genre which is particularly appropriate to plastic harmonies or metaphorical suggestions, and one which in contemporary western painting has become the favourite territory of the Cubists and Surrealists, originally implied a desire to let the objects dominate their domestic setting and utility. But Chinese artists are reluctant to include manufactured objects in a picture, lest they break the natural rhythm on which its vigour is based. The open surface on which the freely-spaced grapes and walnuts are drawn in this picture is like an inverted landscape.

Except for an occasional study of swirling waves after the fashion of Leonardo da Vinci, seascapes are rather rare in Chinese painting, for the water in the classic landscape, usually associated with mountains, is the water of rivers or lakes, streams or waterfalls, or else water dispersed in clouds and mists. A popular Chinese subject, very suitable for linear techniques and taken up afresh by Zao Wou-Ki during his early days in Paris, is that of the angler sitting motionless on a river bank lined with quivering reeds, the green expanse punctuated by touches of bright red. The more independent Chinese painters loved to retire to the shores of some fish-stocked lake, where they found nourishment and calm; and the first to do this, painters of the T'ang period, used to do their angling without any bait, like the Taoist sages.

May and Wou-Ki in the garden (Rue Jonquoy). 1963. Photo: Sin-May.

May and Wou-Ki. 1964. Photo: Weintrob.

With Thérèse and Alfred Manessier in New York. 1962.

White sail, with its two main tones (sky and sea) and the use of a comb to draw the lines of the waves, is a delightful little seascape that is half-way between Whistler and Max Ernst.

When Zao Wou-Ki visited Belgium and Holland, he was dazzled by the fantastic spectacle of the ports of Antwerp and Amsterdam; and it was in the museums of these two countries that he discovered the true specialists in seascapes. In *Ships in port* (Virgin Island Museum, St. Thomas), the profusion of lines becomes even greater to express the bustling life of the shipyards, chock-a-block with cranes, and the forest of sailing-boat masts over the gleaming water. The panoramic view of the Pool of London seen from above in *Coming into port* (Herbert F. Johnson Museum of Art, Ithaca, New York) is at once a seascape and a townscape. The pictographic crystallization still operates on a foundation of fine lines in a delicate harmony of ash-grey and aquamarine, but there is a secret fermentation at work which penetrates the more fluid pictorial substance and disintegrates the figurative strata.

In the postwar years in Paris there was a great revival in the entertainment arts and young painters were sometimes commissioned to design the décor for stage productions. At the Théâtre de l'Empire, in the spring of 1953, Roland Petit's company presented *La perle,* a ballet in one act based on a libretto by Louise de Vilmorin, with music by Claude Pascal and choreography by Victor Gsovsky. The plot is taken from the Japanese legend of the young man whose beloved has been bewitched by a swan, and who decides to transform himself into a bird to win her back, but succeeds only in becoming a laughing-stock. For this ballet Zao Wou-Ki created a simple, light-filled setting in yellow with streaks of black.

The transition to total abstraction was made between 1953 and 1957, by means of signs devised as supports in this crossing of the threshold of appearances. These invented signs did not come, as has often been said, from calligraphy, which Zao Wou-Ki has always thought of as a handwriting, with rules and a meaning of its own, but rather from more remote and mysterious sources; the archaic inscriptions incised, between 1500 and 1000 B.C., on the augural bones and ritual bronzes of the Chang dynasty. These witnesses to such a remote past have been only recently discovered and have not yet yielded up all their secrets. But their striking and enigmatic beauty, in which we find the spirals of the steppes, square ideograms and a mythical bestiary, have the same fascination for Zao Wou-Ki as the still undeciphered prehistoric carvings in the Spanish caves have for Miró. It is something of their magic power rather than their density of symbolism that we find in the signs they have inspired Zao Wou-Ki to invent for the necessities of his development as a painter. A similar experience, though in the opposite

direction, was that of the German painter Julius Bissier (1893-1965), one of the most honest and discreet pioneers of lyrical abstraction. Initiated into the techniques and philosophies of the Far East at an early age by the great sinologist Ernst Grosse, during the dark years of the Third Reich he devoted himself entirely — for reasons of discipline and asceticism — to monochrome wash drawings in India ink. These wash drawings, which were abstract at first, soon came to include symbols taken from the funerary motifs of the ancient burial grounds which had first come to his knowledge through the remarkable studies published by the historian Bachofen. These symbols, or elementary motifs, were unchanging in their structure, but the figuration varied: circles, squares, arrows — walnuts, pomegranates, scallops — lamps, vases, urns — eggs, birds, serpents, etc. Rhythmically integrated into the spontaneous movement of the drawing, their true significance was of less importance than their scriptural character and their mysterious vibrations. "Symbols," wrote Bissier, "are mute allegories which the viewer seldom understands, but which he feels to be something inexpressible or appealing."

1963. Photo: May Zao.

Technical changes always have aesthetic justifications. In 1953, the decisive year, Zao Wou-Ki replaced the round-tipped brushes he had used up to then, for their delicate strokes and the fine film of colour they produced, with flat, rectangular ones that gave broader strokes and a thicker, more fluid coat of paint. His mastery of the western idiom grew ever more assured, though he took good care not to lose his native expertise with the brush. For the Chinese not only invented the soft-bristled brush, the most sensitive painting and writing instrument in the world, together with its supports of silk and paper, but also devised the rules for its proper handling, which entail discipline just as severe, and of much the same nature, as that of fingering for a pianist. In his *Discourse on Painting* — written in the early 17th century, as a sort of compendium of earlier theoretical and practical treatises, and giving absolute and universal pride of place to the *single brushstroke* — Shi Tao, the last of the great independent painter-monks, devoted one of the first paragraphs, and the whole of the sixth chapter, to the *movements of the wrist*. "One should work," he concluded, "with an easy assurance, and freehand, and then the brushstroke will be capable of swift metamorphoses. If the brush begins and ends its strokes incisively, the form will never be awkward or uncertain. A firm wrist will give the brush sufficient weight to penetrate deeply, while a looser wrist will let the brush dance and fly with gay insouciance. Hold the wrist straight, and it uses the tip of the brush; bend it, and the brush will move slantwise. If the brush moves faster, the stroke is stronger; a slow-moving wrist produces delicious curves. All these various positions of the wrist, in short, can create effects of an entirely unconstrained character; its metamorphoses give rise to unforeseen and even bizarre effects; its eccentricities work

In Mexico with Olga and Rufino Tamayo and his cousin. 1969.

With Jacques Lassaigne. 1972.
Photo: André Morain.

With Pierre Schneider and Raimond Herbert. 1972.
Photo: André Morain.

With Danielle and Vadime Elisseeff, and Jean
Lescure.
Photo: André Morain.

miracles — and when the wrist is animated by the spirit, rivers and mountains deliver up their souls!"

It is the hand — with the palm properly hollowed and the fingers tightly clenched — that holds the brush; but it is the wrist alone, as a prolongation of the free, unsupported arm, that must move, according to one old writer, with the suppleness of a goose's neck. The infinite variations of direction, pressure or speed imparted to the brush are made in response to the nature of the subject or the quality of the stroke and express the evolution of the artist's inner life. Chinese painters have no tradition of framing their pictures or supporting them on easels; they first lay their horizontal or vertical rolls on the floor, or on a low table, and then paint them in a direction that goes from right to left and from top to bottom. Zao Wou-Ki, too, paints his canvases without an easel, sometimes propping them against the wall and sometimes laying them on the floor. This direct way of letting the task in hand absorb one, becoming one with the work itself, was one of the characteristics of that abstract painting of an organic or non-formal tendency which was then becoming popular all over the world and, in the United States, was developing into the potent and original style known as Action Painting. "I prefer," said its leader, Jackson Pollock, "to attach the unframed canvas directly to the wall, or else to leave it flat on the floor. I need the resistance of a hard surface. On the floor I feel more at ease. I feel closer to my painting and can identify with it better because I can walk around it, work on all four sides at once and place myself literally *inside* the picture."

In a composition in green with pink gleams that he did in 1953 (Mme R. Cartier Collection, Paris), the shorthand Wao Zou-Ki had evolved for trees, birds, human figures or the sun can still be identified in its different elements scattered all over the surface in a rather offhand way, and with a fairly uniform texture. A few months later, however, this arrangement of pictographs in a network of fine, continuous lines had disappeared. Unrelated to appearances, and with a powerful structure deriving from the primitive signs incised on bronze or bone, invented signs now emerged to create an organic environment of variable density and with contrasting tensions. Of the two 1954 works that mark this change, one was *Black moon* and was painted early in the year, the other was *Wind,* which was done in December. Here we might well consider these lines by Li Po, the great T'ang poet:

> *The moon and the wind are always my friends:*
> *My fellow men here below*
> *Are but travelling companions.*

If it is true that ideograms were created in the likeness of constellations, then all writing, however arbitrary, must have its astral references. The

signs made of dark filaments on a blue-green ground evoking *Black moon* come together towards the centre to form a nebula, leaving the edges empty. As for the wind, which in the words of Wang Po, another great T'ang poet, "comes and goes, but leaves no trace", and is therefore a model of perfect activity (in truly accomplished Chinese painting no trace of the brush should be visible), it is the breathing of the earth, the very afflatus of celestial space. To ride on the wind has always been the dream of poets and sages. The picture entitled *Wind* — which the painter has kept for himself, as being the principal evidence of his transformation — is a narrow, vertical painting, more than twice as high as it is long, a format the artist was to use again from time to time. The signs, white-sheathed black fibrillae springing from a source of energy at the bottom of the picture, rise in two slender columns, one on the left and the other in the middle. Their course is like a magnetic flux crossing the vast, empty space of the pictorial area, which is rendered in half-tones and transparencies in an almost monochrome combination of grey and purple enlivened by a hint of yellow. Varying the light with the signs was still rather difficult, which explains the uniformity of the colour.

In this picture the void plays a most important role and is given a new meaning. We know how essential this notion of the void as something active is to Chinese aesthetics and philosophy. Lao Tzu, the founder of Taoism, reminds us that the basic virtue of a vase or a house is that of being a receptacle; and in a striking image he compares the infinite space between earth and sky to a blacksmith's bellows perpetually blowing. Painting is based on the rhythmic throbbing between voids and solids, the void being that dimension in depth which binds the elements to one another and to the viewer, and introduces the notion of time into the space circuit. Since the Impressionists the void has undoubtedly occupied an increasingly important place in modern painting, but it is still regarded more often than not as a surface held in reserve, the whiteness of the canvas being very lightly covered or even left bare. But for Zao Wou-Ki the void is a surface in its own right, demanding more complex and elaborate treatment than the other parts of the picture, and its *vibrations* are poles apart from those of the "perforated" void of western painting.

In the introduction to his remarkable anthology of the T'ang period, François Cheng reveals that the void also governs *Chinese poetic writing* and its inner cadences. "The void gives a form to the vase as music gives one to silence," wrote Braque, in those notebooks of his that are so steeped in eastern wisdom. While contemporary western art — and, more particularly, abstract art — aspires to the status of music, painting and music in China have always been closely linked and the necessarily sequential nature of painting on rolls opens up a communication of the same nature as that of music. In his rigorous and

Zao Wou-Ki with Myriam Prévot-Douatte, his daughter Sin-May, Bert Leefmans and Hans Hartung. 1972
Photo: André Morain.

With Michel Leiris. 1972. Photo: André Morain.

With Cyrille Koupernick, Micheline Ravoire, Henri Michaux, René Ravoire and Myriam Prévot-Douatte (with her back to the camera).
Photo: André Morain.

1972. Photo: André Morain.

With Gildo Caputo, in front of a sculpture by May.
1972. Photo: André Morain.

closely-written essay on Zao Wou-Ki's pictorial syntax and its development, Jean Laude — who specializes in the relationships between the exotic arts and the modern arts — when he comes to the critical year of 1954, institutes a useful analogy between painting and music, which were then undergoing parallel transformations brought about by their resorting to variable structures and open combinations. Zao Wou-Ki was one of the first members of the *Domaine musical*, founded by Boulez in the autumn of 1954 precisely in order to introduce the public to the changes effected, in composition, execution and even listening, by the serial method and the electronic system. A devoted aficionado of Bach, and even more so of Mozart (he plays his favourite records at work and loves to sing Mozart arias), among his favourite modern composers Zao Wou-Ki immediately mentions Debussy, Bartok, Satie and Webern, whom he prefers to Schoenberg, Stravinsky or Stockhausen. But the composer (they first met in 1954) for whom he felt a truly reverent affection until they were separated by death in 1965, and the one who had the most lasting influence on his work, was the prophetic Edgar Varèse. After an absence of twenty years, Varèse returned to Paris at the beginning of October 1954 and stayed there until the end of January 1955. Passionately interested in the relationships between sounds and light, his closest friends had always been painters and sculptors — Picasso, Léger, Miró, Calder, Giacometti — and his wife, Louise, had translated the works of poets who were also very good friends of his, like Saint-John Perse and Michaux. At a time when he was still largely misunderstood and little-known in his own country, Zao Wou-Ki, who admired his work enormously, was almost at once admitted to his circle of intimates and remained one of his staunchest friends until Varèse's death. After the first performance of *Déserts* at the Théâtre des Champs-Élysées on 2nd December 1954 — which caused just as great a scandal as had Stravinsky's *Sacre du Printemps* forty years earlier — Varèse spent part of the night at the house of the young architect Xenakis; and it was Zao Wou-Ki who took him, at dawn, to catch his plane for Hamburg, where the second performance was to take place. In this work — entitled *Déserts,* in the plural, because for its composer it meant not only the physical desert but also the moral desert that each man's essential solitude creates within him — the intervals of silence are charged with as much intensity as the paroxysms of sound. The music, based on opposing volumes and planes, and combining in antiphonal form the normal playing of the orchestra with interpolations of recorded sound, rises from the very roots of the earth to the stars, troubling the whole of space with its sublime power.

With the picture entitled *Wind,* at once a recapitulation and a break with the past, Zao Wou-Ki's painting began to develop with new energy, thanks to the provisional support of the signs, which grew larger and more intense before disappearing altogether. First shown at

the 1954 Salon de Mai, at which Matisse's great cut-out gouaches caused such a sensation, *Tracks in the city* (Private collection, Amsterdam), in which he again makes use of the comb, still belongs to the previous stage, with its delicate streaks evenly applied. The Chinese term *wen,* which has finally come to mean language, style or civilization, was originally applied to the spoor of animals or the traces of plants, the grain of wood or the graining of stone — in short, to the spontaneous "tracks" of nature, models and warranties of the human signs which are the "imprints of the heart". In contrast to European illusionism, with its projecting volumes, oriental painting dissolves its forms and condenses its signs. The abstract signs, the appearance of which is previous to their significance, are original compounds of mind and matter, nuclei of energy which catalyse space and reveal subjectivity. With a punctuation of the light that is in rhythm with the impulses of each passing moment, the intimate journal written in Zao Wou-Ki's canvases is revealed to us. The formats grow larger and the meditative grace of his earlier work becomes a turbulence of passion. At this time the painter was going through a profound crisis that ended with his separation from Lan-lan, his companion from the age of sixteen, after a dramatic struggle of which the 1957 *We two* (Fogg Art Museum, Harvard University), with its violent confrontation of black signs, is the final evidence.

The first rumblings came from some works with a sulphurous atmosphere, such as *Before the storm* (Tate Gallery, London) and *Black crowd* (Carnegie Institute, Pittsburgh), and the storm itself really broke in vast compositions of leaping flames, like *The fire* (National Museum of Modern Art, Paris), or of seismic upheavals, like *Riven mountain* (Walker Art Center, Minneapolis). The flames ravaging the city or licking the mountain slopes glow fiercely in the shadows haunted by black spectres. *The night is stirring* (The Art Institute, Chicago), with a title taken from Michaux, indicates this stormy, nocturnal phase that coincides with the artist's forsaking of formal appearances. There is an explosion of vivid colour, lacquer reds and cobalt blues, laid in thin, transparent coats or kneaded into thickness, and then thrown upon the whirlwind of the light and the signs on their vertical axis. *Mistral,* a masterpiece immediately acquired by the Solomon R. Guggenheim Museum of New York, was the last of this series; in it the whirlwind has changed its course and now spreads transversally. The dispersed signs cluster together, absorbed by the gesture, and fusion takes place between the dynamic sweep of that same gesture and the luminous splendour of the colours — carmine and ultramarine, black ivory and white mother-of-pearl, in superimposed layers. The mistral, that raging wind of Provence that always howls louder at night, is here ridden by the dragon of Chinese legend, "breaking his bonds", as the saying goes, and taking wing in the gathering darkness.

With Claude Roy, and Nicole and André Tedesco.
Photo: André Morain.

With his brother Wu-Wai at Fontainebleau. 1973.

In the midst of all this emotional upheaval, Zao Wou-Ki's thoughts turned yearningly to China, which was all the more present in his heart now that his physical absence from it was redoubled. In an attempt to rally his spirits, he gave one of his glowing canvases the title *Homage to Tu Fu* — Li Po's great friend and rival. In these two poets, who represent the two supreme and complementary aspects of Chinese lyricism, the frequently dramatic vicissitudes of fate never subdued the surge of genius or the independence of their characters. Another work of this period is *Stele for a friend* (Galerie Stangl, Munich), an apparent high-relief in dark brown on a coppery-red background, and beside it a white banner (the colour of mourning) with funerary signs, which commemorates a fellow student at the School of Fine Arts in Hangchow. Victor Segalen speaks in one of his books about these "flat-fronted" stelae standing out against the Chinese horizon, which face different ways according to their nature and function, and which are complete beings, at once epigraphs and statues, bodies of stone inhabited by the souls of their signs.

A feeling for art is inseparable from a feeling for nature, and all over the world, but above all in China and Japan, gardens — our images of paradise — have always delighted art-lovers. In his various residences, Zao Wou-Ki's father always had a garden, which he looked after himself with the greatest care. And this memory is charmingly evoked in the little canvas entitled *My father's garden,* which is like a fragrant, miniature flower-piece. The hazards of war had taken Zao Wou-Ki into different regions of China, their scenery varying from tranquil plains to towering massifs, but the countryside recalled in *My country* (Private collection, Paris) as a maternal refuge is rather that of the lakes, floating expanses with golden mirages. To his eyes the light that comes closest to that of his homeland is the soft, misty light in tones of almond or amber that one finds *Near the Loire* (Wadsworth Atheneum, Hartford, Connecticut). But there are several canvases painted around this time on the theme of *Le fleuve* — rivers with wavy trails of ripples and airy music, rivers slowly winding their way across the land and reflecting the sky, identifying with the flow of memory and periodically transforming space into time. "Water," we are told by Claudel, who knew China well, "is the gaze of the earth, its device for looking at time." Zao Wou-Ki — like so many other painters of his generation, from Sam Francis to Riopelle — was at that time fascinated by Monet and by the eastern magic of his *Water lilies.* "In Monet," he says, "there are no longer any boundaries between things, nature and air. In the *Water lilies* everything blends into a single block."

The strange pool that mirrors the clouds, watched over by the immense "eyes" of the flowers, became his symbol of pictorial activity and its germinating surface. Other canvases — *Burgeoning* (Galerie de France), for instance, in which the forces of eruption thrust outwards

from a central nucleus — are reminiscent of the work of Wols, that visionary of the microcrosmos who pioneered the existentialist approach. The break with formal appearances, and their disintegration into clouds of red and pink, is finally consummated in *And the earth was without form* (Private collection, Switzerland), which indicates a return to the original chaos, whence creative energy comes. From about this point on, he ceased to give titles to his pictures, which had become independent organisms. One of them (now in the Nagaoka Museum of Contemporary Art in Japan), a composition in sombre, pathetic tones, sooty blacks and browns or deep blues and violets springing forth from the interior, with white accents on the surface, attains to the considerable dimensions of two metres by three, a size that is needed for the unencumbered sweep of the gesture and the proper handling of this tumultuous composition.

1975. Photo: Olivier Garros.

In May 1957, Zao Wou-Ki had his first one-man show at the Galerie de France — at which he still shows, along with other abstract painters such as Soulages, Hartung and Manessier. He is very much aware — and he has, indeed, been quoted to this effect by Georges Charbonnier in his *Monologue du peintre* — that no artist today can achieve more than one facet of the complete crystal they all aspire to create. At his new gallery he showed twelve of his most recent canvases, which set the seal on his transition to abstraction by means of the provisional expedient of signs. "This slow disintegration of the sign in the pictorial space," wrote Pierre Restany, "increases the rhythmic harmony of the whole." Yvon Taillandier described the largest of the pictures, the one in Nagaoka which I have already mentioned, as being "like a floating island, a volcano in eruption, a swarm of insects, the flashing of sunlight through a translucid veil, etc." Frank Elgar, for his part, saw, "within a specifically Chinese space, an effervescence of western light". This exhibition also gave rise to the publication of a short but brilliant and enthusiastic monograph by the poet Claude Roy, whose endeavours to see the art forms of the whole world through a modern eye had led him to China among other places. Modern transport facilities have indeed made round-the-world travelling accessible to contemporary artists with universalist leanings.

1975. Photo: Olivier Garros.

In an attempt to take his mind off his personal troubles, and also to broaden his experience and his vision of things, in September of the same year Zao Wou-Ki set out on a long journey without any fixed itinerary. He went first to New York, where paintings and watercolours of his had been shown in January 1956, at the Kleeman Gallery, and had been compared to the work of Tobey on account of their poetic charm and subtlety of allusion. Much influenced by his years on the Pacific coast, and with a great attraction to Asia, Tobey, the creator of "white writing", had visited China and Japan in 1934 to study calligraphy and wash-drawing techniques. Zao Wou-Ki stayed with his

With Arpad Szénes and Vieira da Silva. 1973.
Photo: D. Rabourdin.

With Hans Hartung. 1973. Photo: D. Rabourdin.

engineer brother Wu-wai and renewed his acquaintance with Varèse and with one of his own earliest admirers, the brilliant architect I. M. Pei, whose family in China was related to his own. He was, inevitably, overwhelmed by New York as a phenomenon among cities, a centre of the arts and a bewildering collection of museums and private collections. He was now able to admire, first-hand, the straightforward, invigorating effect of American painting, of which he had already seen something in Paris, and to meet several American artists: Kline, Guston, Marca-Relli, Gottlieb and Baziotes. He also met Samuel Kootz, a well-informed connoisseur with no nationalistic prejudices, who was to be the painter's American dealer until his gallery closed ten years later. Kootz held regular exhibitions of Zao Wou-Ki's work and each one was an excuse for the artist to return to New York and broaden his acquaintance among American artists and collectors.

During the three months he stayed at his brother's house in New Jersey, Zao Wou-Ki painted a very large oblong picture — exactly the length of the wall in his bedroom there — which his brother later presented to the Detroit Institute of Art. With its muted luminous power and its convulsive development, it is at once a dramatic confession and a splendid summing-up of his achievement as a painter. He was now joined by Pierre and Colette Soulages, and together they visited Philadelphia, Washington (where they lingered admiringly over the superb Asian collection in the Freer Gallery), Chicago and San Francisco. Zao Wou-Ki was enchanted by San Francisco's magnificent situation and he particularly enjoyed exploring Chinatown. The two painters were very different in temperament — the one basing his rhythm on architecture, the other on dancing — and they spent much of their time comparing their reactions to the masterpieces of all kinds that they discovered together in such profusion. After a short stay among the flower and pineapple plantations on one of the Hawaiian islands, they went on together to Japan, where they visited Tokyo, Kyoto and Nara, and finally separated in Hong Kong. Soulages and his wife continued their journey to India, while Zao Wou-Ki remained in Hong Kong for several months, where he lived constantly in a Chinese atmosphere, though not permitted to enter China itself.

In Hong Kong he met Chan May-Kan, a young actress of rare and striking beauty, whom he married there and brought back to Paris in August 1958, after a wedding journey that included Thailand and those cradles of western art, Greece and Italy. They also visited Brussels, during the International Exhibition, to attend the first performance of Varèse's *Poème électronique,* in the pavilion specially designed by Le Corbusier and Xenakis for the spatial diffusion of this pioneer piece of computer music.

Of the nine pictures that he painted in Hong Kong — in a studio overlooking the bay, flooded with the light from sky and sea, and filled

with eastern motifs, books and objects — Zao Wou-Ki retained only what he considered the purest: a nebula of calligraphic curves drifting through the clear air, a jellyfish stretching its tentacles through crystalline waters (Private collection, U.S.A.).

Gradually regaining something of happiness, dazzled afresh by the light surrounding him in Paris, he freed himself from the pressure of signs, the tension of gesture, the weight of colour, and came to the breath of the void, the grace of transparency. The pictures he painted on his return in 1958, most of them now in the United States, are characterized by a new fluidity and a suspended modulation. The composition in the Art Institute of Chicago is based on a diagonal rhythm of red and black elements surrounded by whites; the one in the Hirshhorn Museum in Washington, in the brown tones of a wash drawing, is the first of his works to invert the traditional relationship between earth and sky by placing the dark, heavy masses in the upper part of the canvas with the clear, light ones beneath them, the balance being ensured by the linear vibration.

After his return from China. 1972.
Photo: Jean-Régis Roustan.

Zao Wou-Ki would find it intolerable to live in an apartment that gave him no direct contact with the earth. Towards the end of 1959 he bought a small house with a garden in the Rue Jonquoy; the same quiet neighbourhood in Montparnasse to which he had grown so accustomed. Then he engaged the architect Georges Johannet, who had just executed similar commissions for Vieira da Silva and Hadju, to make a studio to measure for him there — a large, windowless room lit by a grid of skylights, a place to work and meditate in. The small garden with an oriental air between the studio and the house — which was charmingly decorated by May — contains green plants, flowers, some sculpture, a cherry tree and a goldfish pool. One enters the house at street level by this rustic passage, which takes one immediately from the noise and fumes of the town to the painter's home, simple but refined and filled with his art treasures. For the classic artists of China the fact that there were no public museums made collecting a matter of necessity; and the literary-minded painters of the Sung dynasty, with whose traditions Zao Wou-Ki feels such strong links, were all passionate collectors, both for their own pleasure and by reason of their sensitivity to culture and their spiritual discipline. Mi Fu, for instance, never travelled anywhere without the treasures that he cherished with anxious care. His taste and judgment were impeccable and he considered the true connoisseur, as distinct from the mere lover of art, to be as indispensable to the life of art as the creator of the art himself. Apart from examples of Chinese art in such diverse forms as bronzes, statuettes, pottery, plaques and stelae, and for want of original paintings, calligraphy or engravings of the great classic periods, Zao Wou-Ki has collected, for his own instruction and enjoyment, specimens of the ancient arts that have impressed him most: prehistoric, Mesopotamian, Egyptian, pre-Hellenic, Mexican

With his mother and his youngest sister, Wou-hsi, in Soochow. 1974.

With Conrad Marca-Relli in Ibiza. 1975.
Photo: Sin-May.

With Pierre Soulages, Mrs Rosenberg and James J.
Sweeney. 1973. Photo: André Morain.

1974. Photo: Henri Cartier-Bresson.

and African. He has also built up, by exchange or purchase, a personal anthology of contemporary art. Thus, he owns drawings by Matisse, Picasso, Klee, Miró, Max Ernst, Reichel, Giacometti, Tobey, Wols, Dubuffet, Kline, Jorn and Matta, as well as paintings or drawings by his friends and fellow painters Michaux, Hartung, Soulages, Manessier, Riopelle, Joan Mitchell, Vieira da Silva, Szènes, Sugaï, Marca-Relli, Singier and Musie, or by such younger confrères as J. M. Meurice and B. Saby.

The proper designation of abstract pictures is a delicate problem. Some painters follow a strictly numerary system year by year, while others give their pictures names suggested by the colours. In this regard Zao Wou-Ki deals with his canvases as if they were human beings, giving each one as it were its birth certificate, with its size and the date of birth — that is to say the exact day on which it was finished, after its long or short gestation period — in order to give it its proper place in the time sequence that relates work to life, while the figures for height and width establish its physical aspect and have also determined the pace of its execution. The artist first began to do this in 1959, the year in which, with the approach of his forties, he had gone back to his original sources and had attained his maturity. A little later — in 1961, to be precise — he said, in the course of an interview: "Though the influence of Paris on the evolution of my career is undeniable, I must also say that I have gradually rediscovered China as my artistic personality developed, and this is intrinsically expressed in my most recent canvases. Paradoxically, it is to Paris that I am indebted for this return to my most profound origins." Which helps to explain why Zao Wou-Ki was the most significant contemporary painter exhibiting at the fascinating East-West "confrontation" organized at the Musée Cernuschi during the winter of 1958-1959.

His 1959 pictures, with their rich, soft colours, were painted in four or five types of the fairly large formats he had by then adopted, all of them admitting innumerable rhythmical combinations along horizontal, vertical or diagonal axes, and especially by activating that nerve-point at the centre which the Chinese call the fifth cardinal point, and in which the centripetal or centrifugal power opposes the rigidity of the rectangular system. Bonnard is perhaps the only western painter who comes close to the eastern way of seeing things, with the centrifugal character of his compositions that go beyond the edges of the canvas and thus suggest the invisible part of space and its mysterious aura. As regards technique, apart from the supple handling of the brush the really essential factors in any understanding of Zao Wou-Ki's evolution are the ideas of the active void and the central nucleus. The sign-elements now lost the appearance of engraving altogether and either spread all over the coloured surface in twisting currents or clustered in masses of effervescence subsiding at the edges. These

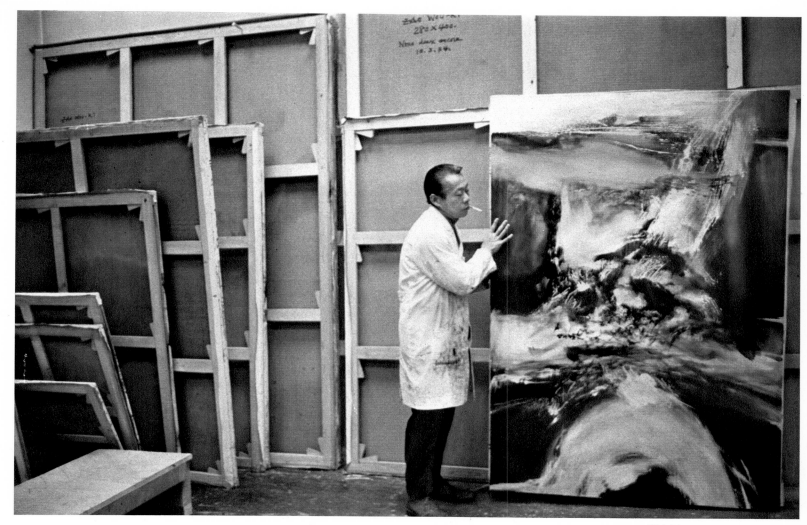

1974. Photo: Henri Cartier-Bresson.

experiments were made in *all directions*; the canvas "entitled" *2-4-59* (Private collection, London), for instance, rather daringly introduces the composition in the form of a cross, which is forbidden by the Chinese rules (for bamboos never overlap in nature). And this composition appears again, repeating the transversal axis *(14-3-60)*, in a movement of intersecting creepers, or on a vertical axis *(10-12-60)*, in a sort of geyser or will-o'-the-wisp.

In June and July 1960, Zao Wou-Ki had his second exhibition at the Galerie de France. The introduction to the catalogue was written by Myriam Prévot, the prime mover of the gallery and a very popular figure in the artistic world. When she questioned Zao Wou-Ki on the meaning of his work and its spiritual climate, he inevitably referred to his Chinese sources, speaking of his favourite books, the ancient treatises of Taoist wisdom, and particularly to the cosmogonic lyricism

At Strasbourg for the performances of the ballets of the Opéra du Rhin. 1975.
From left to right: Zao Wou-Ki, Françoise Marquet, Pierre Schneider, Geneviève Baude, Raymond Haas, Juliette Haas and Gildo Caputo. Photo: Sin-May.

The Wonderful Mandarin, by Béla Bartók
Photo: Sabine Strosser.

of Chuang Tzu, which he aspired to emulate within his own artistic context:

In the northern ocean there lives a huge fish that can take on the shape of a bird. When this bird takes flight, its wings spread over the sky like clouds. Skimming over the waves on its way to the south, it flies low for a distance of three thousand stadia, then soars on the wind to a height of ninety thousand stadia, in the space of six months. What do we see up there in the blue? Is it herds of wild horses galloping? Is it a cloud of swirling dust? Is it the winds that breathe life into beings? And is that blue sky Heaven itself? Or is it simply the colour of remote infinity, in which Heaven, the personal being of the Annals and the Odes, lies hidden?

With its froth of blacks and whites on a swell of blue and violet, the large-format *6-1-60* (Private collection, Paris) was painted, without retouching or interruption, in a single night. A tour de force of this kind, which the classical Chinese painters could bring off after a long period of brooding, is quite unique for Zao Wou-Ki, who normally works by daylight and does not go in for the present mode of speed and immediate effects. In the spring of 1961, a selection of his works was shown in Tokyo. The Japanese critics were quick to point out the European feeling of the light in these paintings, as it contrasted with the polyvalent conception of the space, which belonged rather to the Asian tradition. One of these critics, Takashima, particularly noticed the often dramatic tone of the painter's inspiration, observing that he seemed to confess his pessimism in his watercolours, but to fight against it in his oils. At his annual show in New York in the autumn, however, what struck the critics most was the broadening of his style and the new richness of both the colour, in a range of reds and oranges, and the texture, which was light or woody. For some years after 1961 he sometimes resorted to the palette knife, already used by Courbet and Cézanne to give their brushstrokes greater solidity, and favoured by the gestural painters as an ideal tool on account of its rapidity and its direct control of the paint, whether in spreading it or in scraping it off.

On the occasion of his Madrid exhibition in April 1962, he and May spent a month travelling around Spain, that country of violent contrasts in which the hard earth and the flame of mysticism attracted Zao Wou-Ki so strongly. He also renewed his acquaintance with Velázquez and Goya, those inexhaustible sources of modern art, supreme masters of greys and blacks.

November of the same year saw the presentation, at the La Hune bookshop, of the ten six-colour lithographs done by Zao Wou-Ki to illustrate one of André Malraux's first books, *La Tentation de l'Occident,* a brilliantly-written comparative study of France and China with regard to the erosion of their respective cultures by the universal

crisis of values brought by the machine age. Of these lithographs Claude Roger-Marx wrote: "These huge plates — veined, mottled or watered, incorporating all the colours of waterfalls, of the dawn, of fire, seaweed or agates, washed in azure or night's deepest blue — are the artist's response, in sensations of colour, to the ideological conflicts in Malraux's work." It was thanks to the support of the writer-minister Malraux that Zao Wou-Ki became a naturalized citizen of his adopted country two years later.

In the summer of 1963 he had another show at the Galerie de France, with ten canvases that were rather broader in scope and more varied in execution. One of them *(21-6-62)*, which was bought by the English art historian and connoisseur Kenneth Clark, is a fine combination of calligraphic sharpness and pictorial enchantment. *Homage to Henri Michaux* (Henri Michaux Collection, Paris), a jousting of whites and blacks spread with a palette knife and then re-worked with a fine brush, evokes the earth and the sky in a nocturnal atmosphere that is at once rugged and tender. In the large picture in Essen's Folkwang Museum *(31-1-63)*, for which Zao Wou-Ki confesses to a certain partiality, three simple colours — ivory black, mother-of-pearl white and the blue of a nun's robe — are subtly merged in the midst of a fluid, unorientated pictorial area. The quivering of the calligraphy becomes an integral part of the continuous movement of the light.

This creative energy became even more intense in 1964, one of Zao Wou-Ki's most fertile years. Except for a few grey-pink canvases of a heavenly purity, like *2-3-64,* everything is convulsed once more by the dramatic vehemence that then possessed him. For May, whose health was fragile, was often very ill, and her chronic relapses worried her husband very much. His painting, always a faithful mirror of his state of mind, now became a refuge — or, more often than not, a battlefield. Sometimes we find pellucid areas of ineffable serenity, as in *4-5-64,* but they are won from a tumult of elements unleashed on a cosmic scale; at other times we see giant trees standing up straight in the storm *(29-1-64)*, raging oceans or stormy skies *(29-9-64)*, cataclysms of the earth or the stars. The general tone remained sombre, with shimmering opacities and dimmed fires, but sometimes there is an explosion of strident chords in yellow *(9-7-64)* or vermilion *(1-2-64)*, bordered by light-coloured margins. The largest picture in this series was *25-10-64,* which was conceived as an act of *homage to Varèse* and was completed only a few months before the composer's death; it measured 255 by 345 centimetres. In this work the painter's inspiration matched the prodigious harmonies of the composer, and the whole space trembles under the alternating waves of black and amber.

In May 1964, the essayist and critic Pierre Schneider invited fifteen contemporary artists — among them his friend Zao Wou-Ki, whose

1975. Photo: Bruno Cusa.

With Michel Troche and Françoise Marquet. 1975.
Photo: Sin-May.

With Jacques Rigaud. 1975. Photo: Sin-May.

With Eileen and I. M. Pei. 1976.

work he followed with keen interest — to take part in an exhibition of large-scale paintings entitled *Peinture hors dimensions.* The vogue for large formats had come from the United States, where the scale of relationships and the nature of the materials of plastic art are not the same as in Europe; some of the apparently paradoxical reasons that best explain this fashion were expounded in 1951 by the American painter Rothko: "I realize that, from the historical point of view, painting large pictures is anachronistic and pompous. Nevertheless, I paint them — and I think other painters do so for the same reasons — precisely because I am trying to be as intimate and human as I can. When you paint a small picture, you must place yourself outside your experience. But when you paint a large-scale picture, you are inside it. It is not something that you can command at will." Rothko wanted his vast paintings to be hung in small rooms, so that the viewer, too, could experience this enveloping presence more completely. Zao Wou-Ki continued to paint small-scale works — usually considered more difficult — as exercises in control or preliminary investigations, but he felt more at ease with large surfaces, believing that they allowed greater freshness in the gesture and more freedom to improvise. "Painting," he once said, "is a struggle between the canvas and me, a physical struggle. Especially with the large formats, which permit more human gestures, a true projection of oneself. One must plunge into them altogether, body and soul."

In 1965, Zao Wou-Ki had exhibitions in many different places. Among these was the retrospective show of his graphic work at the Albertina in Vienna, which gave him a good excuse for visiting that city and seeing the Brueghels there for himself. Then there was a retrospective of his work in painting at the museums of Essen and Cologne, the catalogue of which contained these moving words from the painter Manessier:

And so we suddenly see, thanks to you, that Fan K'uan makes the same sort of gesture as Rembrandt, and that Cézanne diffuses the same luminosity as Mi Fu and Ni Tsan — in short, that the whole great family of painters is made one, and strangers discover themselves to be brothers.

Dear Wou-Ki, faithful to the Spirit of men's hearts, of all men's hearts, this is what makes you the unique and universal painter that I love and admire.

In the spring of 1967 the painter's annual exhibition at the Galerie de France consisted of the watercolours he had done under the inspiration of Rimbaud's *Illuminations,* poetical effusions which did so much to shape the modern vision, and twenty works in oils which were the magnificent result of four years' work. Among them were some new formats taken from the eastern tradition, such as a triptych *(1-4-66)* and a tondo *(21-10-66)*. In his introduction, Pierre Schneider pointed

out the change of relationship that had come about between the dynamic of the gesture and the permeability of the background. "Instead of absorbing the gesture, the background is increasingly harassed by it. The effervescence first reached the intermediate areas, but now it has been communicated to the whole picture. A broadly sweeping, irresistible movement crosses it from edge to edge." The painter now abandoned the use of the palette knife, finding it a little too spectacular. He did not yield, however, to the temptation of the greater facility offered by acrylic paint, but remained faithful to the well-tried resources of oils and brushes. He also ruled out the collage processes of the Surrealists and the projection techniques used by the Expressionists, feeling them to be unsuited to the fluidity of his style.

His art developed constantly on its foundations, branching out into new rhythms, textures, modulations of colour, by means of contrasts or harmonies created on the basis of ever-open variables. There are canvases that are almost monochromatic, sometimes dense and sombre, in brown wash with black scratches *(24-5-65)*, sometimes light and opalescent, ash-grey and silvery mist *(19-12-66)*. Others are sumptuous harmonies of snow and sapphires *(24-1-66)*, or of moss and rubies. And the composition that synthesizes the whole cycle is *13-2-67* (Private collection, Paris), a canvas measuring 200 by 300 centimetres on the right of which, where the dragon makes its spring, there is a luminous opening which balances the storm clouds and showers of sparks massed on the left, like a cliff exploding at the point where the sky meets the sea.

1976. Photo: Claude Ferrand.

In June 1967, Zao Wou-Ki confided to the critic J. D. Rey: "I like people to be able to stroll about in my canvases, as I do myself when I am painting them." And it was at that time, too, that Claude Roy wrote the article that invited us to travel with him through *A country called Zao Wou-Ki:* "I walk for days and days through this marvellous world, which is sometimes frightening, occasionally delightful, and constantly renewed." In such a world, of course, one must abandon the carefree sauntering of the Impressionists and at times pull on one's seven-league boots, to return to inner space and travel back in time to the dawn of the world and primeval chaos. The painter's imaginary travels had their basis in real ones. In 1969, for instance, he visited his friend Riopelle's native land of Canada, and from there crossed the United States and spent a month in Mexico, where he stayed with the painter Rufino Tamayo and visited the archaeological sites. Then in 1970, for the pleasure of hearing Mozart's music in the composer's own country, he agreed to conduct an art seminar in Salzburg during the Mozart Festival.

It was also in 1969 that René de Solier asked him about his preferences in colours: "I love all colours," was his answer. "Which ones in

With Lian, Eileen and I. M. Pei. 1976.

With Joan Miró. 1977.

particular? None. I have no favourite colours. I am sensitive, above all, to vibrations." This brief reply is one of the keys to his painting and to its mysterious radiance. In China, where the intangible is so powerful, where scientists have always favoured the undulatory rather than the corpuscular hypothesis, and the notion of a field rather than that of mechanism, painters know nothing of the theatrical quality of chiaroscuro and tend to reject the pomp and splendour of chromatism. In Zao Wou-Ki's eyes, therefore, colours are not substances but radiations, nor are they opposed to graphic work. They give life to space and describe the flow of the light.

In 1970, on the occasion of one of Zao Wou-Ki's regular exhibitions at the Galerie de France, Claude Roy's monograph was republished, with the documentation brought up to date. The new edition contained a preface by Henri Michaux which should be read in conjunction with that poet's original (1952) text, if we are to catch Zao Wou-Ki's scintillating career at source and follow its later development.

Zao Wou-Ki, too, has abandoned the figurative. But his pictures have kept a family resemblance to nature.

It is there. It is not there. What we see cannot be nature. And yet it must be.

But it is quite different. We no longer see it in detail.

Nature captured in the mass.

Still natural, but warmer, more passionate. Telluric.

Still pliant.

Neither strange nor unsettling, but fluid, in warm colours that are not so much colours as lights, splashing streams of light.

Empty of trees or rivers, of woods or hills, but full of cloudbursts, quiverings, burgeonings, of surges and flows, of vaporous blendings of colour that swell, rise and merge.

Nature is beset by new problems, dramatic situations, encroachments.

It is through nature that Zao Wou-Ki moves, reveals himself, is cast down or cheered up, falls and gets to his feet again; thanks to nature he becomes enthusiastic, is totally "for" or totally "against", bubbles over with feeling, tells us what is stifling him.

It is through nature that he can speak unrestrainedly, that he can make

gestures that are really expansive, and not simply inspired by the tedious exasperation of mankind.

When a man is at one with nature, what he lived alone can be lived more intensely. His sufferings overcome, his ambitions appeased, he can relive it generously, with a magnificent generosity.... without making a fool of himself.

If a man takes his range and his depth from nature, he can live on another scale.

In Zao Wou-Ki's paintings, with their sometimes gigantic dimensions, as befits the present scale of what he feels, we increasingly find — in a magnificent transference — a powerful telluric levitation. Huge masses, when the moment comes, must rise into the air.

This is the nature that re-creates for Zao Wou-Ki a splendid geological era, an era in which levitations, fermentations and upthrusts are the predominant features.

Zao Wou-Ki's paintings — as is by now common knowledge — have one great virtue: they are beneficial.

Rue Jonquoy. 1976. Photo: Sanjiro Minamikawa.

Since it is a spiritual fulfilment, and not merely an artistic achievement, a work of beauty has an invigorating effect on both its creator and its viewer. At the very same time as Michaux was writing his testimonial, Zao Wou-Ki painted *26-10-70* (Private collection, Huy, Belgium), a composition with a turning rhythm of areas alternately light and dark, empty and crowded, the whole drawn in as though by a magnet towards the central nucleus; this was bought by a collector suffering from a serious illness.

In 1968 there were some exquisite small-scale pictures, like the snow crystals of *22-10-68* or the moiré ribbons of *7-11-68,* alternating with larger formats in which the composition winds across the surface like a lazy river, as in *21-12-68,* or rises almost vertically, as in *31-8-68,* a picture that evokes the rugged mountain scenes of Fan K'uan, an artist who was a kind of Giotto among the landscape painters of the early Sung dynasty, and for whom Zao Wou-Ki, like Mi-Fu, has always had a great veneration. The whites and the blacks interpenetrate more intensely *(6-1-68),* there are interstices between the streams of monochrome *(1-4-68)* and, for the first time, the cutting of the space is arranged around a central void with jagged edges *(18-1-68).* In *12-8-69,* a picture measuring two metres by three which the artist has kept for himself, the brushwork has become freer and more flexible. There is a variety of alternations — wet and dry, smooth and granular, transparent and impastoed — according to whether the movements of

Sian. 1974. In front of the pagoda of the T'ang period (618-907).

the brush are insistent or restrained. The luminous whites are given a different nature and different values; they rise to the surface and play a more important role in the composition as a whole. The broad waves of colour with their graphic intricacies can now be spread over vast surfaces *(29-1-70)*, and the void, with its throbbing green *(12-10-70)* or radiant yellow *(14-7-71)*, can occupy almost the whole surface of the picture. For Zao Wou-Ki the moment had come — and the worsening of May's illness provided a further incentive, since he felt incapable of painting — to rediscover the ancestral technique of wash drawing, based on the force of the void and the surprises of chance effects.

Enjoying the status of the highest learning and art, calligraphy is the very foundation of Chinese civilization and, in the strictest sense of the word, its religion — that is to say its ritual and its unifying force. There are numerous treatises celebrating the importance of calligraphy, in the exercise of which even emperors have engaged, and some of the great masters of the art have recorded how, after years of practice, it had suddenly been revealed to them what their style should be: one of them, of the T'ang period, as he watched the sedan-chair carriers clearing a way for themselves along a crowded street; another, under the Sung dynasty, from seeing two snakes fighting on a country road. We are told, in effect, by theorists of the art that calligraphy is based on the principle of *spontaneity* and must follow the same sort of course as flute-playing or fencing. The rhythm of the brush, which must move uninterruptedly under varying pressure, may be compared to that of a person's voice. Every calligrapher has his own preferences as regards the choice of the *four treasures of the library* that are indispensable to his art: the paper, the brush, the hard sticks of ink and the stone for crushing them before they are mixed with water. During the winter of 1971-1972, Zao Wou-Ki created a series of astonishingly accomplished and spontaneous wash drawings in India ink, on beautiful old bamboo-fibre paper which had been a present from his father and using special calligrapher's brushes imported for the purpose from China — brushes made from goat's hair, which (along with those made from rabbit's hair) are considered the best. *The marvellous game of ink and brush,* the rules of which he had been familiar with from childhood, but which so many western artists of today despair of ever properly assimilating, seemed to him in one sense too easy — and, above all, too typically national — to be continued for long, but the experience had to be undergone at the right moment and the benefit gained from it was reflected in his painting.

"In 1971 and 1972," he says, "I found it impossible to paint, so I went back to this wash-drawing technique, which combines chance, ink and the brush. Since I had learnt it at school, I had no trouble in handling it. But I am not overfond of this absolute, almost diabolical fortuitousness; and, certainly, I do not like this limiting label of 'Chinese painter'.

This wash-drawing interlude, however, helped me a lot by giving me greater freedom and a more expansive gesture. But it is impossible to use oils with as great an ease as one does India ink. In a wash drawing one is playing with the void. But one cannot treat the canvas as one does the paper, and oil paints are greasy, so the void must be filled. Now, Chinese paper is in itself too dense to need any filling. It is as thirsty as blotting-paper — a single brushstroke is enough." The India ink obtained from the charcoal of old pine wood is essentially black — smoke black — in colour, but the varying proportion of water used gives it every possible shade from pearly grey to jet black.

The porous surface of the paper absorbs the flow of the ink in proportion to the pressure of the hand and the whims of chance, thus leaving certain untouched areas and lacunary interstices. *6-10-71* is a reiteration in abstract terms of the marriage between painting and writing accomplished by the artists of the Sung dynasty. It is also the first of Zao Wou-Ki's works to feature the transparent blacks, the result of the artist's experiments with wash drawing and of the consequent greater freedom of his brushwork. In *14-7-71* the blacks and reds, in transparent streams or opaque streaks, overhang an immense void which is magnificently "filled" by the superimposition of different coats of yellow on a green ground that shows through in places. Many of the pictures that received their finishing touches in 1971 were complete re-workings of earlier ones painted in different periods and are therefore designated with the two "finishing" dates. The one chosen by Tamayo for his museum of contemporary art, *9-5-59/8-1-71,* is a sumptuous harmony of red and black glorifying the colours of earth and fire in Mexico. In *21-2-72* (Dr R. Cherchère Collection, Paris), on the contrary, the reds and blacks streaked with sharp-pointed fibrillae have a pathetic effect. This was the last picture he painted before May's death. She died on March 10, leaving a considerable amount of sculpture on which she had been working secretly during any temporary respite from her illness. Her delicately rounded marbles and bronzes were exhibited at the Galerie de France in November of the same year, along with her husband's wash drawings. Their friends, shattered by May's untimely death, all came to pay homage to her personal charm and her undoubted talent. But between his wife's death and this exhibition, in an attempt to recover from his tragic loss Zao Wou-Ki sought and obtained a visa which permitted him to return to China for the first time since he had left it twenty-four years earlier. He visited his family and prayed over the grave of his father, who had died in 1968, and then he and his mother travelled to Peking and went on to visit all the marvellous places around Shanghai and Hangchow where he had spent so much of his youth. Though he gave himself up to the pleasure of reliving earlier days, he also observed with clearsighted curiosity the changes brought about in all aspects of Chinese life by Mao's great revolution, and on

From left to right: Louis Rabeau, Zao Wou-Ki, Françoise Marquet and Odille Chaudé, outside the mairie of the 14th Arrondissement. 1st July 1977.

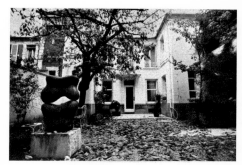

The house in the Rue Jonquoy. Sculptures by May.

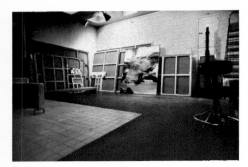

The studio in the Rue Jonquoy.

The studio in the Rue Jonquoy.

his return to Paris he gave an account of these in the course of a long interview.

In the canvas measuring an enormous 200 by 525 centimetres — finished on 10th September 1972, entitled *In memory of May* and donated to the Centre Georges Pompidou — we have an extraordinary painting which shows us the whole course of a love story, with its shadows, its moments of bliss and its final ordeal. Yellows ranging from straw to orange combine to distill this colour of sun-lightened ochre and golden honey that tenderness alone can take from scars, and on which float islets of black still veiled in mourning — a very warm bone black, no longer funereal but of supernatural intensity. The elements here are suspended in that region of supreme acceptance and assuaged gentleness to which we are brought, after the first attempts to revolt, by all great sorrows. The picture gives out strange emanations, of a positively Baudelairean breadth.

> *As the renewed suns rise to the sky,*
> *Washed in the waters of the deepest seas.*

The next time Zao Wou-Ki went to China was in the autumn of 1974, when he was accorded almost a state reception and was permitted to travel freely around the country. Thus he visited ancient capitals of the Empire, cities with a legendary past and a thrusting, dynamic present: Sian, in the north-western province of Shansi, which still possesses several temples and pagodas of the T'ang period and has a triple museum — of historical archaeology, sculpture and stelae — that houses the fabulous spoils of the most recent excavations; Loyan, the granary of China, in the central region of Honan, which also has a brand-new municipal museum, and from which one can easily visit the famous caves of Longmen. And on the road from Nankin to Shanghai he was dazzled by the scenery around Lake Tai, a lake celebrated by poets of all periods and certainly one of the largest and most beautiful in China. Not far from this lake — as rich in fish as it is in magical enchantments — and separated from it by a line of rolling hills where there are many legendary tombs, lies his mother's birthplace, Soochow, famous down through history for its wonderful gardens, where the poets and scholars of the Sung dynasty used to forgather. This long tour together was his mother's last great joy. Only a few months later, in February 1975, Zao Wou-Ki was called back to Shanghai, to attend her deathbed and arrange her funeral. The almost square picture which he dedicated to her memory *(5-3-75)* is a warm harmony of ochres, violets and reds, lovingly mingled on a light green background.

These successive returns to a continent in the throes of total transformation, and of which he could comprehend all the geographical vastness and historical development, undoubtedly interrupted his

work but also strengthened his inspiration and gave him new energy. The catalogue of his exhibition at the Galerie de France in the summer of 1975 had a preface by René Char, whose *Compagnons dans le jardin* Zao Wou-Ki illustrated in 1957. *10-1-73/5-4-73,* a composition of clustering forms under an area of dawn-like paleness painted in the spring of 1973, is an act of homage to the same poet, a visionary of light who once confessed: "My first alphabet was the blossoming hawthorn." With lucid concision René Char sums up the artist's career and the approach he has made to his three levels.

"My reactions to Zao Wou-Ki's work are of three kinds. First there is a profound identification with the graphic quality of his earliest work, with its elusively beckoning, almost nomadic colour and the forms obediently following the painter's hand, travelling distances the enduring importance of which has been revealed to us by a remote and ancient art. Then the interruption of this initial dialogue leads to the discovery of a second chaos which seems to be on the verge of flowing into a figure straying along the edges of deep abysses. These are calling to him, but he remains suspended in the expanse. And at this point the aerial and telluric spell of the wandering Orpheus makes its impact. All the separate elements in his work are constantly interacting, like a transient demarcation line, that line in the evening that separates the colours in a tumultuous whole — a prophecy, in short, the reflection of which should never admit the reference to the mirror of a personal libido.

Zao Wou-Ki's painting went from strength to strength on that "aerial and telluric" rhythm in which the central void is the constant driving force. The China of the geologists and geomancers, so prone to violent earthquakes, is also the China of the astronomers who were the first to decipher the figures of the constellations on which the first ideograms were modelled, to observe the shapes and paths of comets, and to discover meteors, novae, sun spots and the process of cloud seeding. The fluidity of the oil paint and the suppleness of the brushwork create a vibratory environment that permits the constant interpenetration of inner rhythm and cosmic rhythm. The inventory of the artist's engraved work, brought up to date in 1975 by Françoise Marquet, Zao Wou-Ki's new companion, has a frontispiece by Roger Caillois in the shape of a stele, which reads: "He disperses the light into fires, the fires into reflections and the reflections into transparencies that become marriages of gleamings." Since the richness of the colour was at once transformed into luminous energy, Zao Wou-Ki could now risk the most audacious harmonies or the most strident dissonances — pink and cobalt blue *(16-3-73),* for instance, or baryta green and lemon *(13-1-76)* — and assimilate into the continuum of the pictorial texture all such "hazards" of the brush as the impastos, the splashes or the drippings.

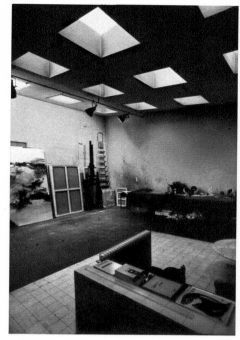

The studio in the Rue Jonquoy.

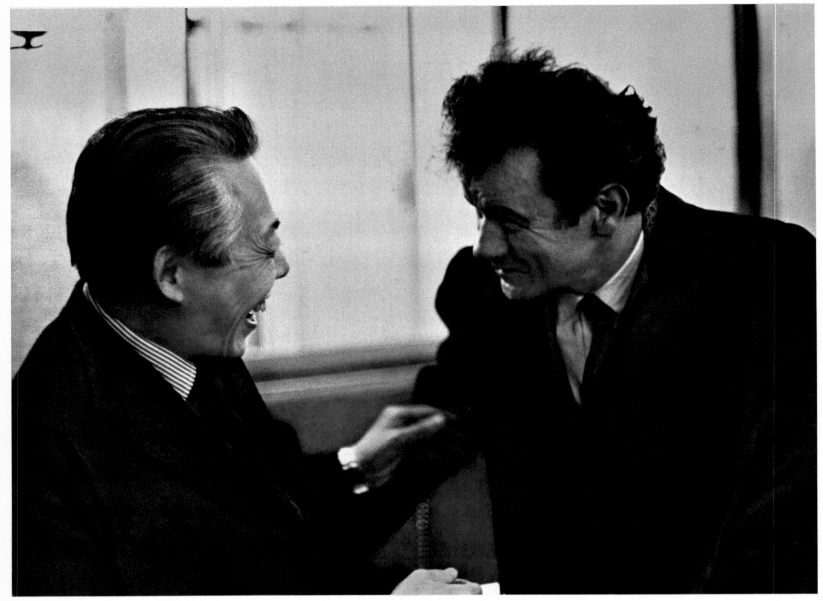

With Jean Leymarie. 1972. Photo: André Morain.

A similar ease is evident in the variations of scale, whether in the lyrical or in the tragic mode. Small square, or almost square, pictures alternate with vast compositions in horizontal or vertical formats, or even in the splendid but difficult quadratic format Braque was so fond of.

We also find the reappearance of an earlier form in a medium-sized but magnificent tondo *(24-4-74)* and in two authentic triptychs, with a compound rhythm, in which each element is at once independent and an integral part of the whole. The first of these, *11-10-75,* is of quite

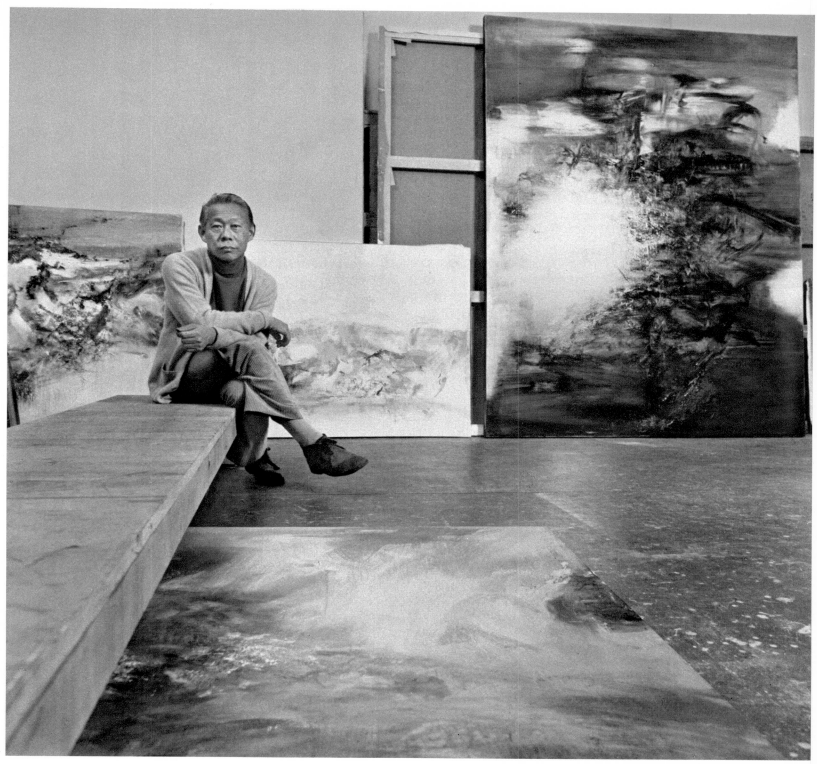

The studio. 1976. Photo: Claude Ferrand.

small dimensions (27 by 60 centimetres), but with an immense opening into space; the second, *1-4-76,* is of monumental breadth (200 by 525 centimetres) and complex orchestration, and it is with the description of this work that my book reaches its conclusion. In the central panel there is an explosion of turbulent masses, black and brown whirlwinds the eddies of which reverberate in the two side panels, and which are balanced by peaceful "clearings" and piercing voids. The threadlike linear motifs are still there, under a pictorial afflatus of epic quality.

With the death of Malraux, a writer obsessed with things Asian, and one who had followed with a friendly interest Zao Wou-Ki's development and his "unique dialogue with Chinese roll painting", this work came to be considered (and called) a *Homage to André Malraux,* that universal fighter with so many controversial qualities but with the same sort of ardent enthusiasm as guided the artist in this painting. "Great Chinese painting," writes Élie Faure (who also observes that its predominant tonality is "a patina of dark amber," which is also found in this triptych), "enters our souls in much the same way as waves of music." Let us listen, then, to the Yellow Emperor in Chuang Tzu's book, as he explains to his minister the inexhaustible meaning of his symphony in three parts:

The first part expresses the contrast of the events on earth that occur under celestial influence; the strife among the five elements; the succession of the four seasons; the birth and the decay of plants; the action and reaction of the light and the heavy, of light and darkness, of sound and silence; the renewal of animal life, each spring, to the sound of thunderclaps, after the winter torpor; the institution of human laws, of civil and military offices, etc. All of this abruptly, without introduction or transition; in jerky sounds, a series of dissonances, just like the chain of deaths and births, of appearances and disappearances, of all the ephemeral realities of this earth. That must have frightened you. — The second part of the symphony renders, in sounds that may be soft or loud, prolonged and drawn out, the continuity of the action of yin and yang, of the course of the two great luminaries, of the arrival of the living and the departure of the dead. It is this sequence, endlessly continuous, that stunned you, with its infinitude, to the point at which, no longer knowing what part you had got to, you leaned against the trunk of a tree sighing, seized by the dizziness and anxiety caused by the void. — The third part of the symphony expresses the productions of nature, the development of destinies. Then there are agitations followed by calm periods; the murmur of the great woods, then a mysterious silence. For it is thus that beings come forth from heaven knows where, and return heaven knows where, in floods, in waves. The Sage alone can understand this harmony, for he alone understands nature and destiny. To seize the threads of evolution, before being, while they are still stretched on the cosmic loom: that is what celestial joy is, which is felt but cannot be expressed.

ILLUSTRATIONS

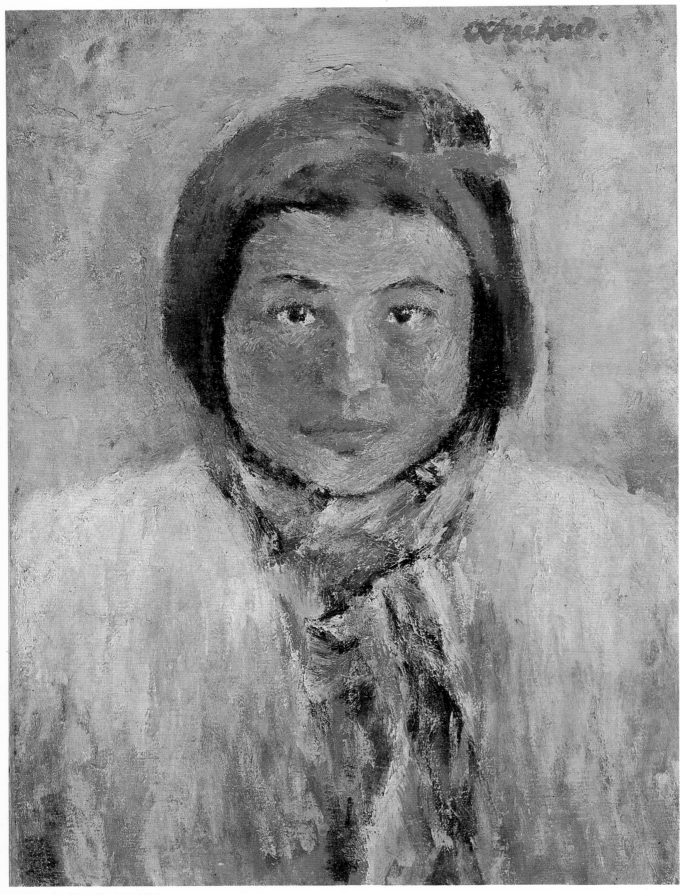

8. Portrait of Lan-lan. 1935-1936.
Oil on canvas, 60 × 44 cm.
Lan-lan Collection, Paris.

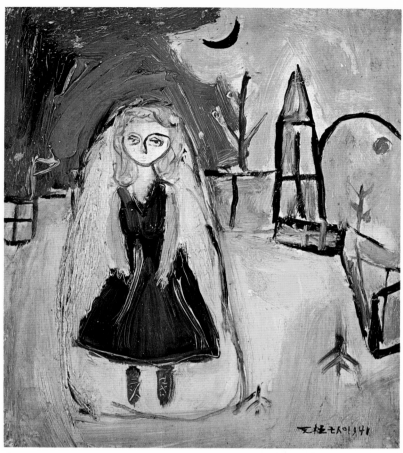

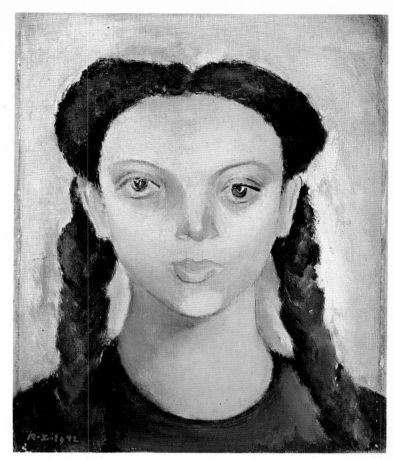

9. Wedding. 1941.
 Oil on wood, 22 × 19 cm.
 Lan-lan Collection, Paris.

10. Portrait of a girl. 1942.
 Oil on wood, 26.5 × 22 cm.
 Property of the artist.

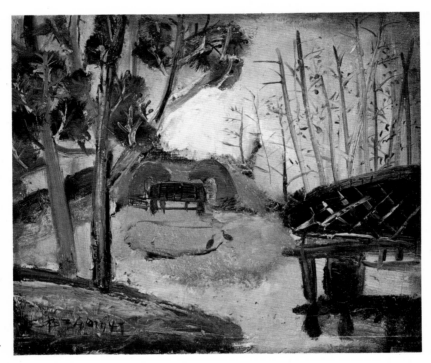

11. Landscape. 1947.
 Oil on plywood, 38 × 46 cm.
 Property of the artist.

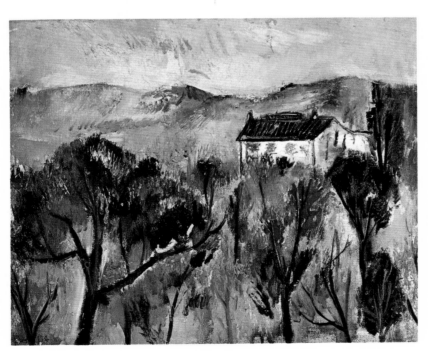

12. Landscape. 1946.
 Oil on canvas, 45,5 × 55 cm.
 Property of the artist.

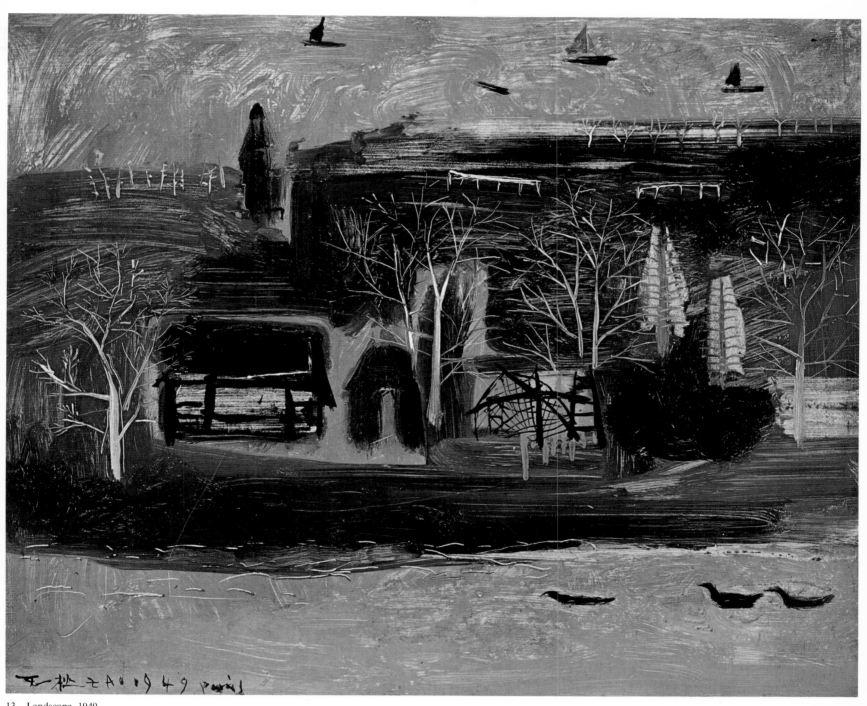

13. Landscape. 1949.
Oil on hardboard, 38 × 46 cm.
Property of the artist.

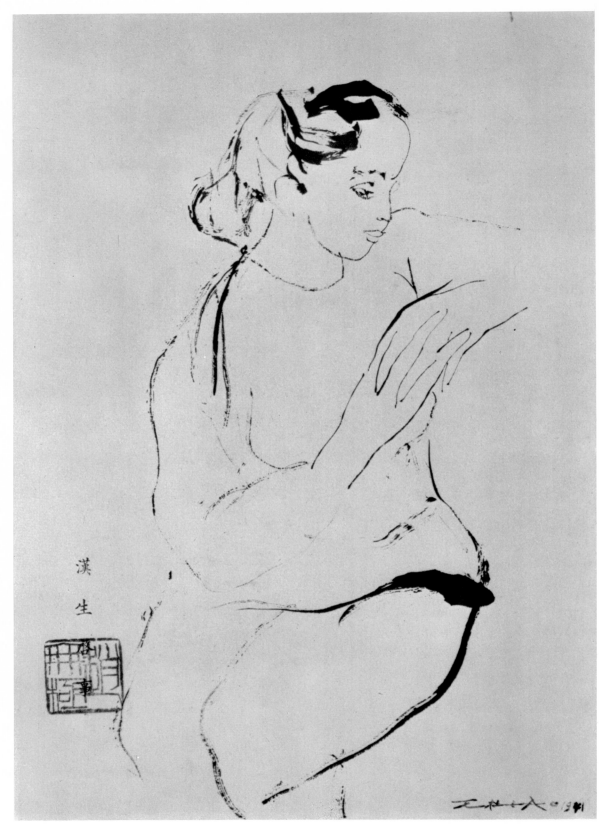

14. Girl. 1941.
India ink on Chinese paper, 29,3 × 20,8 cm
(the paper used was the personal writing-paper used by the artist's father).
Centre Georges Pompidou, National Museum of Modern Art, Paris.

15. Girl doing her hair. 1945.
India ink on Chinese paper, 25,5 × 18 cm.
Property of the artist.

16. Girl. 1943.
India ink on Chinese paper, 26 × 20,8 cm.
Property of the artist.

17. Nude. 1949.
Pen-and-ink drawing on paper, .56 × 44,5 cm.
Property of the artist.

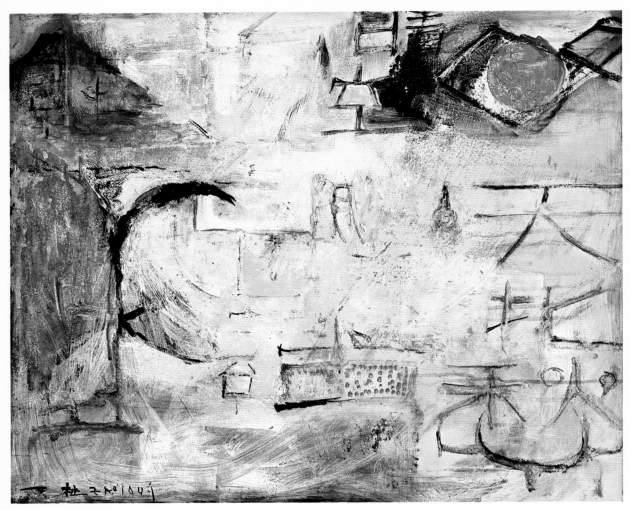

18. Composition. 1949.
 Oil on cardboard, 38 × 46 cm.
 Property of the artist.

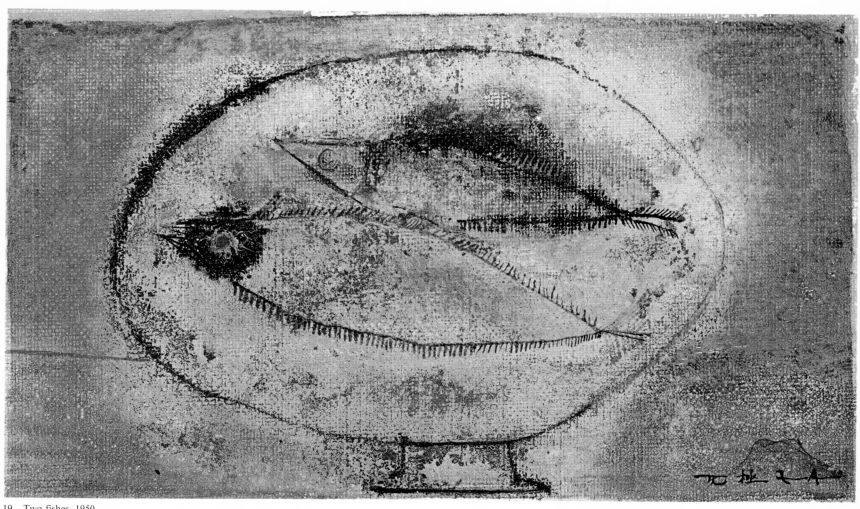

19. Two fishes. 1950.
Oil on canvas mounted on cardboard, 11.5 × 19 cm.
Property of the artist.

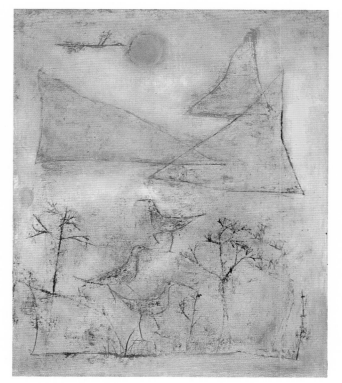

20. Mountains and birds.
Oil on canvas, 55 × 46 cm.
Cincinnati Art Museum, Cincinnati.

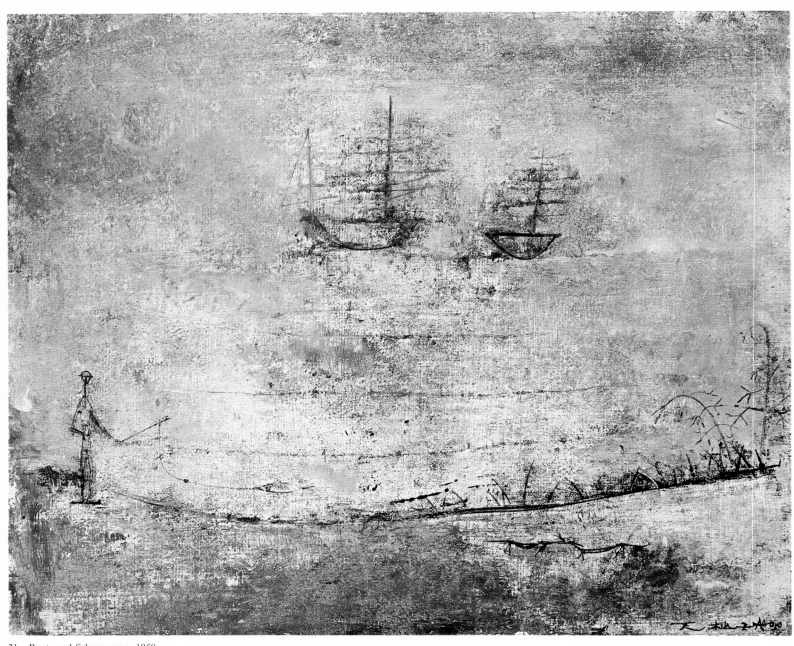

21. Boats and fisherwoman. 1950.
 Oil on canvas, 38 × 46 cm.
 Property of the artist.

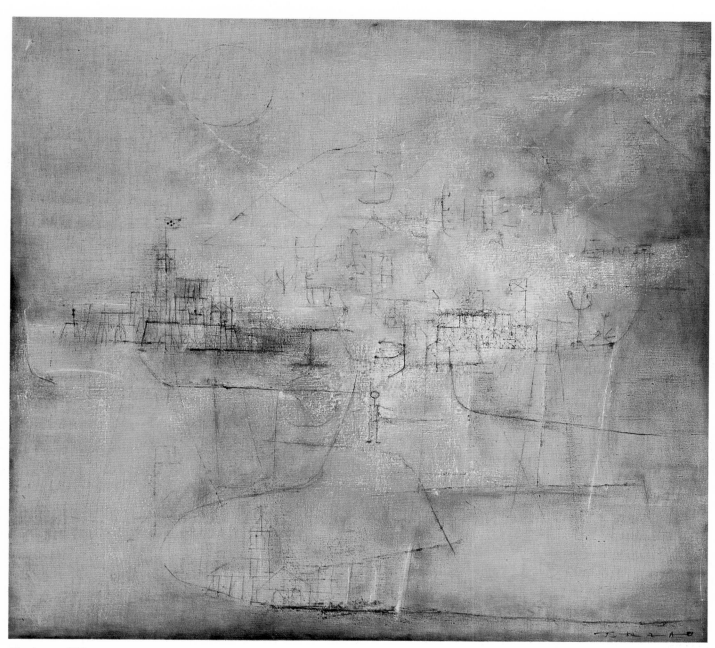

22. Arezzo. 1950.
Oil on canvas, 92 × 100 cm.
Henri Michaux Collection, Paris.

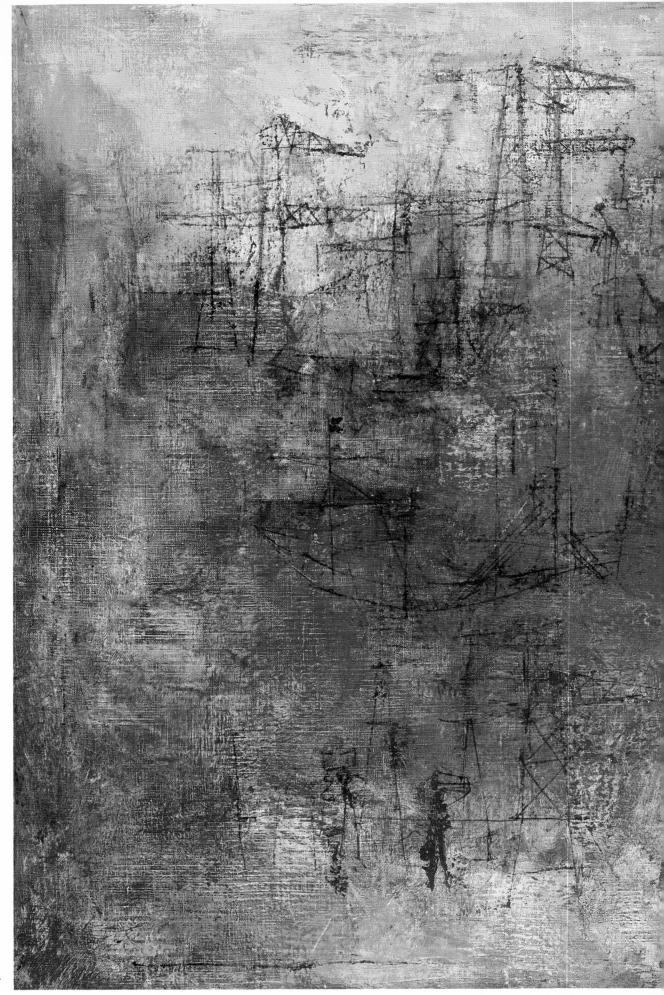

23. Boats. 1951.
Oil on canvas, 73 × 92 cm.
Property of the artist.

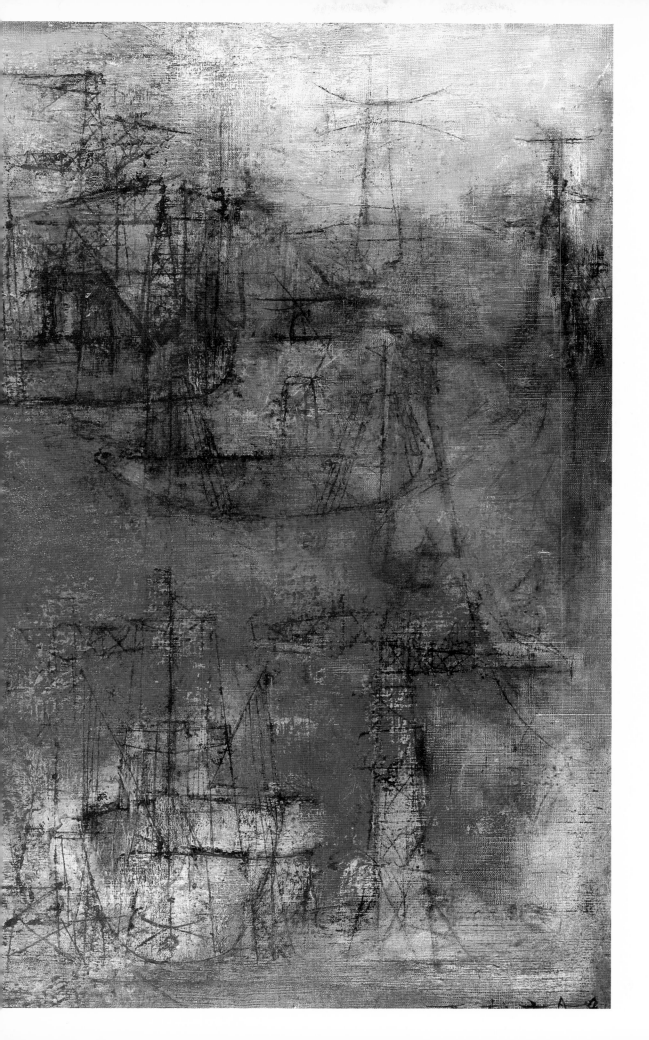

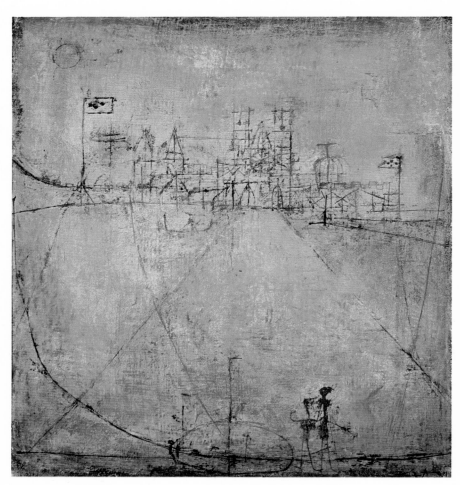

24. Piazza Siena. 1951.
 Oil on canvas, 50 × 46 cm.
 Property of the artist.

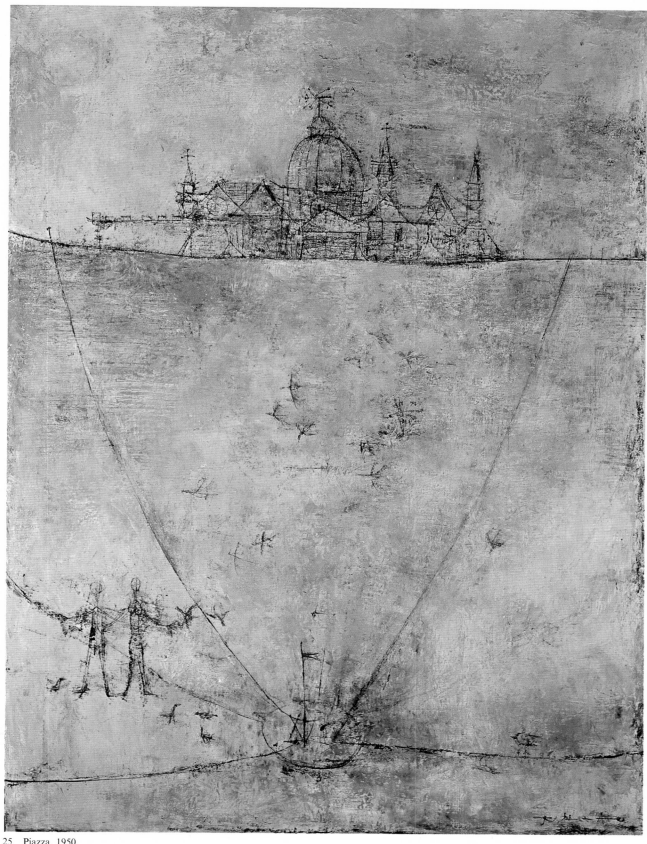

25. Piazza. 1950.
Oil on canvas, 146 × 97 cm.
National Museum of Modern Art, Paris.

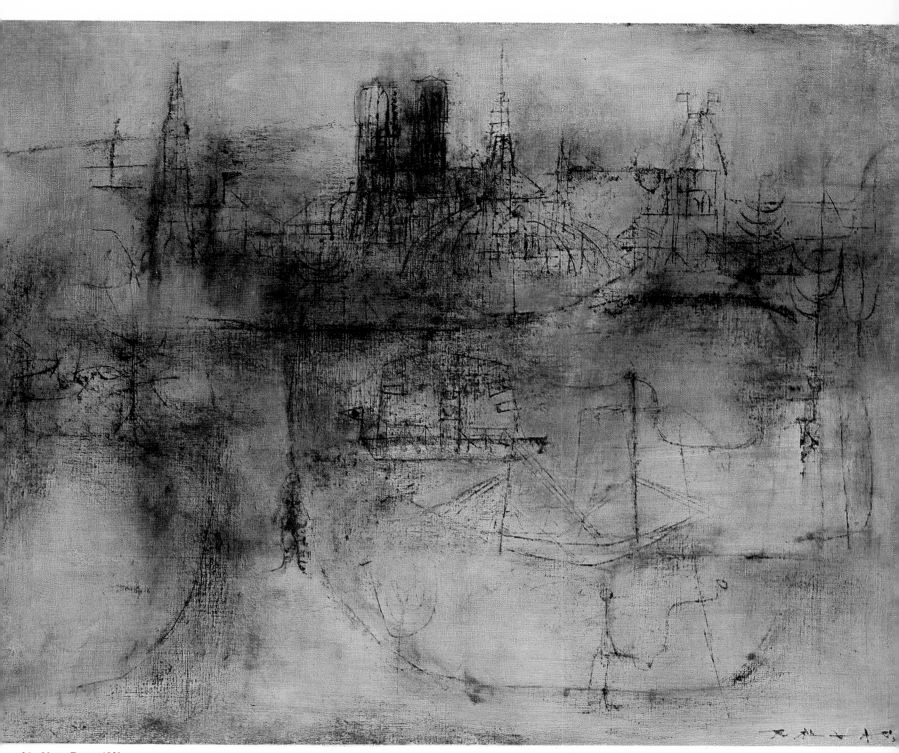

26. Notre-Dame. 1951.
Oil on canvas, 65 × 81 cm.
Property of the artist.

27. Saint-Jeoire-en-Faucigny. 1950.
 Watercolour, 27 × 20.5 cm.
 Property of the artist.

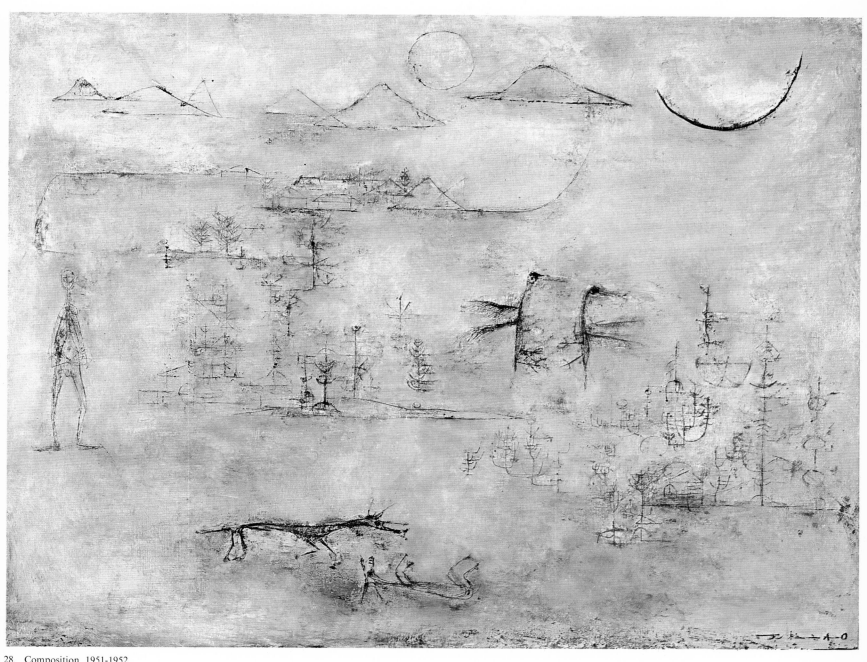

28. Composition. 1951-1952.
Oil on canvas, 89 × 116 cm.
The Art Institute of Chicago. Gift of James W. Alsdorf.

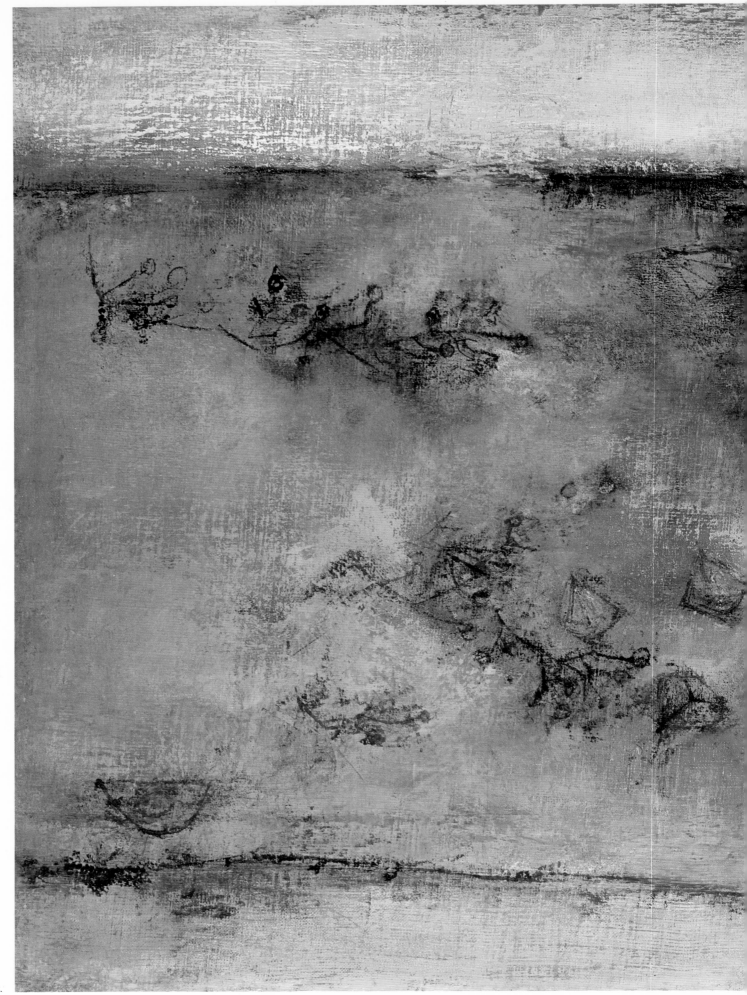

29. Still life. 1952.
Oil on canvas,
53 × 78 cm.
Property of the artist.

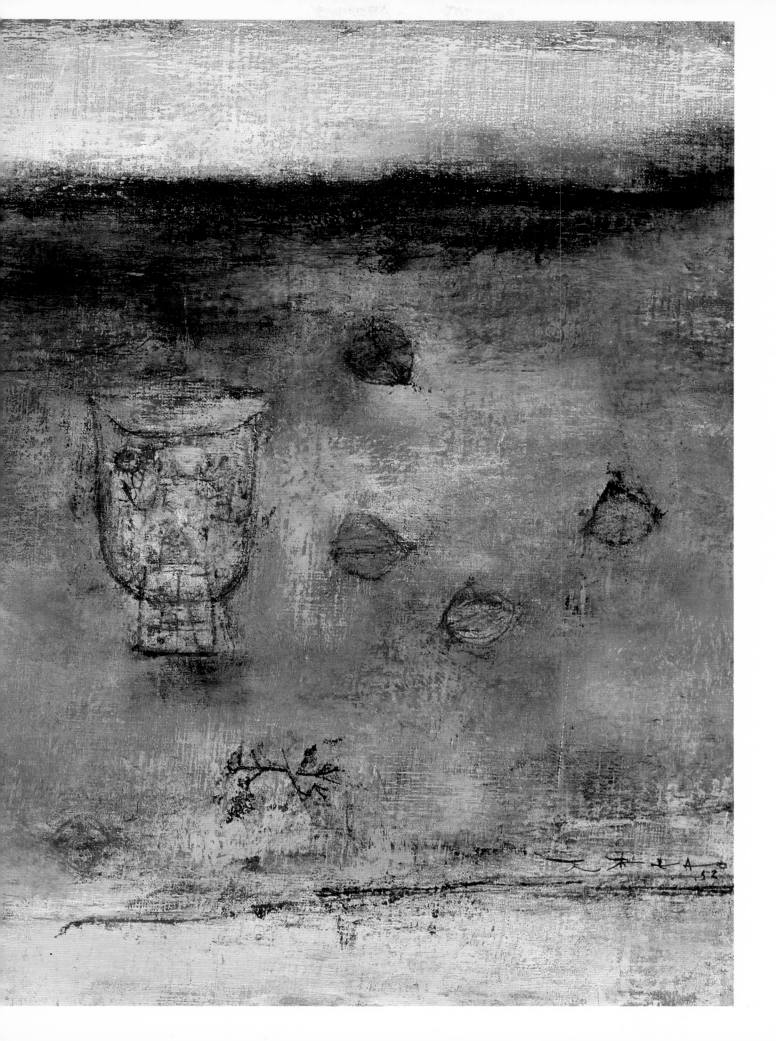

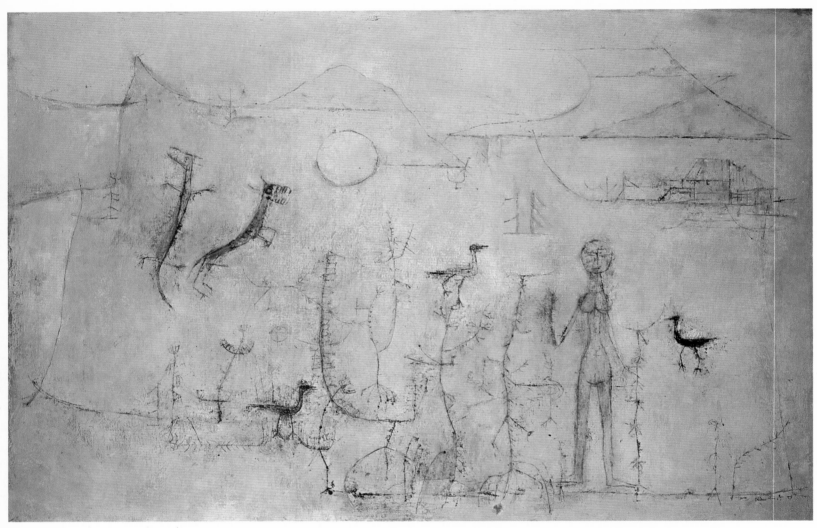

30. Woman and her companions. 1951.
Oil on canvas, 130 × 195 cm.
National Museum of Modern Art, Paris.

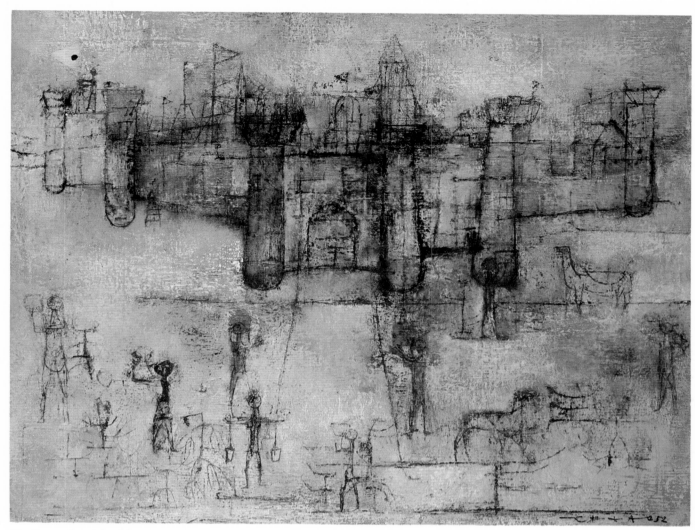

31. Restoration of the old castle. 1952.
Oil on canvas, 65 × 81 cm.
Property of the artist.

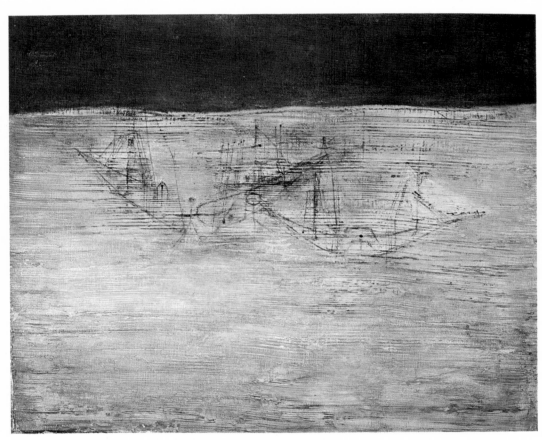

32. White sail. 1952.
Oil on canvas, 46 × 55 cm.
Private collection, Paris.

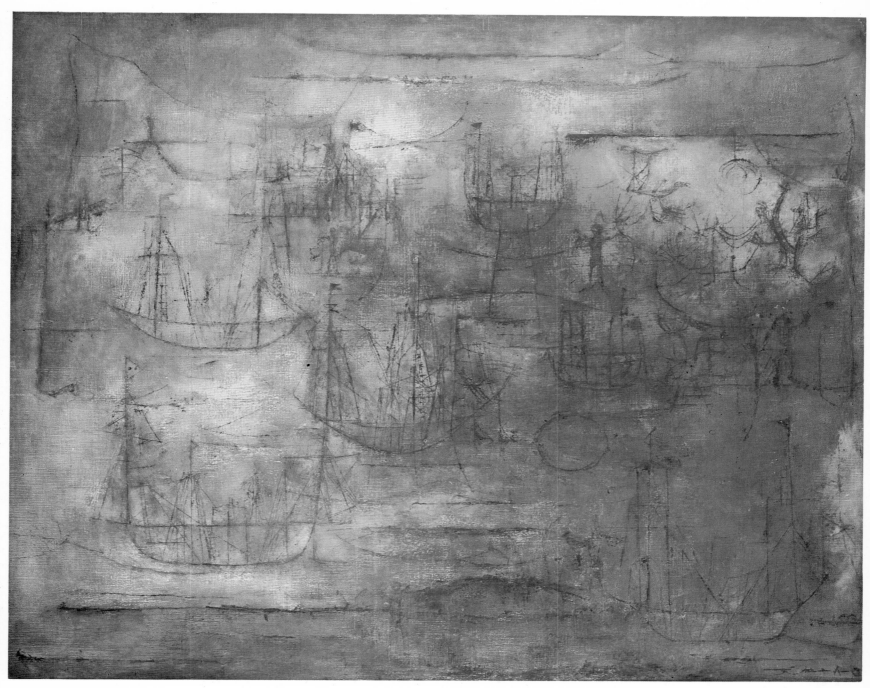

33. Ships in port. 1952-1953.
Oil on canvas, 130 × 162 cm.
Virgin Island Museum, St. Thomas.

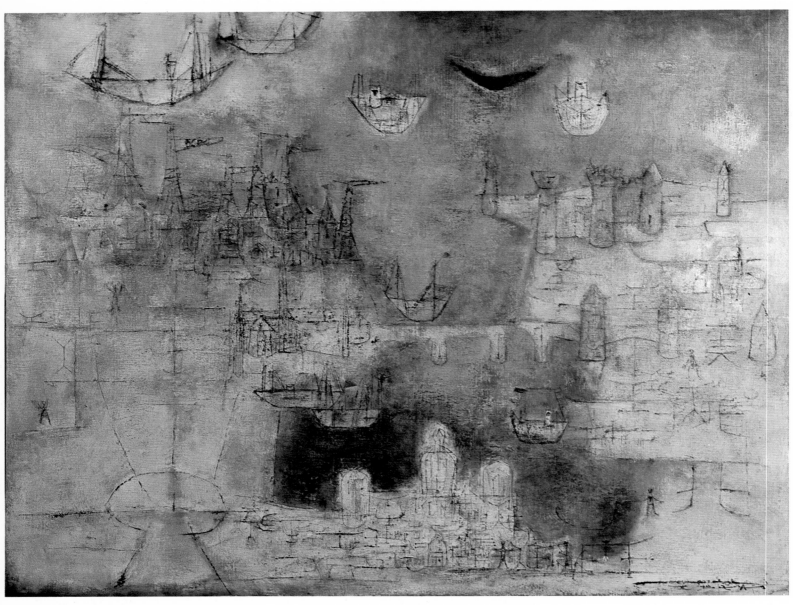

34. Coming into port. 1953.
 Oil on canvas, 130 × 162 cm.
 Herbert F. Johnson Museum of Art, Ithaca, New York.

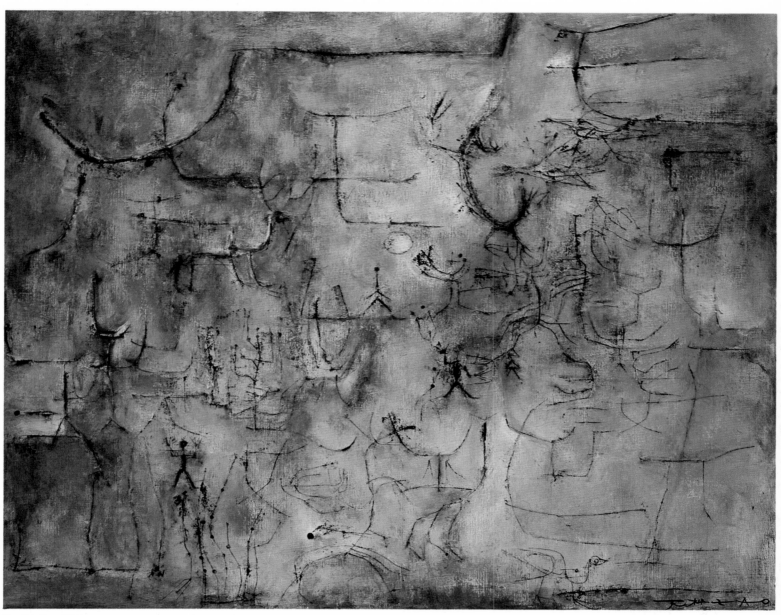

35. Painting. 1953.
Oil on canvas, 130 × 162 cm.
Mme Raymond Cartier Collection, Paris.

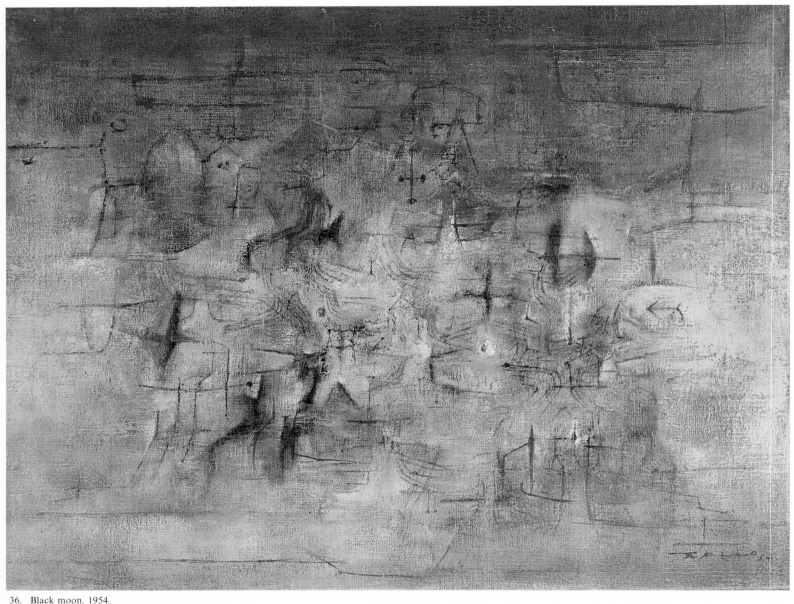

36. Black moon. 1954.
Oil on canvas, 114 × 146 cm.
Herbert F. Johnson Museum of Art, Ithaca, New York.

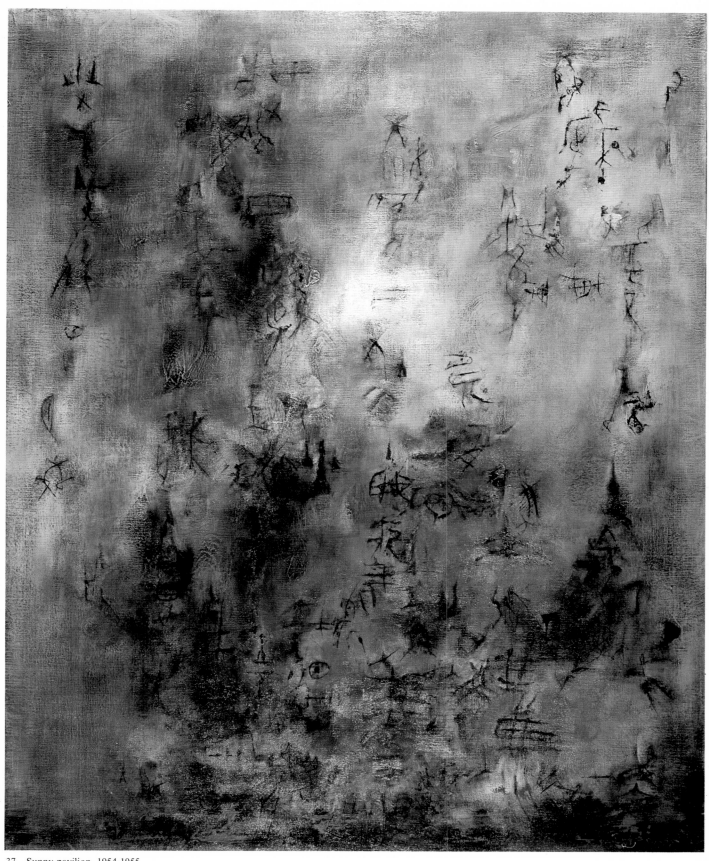

37. Sunny pavilion. 1954-1955.
Oil on canvas, 162 × 130 cm.
Museum of Modern Art, Rio de Janeiro.

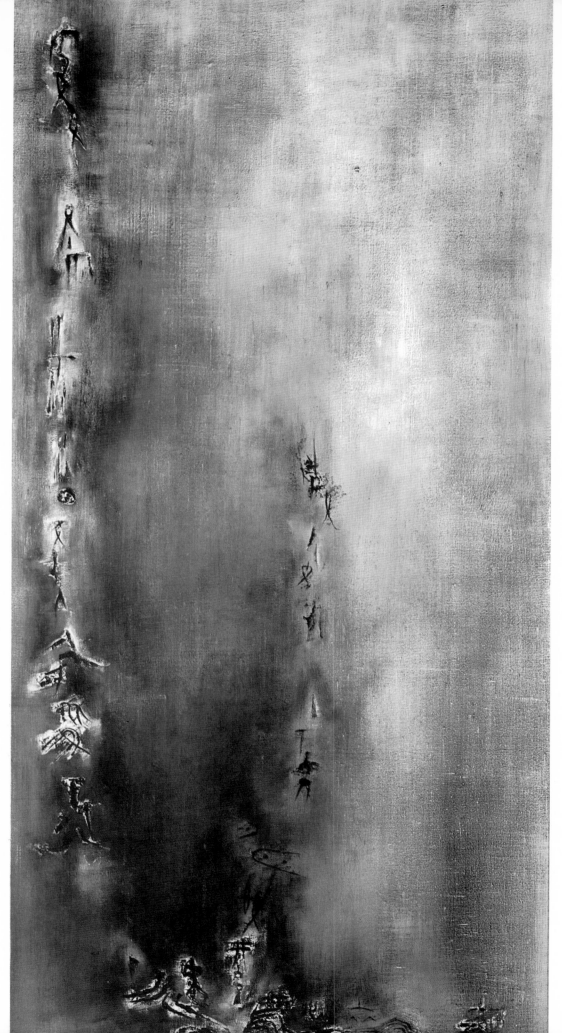

38. Wind. 1954.
Oil on canvas, 195 × 87 cm.
Property of the artist.

84

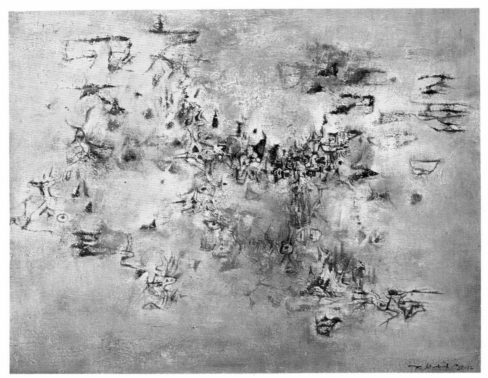

39. Star of the white body. 1955-1956.
 Oil on canvas, 50 × 65 cm.
 Private collection, U.S.A.

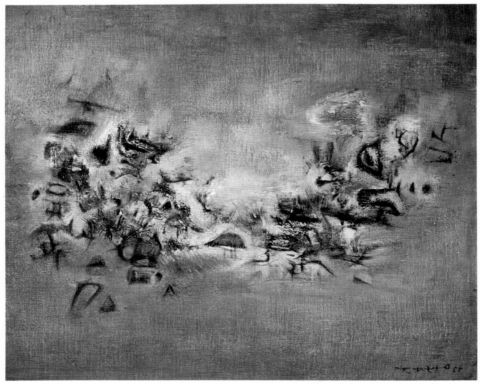

40. My father's garden. 1955.
 Oil on canvas, 38 × 46 cm.
 Galerie de France, Paris.

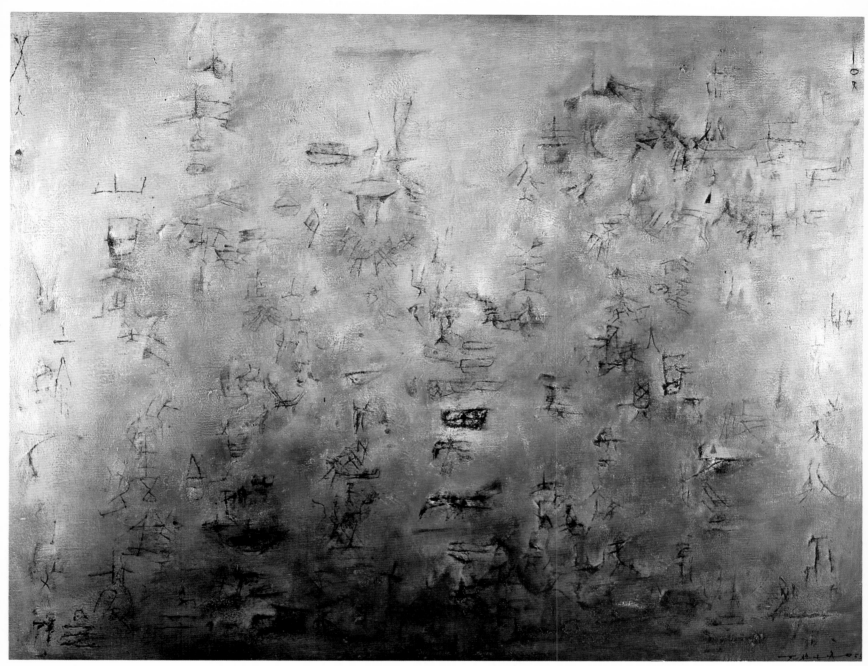

41. White village near the wood. 1955.
Oil on canvas, 97 × 146 cm.
Mme Nioma Bettencourt Collection, Rio de Janeiro.

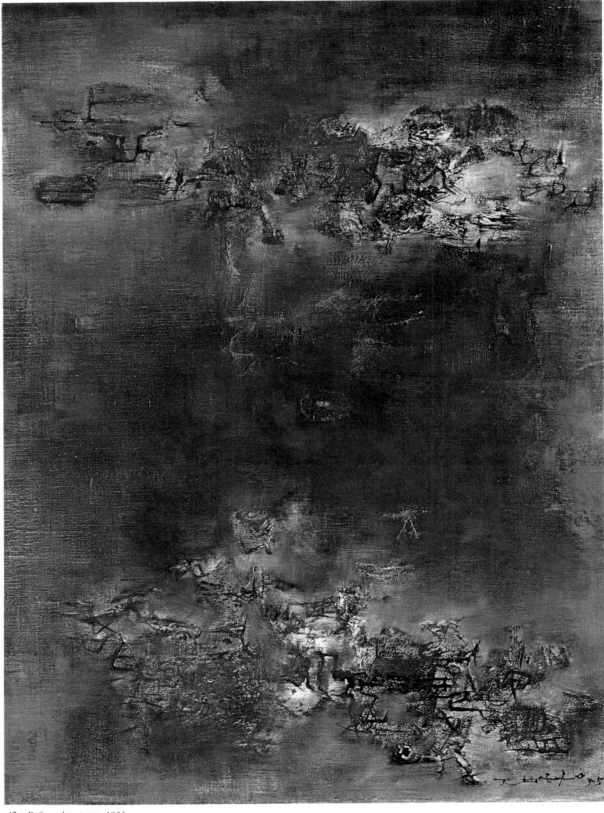

42. Before the storm. 1955.
Oil on canvas, 92 × 73 cm.
Tate Gallery, London.

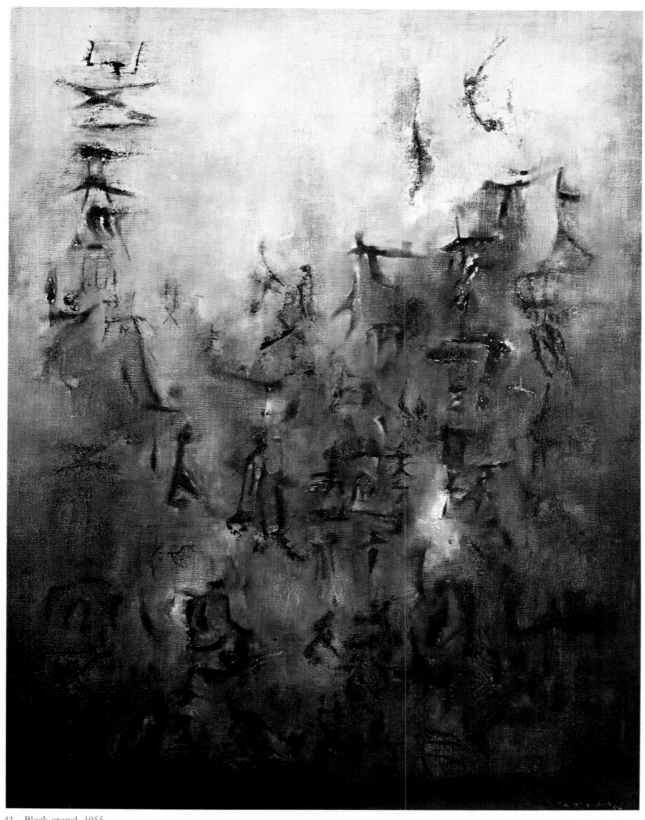

43. Black crowd. 1955.
Oil on canvas, 116 × 89 cm.
Museum of Art, Carnegie Institute, Pittsburgh.

88

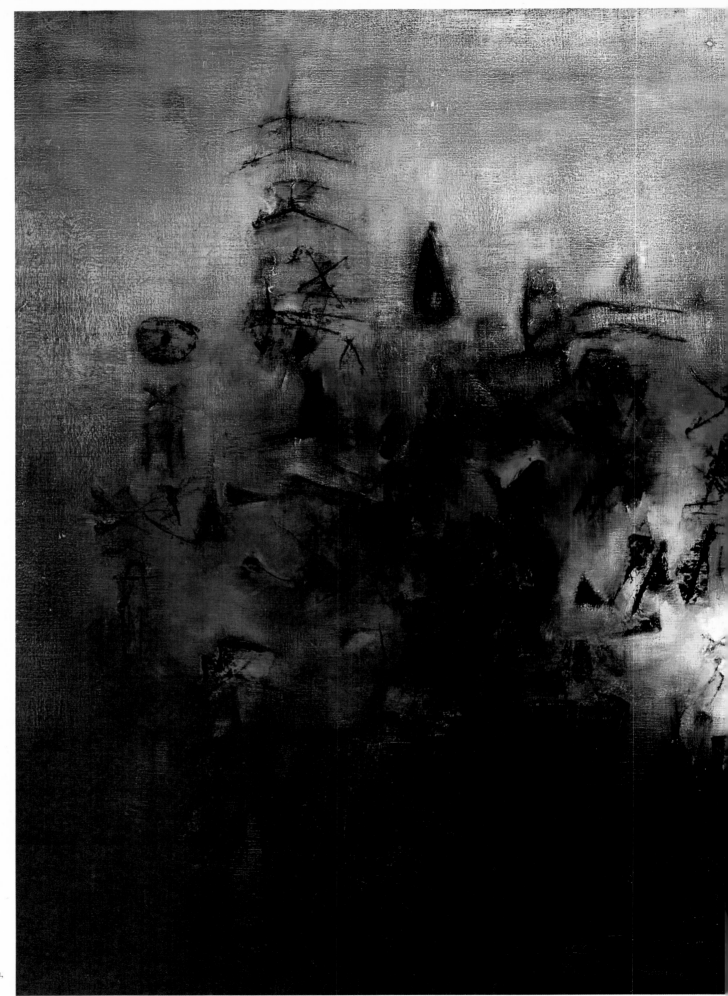

44. The fire. 1954-1955.
Oil on canvas,
130 × 195 cm.
Centre Georges Pompidou,
National Museum
of Modern Art, Paris.

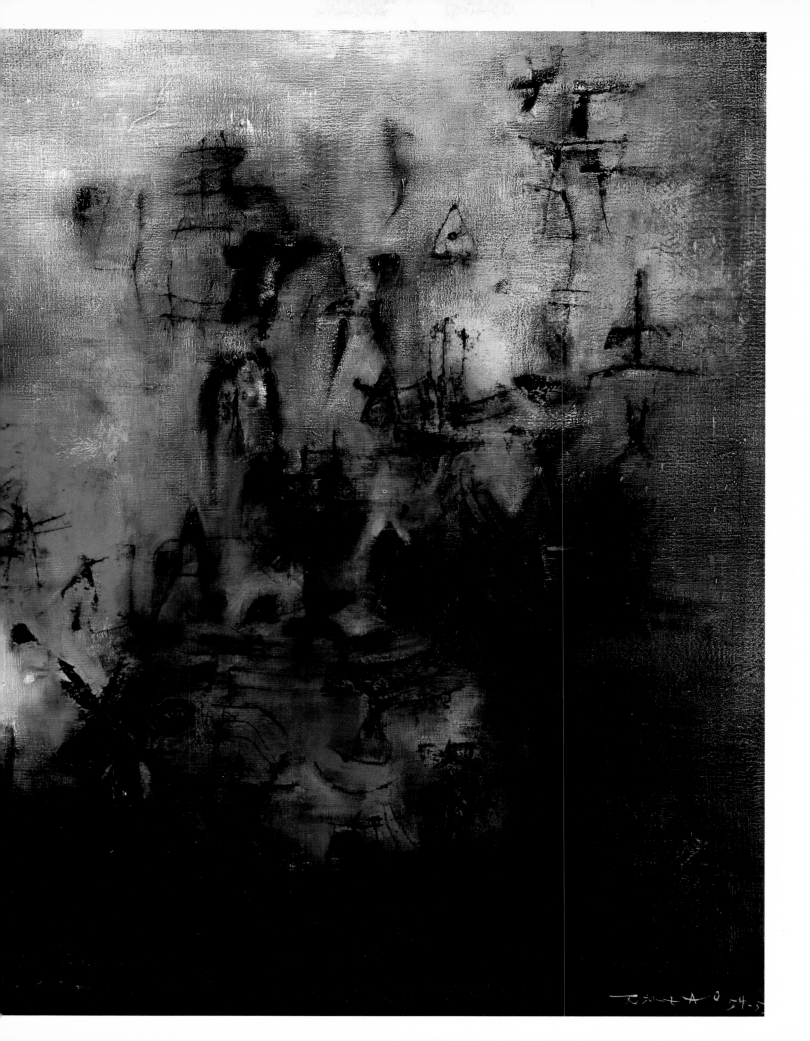

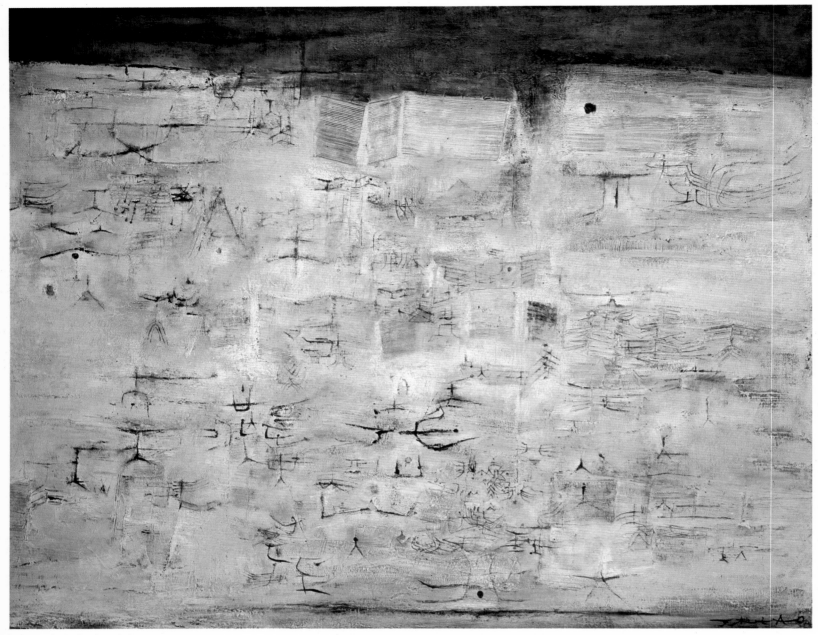

45. Tracks in the city. 1955.
Oil on canvas, 130 × 162 cm.
Private collection, Amsterdam.

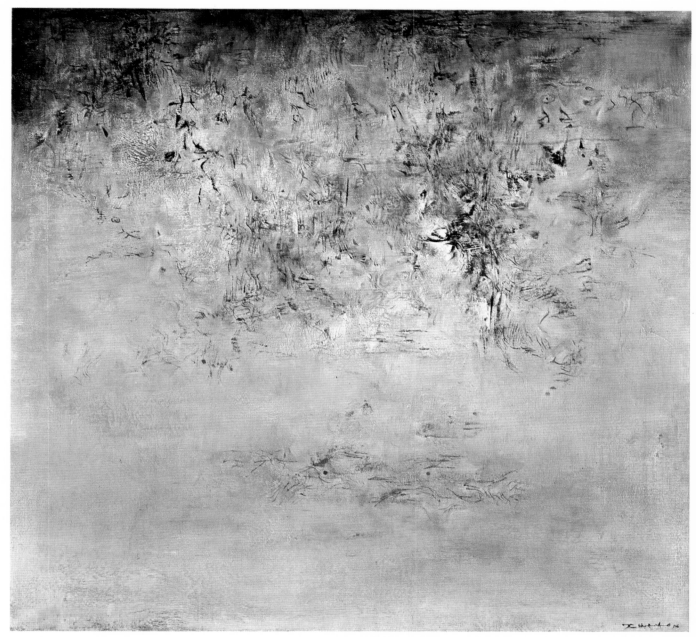

46. The river. 1956.
 Oil on canvas, 95 × 100 cm.
 Property of the artist.

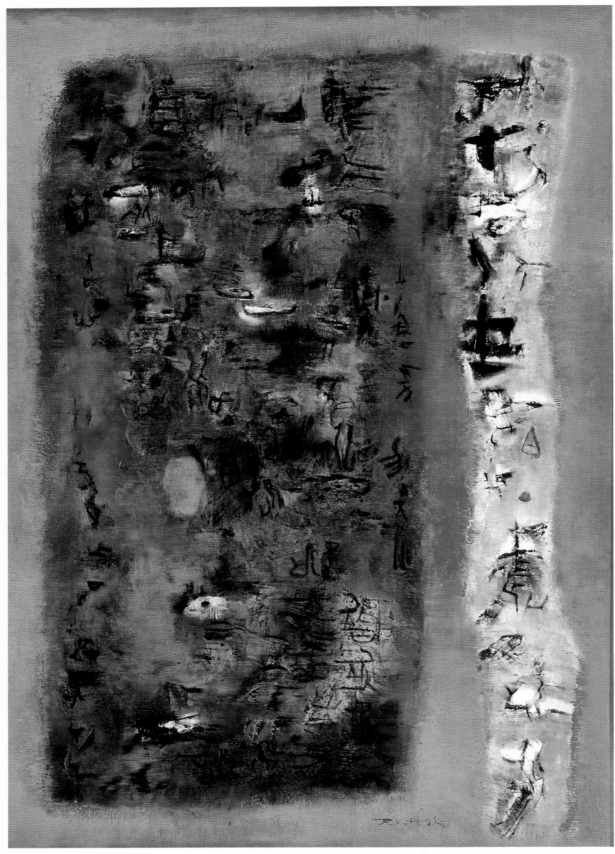

47. Stele for a friend. 1956.
 Oil on canvas, 162 × 113 cm.
 Otto Stangl Galerie, Munich.

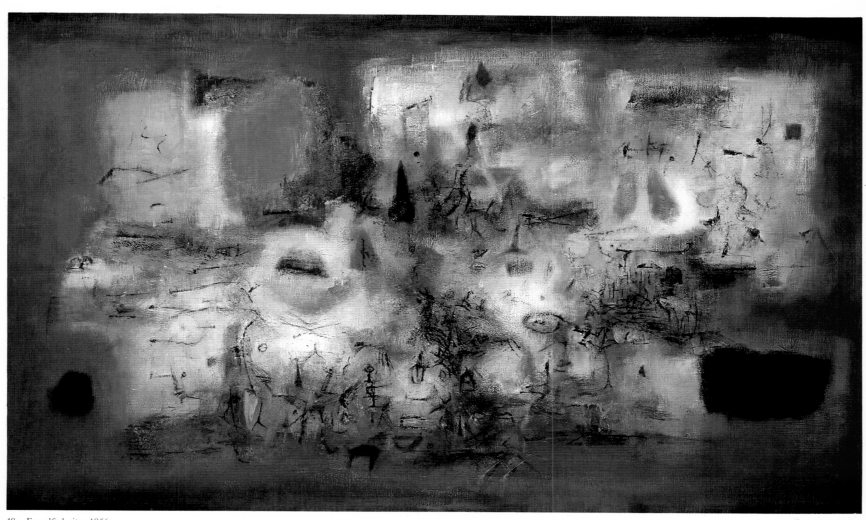

48. Engulfed city. 1956.
Oil on canvas, 89 × 146 cm.
Private collection, Paris.

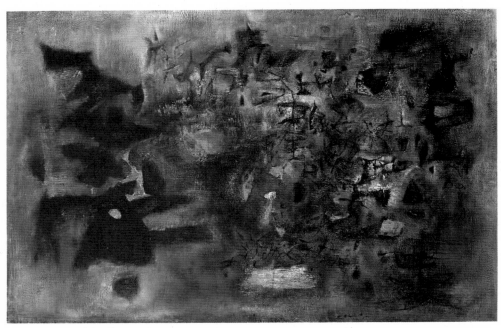

49. Beginning of October. 1955.
Oil on canvas, 97 × 146 cm.
Mr and Mrs James Sherwin Collection, New York.

50. The night is stirring. 1956.
Oil on canvas, 195 × 30 cm.
The Art Institute of Chicago.
Gift of Mrs Samuel M. Kootz.

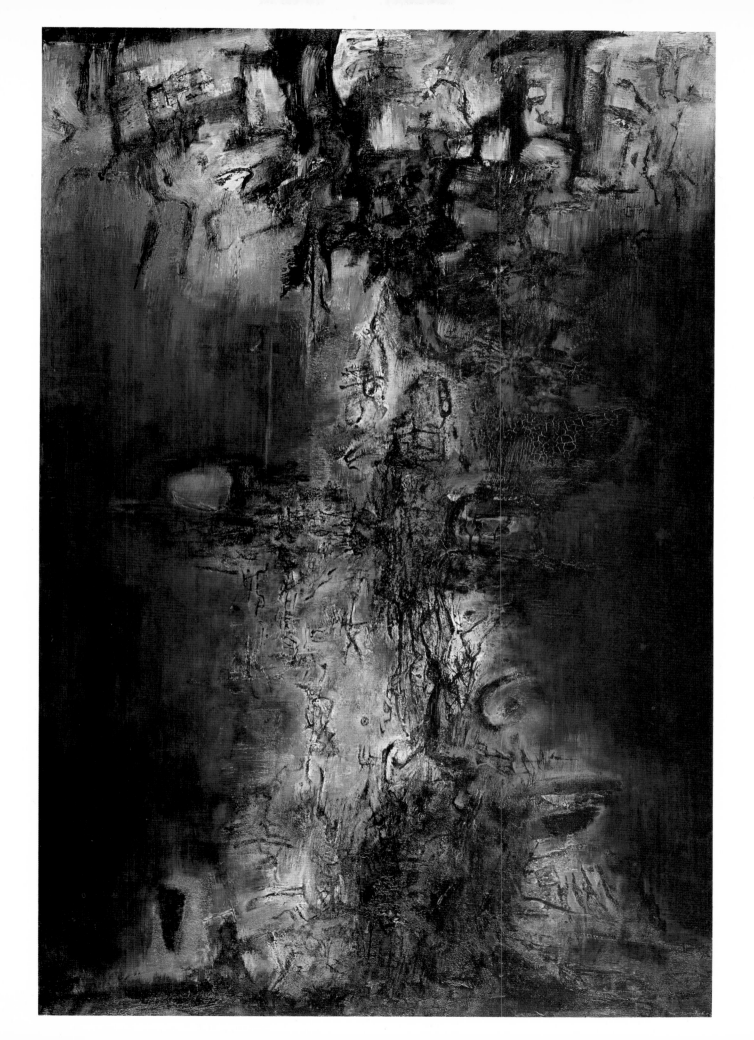

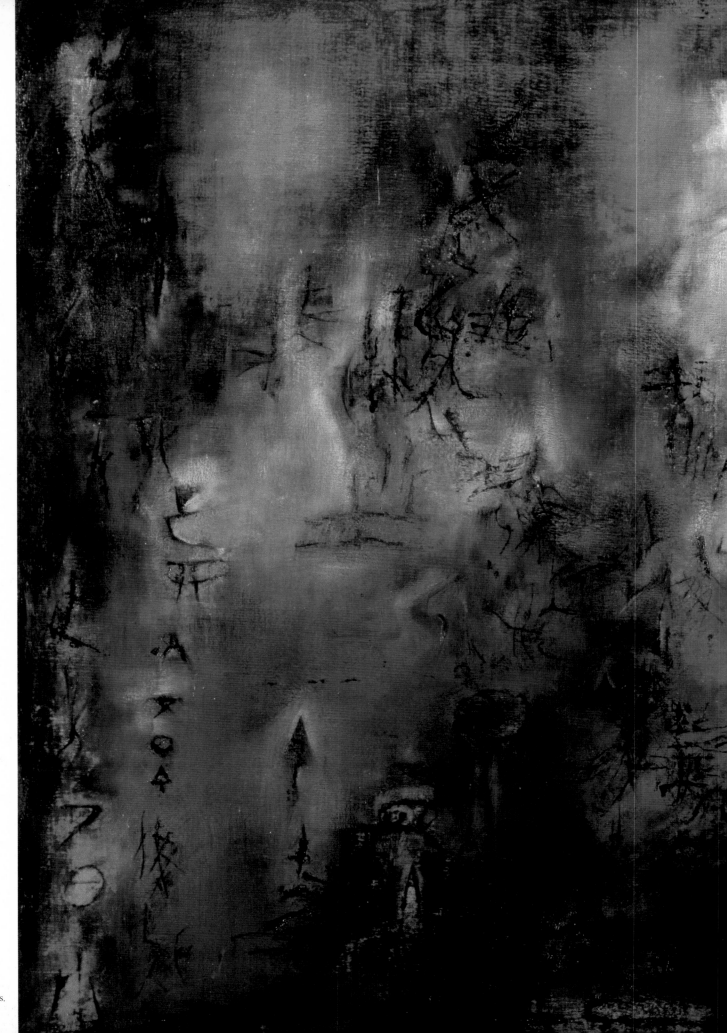

51. Riven mountain.
1955-1956.
Oil on canvas,
130 × 195 cm.
The Walker Art
Center, Minneapolis.

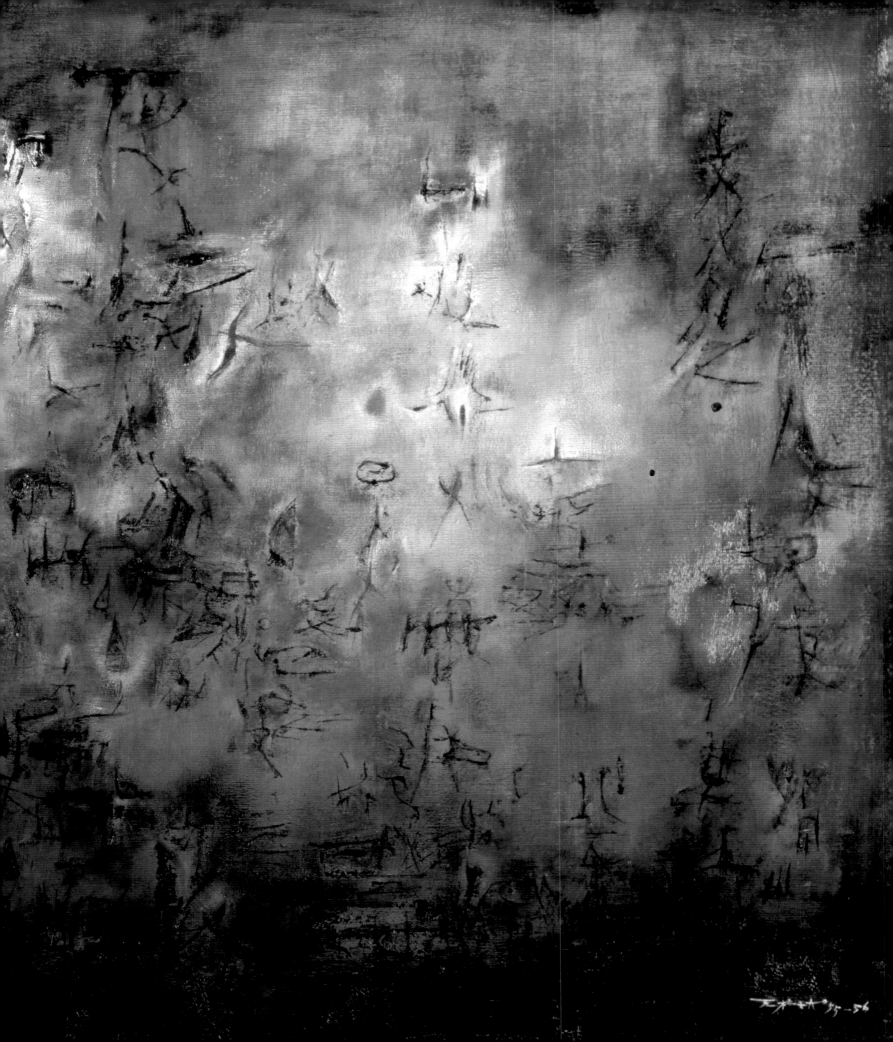

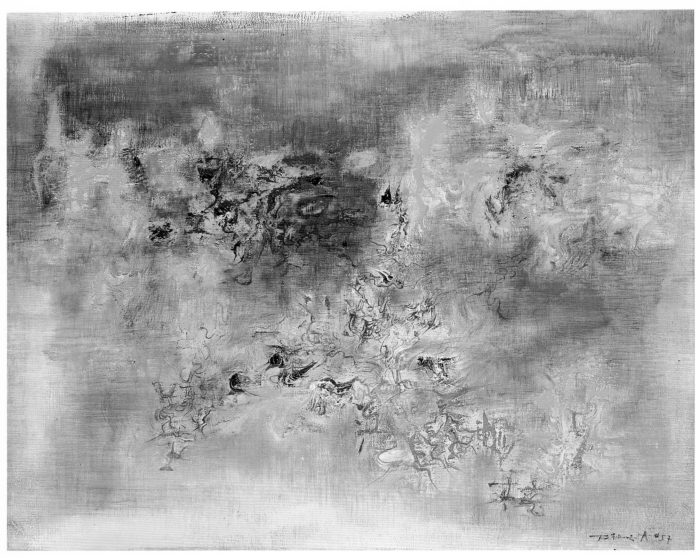

52. My country. 1957.
Oil on canvas, 60 × 92 cm.
Private collection, Paris.

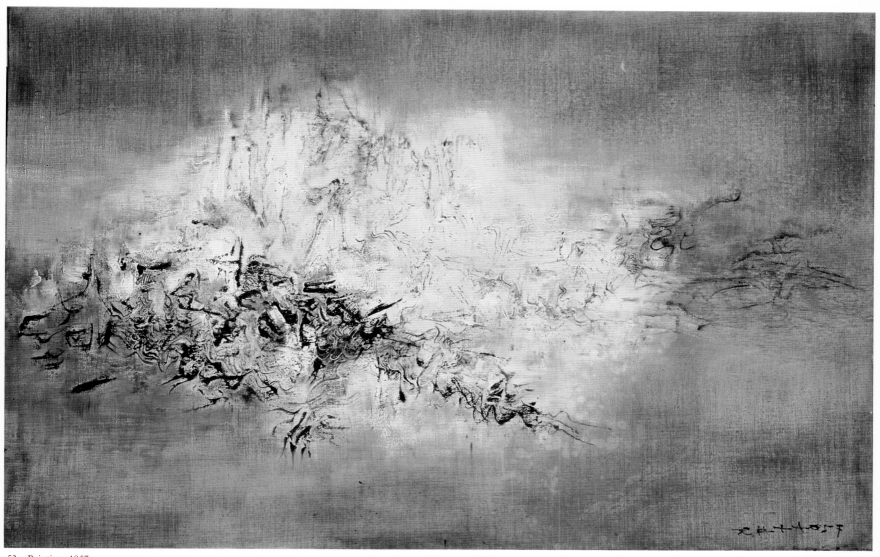

53. Painting. 1957.
Oil on canvas, 73 × 100 cm.
Private collection, Paris.

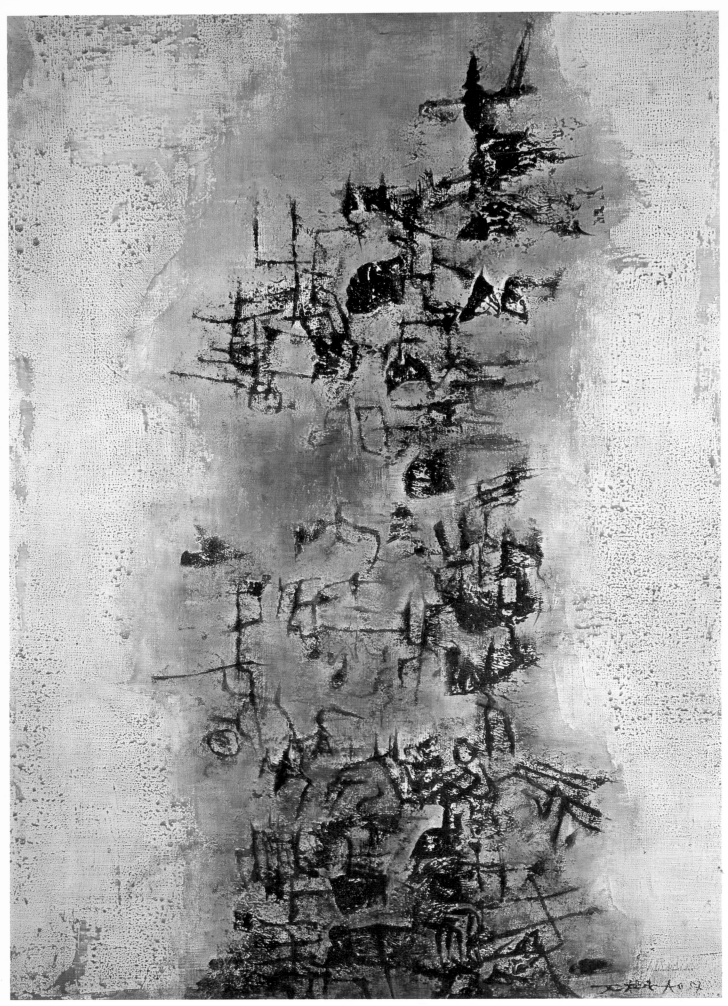

54. 1957.
Oil on canvas,
65 × 46 cm.
Hans Hartung
Collection, Paris.

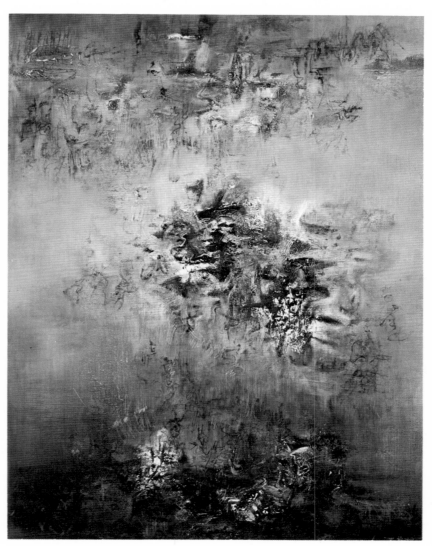

55. Threatening. 1957.
Oil on canvas, 116 × 89 cm.
Mrs F. W. Hillis Collection, New York.

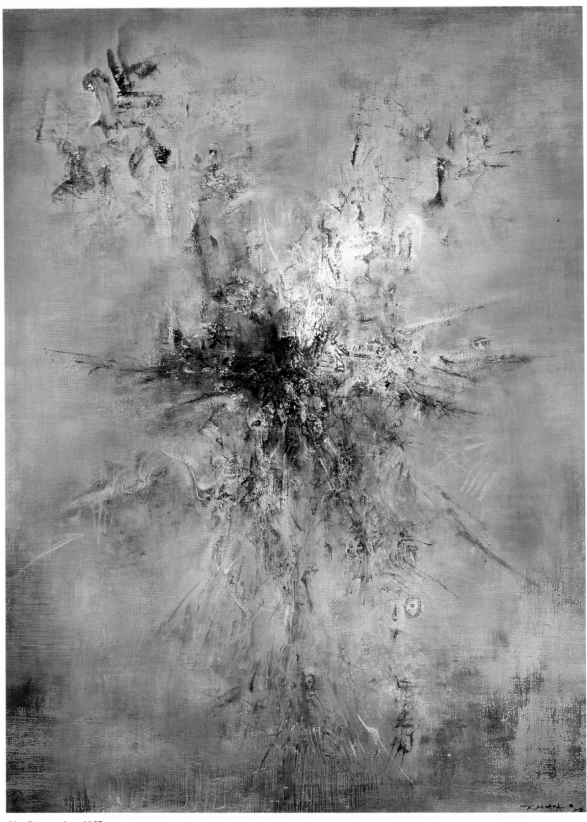

56. Burgeoning. 1957.
Oil on canvas, 162 × 130 cm.
Galerie de France, Paris.

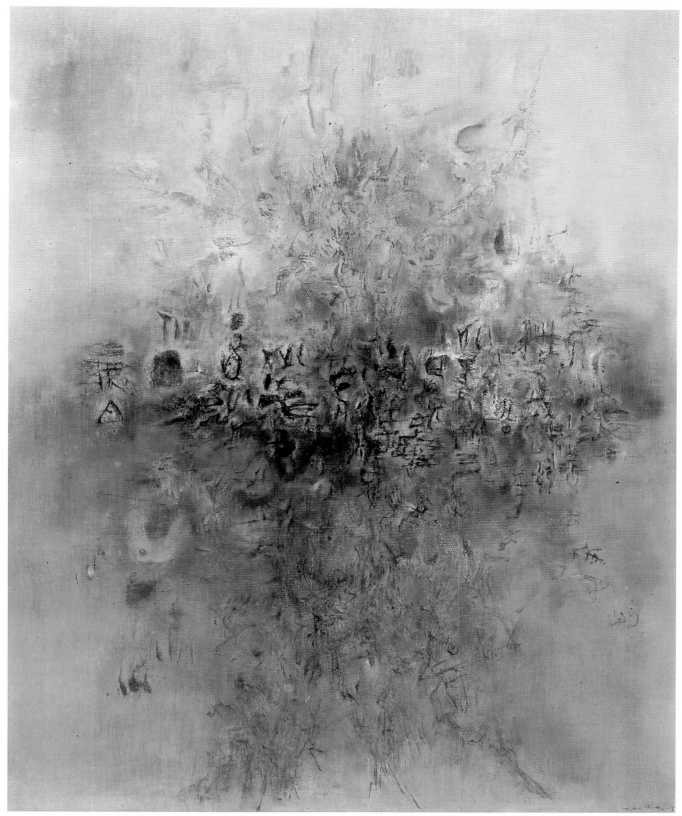

57. And the earth was without form. 1957.
 Oil on canvas, 200 × 162 cm.
 Private collection, Switzerland.

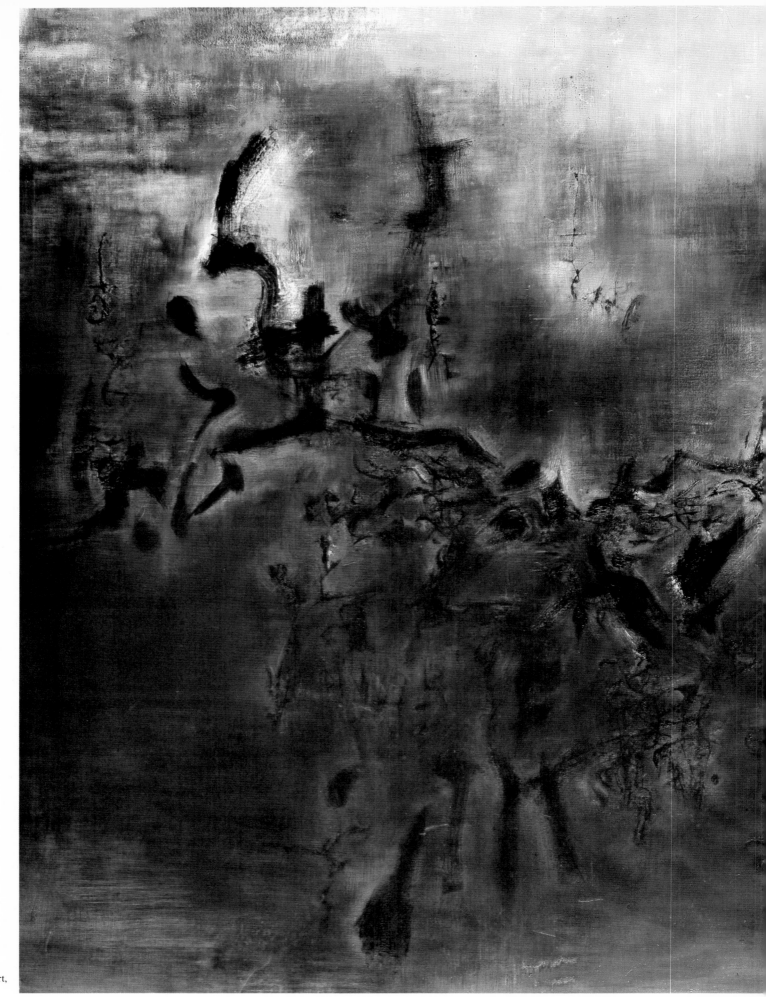

58. Composition.
1957.
Oil on canvas,
200 × 300 cm.
Nagaoka
Museum of
Contemporary Art,
Nagaoka, Japan.

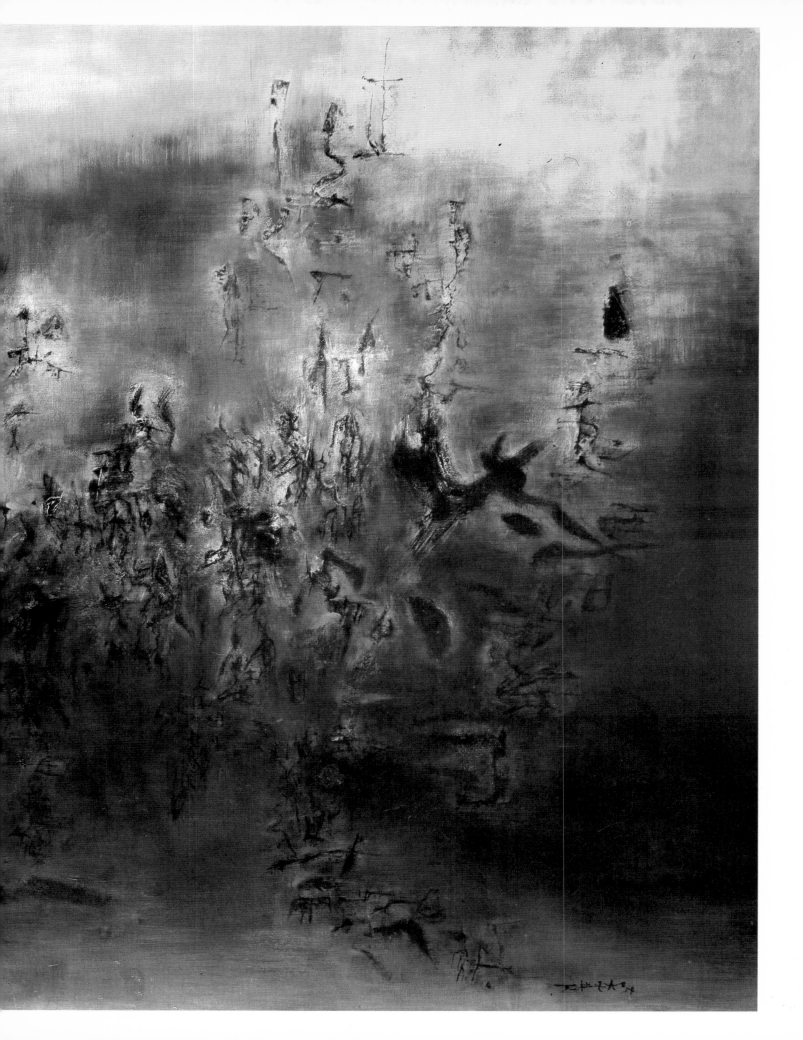

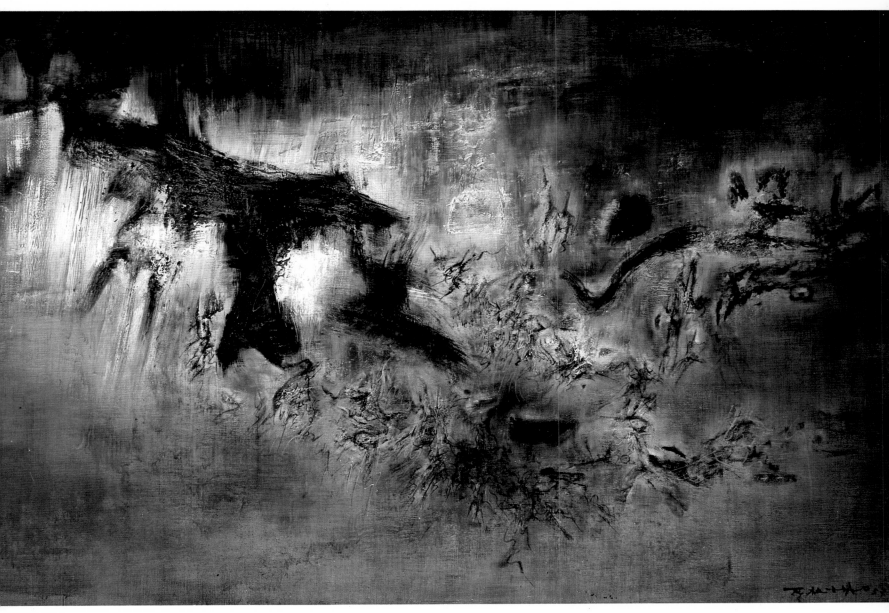

59. Mistral. 1957.
Oil on canvas, 130 × 195.
Solomon R. Guggenheim Museum, New York.

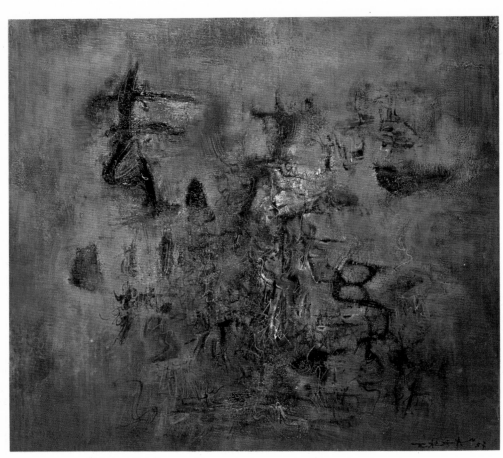

60. Red, blue and black. 1957.
Oil on canvas, 75 × 80 cm.
Mr and Mrs Benjamin Hertzberg Collection, New York.

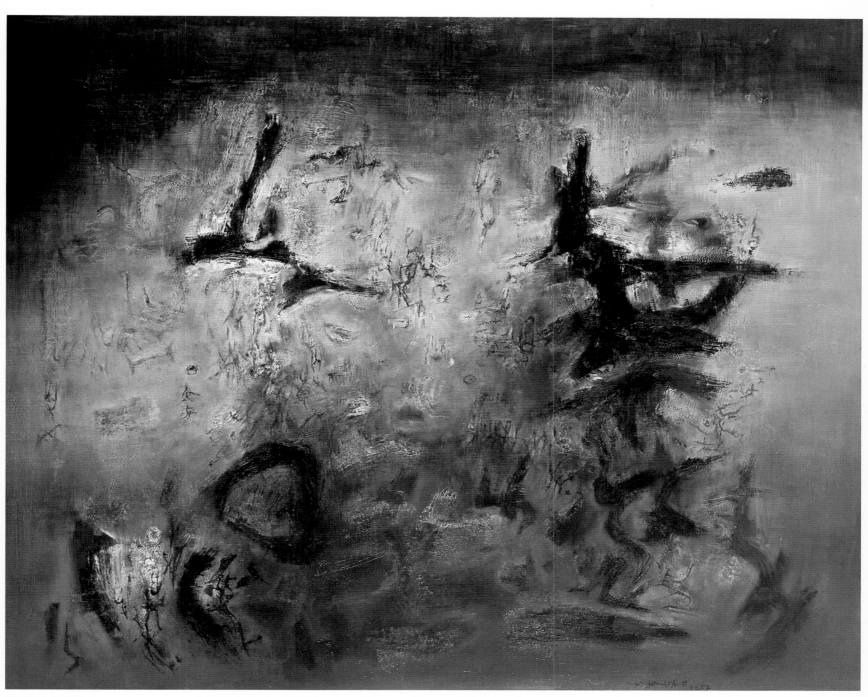

61. We two. 1957.
Oil on canvas, 162 × 200 cm.
Fogg Art Museum, Harvard University, Massachusetts.
Gift of Mr and Mrs John Cowles, New York.

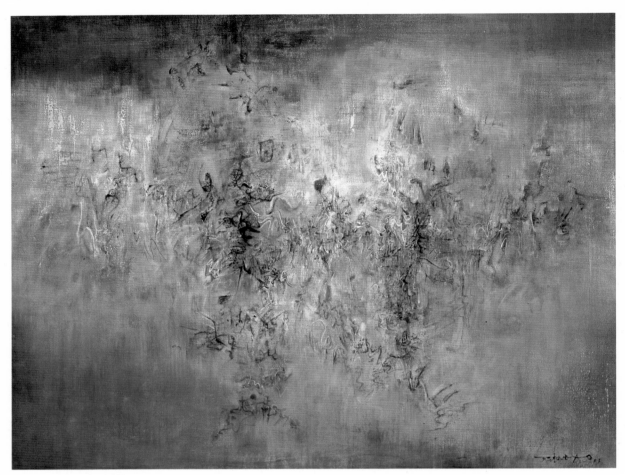

62. Near the Loire. 1957.
Oil on canvas, 114 × 146 cm.
Wadsworth Atheneum Collection, Hartford, Connecticut.

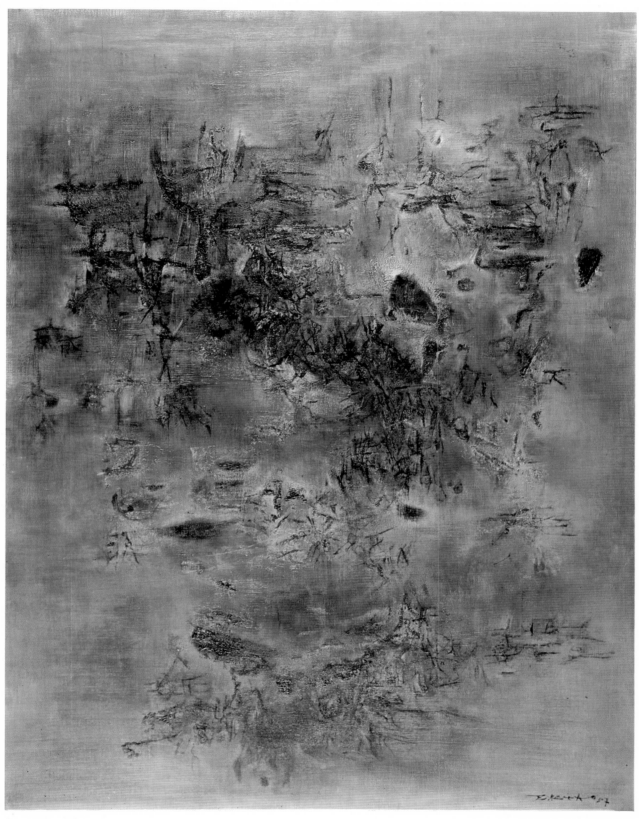

63. Wind and dust. 1957.
 Oil on canvas, 200 × 162 cm.
 Fogg Art Museum, Harvard University, Massachusetts.

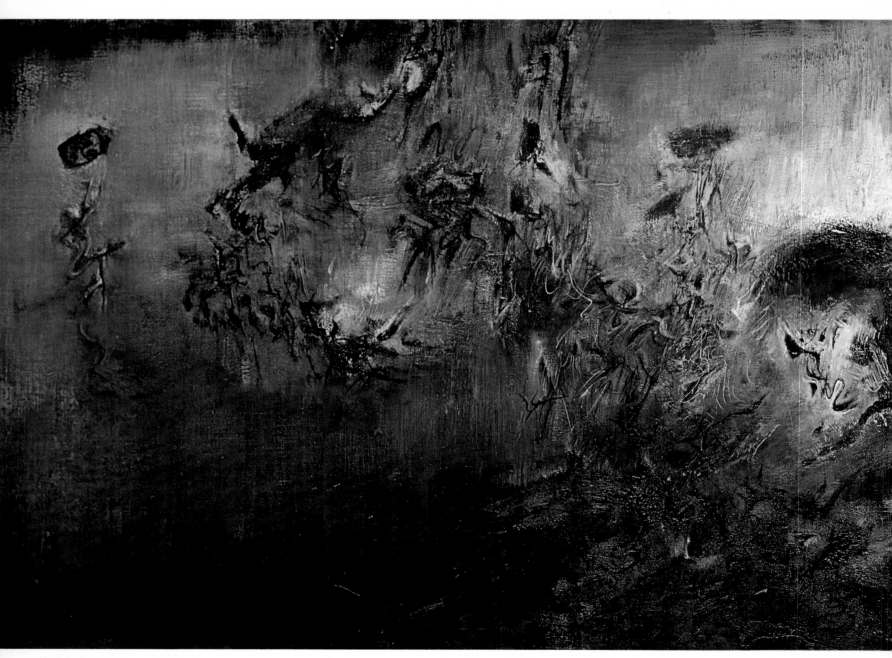

64. Painting. 1957.
Oil on canvas, 97 × 221 cm.
Detroit Institute of Art, Detroit.
Gift of Dr Wu-Wai Chao.

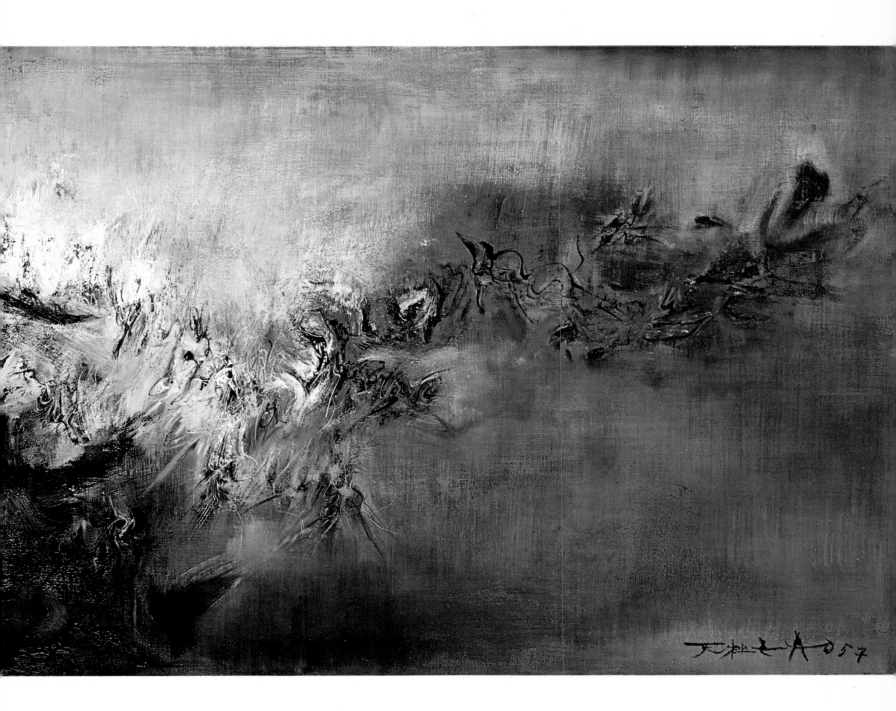

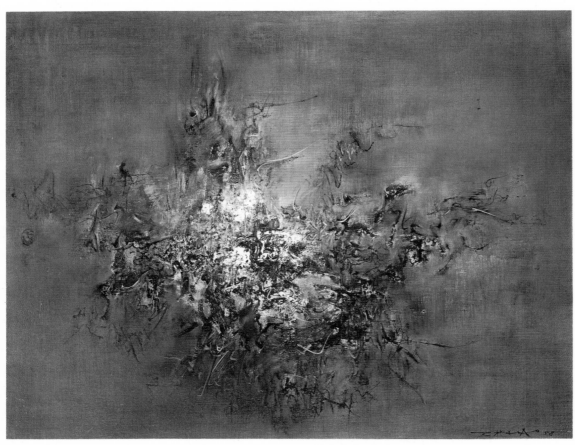

65. Painting. 1958.
Oil on canvas, 73 × 92 cm.
Property of the artist.

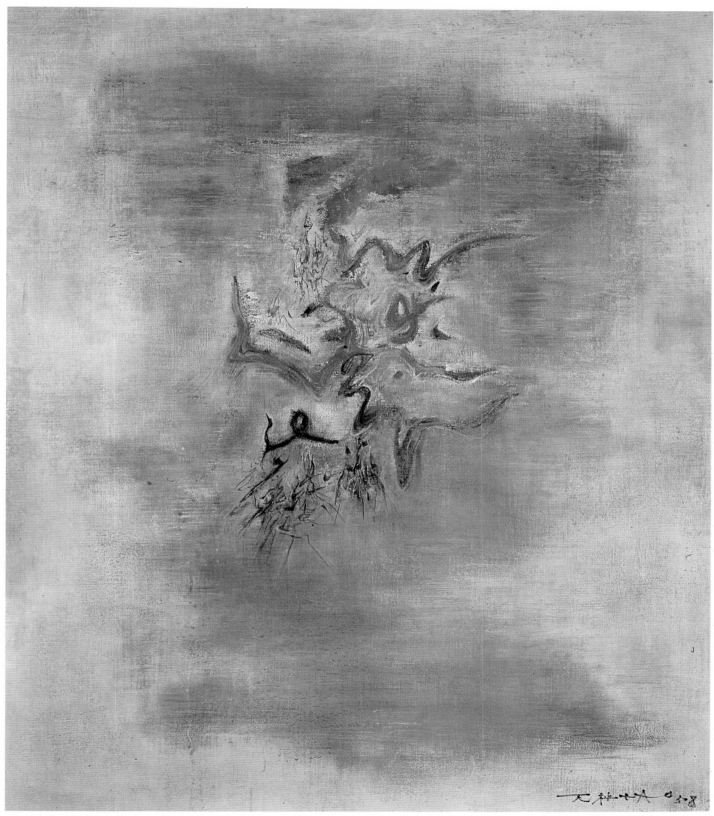

66. Painting. 1958.
 Oil on canvas, 114 × 97 cm.
 Mrs S. I. Rosenman Collection, New York.

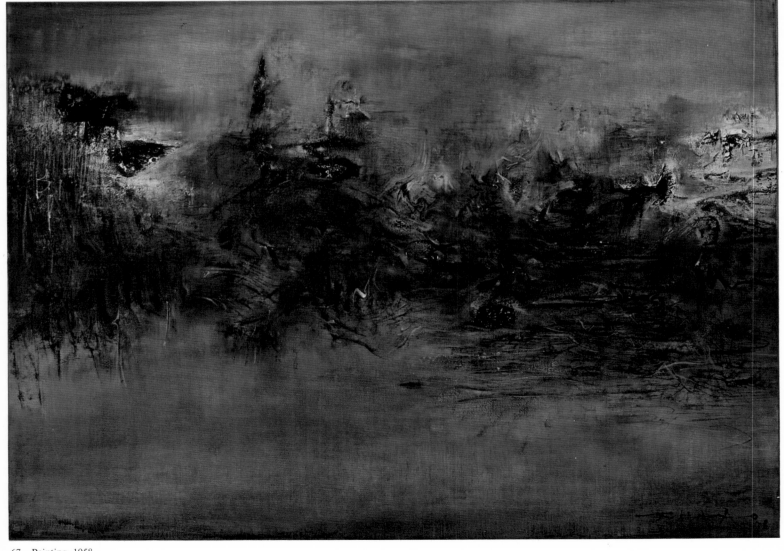

67. Painting. 1958.
Oil on canvas, 73 × 100 cm.
Mrs Lester Dana Collection, Boston.

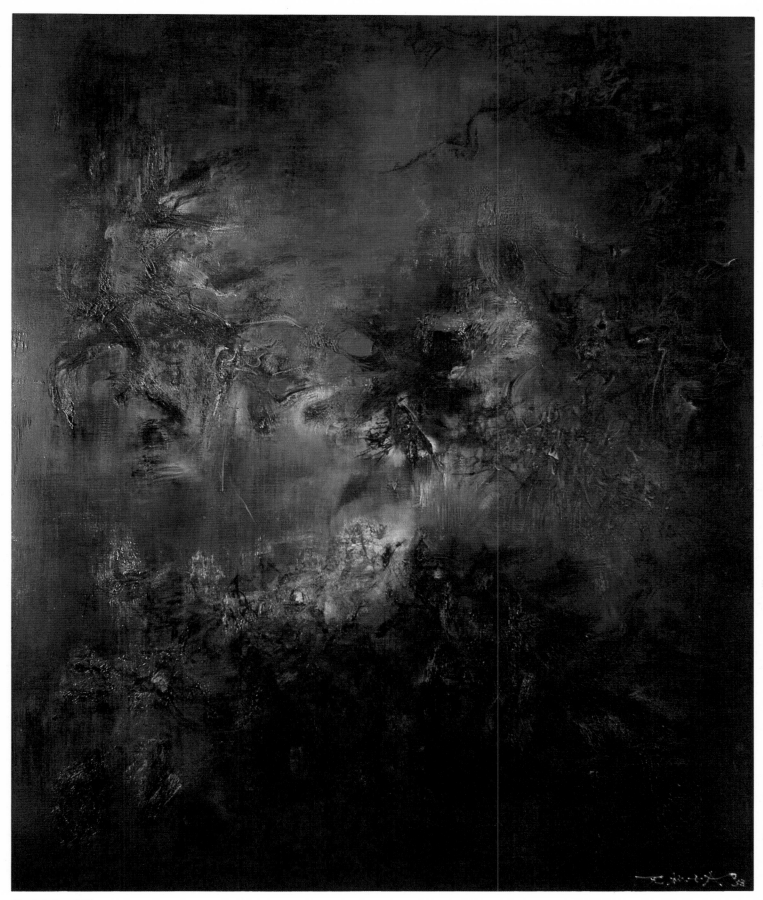

68. Painting. 1958.
Oil on canvas, 200 × 162 cm.
Mr and Mrs Paul Tishman Collection, New York.

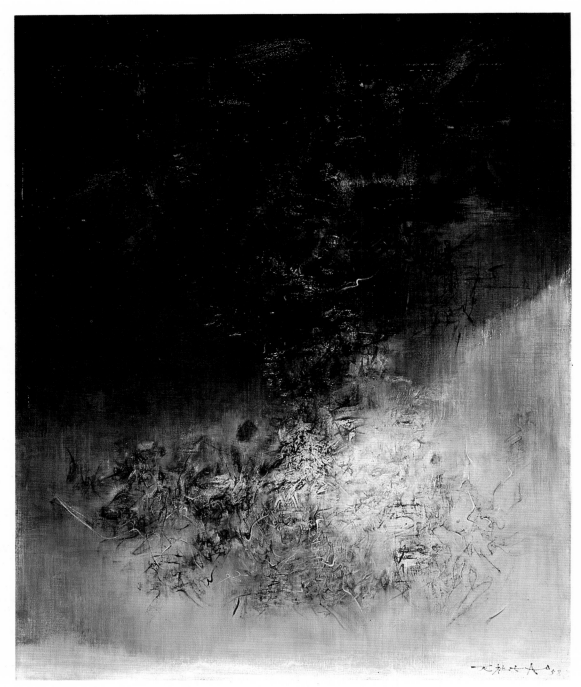

69. Painting. 1958.
Oil on canvas, 162 × 130 cm.
Hirshhorn Museum and Sculpture Garden.
Smithsonian Institution, Washington, D.C.

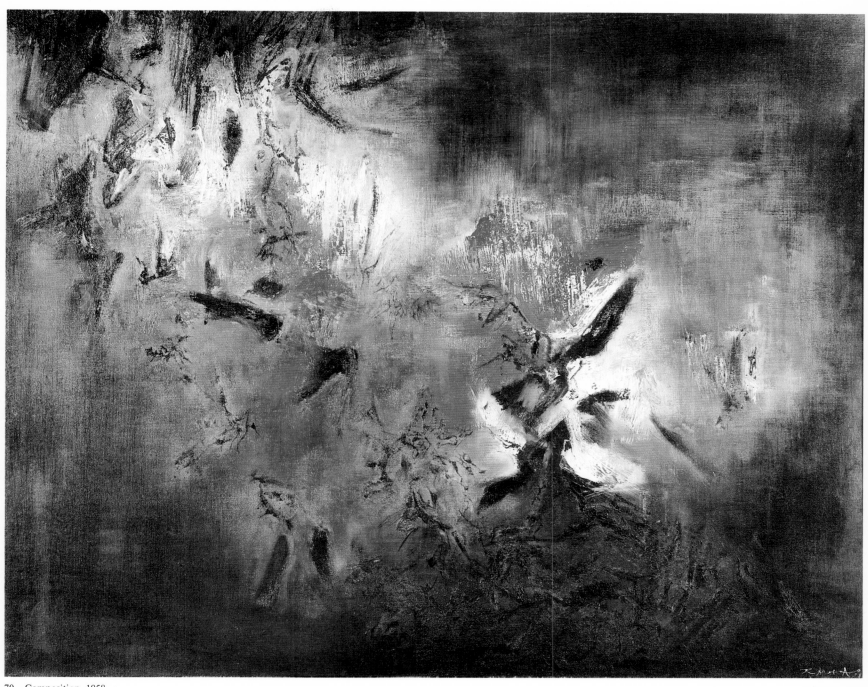

70. Composition. 1958.
Oil on canvas, 130 × 162 cm.
Mery and Leigh B. Block Foundation.
The Art Institute of Chicago.

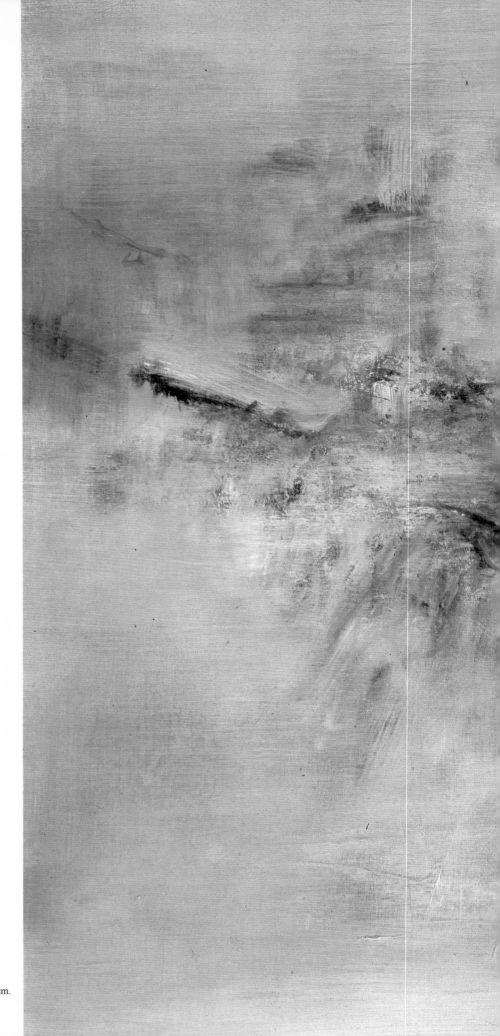

71. 13-10-59.
 Oil on canvas, 114 × 146 cm.
 Private collection, Paris.

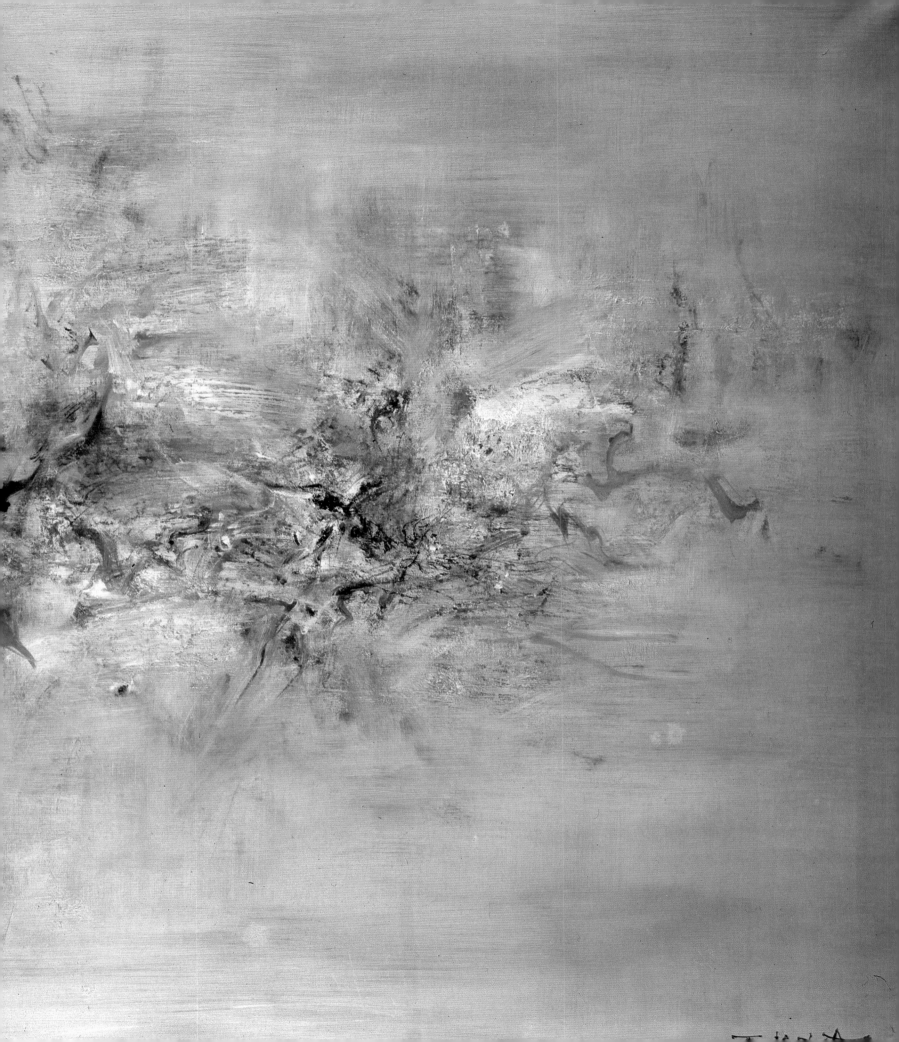

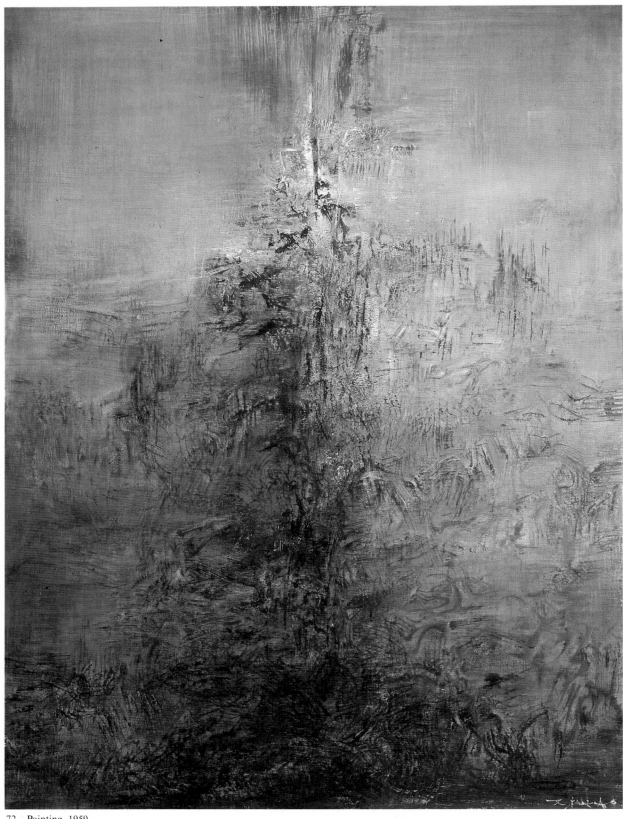

72. Painting. 1959.
Oil on canvas, 130 × 97 cm.
Ateneumin Taidemusee, Helsinki.

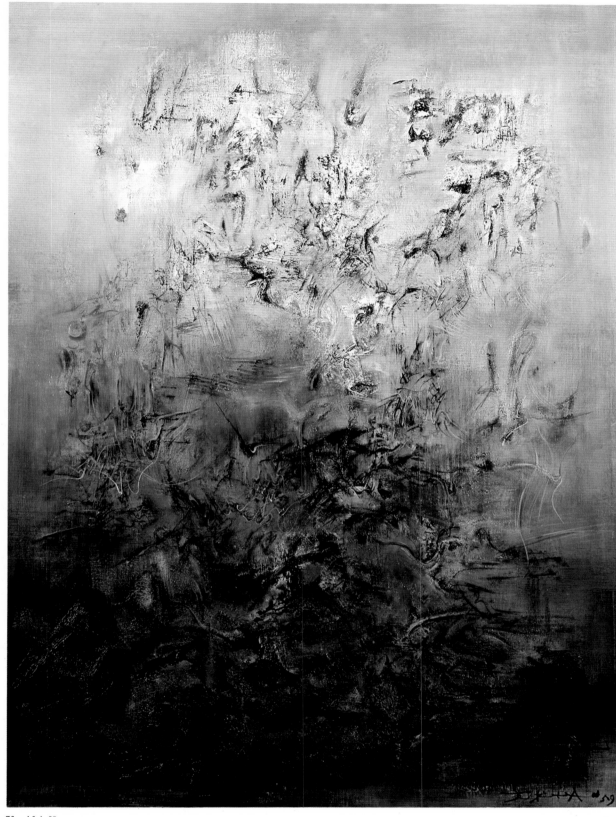

73. 15-1-59.
Oil on canvas, 130 × 97 cm.
Galerie de France, Paris.

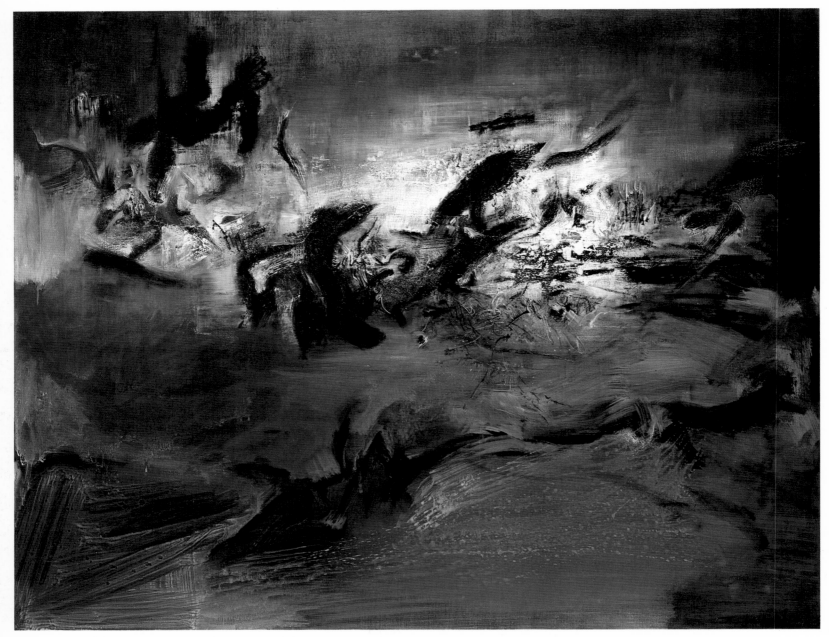

74. 21-4-59.
 Oil on canvas, 130 × 162 cm.
 Private collection, Paris.

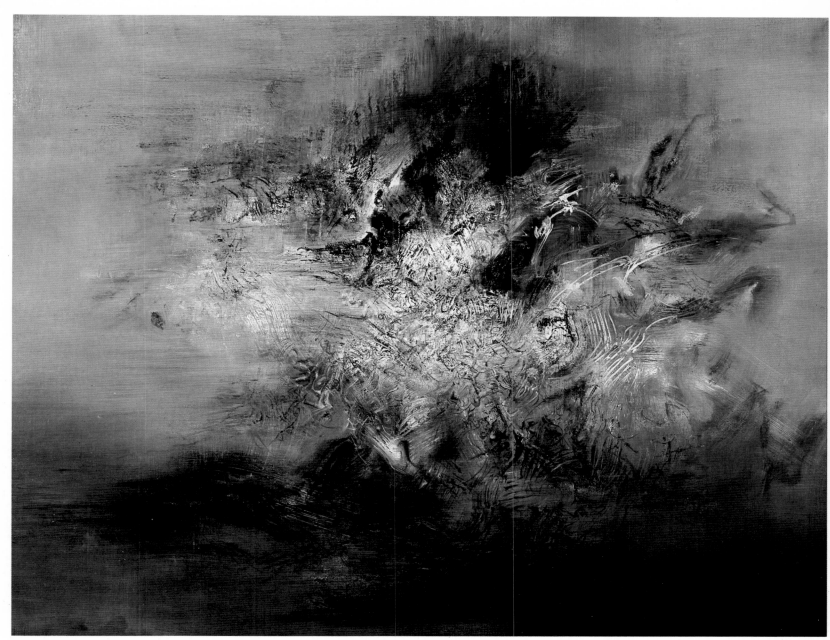

75. 19-11-59.
Oil on canvas, 114 × 146 cm.
Upjohn Company Collection, Kalamazoo, Michigan.

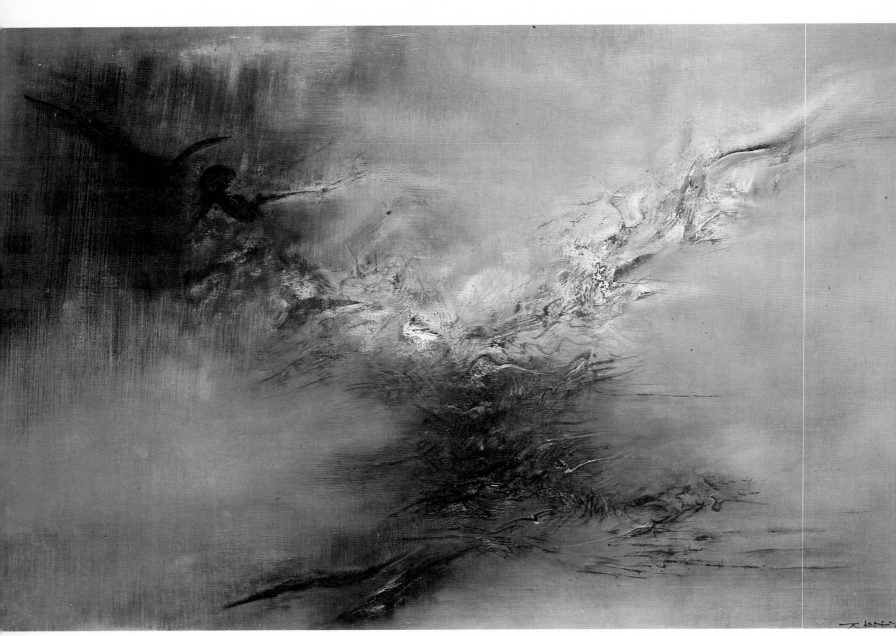

76. 2-4-59.
Oil on canvas, 97 × 130 cm.
Private collection, London.

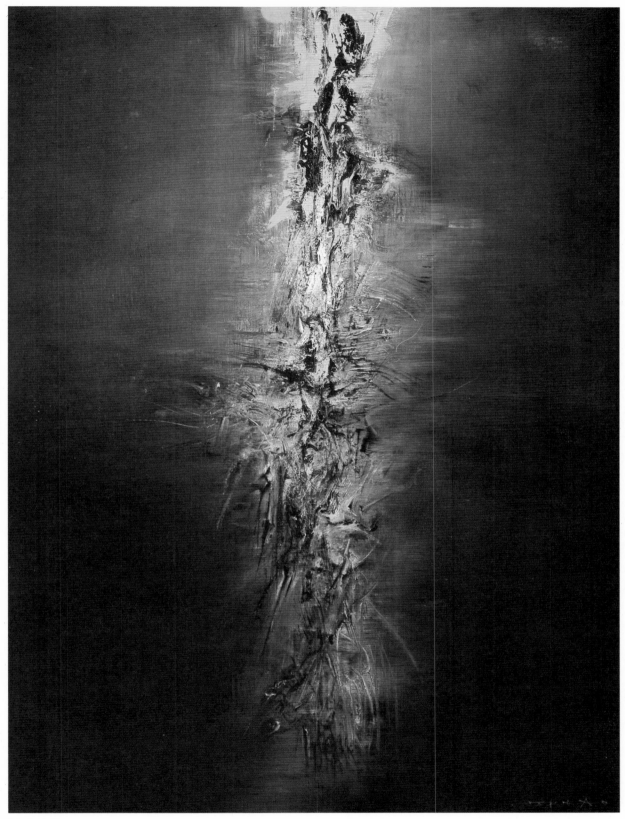

77. 2-11-59.
 Oil on canvas, 130 × 97 cm.
 Private collection, New York.

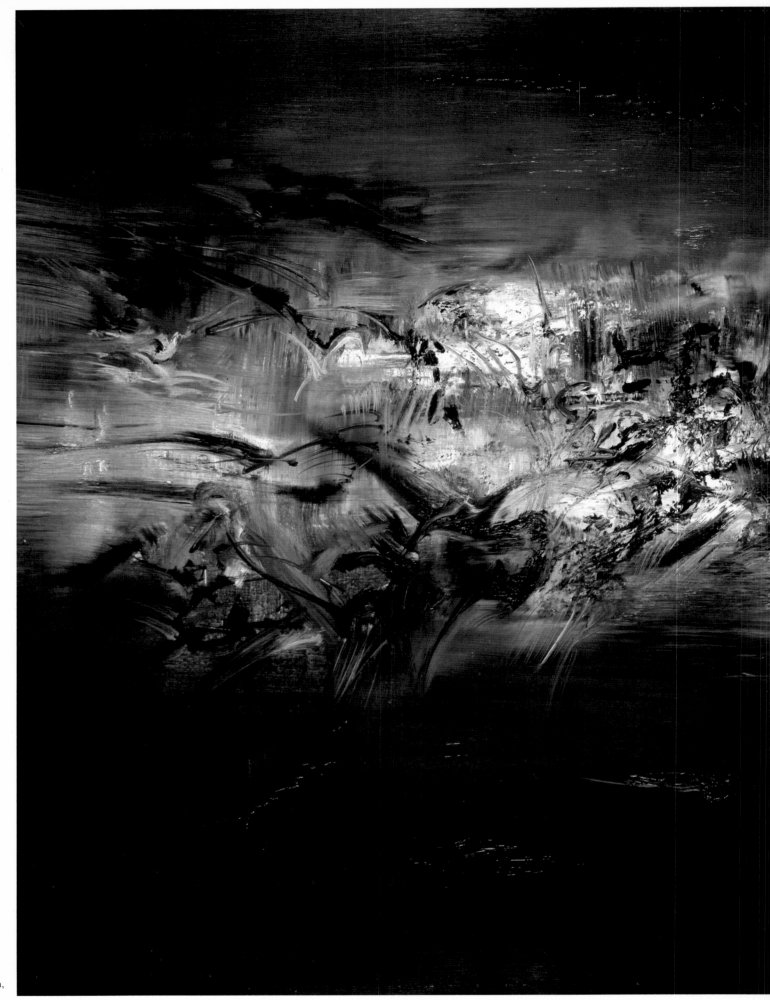

78. 6-1-60.
Oil on canvas.
130 × 195 cm.
Private collection,
Paris.

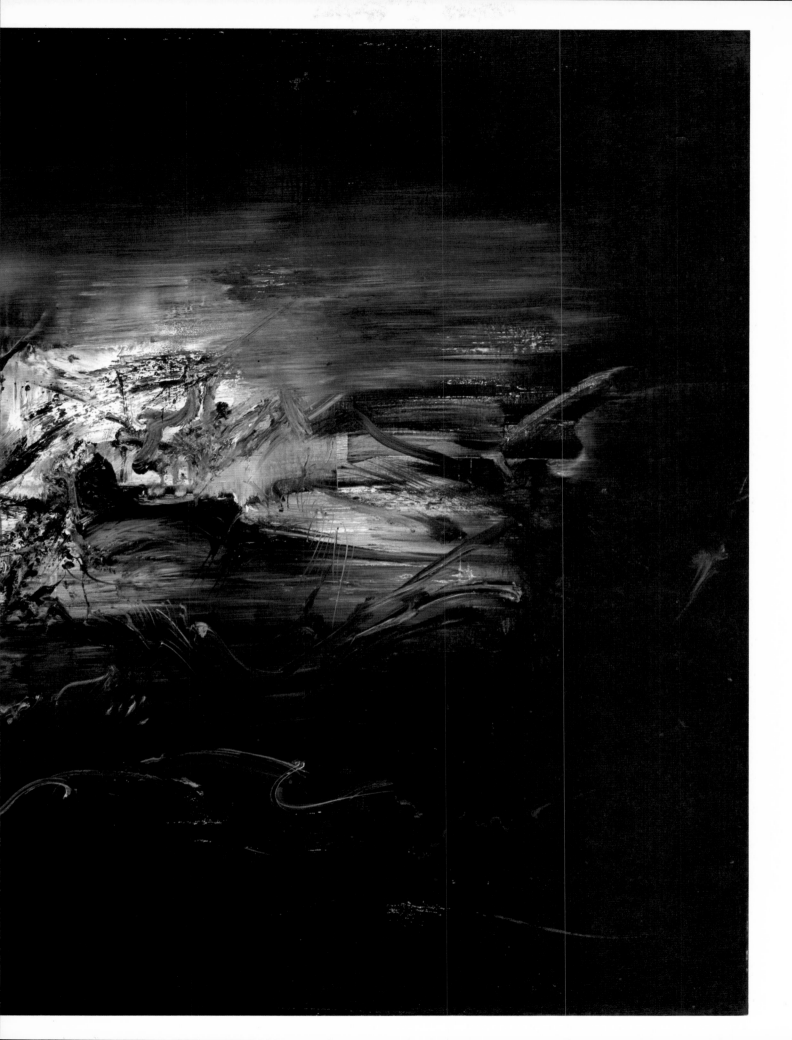

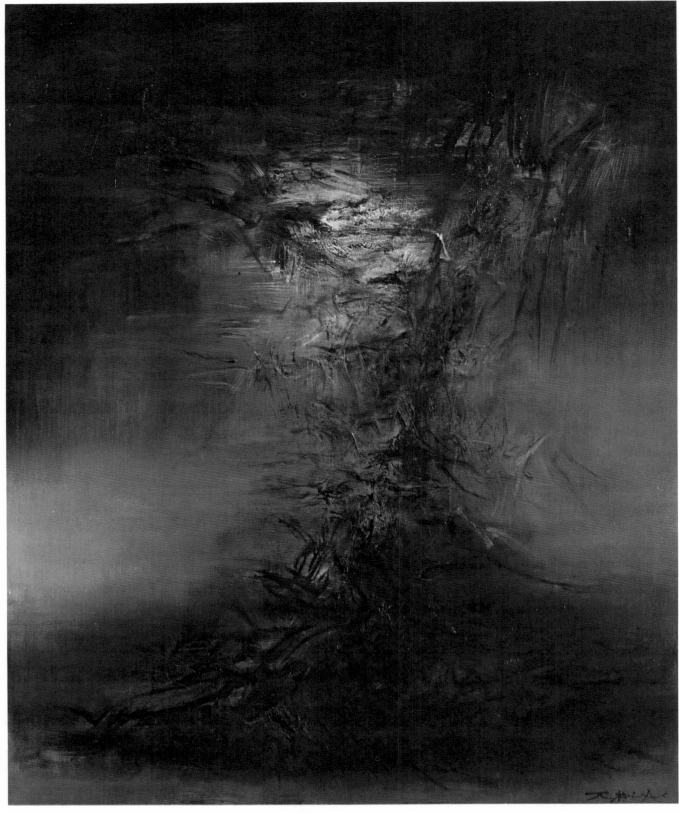

79. 10-12-60.
 Oil on canvas, 200 × 162 cm.
 Upjohn Company Collection, Kalamazoo, Michigan.

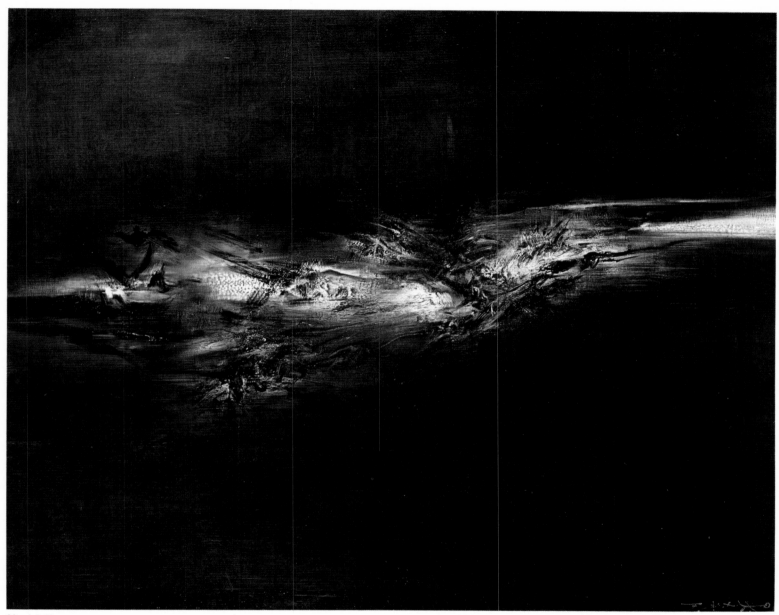

80. 1-3-60.
Oil on canvas, 162 × 200 cm.
Galerie de France, Paris.

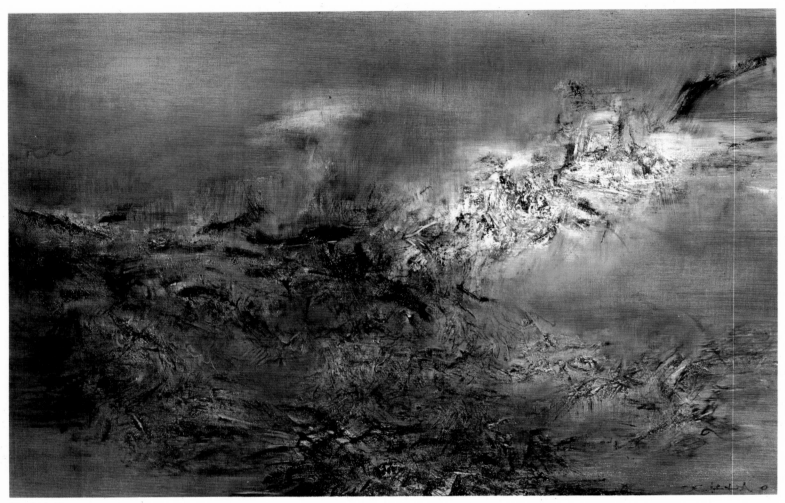

81. 14-3-60.
Oil on canvas, 89 × 116 cm.
Jean Seberg Collection, U.S.A.

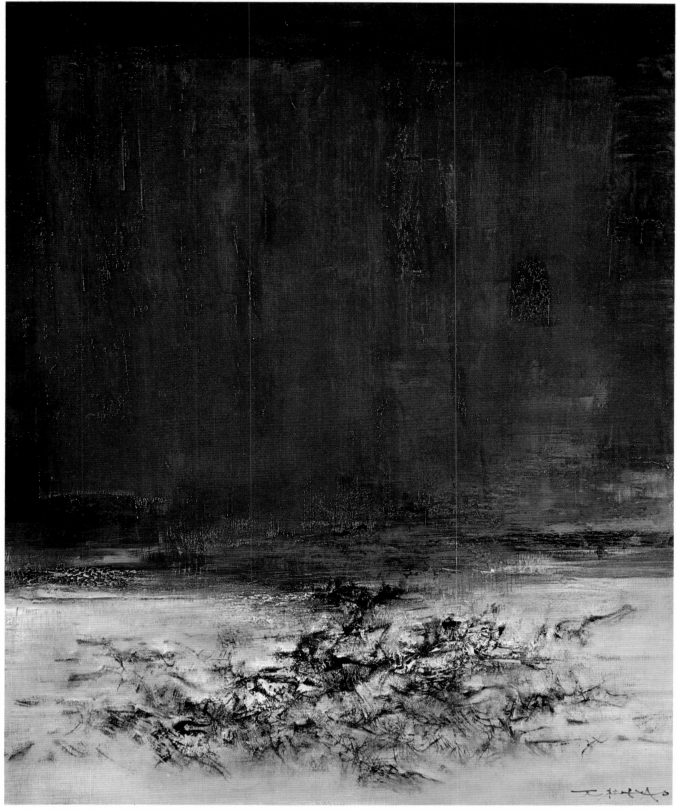

82. 17-12-60.
Oil on canvas, 162 × 130 cm.
Mrs Iola Haverstick Collection, New York.

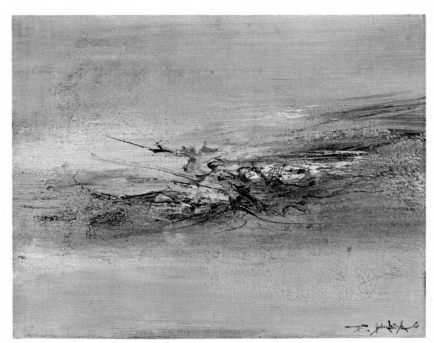

83. 25-8-60.
 Oil on canvas, 24 × 33 cm.
 Jean Leymarie Collection, Paris.

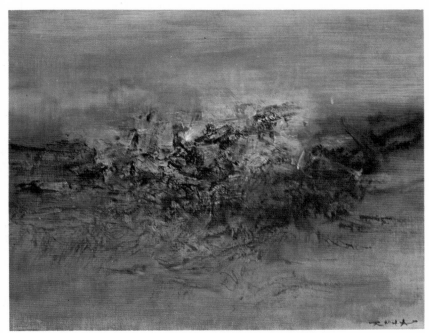

84. 4-9-60.
 Oil on canvas, 65 × 81 cm.
 Private collection, Toronto.

85. 14-10-60.
 Oil on canvas, 162 × 130 cm.
 Mrs and Mrs John Q. Powers Collection, New York.

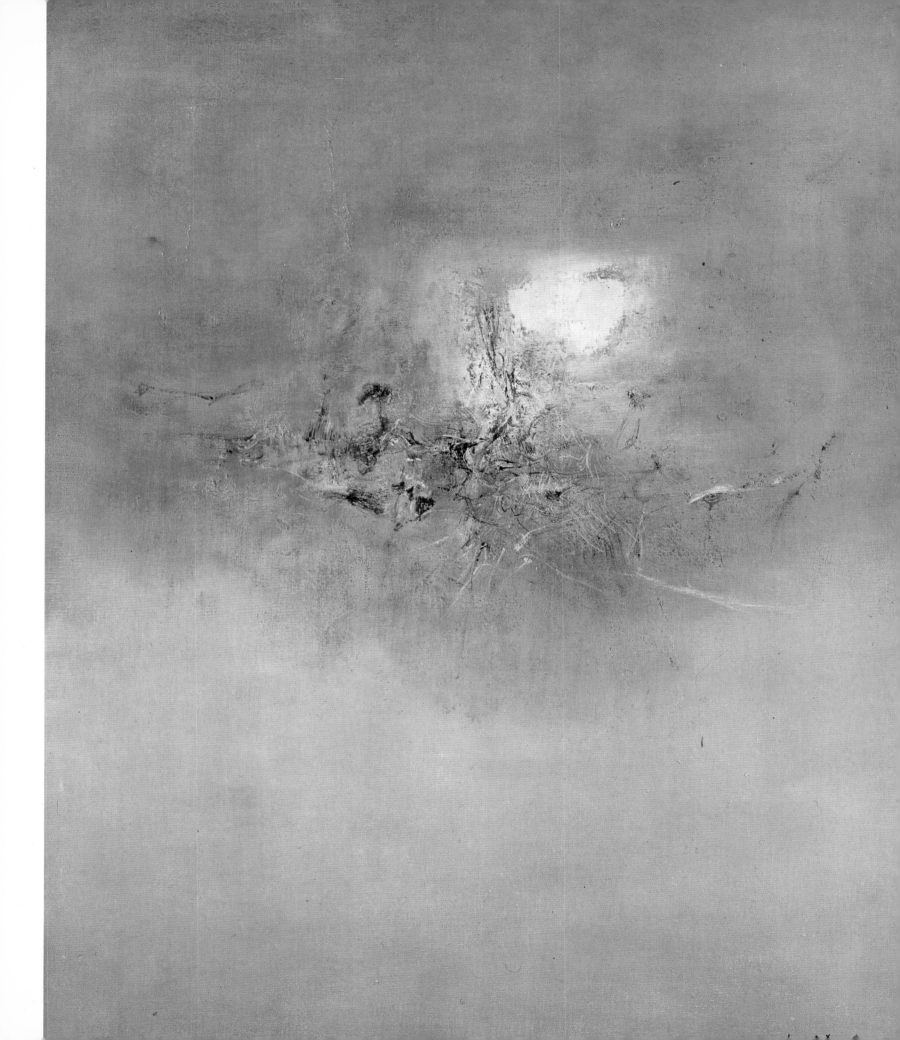

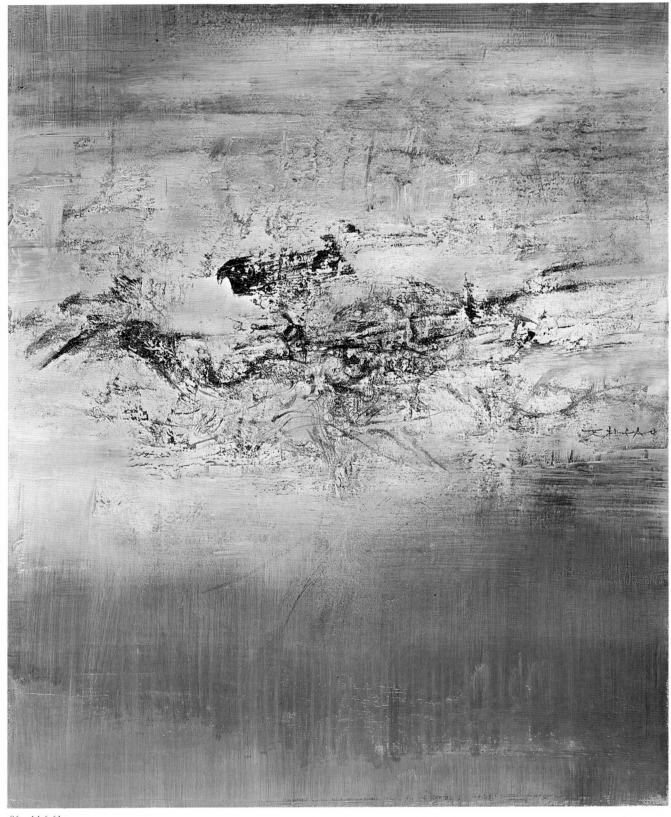

86. 14-6-61.
Oil on canvas, 81 × 65 cm.
Mr and Mrs John Cowles Collection, New York.

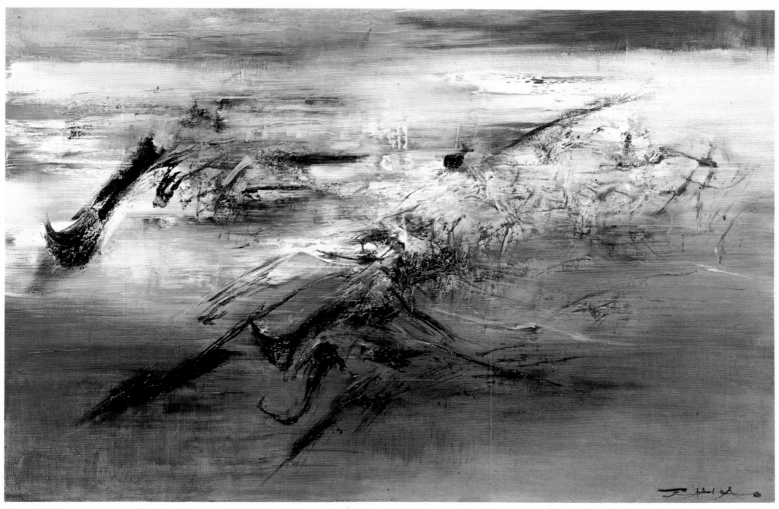

87. 30-10-61.
Oil on canvas, 130 × 195 cm.
Mr and Mrs Abraham M. Lindenbaum Collection, Brooklyn, New York.

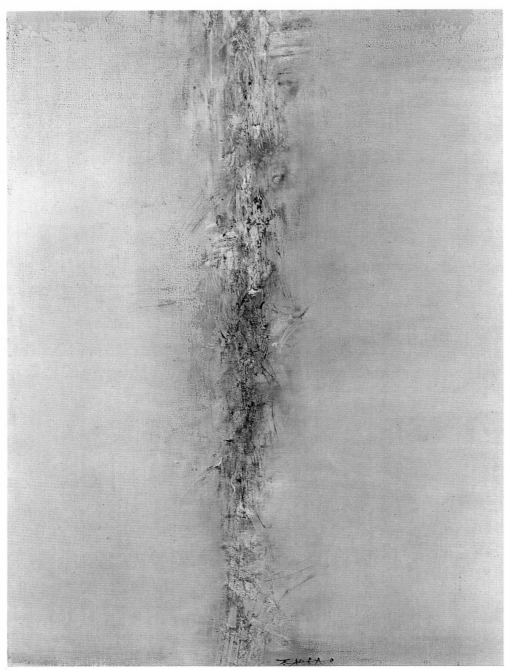

88. 27-5-61.
Oil on canvas, 100 × 73 cm.
Private collection, U.S.A.

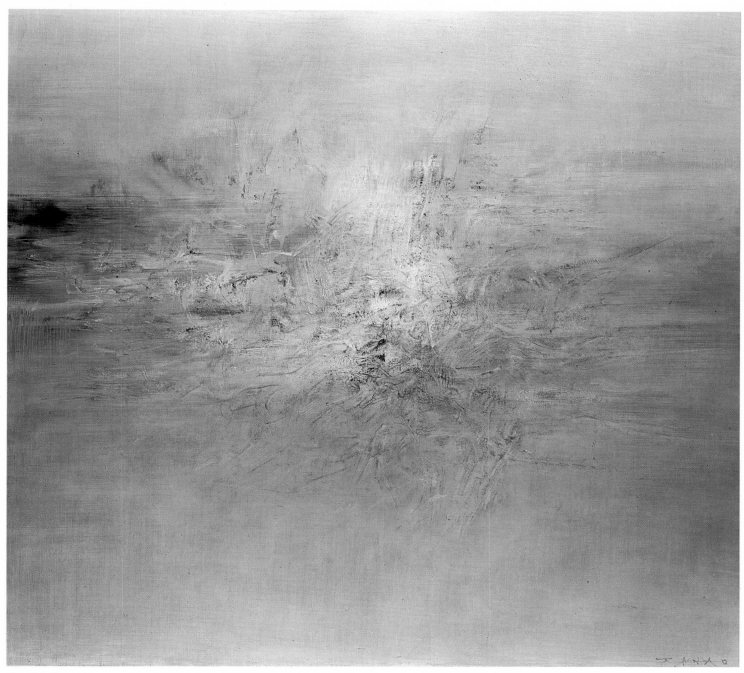

89. 19-7-61.
Oil on canvas, 162 × 150 cm.
Galerie de France, Paris.

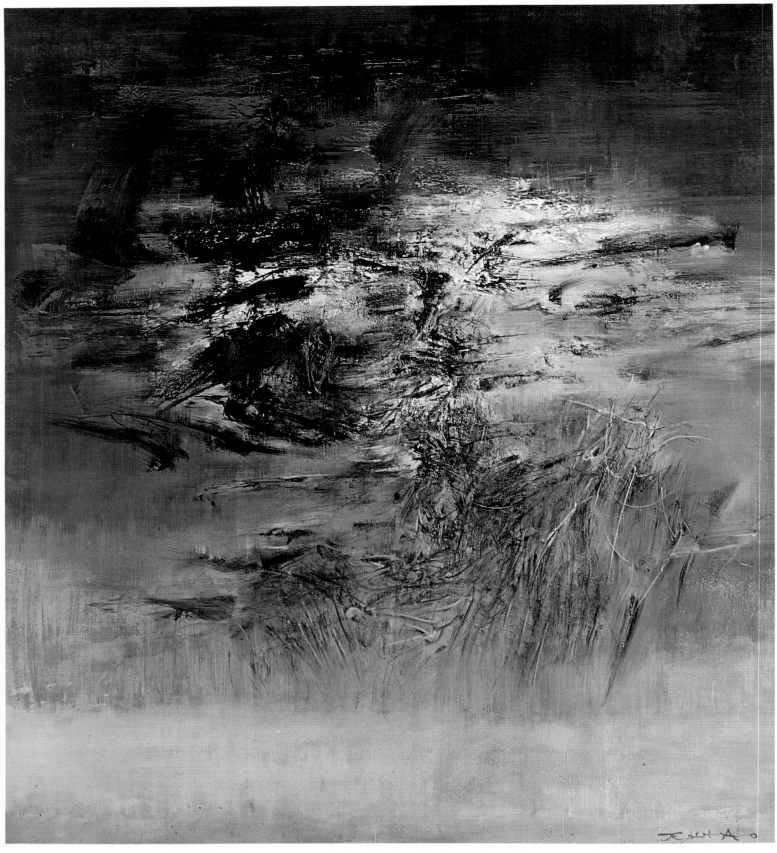

90. 15-12-61.
Oil on canvas, 200 × 180 cm.
Centre Georges Pompidou,
National Gallery of Modern Art, Paris.

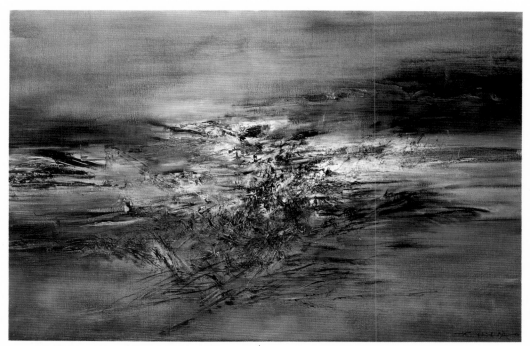

91. 1961.
 Oil on canvas, 130 × 195 cm.
 Private collection, Tokyo.

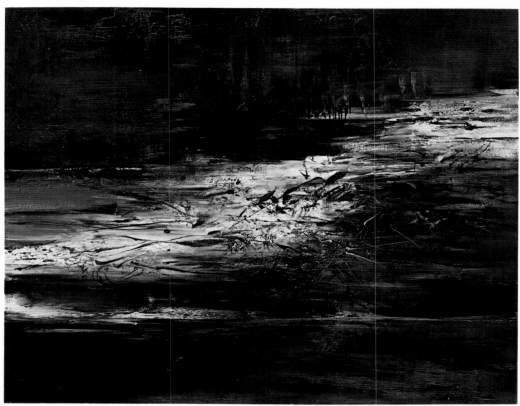

92. 14-11-61.
 Oil on canvas, 130 × 162 cm.
 Property of the artist.

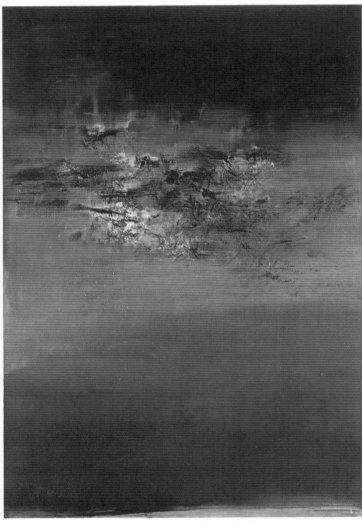

93. 23-5-62.
 Oil on canvas, 195 × 130 cm.
 Mrs William R. Thompson Collection, New York.

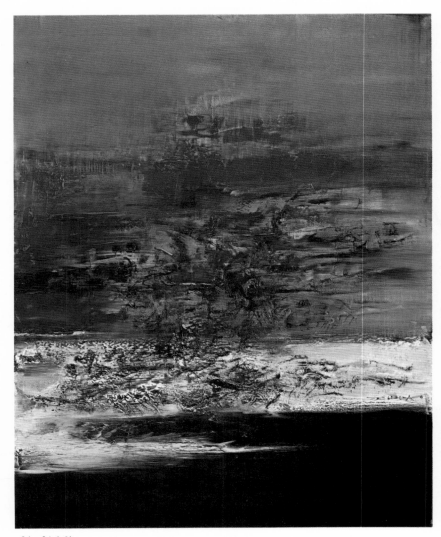

94. 24-6-61.
 Oil on canvas, 146 × 97 cm.
 Galerie de France, Paris.

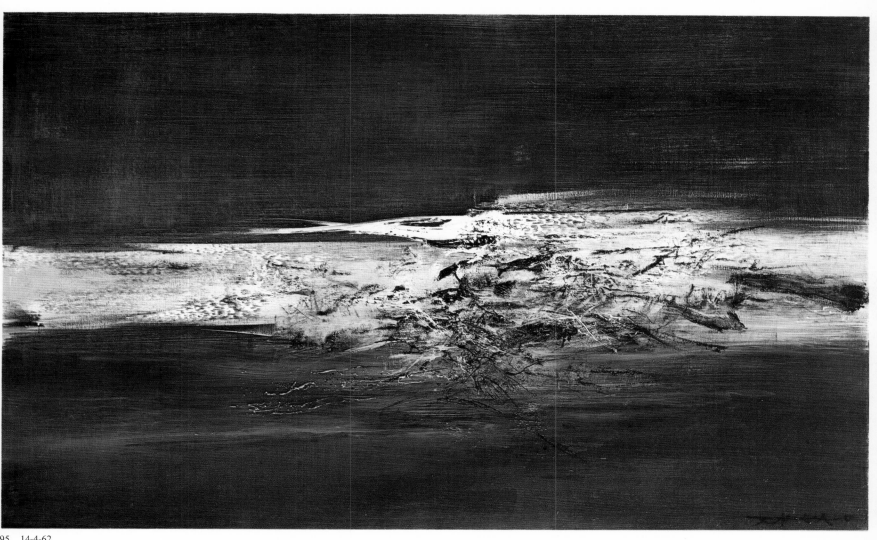

95. 14-4-62.
Oil on canvas, 81 × 130 cm.
Galerie de France, Paris.

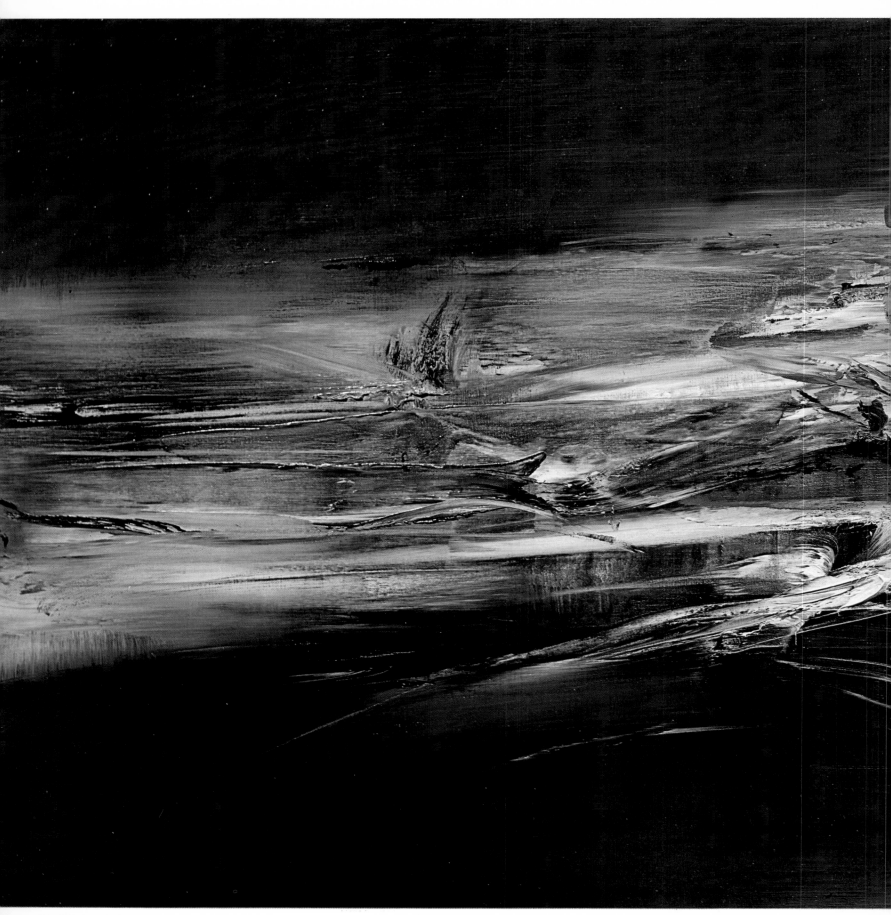

96. Painting. 1962.
Oil on canvas, 114 × 195 cm.
Private collection, Paris.

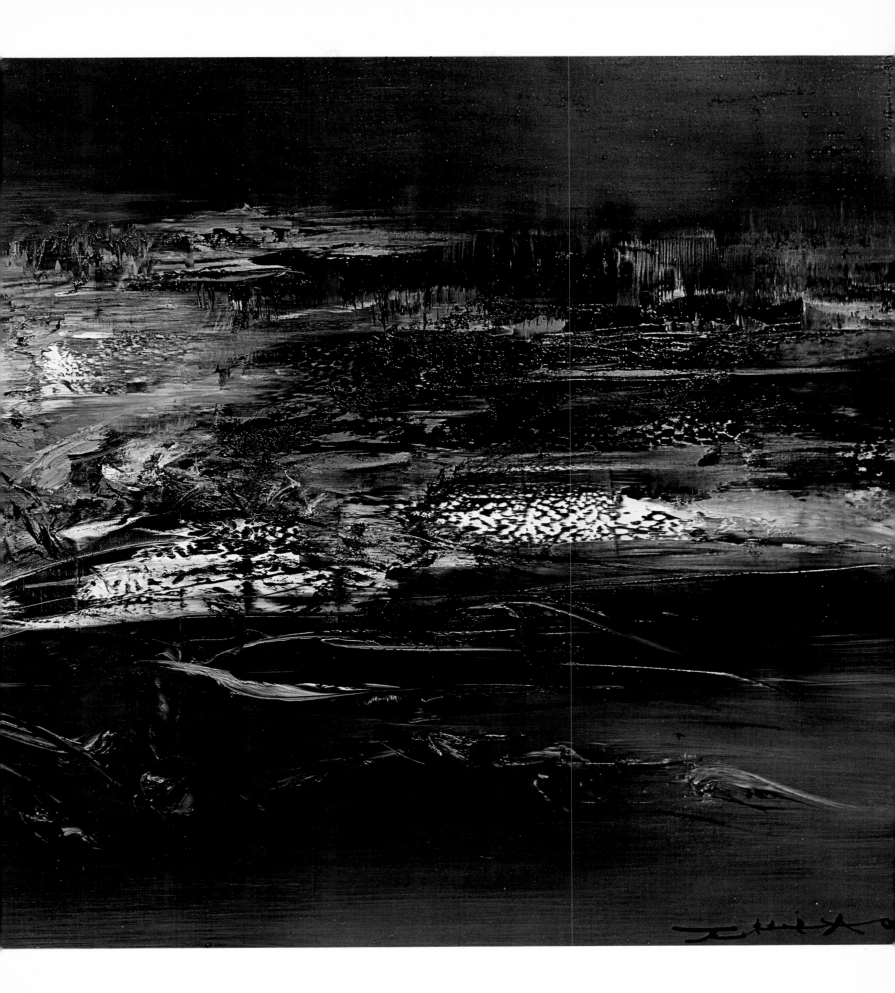

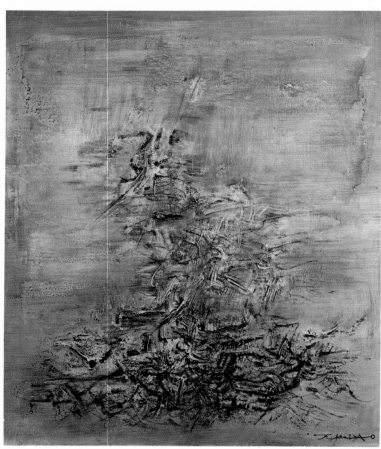

97. 4-3-62.
Oil on canvas, 65 × 54 cm.
Private collection, Geneva.

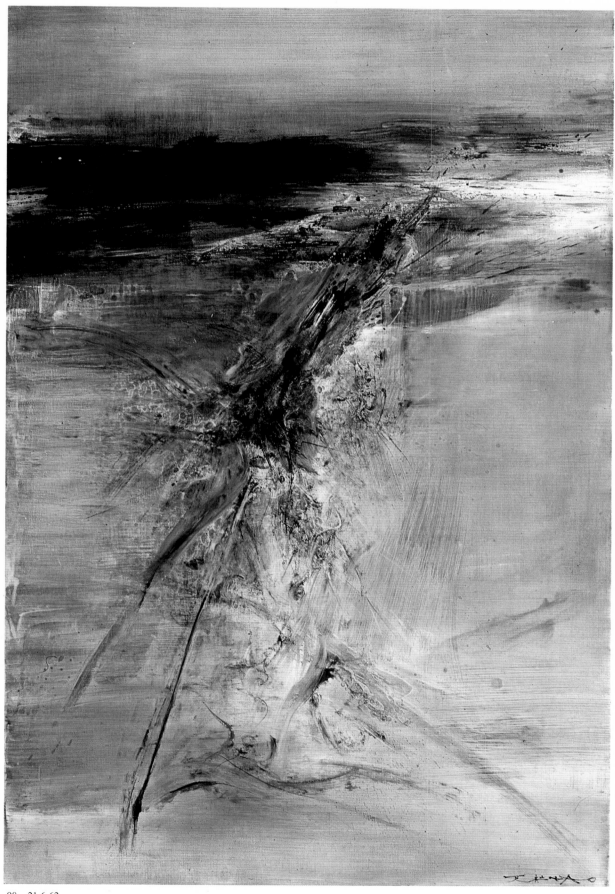

98. 21-6-62.
Oil on canvas, 146 × 97 cm.
Lord Clark Collection, London.

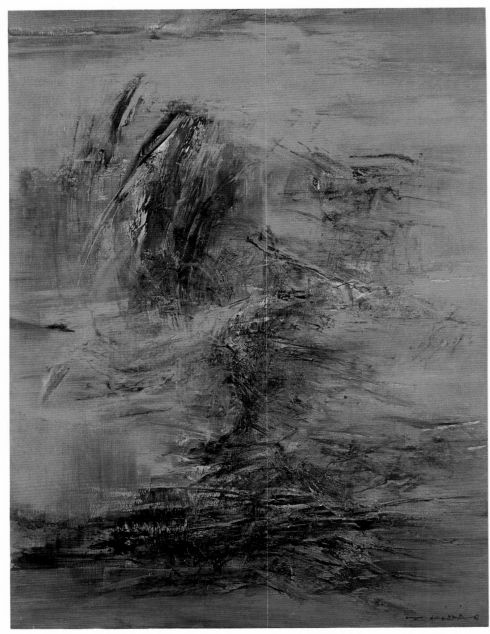

99. 17-3-63.
Oil on canvas, 130 × 97 cm.
Private collection, Le Vésinet.

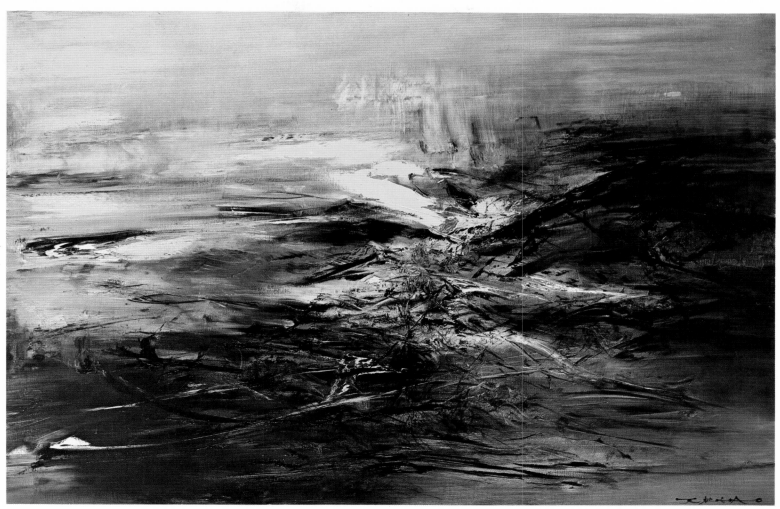

100. 14-11-63.
Oil on canvas, 130 × 195 cm.
Marsteller Inc. Collection, Chicago.

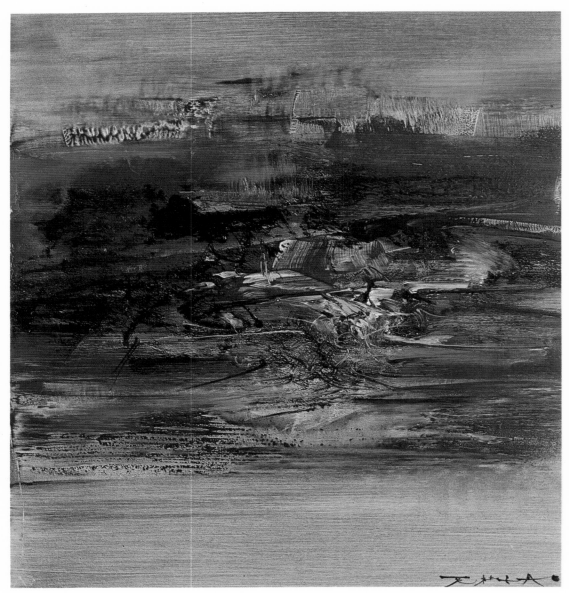

101. 28-3-63.
 Oil on canvas, 50 × 46 cm.
 Private collection, Paris.

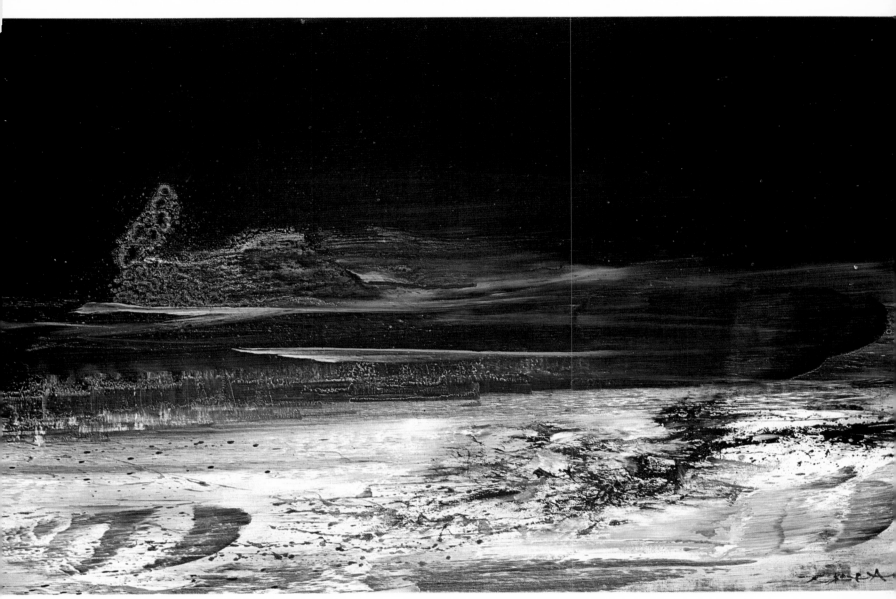

102. Homage to Henri Michaux, 18-1-63.
Oil on canvas, 60 × 92 cm.
Henri Michaux Collection, Paris.

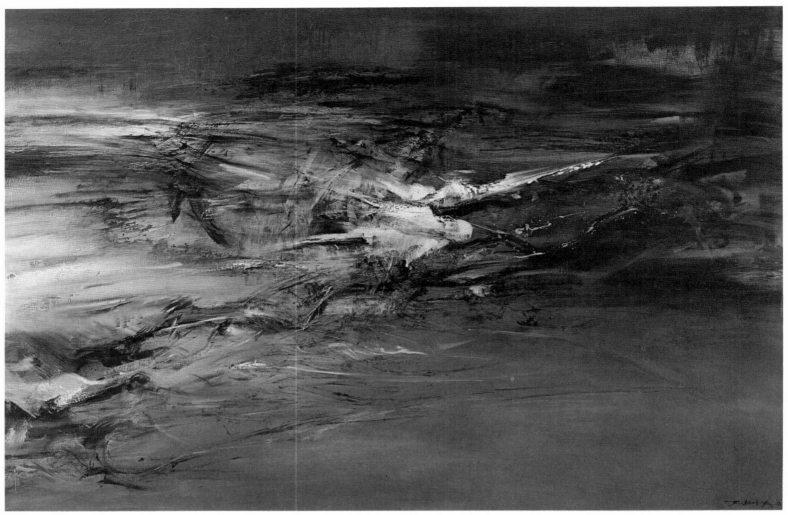

103. 7-6-63.
Oil on canvas, 130 × 195 cm.
Private collection, Paris.

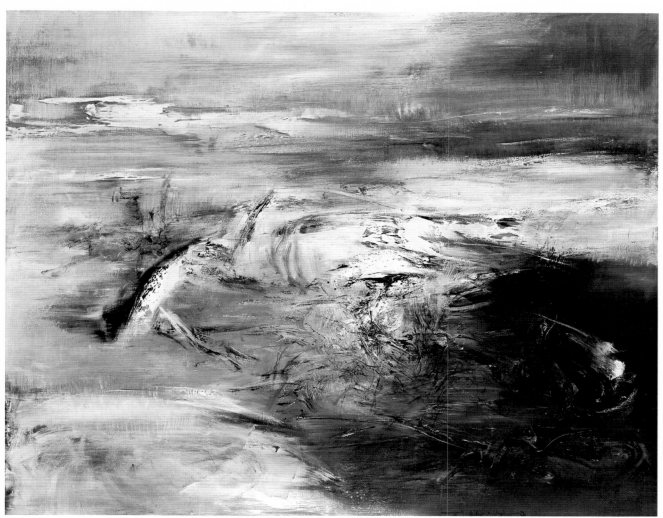

104. 31-1-63.
Oil on canvas, 162 × 200 cm.
Folkwang Museum, Essen.

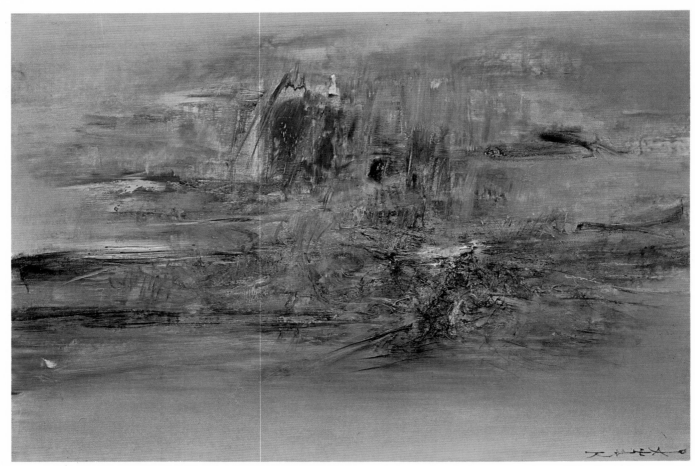

105. 18-2-63.
Oil on canvas, 89 × 130 cm.
Private collection, Paris.

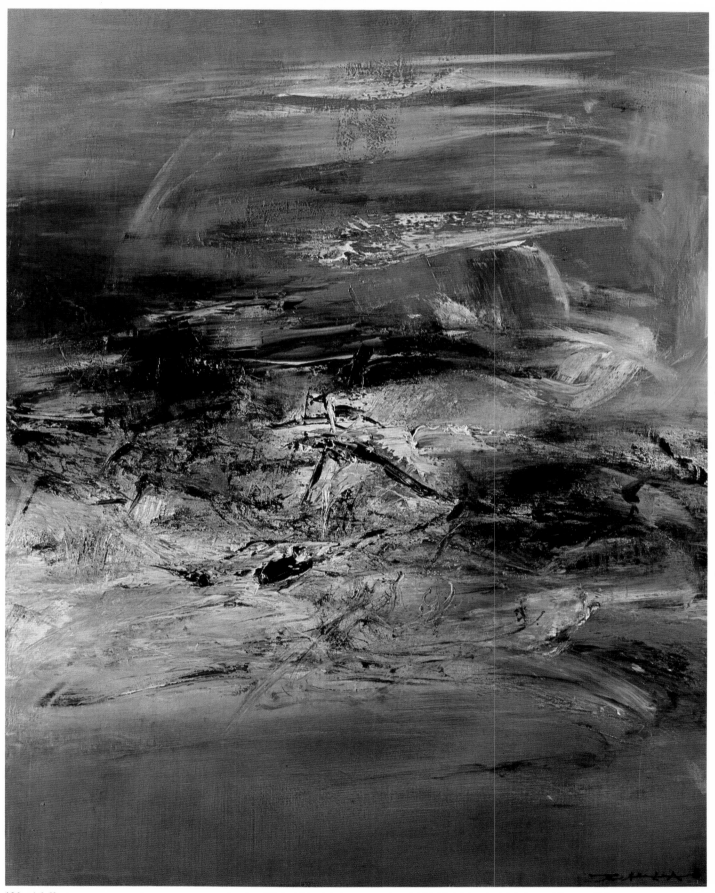

106. 4-6-63.
Oil on canvas, 146 × 114 cm.
Mr and Mrs Donald Benjamin Collection, Long Island, New York.

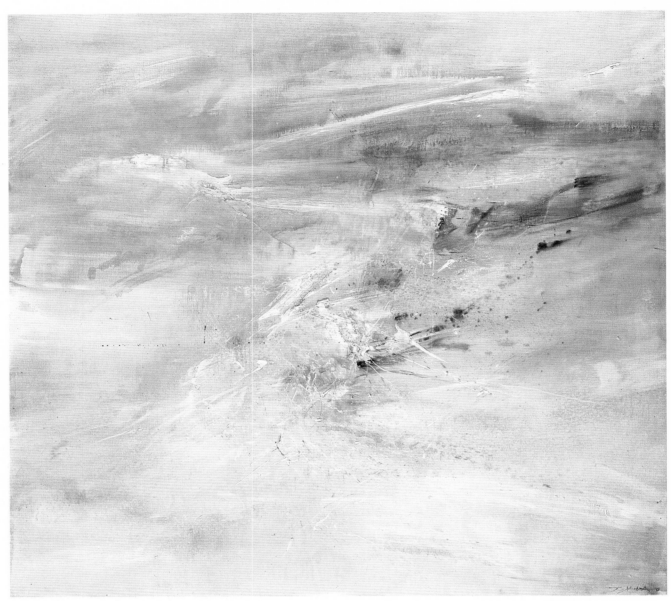

107. 2-3-64.
Oil on canvas, 135 × 145 cm.
René Char Collection, L'Isle-sur-la-Sorgue, France.

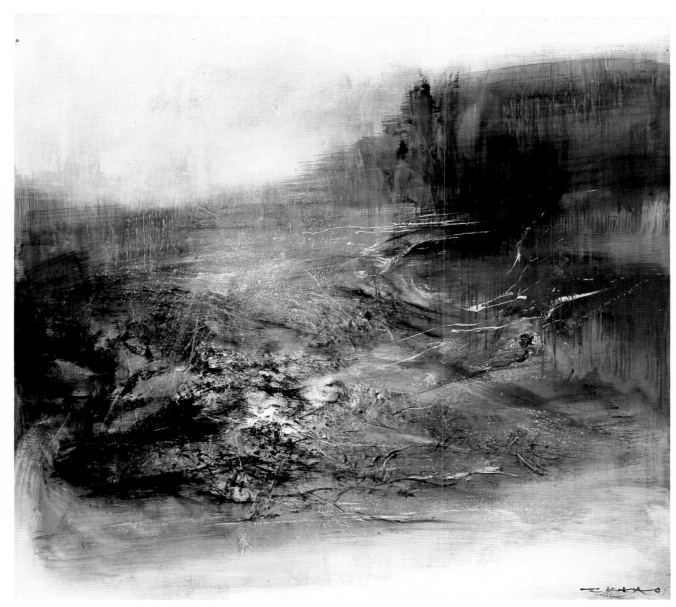

108. 5-9-64.
Oil on canvas, 150 × 162 cm.
Lefebvre-Foinet Collection, Paris.

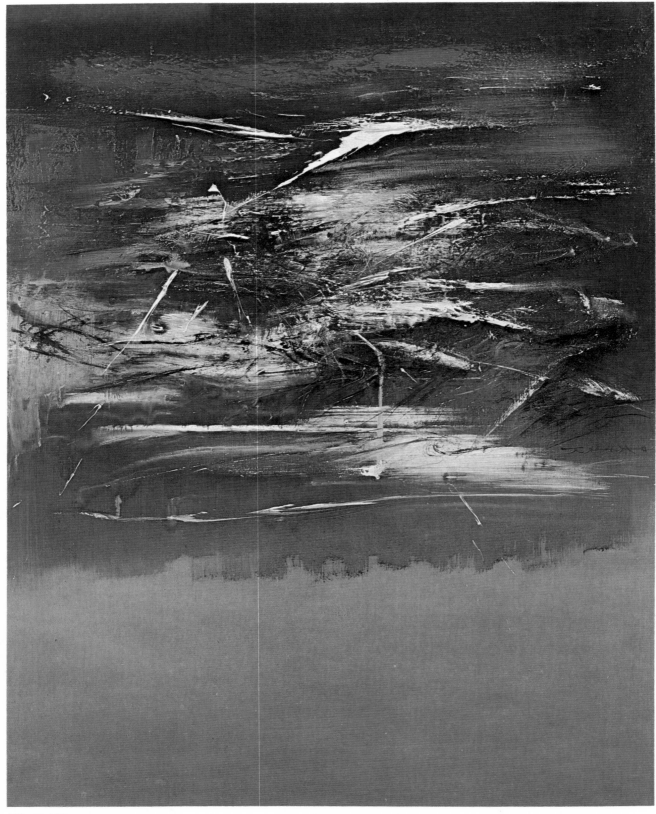

109. 16-6-64.
Oil on canvas, 146 × 114 cm.
Cuyahoya Saving Association Collection, Cleveland, Ohio.

110. 29-1-64.
Oil on canvas, 260 × 200 cm.
Private collection, Paris.

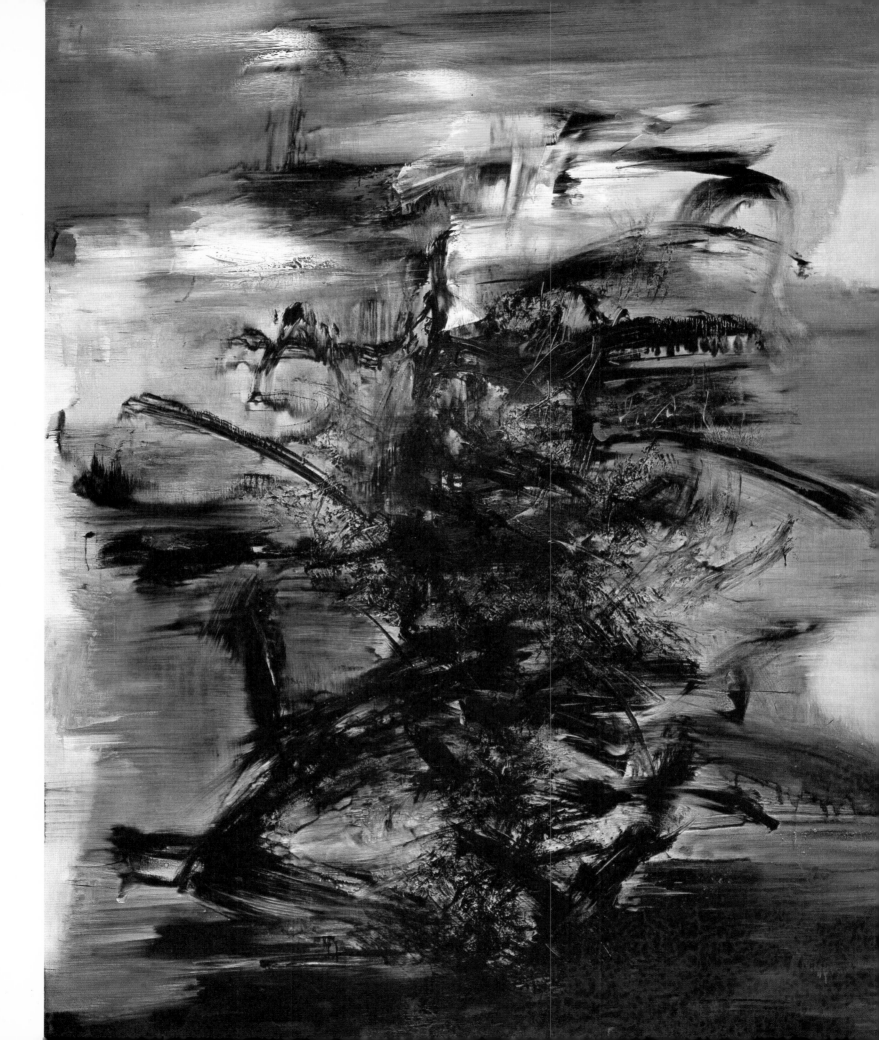

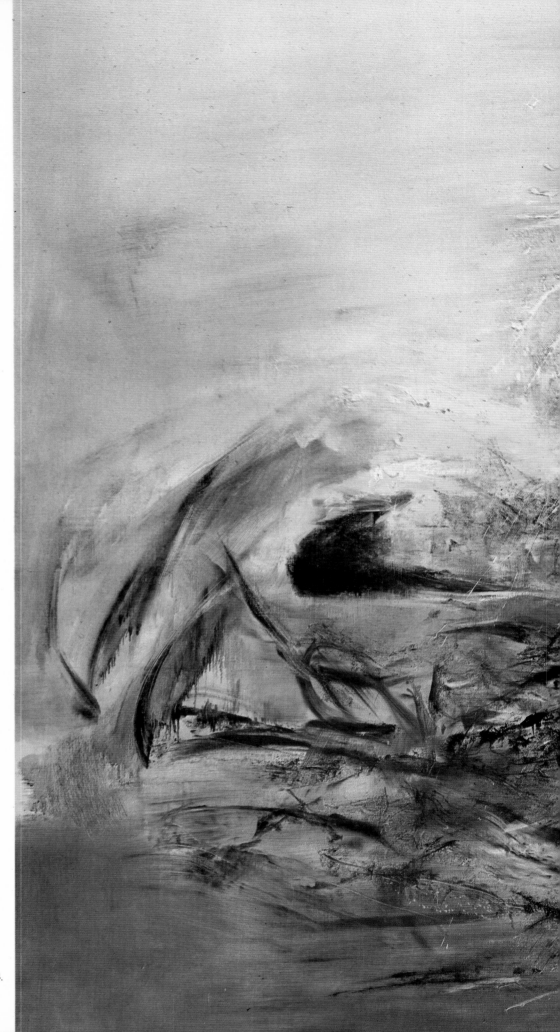

111. Homage to Edgar Varèse. 25-10-64.
Oil on canvas, 255 × 345 cm.
Private collection, Paris.

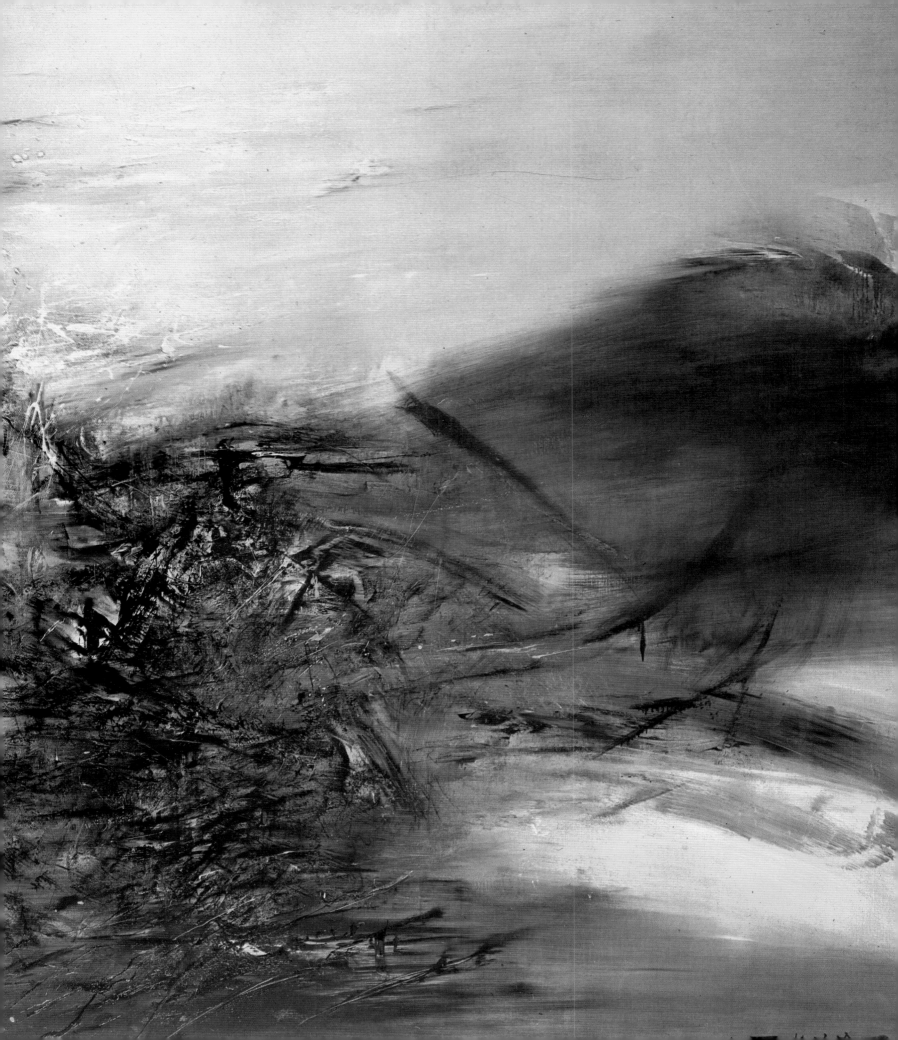

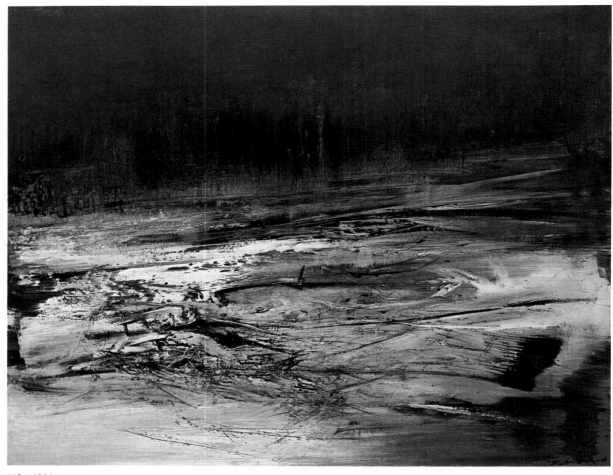

112. 1964.
Oil on canvas, 65 × 81 cm.
Cuyahoya Saving Association Collection, Cleveland, Ohio.

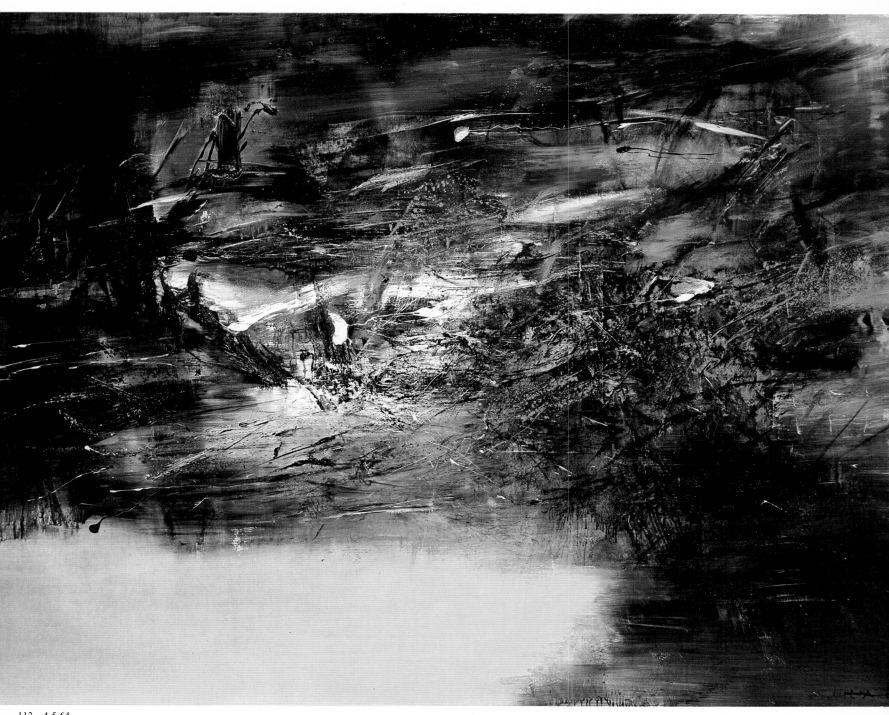

113. 4-5-64.
Oil on canvas, 200 × 260 cm.
Centre Georges Pompidou,
National Museum of Modern Art, Paris.

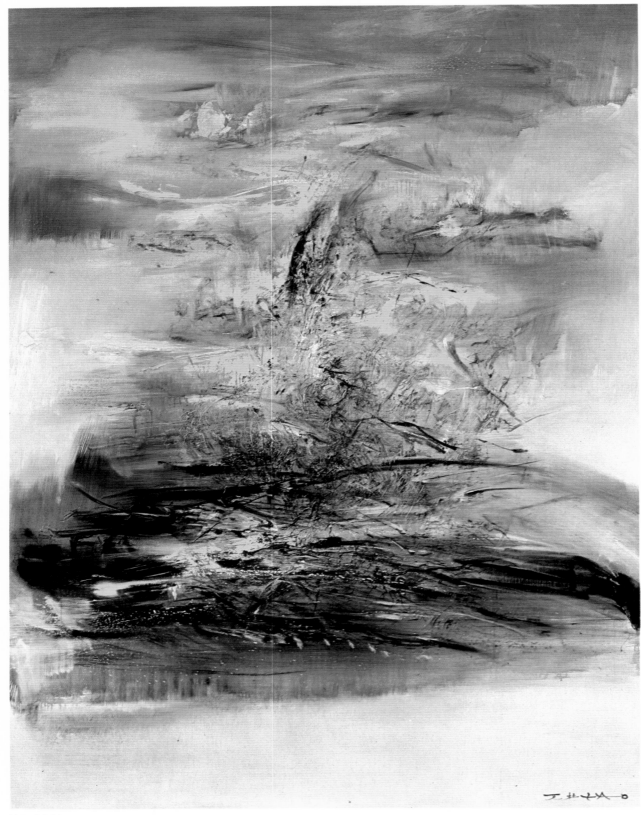

114. 9-7-64.
Oil on canvas, 260 × 200 cm.
Mrs Ruth Roskaner Smith Collection, New York.

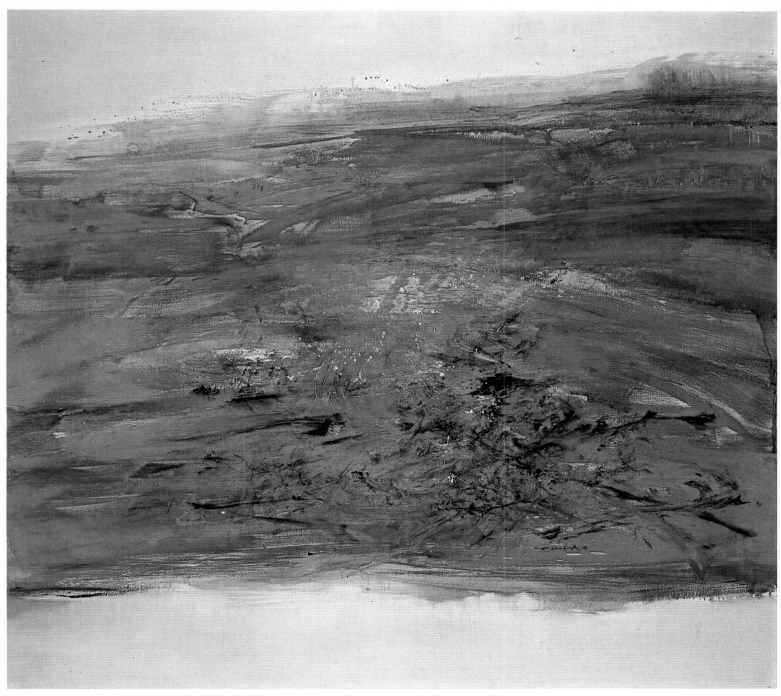

115. 1-2-64.
Oil on canvas, 150 × 162 cm.
Jean-Paul Riopelle Collection, Vétheuil, France.

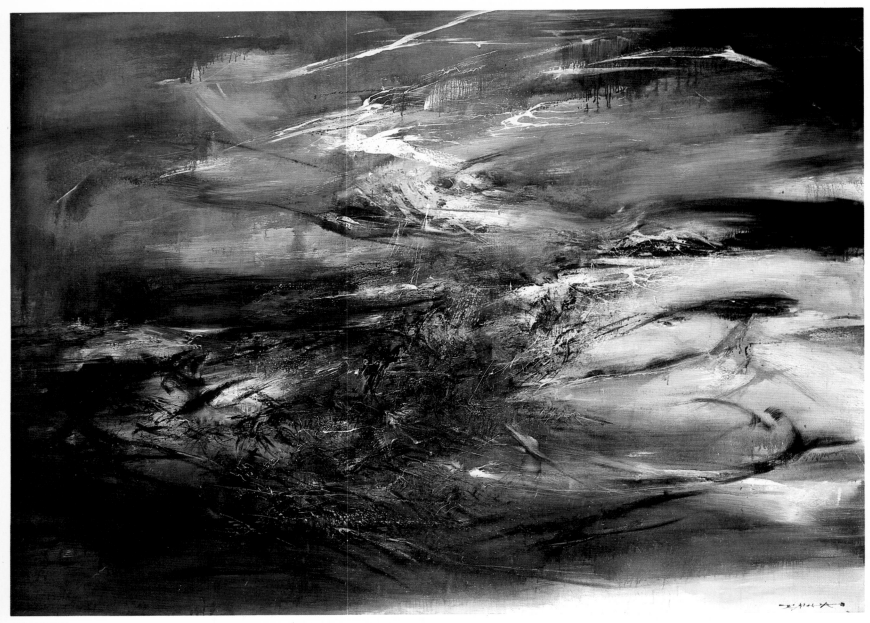

116. 29-9-64.
Oil on canvas, 255 × 345 cm.
Private collection, Meudon, France.

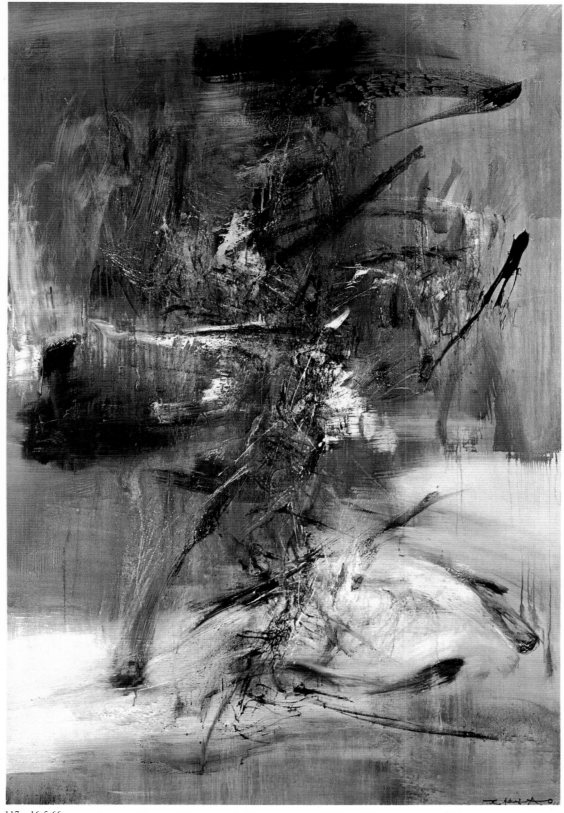

117. 16-5-66.
Oil on canvas, 195 × 130 cm.
Private collection, Geneva.

118. 1-4-66. Triptych.
Oil on canvas, 195 × 358 cm.
Private collection, Paris.

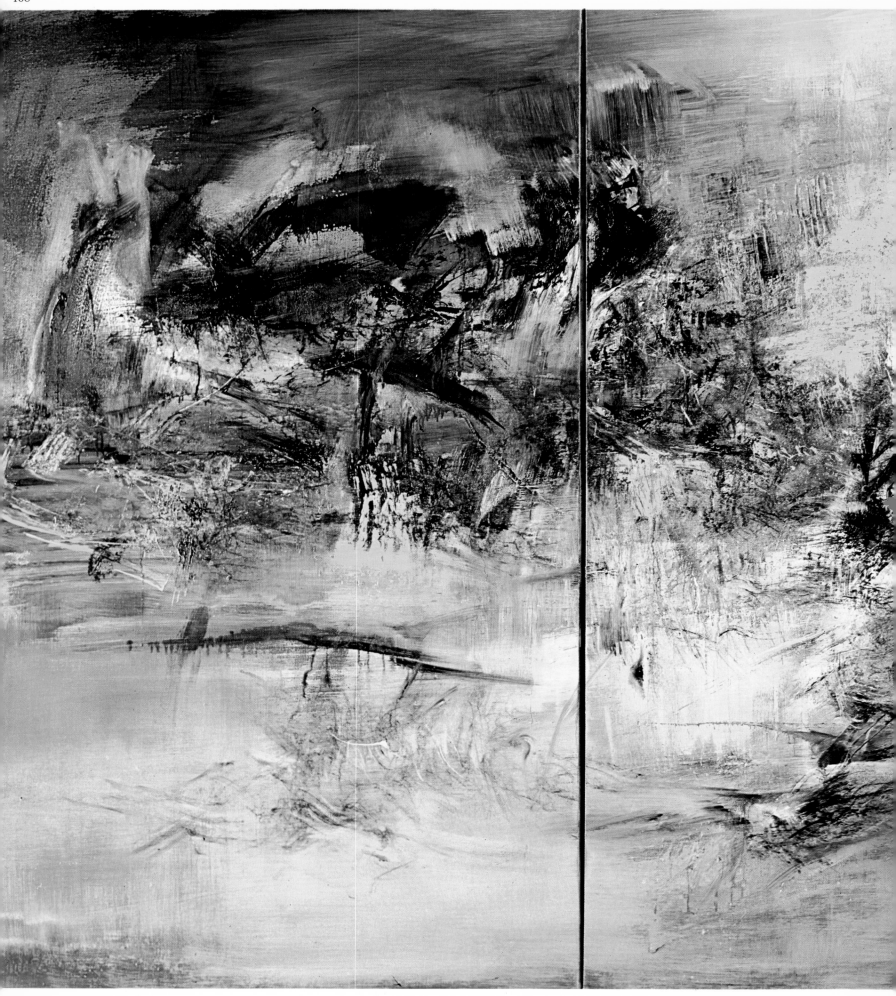

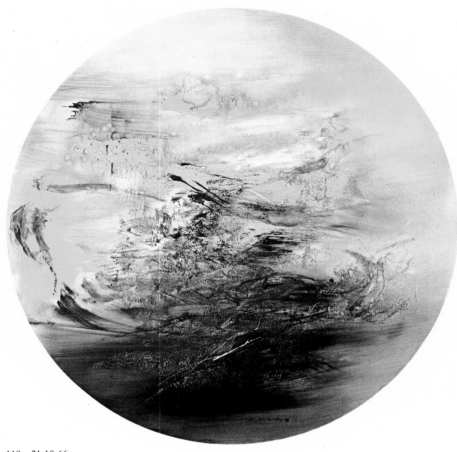

119. 21-10-66.
 Oil on canvas, ⌀ 100 cm.
 Private collection, U.S.A.

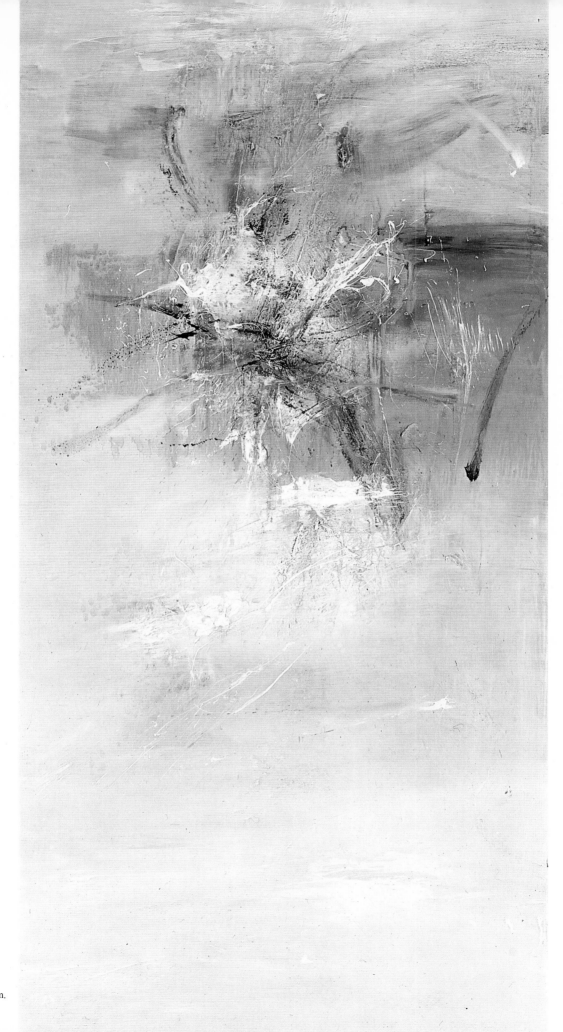

120. 19-12-66.
Oil on canvas, 195 × 97 cm.
Private collection, Paris.

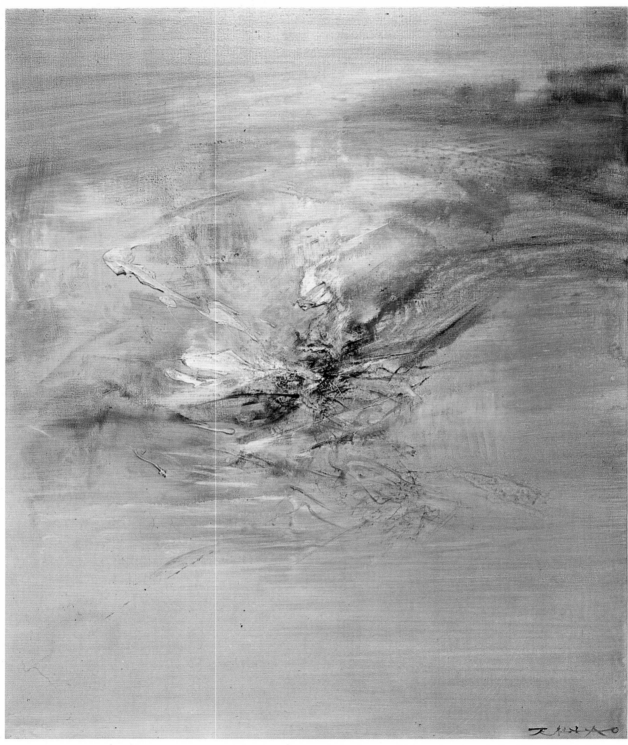

121. 5-6-65.
Oil on canvas, 100 × 81 cm.
Private collection, Paris.

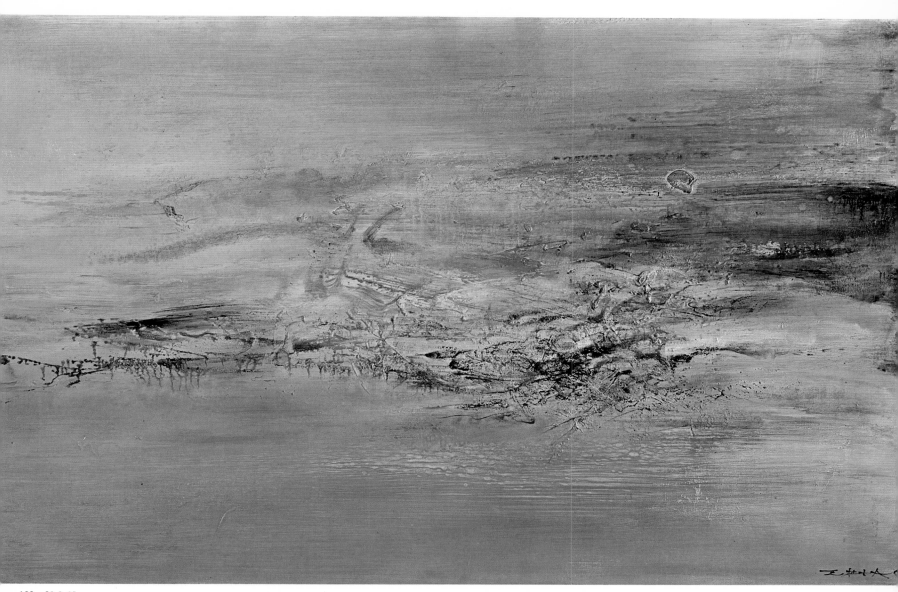

122. 29-9-65.
Oil on canvas, 73 × 116 cm.
Private collection, Paris.

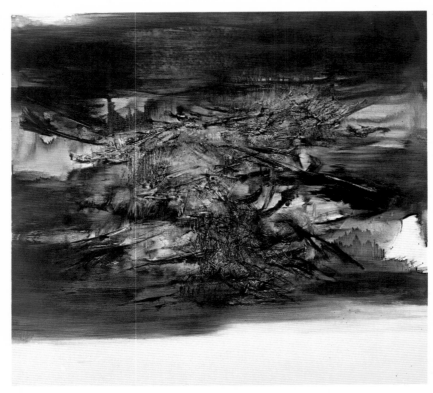

123. 20-1-67.
Oil on canvas, 150 × 162 cm.
Property of the artist.

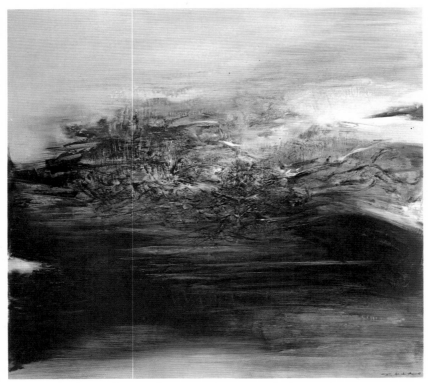

124. 8-3-66.
Oil on canvas, 150 × 162 cm.
Mrs Neil J. McKinnon Collection, Toronto.

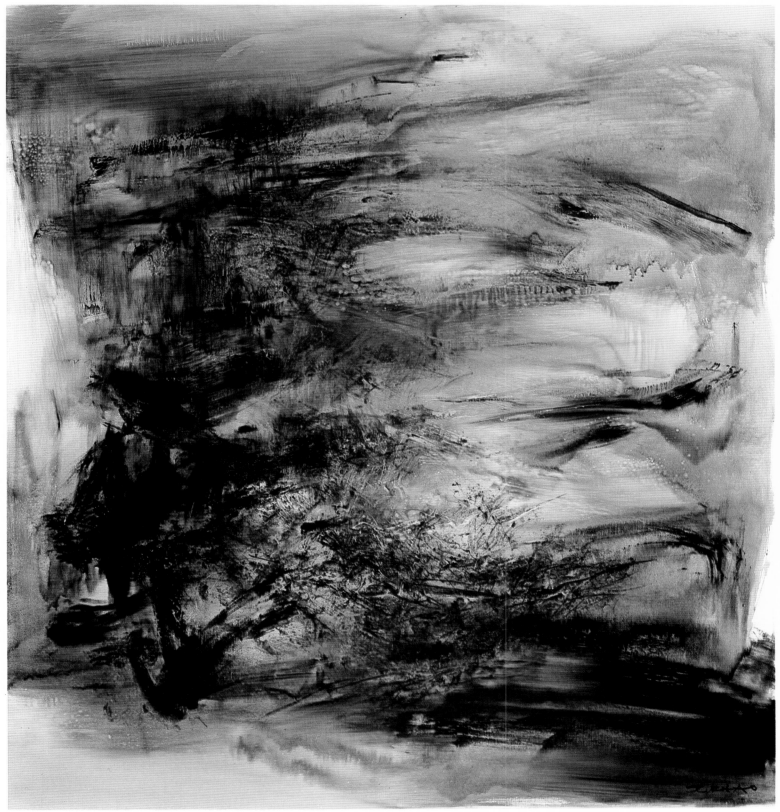

125. 24-5-65.
Oil on canvas, 162 × 150 cm.
Stanford University, Stanford, California (on loan from H. Harvard Arnason).

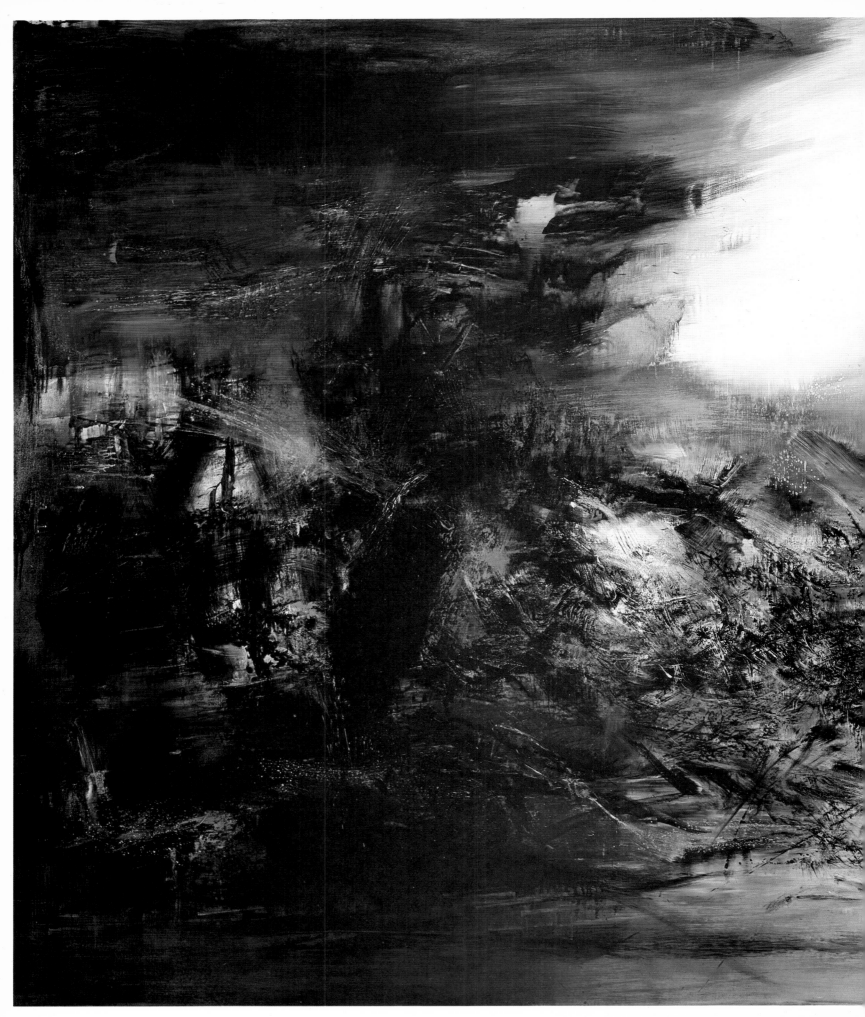

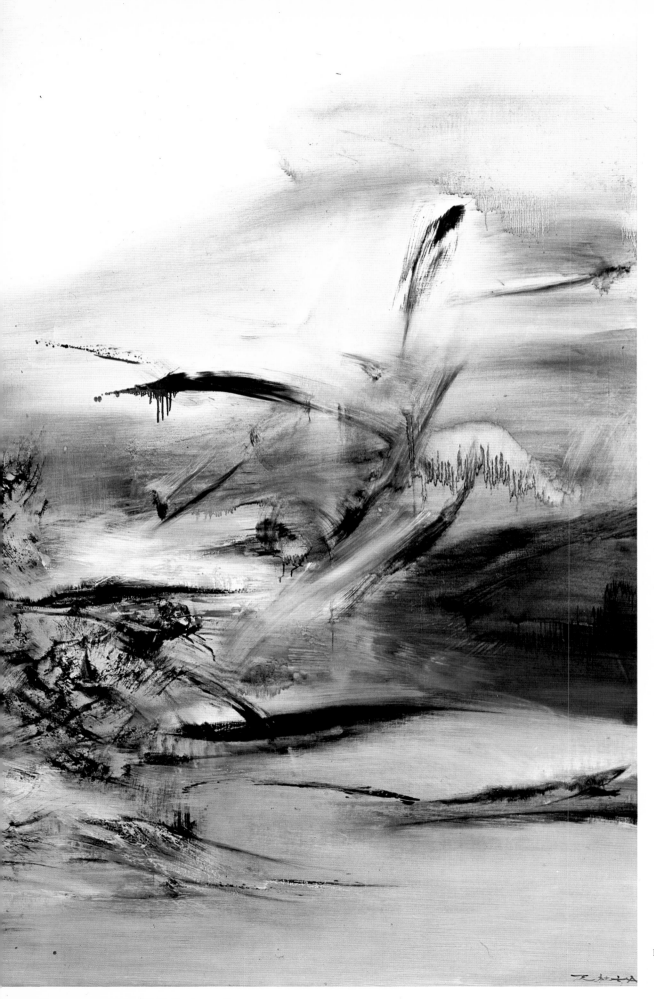

126. 13-2-67.
Oil on canvas, 200 × 300 cm.
Private collection, Paris.

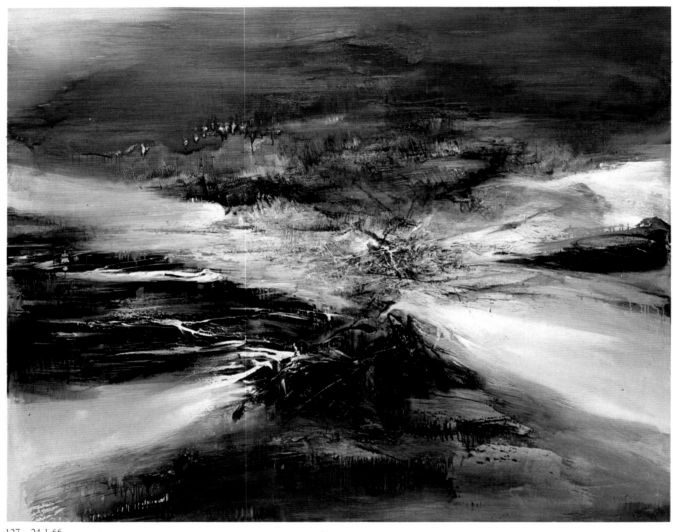

127. 24-1-66.
 Oil on canvas, 162 × 200 cm.
 Arthur Goldberg Collection, New York.

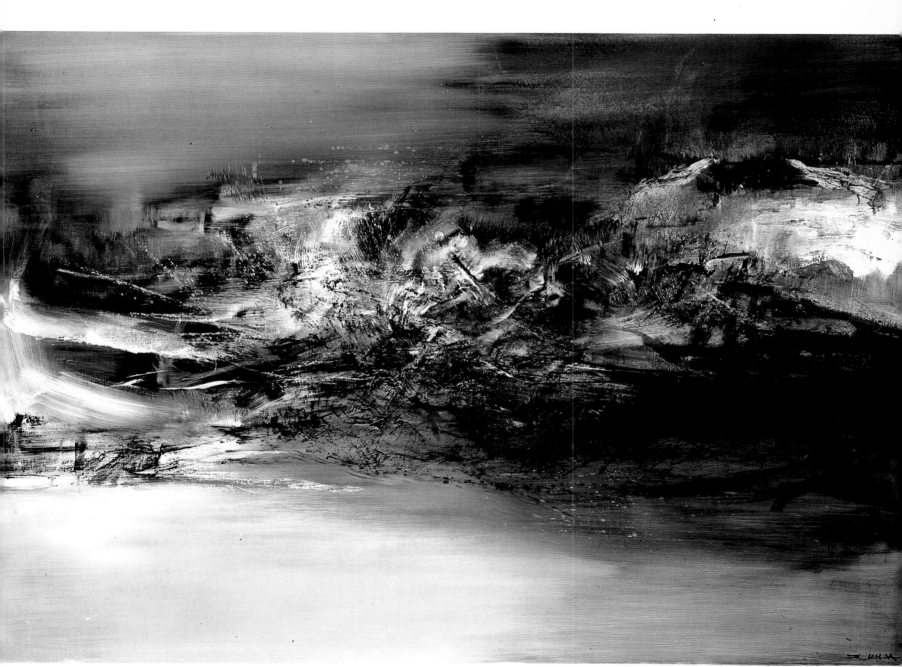

128. 9-6-67.
Oil on canvas, 114 × 162 cm.
Private collection, London.

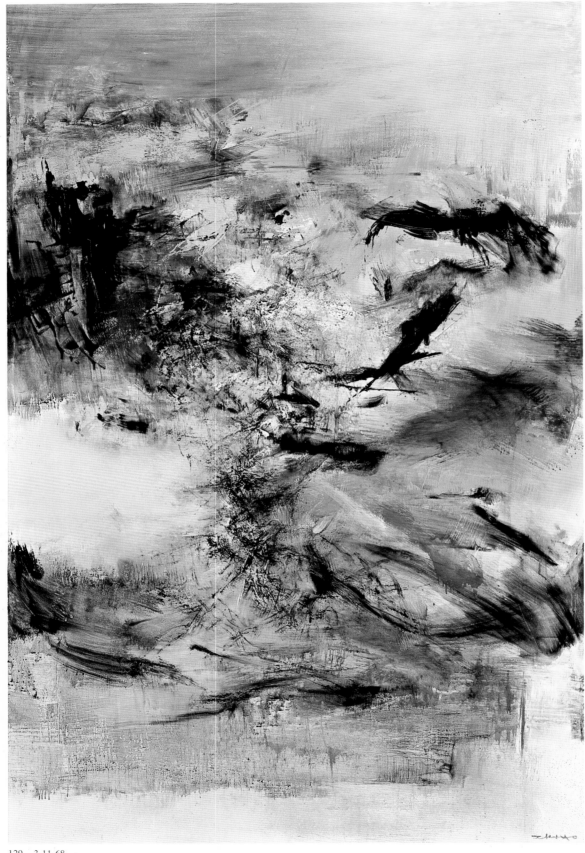

129. 3-11-68.
 Oil on canvas, 195 × 130 cm.
 Galerie de France, Paris.

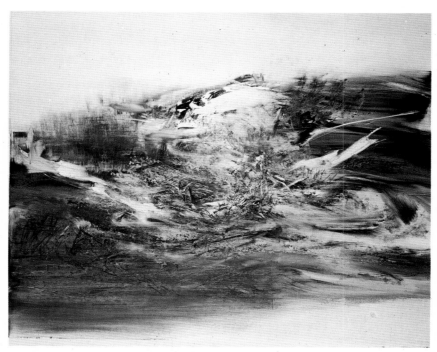

130. 26-2-66.
 Oil on canvas, 130 × 162 cm.
 National Fund of Contemporary Art, Paris.

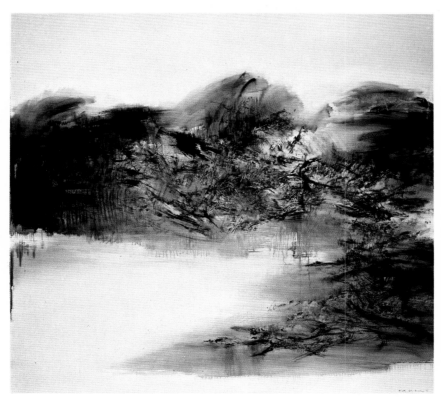

131. 9-7-67.
 Oil on canvas, 150 × 162 cm.
 Private collection, Paris.

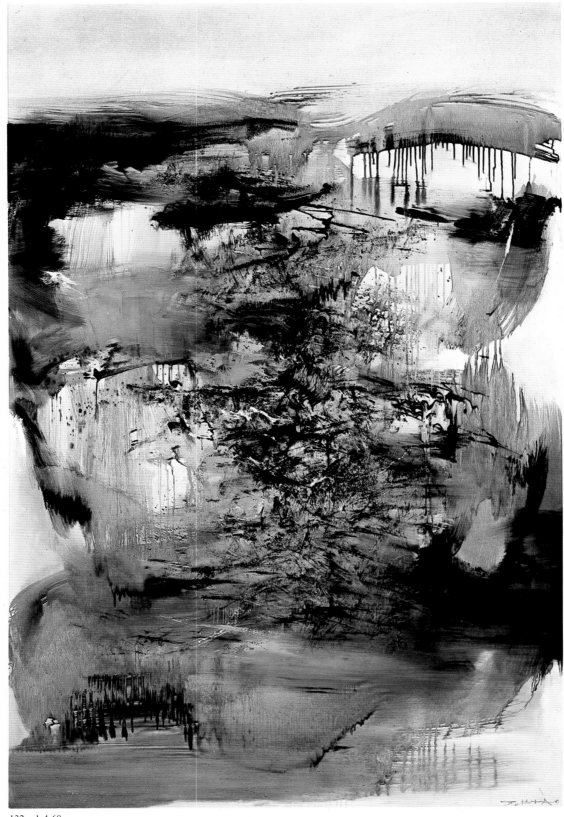

132. 1-4-68.
Oil on canvas, 195 × 130 cm.
Property of the artist.

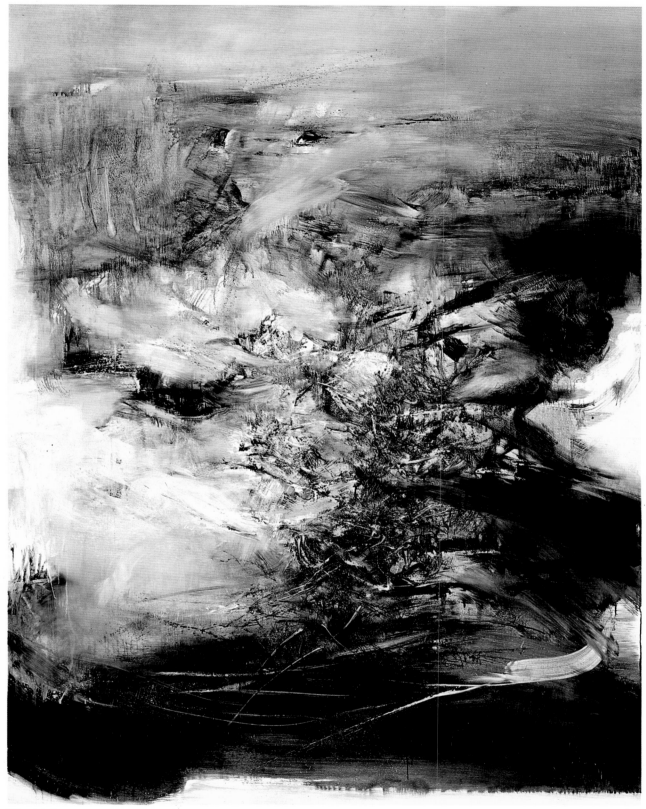

133. 6-1-68.
Oil on canvas, 260 × 200 cm.
City of Paris Museum of Modern Art.

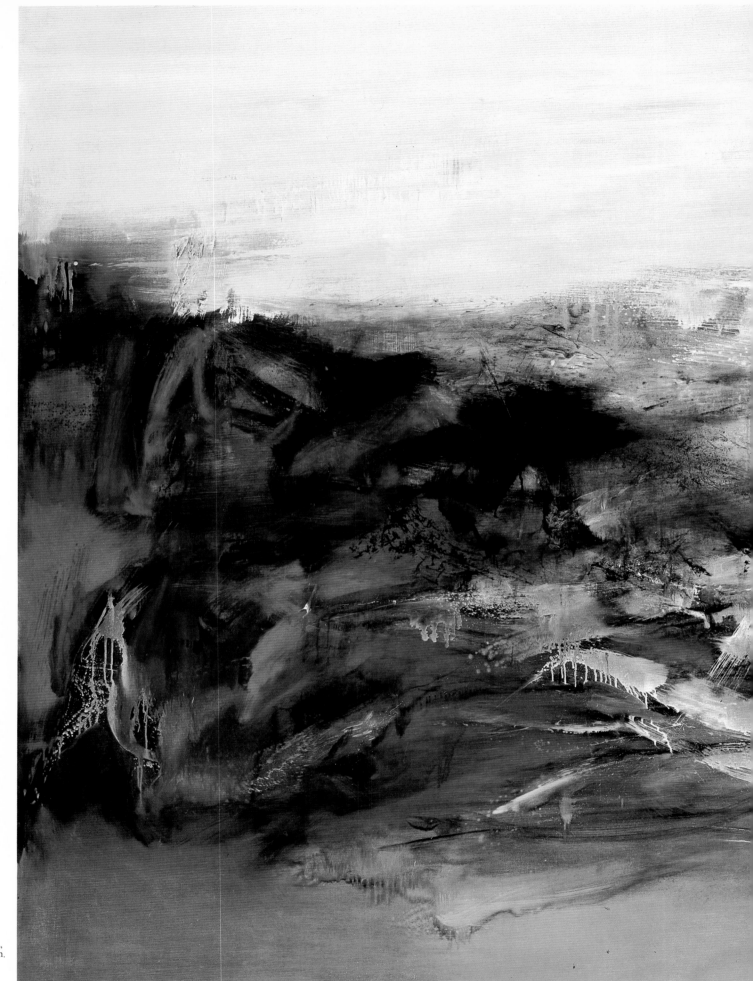

134. 12-8-69.
Oil on canvas,
200 × 300 cm.
Property of
the artist.

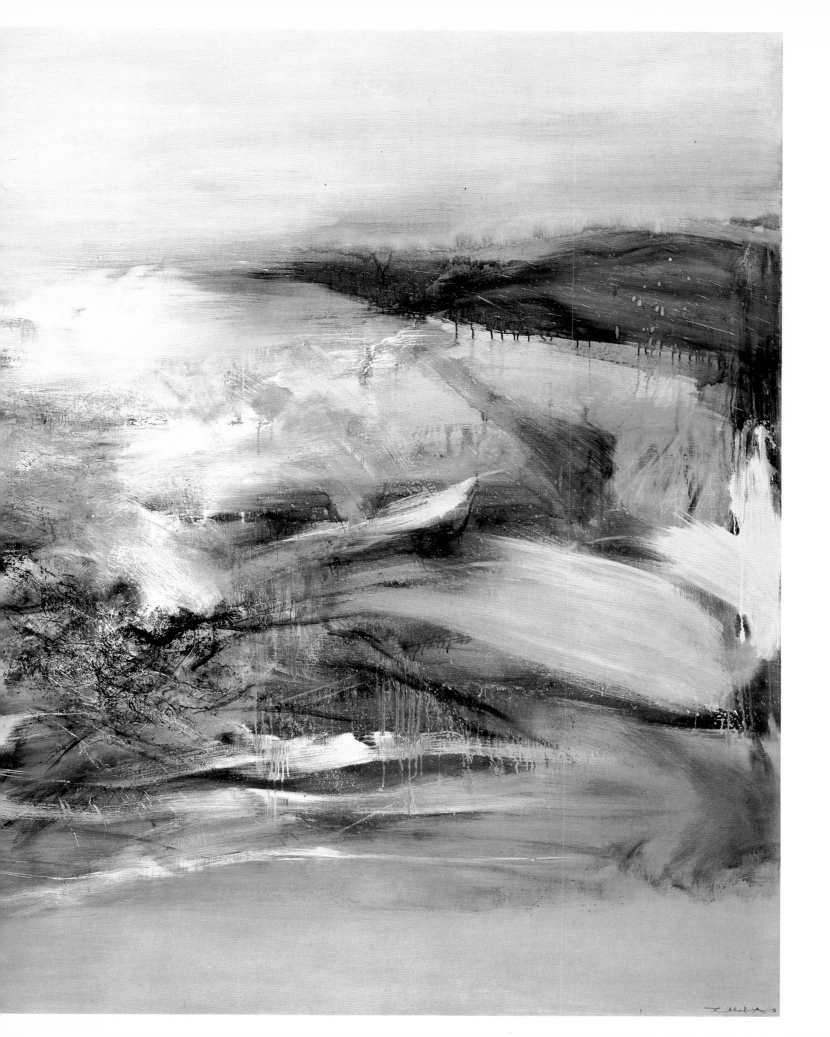

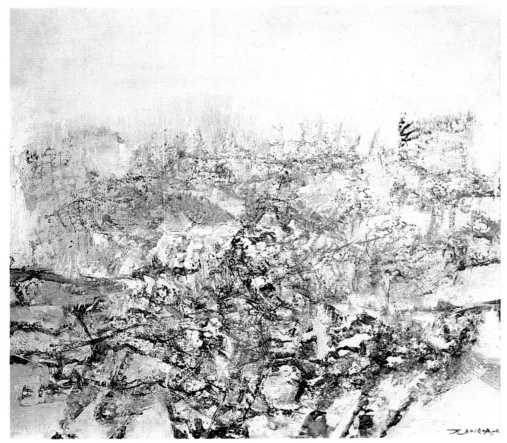

135. 22-10-68.
 Oil on canvas, 46 × 50 cm.
 Private collection, Paris.

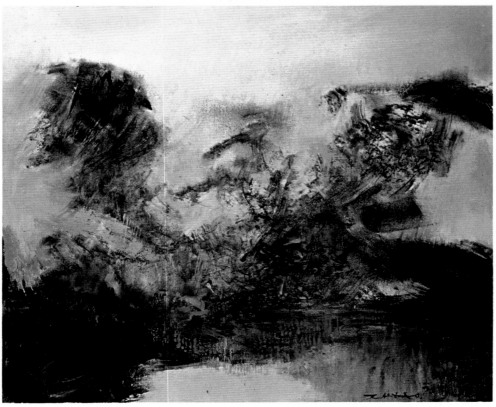

136. 7-11-68.
 Oil on canvas, 46 × 55 cm.
 Bert Leefmans Collection, New York.

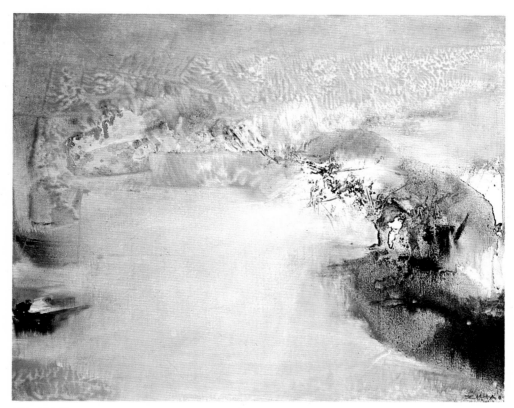

137. 16-1-69.
Oil on canvas, 46 × 55 cm.
Private collection, Le Havre.

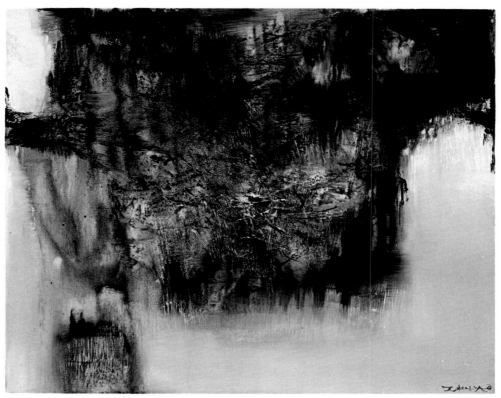

138. 25-2-69.
Oil on canvas, 54 × 65 cm.
Private collection, Essen.

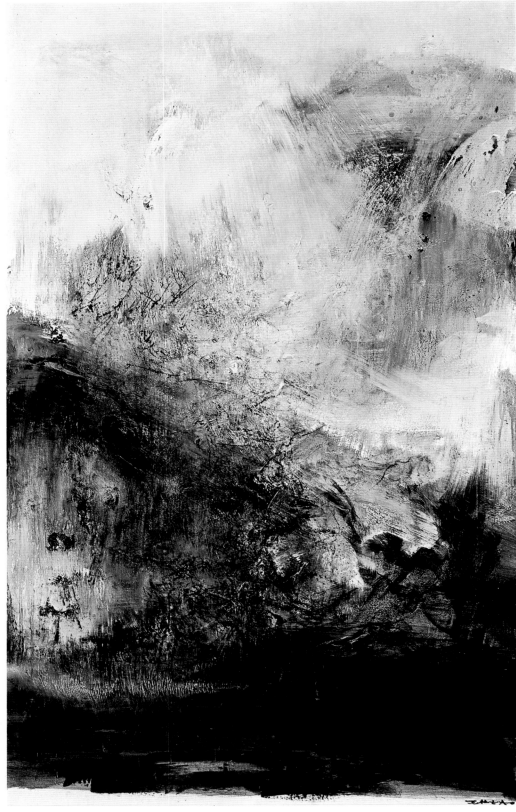

139. 31-8-68.
Oil on canvas, 146 × 89 cm.
Galerie de France, Paris.

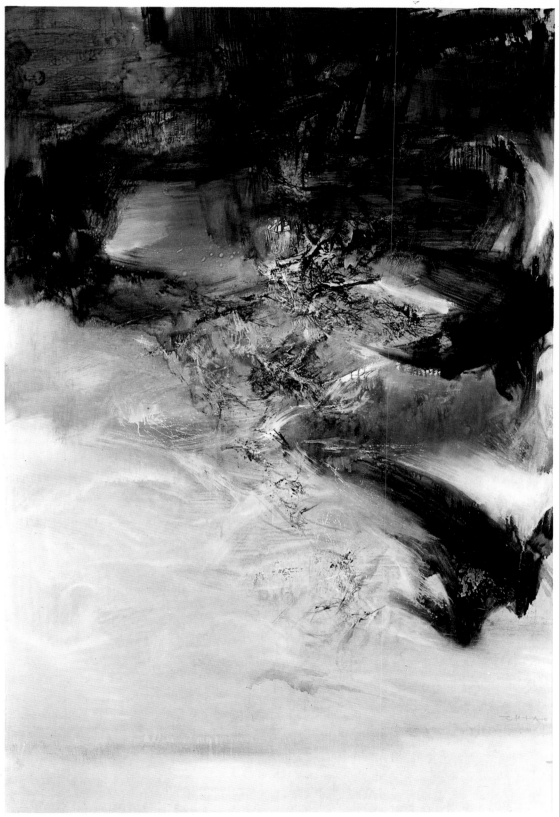

140. 5-9-69.
 Oil on canvas, 195 × 130 cm.

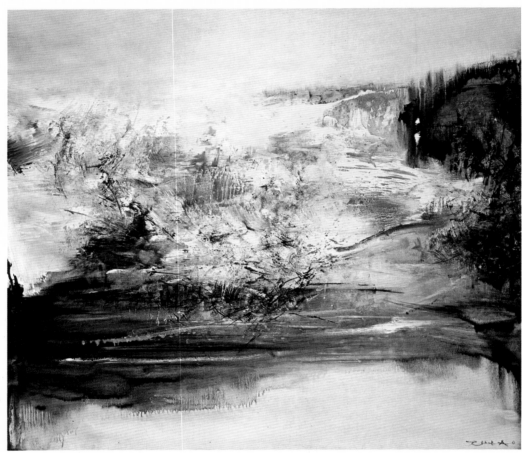

141. 18-3-68.
 Oil on canvas, 95 × 105 cm.
 Private collection, Los Angeles.

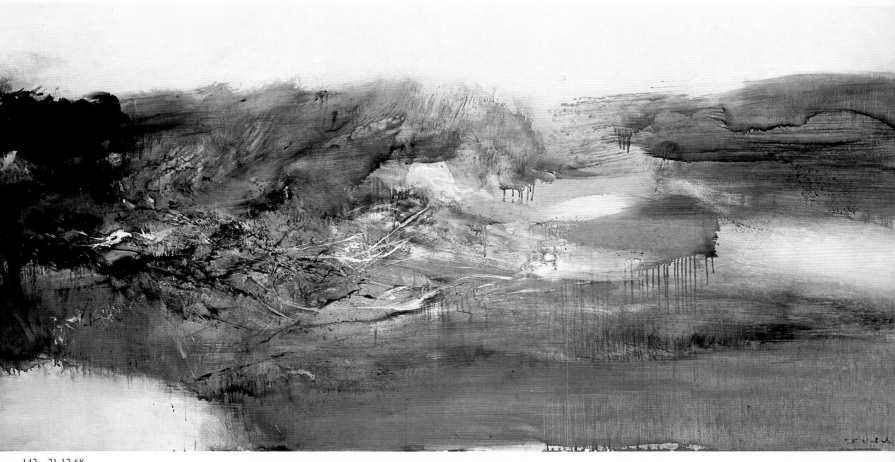

142. 21-12-68.
Oil on canvas, 97 × 195 cm.
Mr and Mrs Chi-Ming Cha Collection, Los Altos Hills, California.

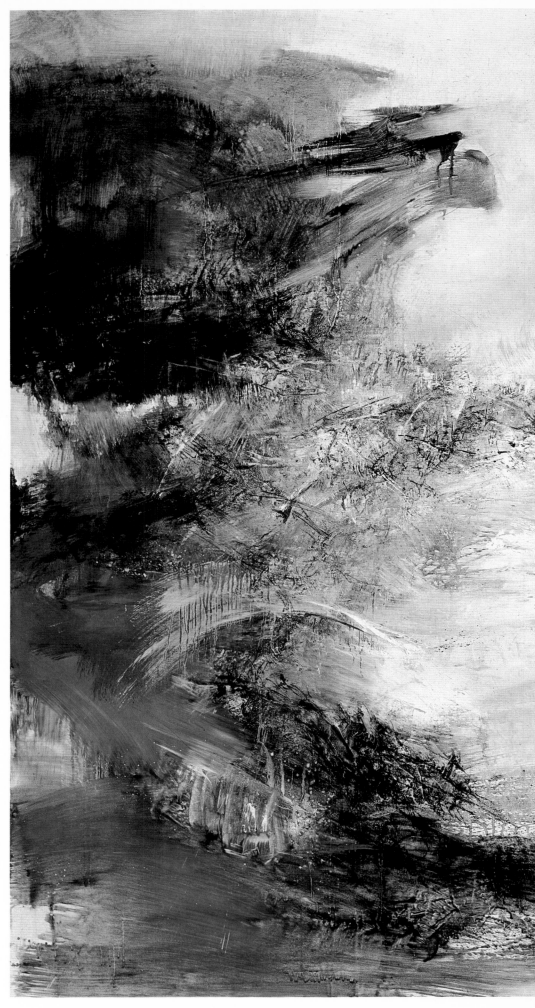

143. 18-1-68.
Oil on canvas, 150 × 162 cm.

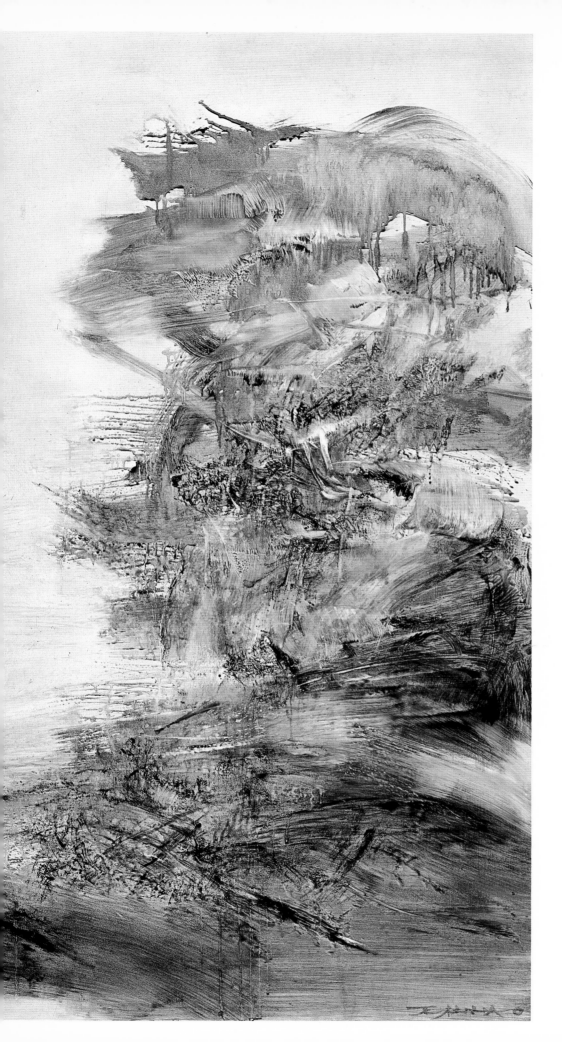

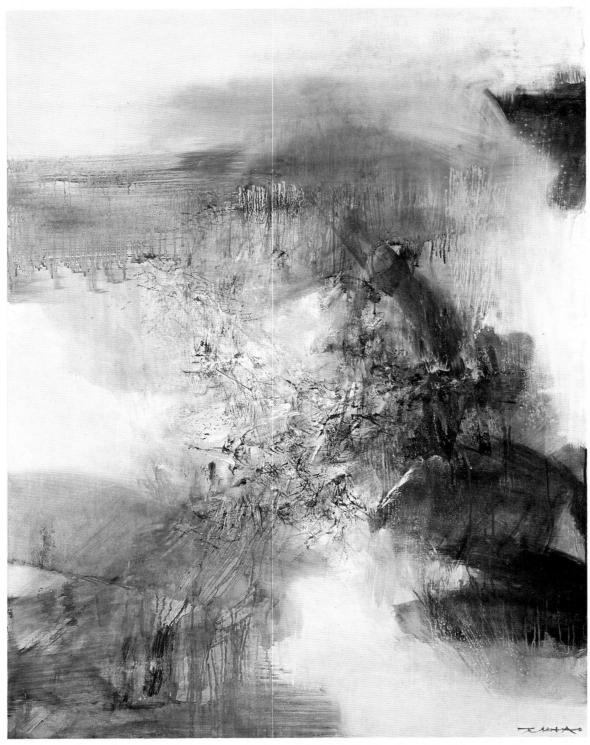

144. 18-12-69.
Oil on canvas, 116 × 89 cm.
Property of the artist.

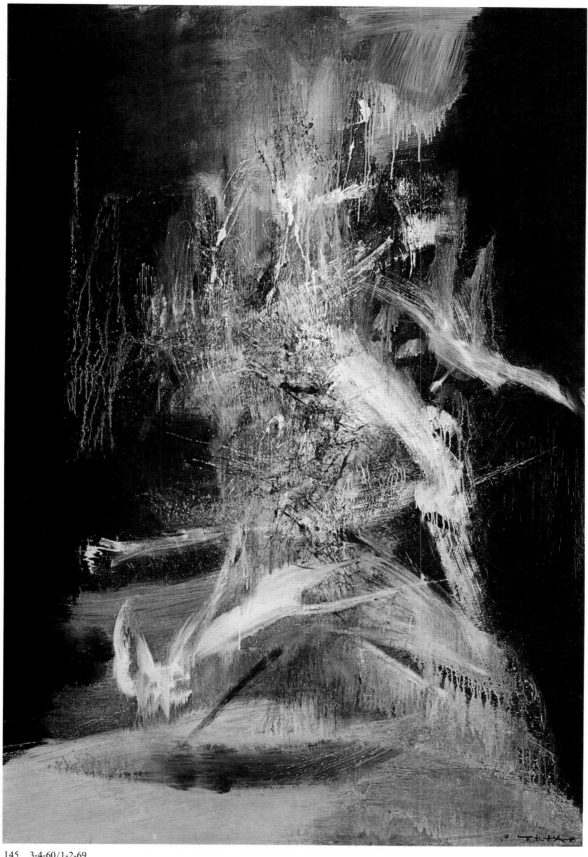

145. 3-4-60/1-2-69.
Oil on canvas, 195 × 130 cm.
Galerie de France, Paris.

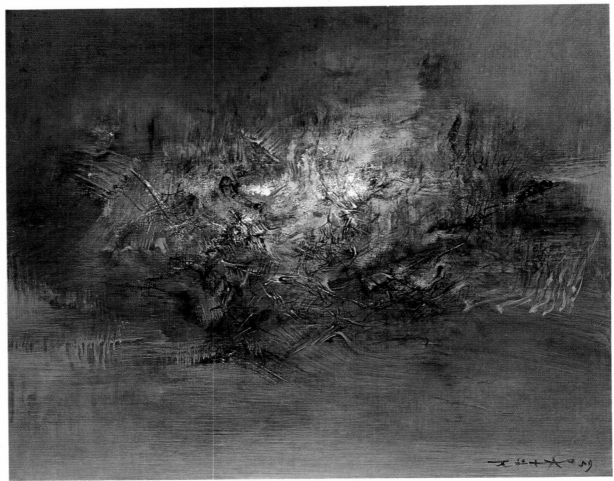

146. 31-3-59/1-3-69.
Oil on canvas, 60 × 73 cm.
Private collection, Paris.

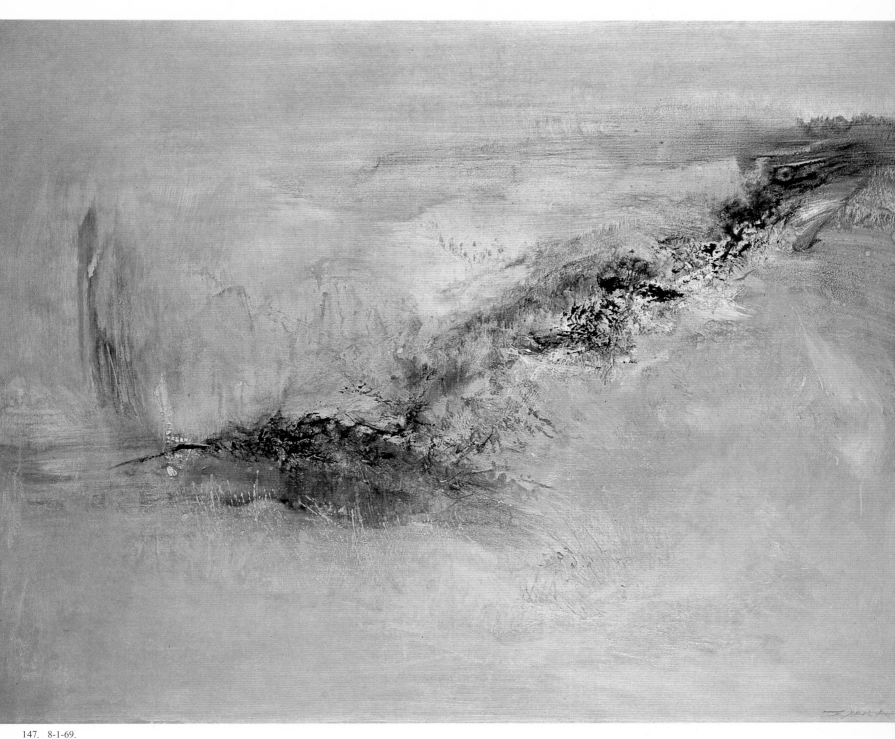

147. 8-1-69.
Oil on canvas, 114 × 146 cm.
Private collection, Paris.

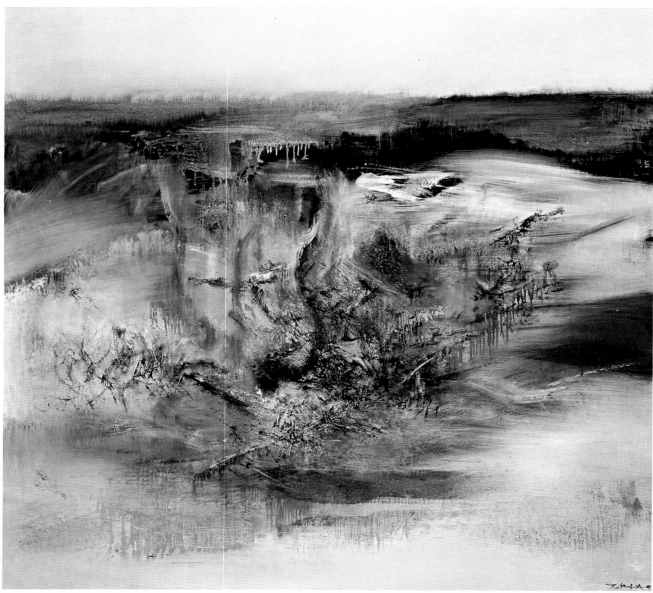

148. 23-1-67/27-1-69.
Oil on canvas, 135 × 145 cm.
Private collection, Paris.

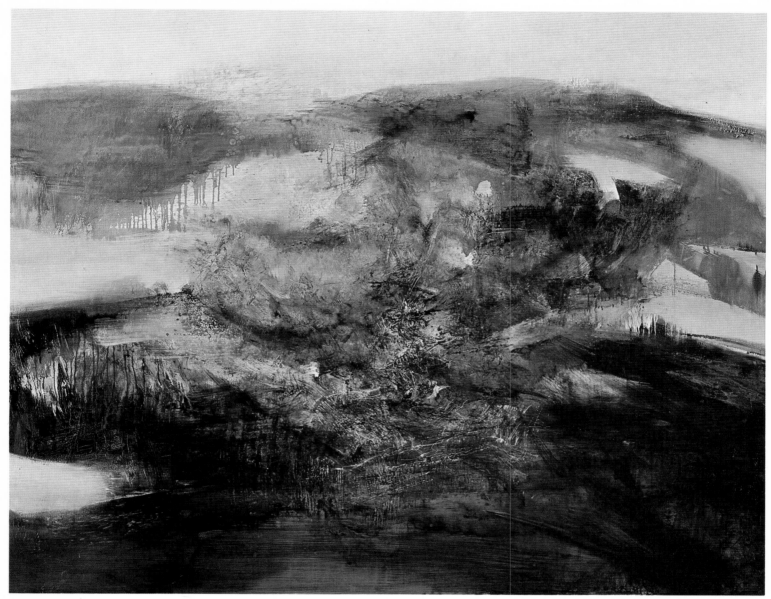

149. 15-4-69.
Oil on canvas, 130 × 162 cm.
Private collection, Paris.

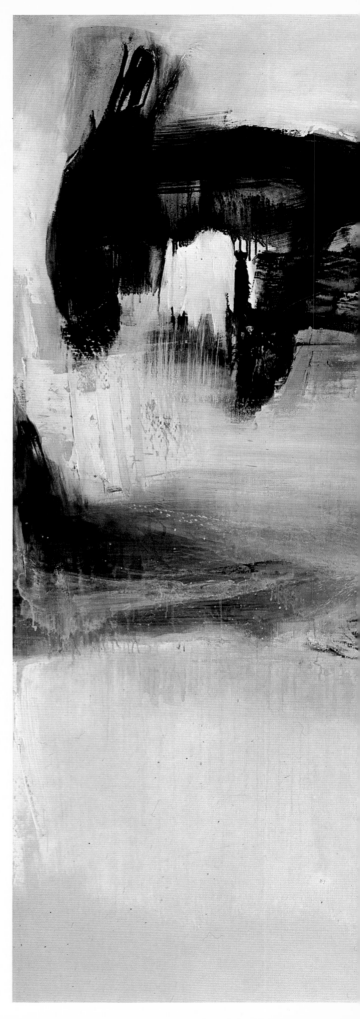

150. 1-10-70.
Oil on canvas, 162 × 200 cm.

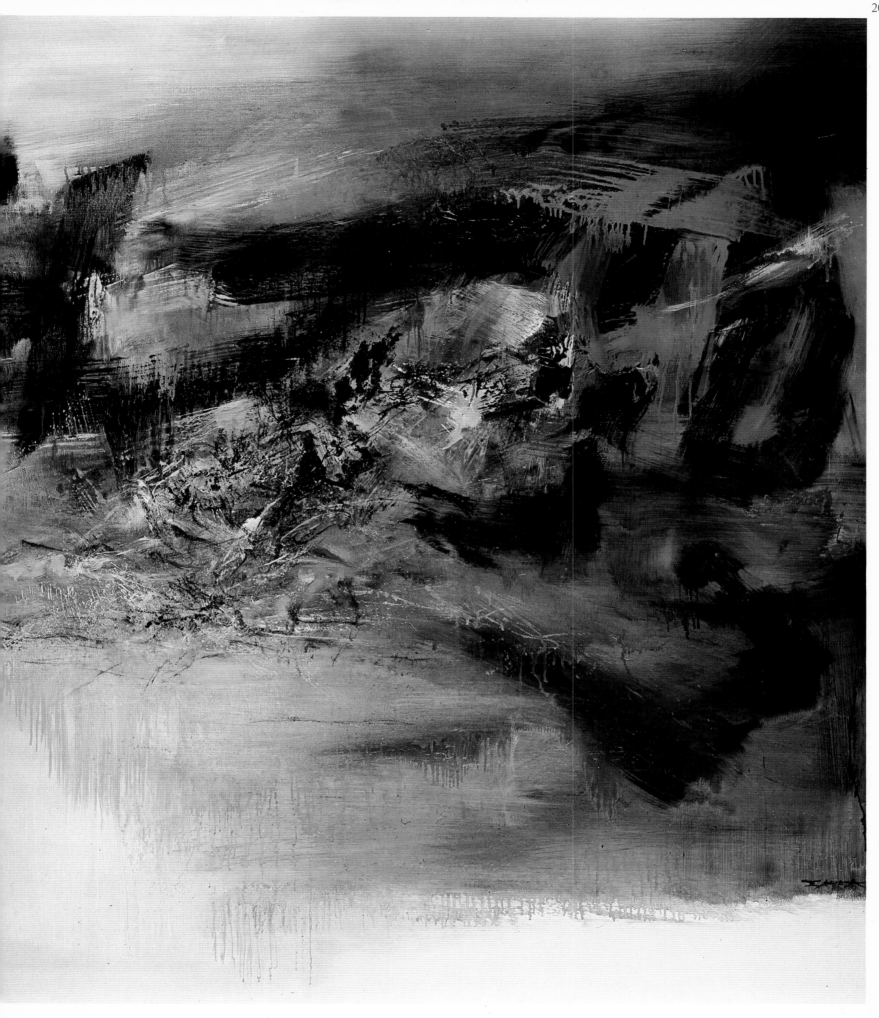

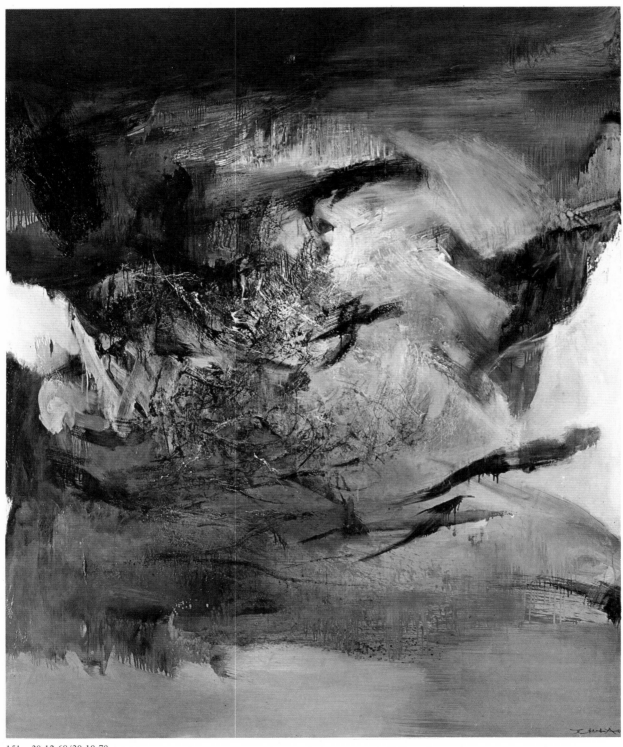

151. 30-12-68/30-10-70.
Oil on canvas, 200 × 162 cm.
Galerie de France, Paris.

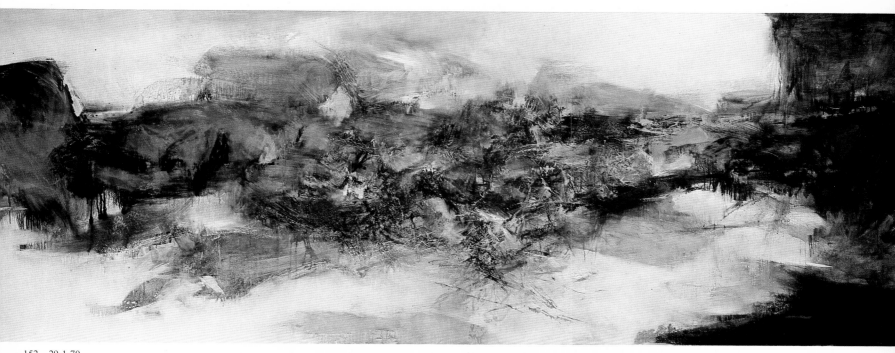

152. 29-1-70.
 Oil on canvas, 200 × 525 cm.
 Private collection, Paris.

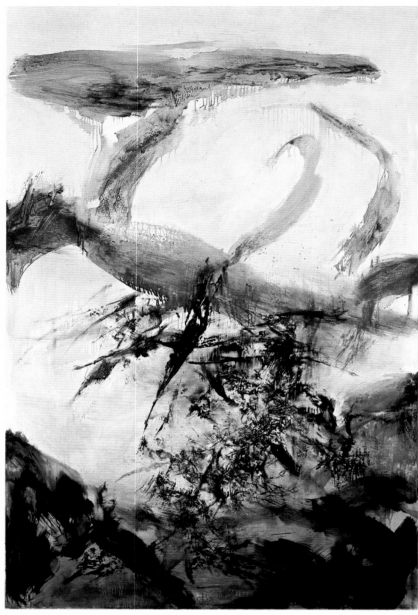

153. 6-10-71.
Oil on canvas, 195 × 130 cm.

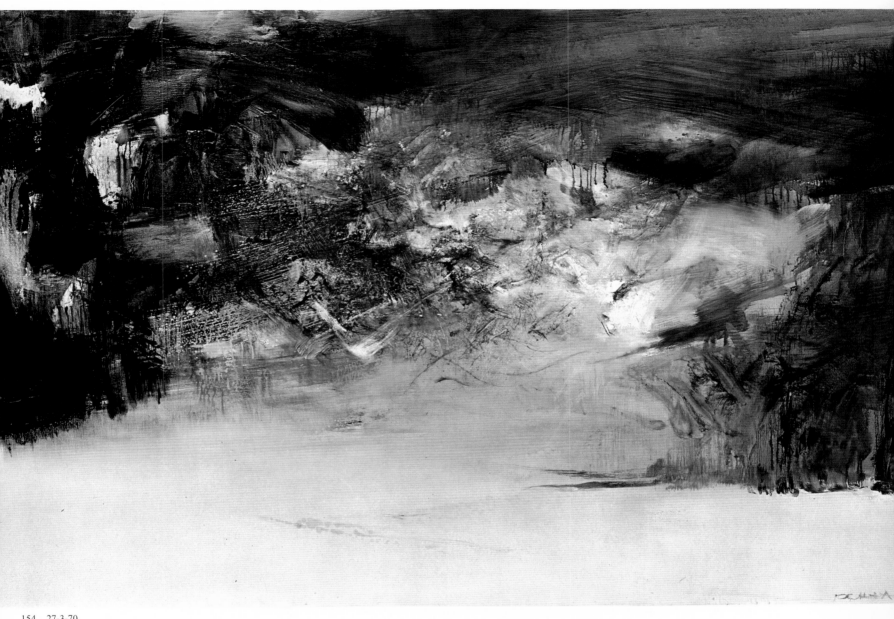

154. 27-3-70.
Oil on canvas, 130 × 195 cm.
Mr and Mrs I. M. Pei Collection, New York.

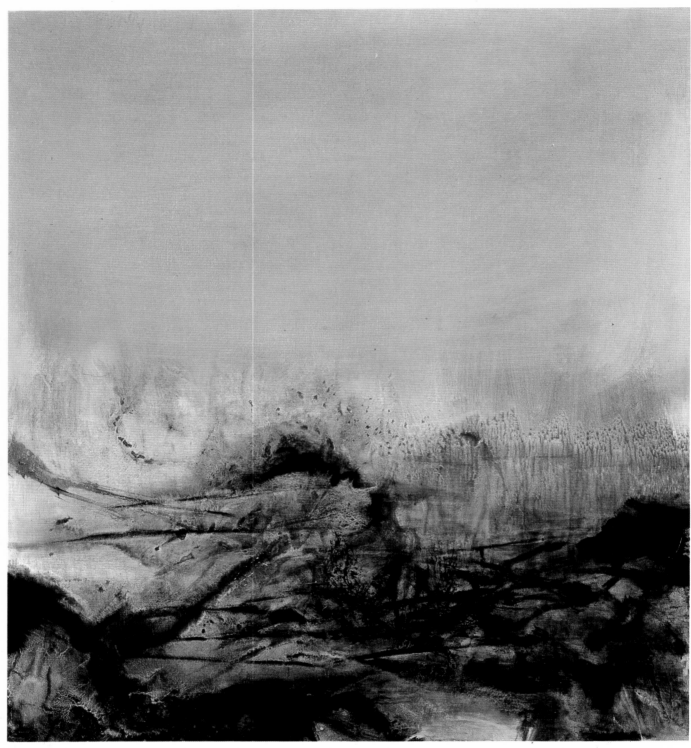

155. 30-3-71.
Oil on canvas, 105 × 95 cm.
Private collection, Paris.

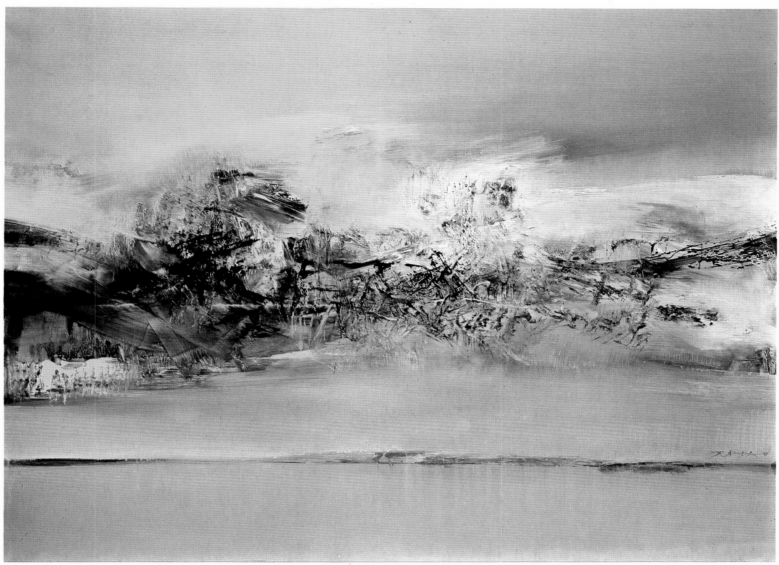

156. 15-4-70.
Oil on canvas, 97 × 130 cm.
Private collection, Lisbon.

208

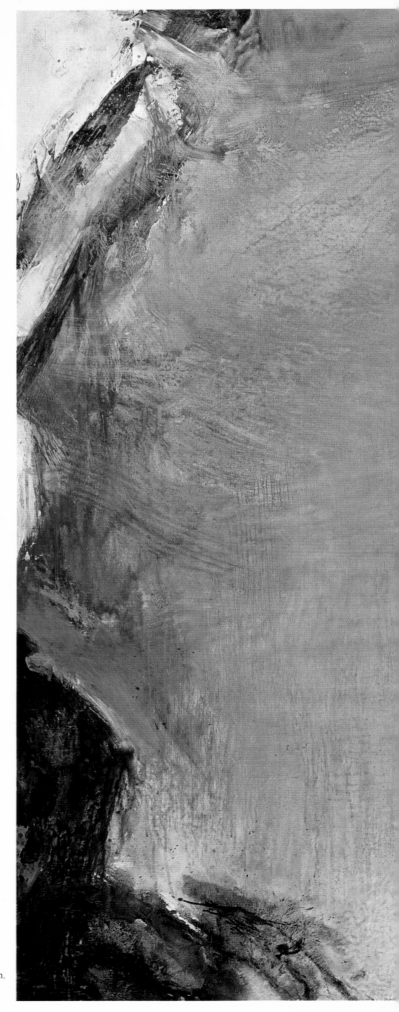

157. 12-10-70.
Oil on canvas, 130 × 162 cm.
Private collection, Paris.

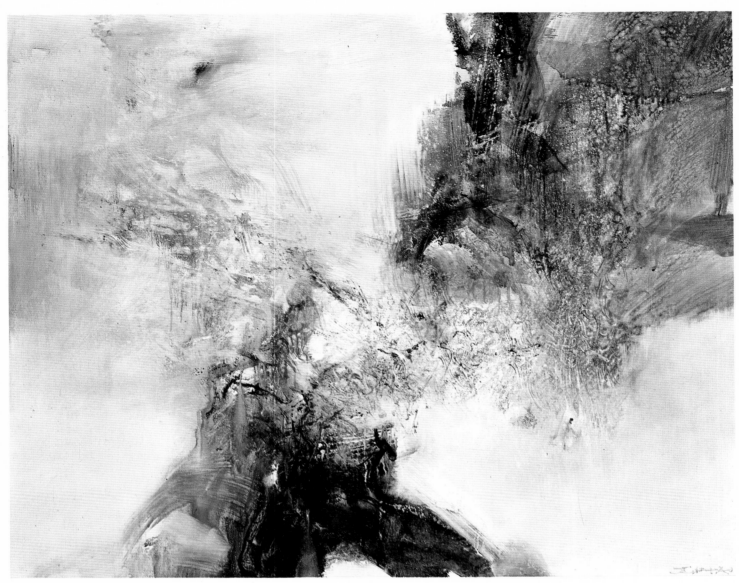

158. 26-10-70.
Oil on canvas, 81 × 100 cm.
Private collection, Huy, Belgium.

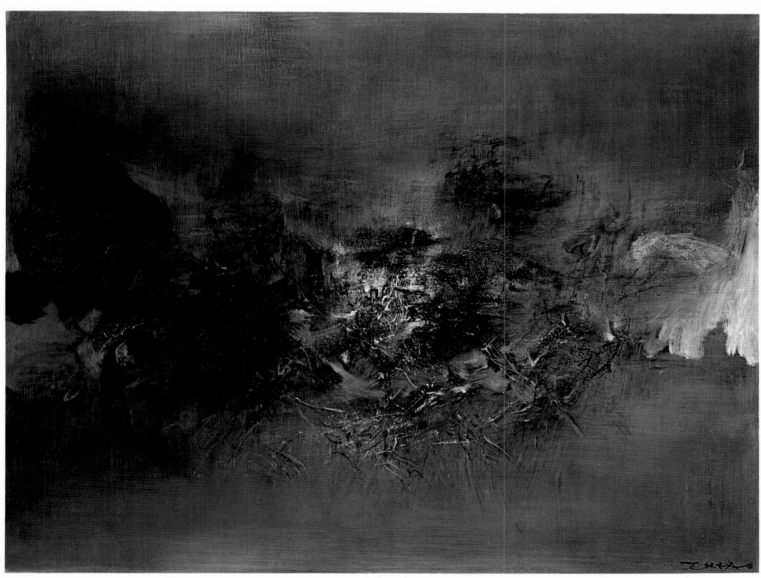

159. 15-6-69/26-12-70.
 Oil on canvas, 89 × 116 cm.
 Private collection, Antony, France.

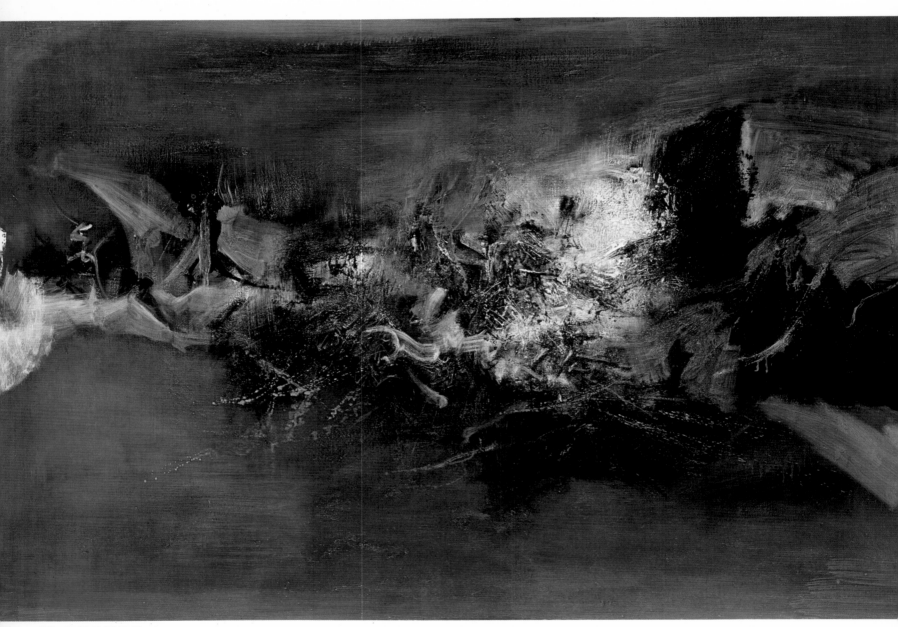

160. 10-11-58/30-12-70.
Oil on canvas, 130 × 195 cm.
Private collection, Mexico.

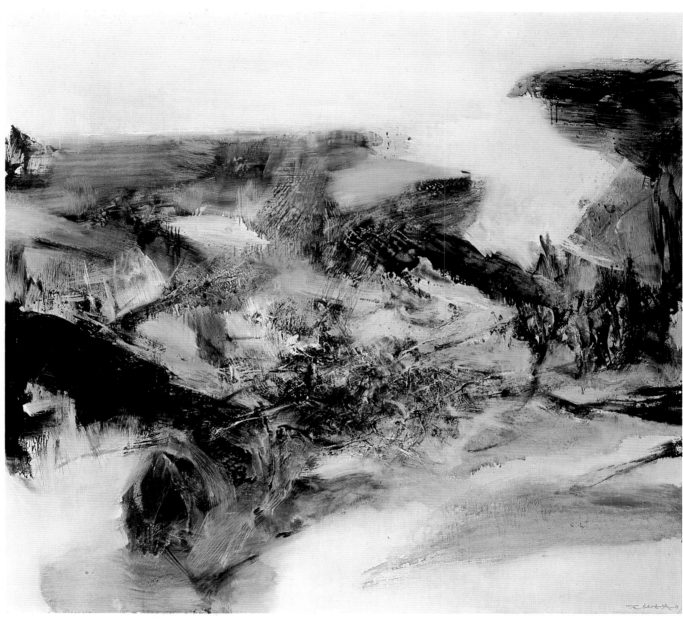

161. 25-5-70.
Oil on canvas, 150 × 162 cm.
Private collection, Lisbon.

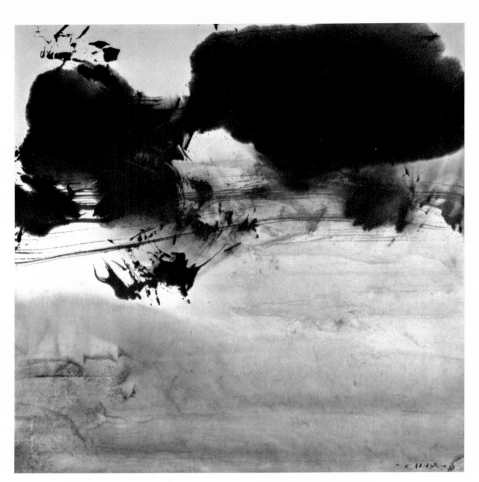

162. No. 30. 1971.
India ink on Chinese paper, 34 × 34 cm.
Private collection, Amsterdam.

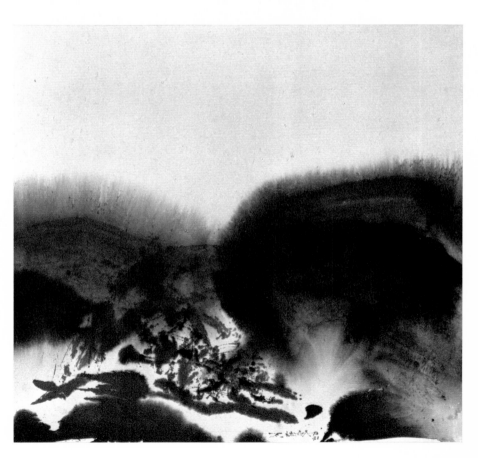

163. No. 16. 1971.
India ink on Chinese paper, 21.5 × 21.5 cm.
Sin-May Zao Collection, Paris.

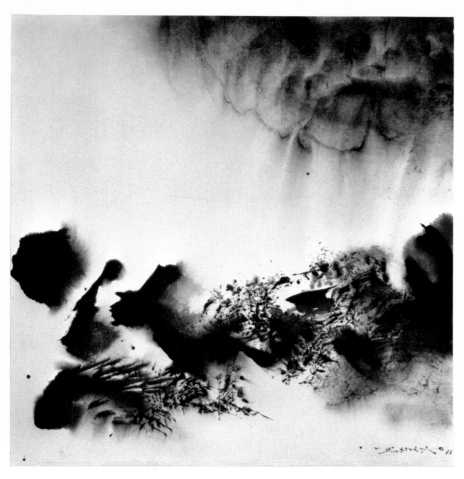

164. No. 9. 1971.
India ink on Chinese paper, 34 × 33.5 cm.
Private collection, Paris.

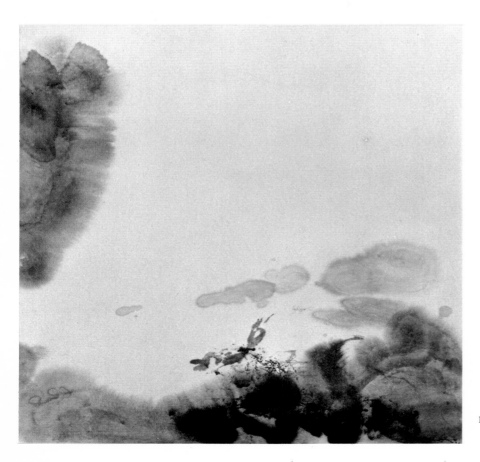

165. No. 39. 1971.
India ink on Chinese paper, 34 × 34 cm.
Private collection, New York.

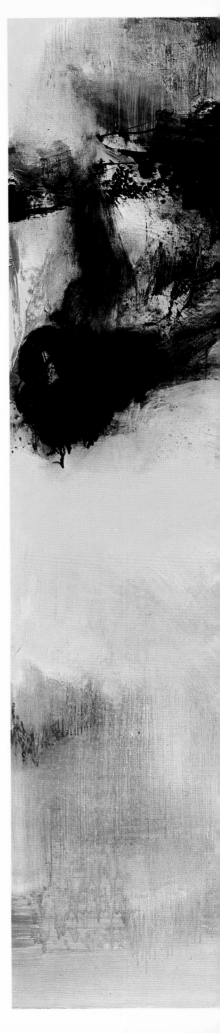

166. 14-7-71.
Oil on canvas, 150 × 162 cm.

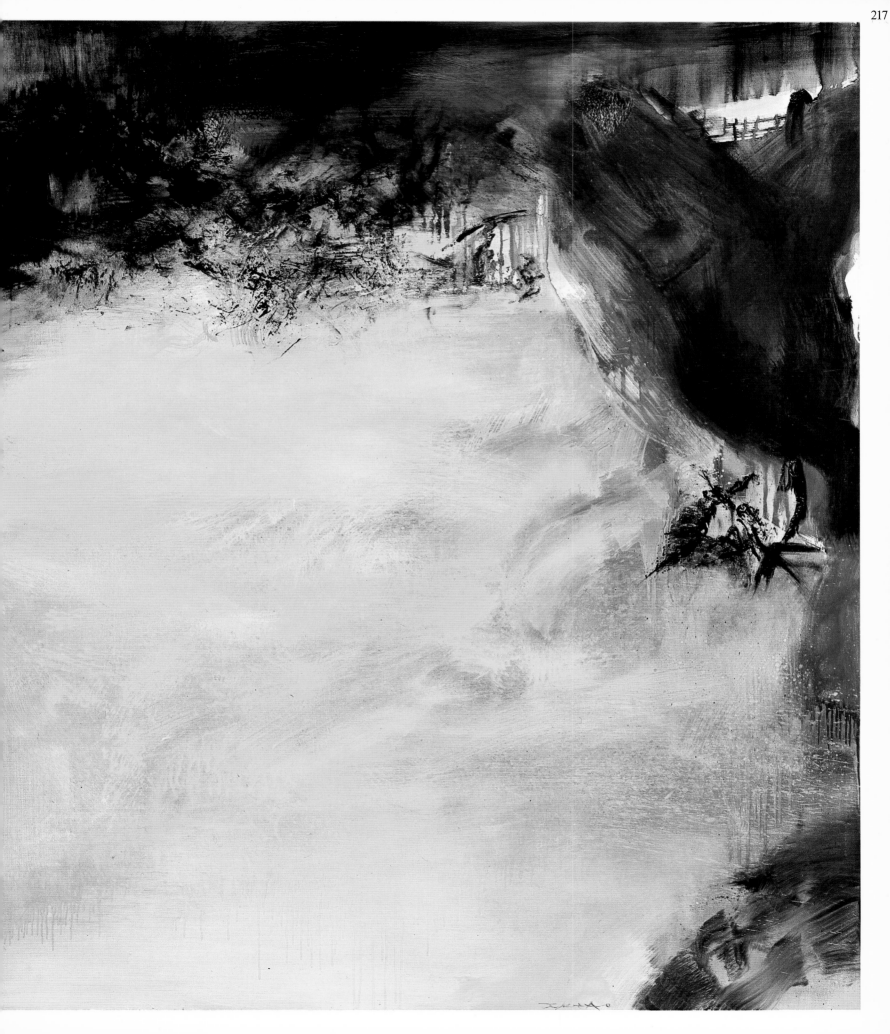

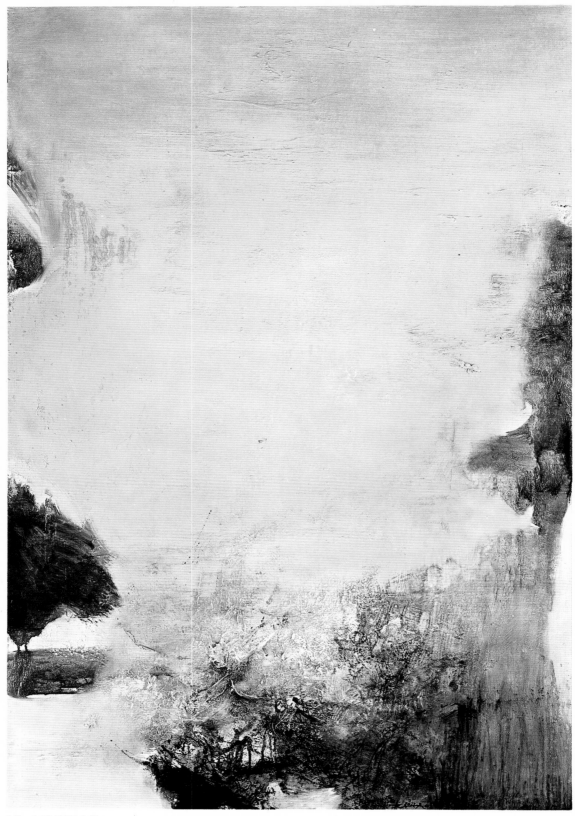

167. 1-12-61/27-1-71.
 Oil on canvas, 130 × 89 cm.
 Private collection, Paris.

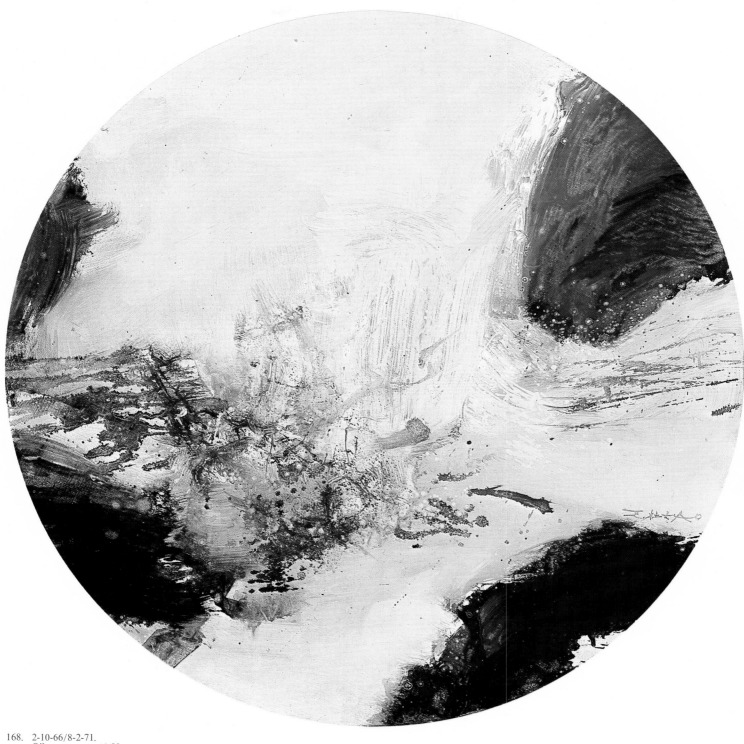

168. 2-10-66/8-2-71.
Oil on canvas, ⌀ 55 cm.
Private collection, Paris.

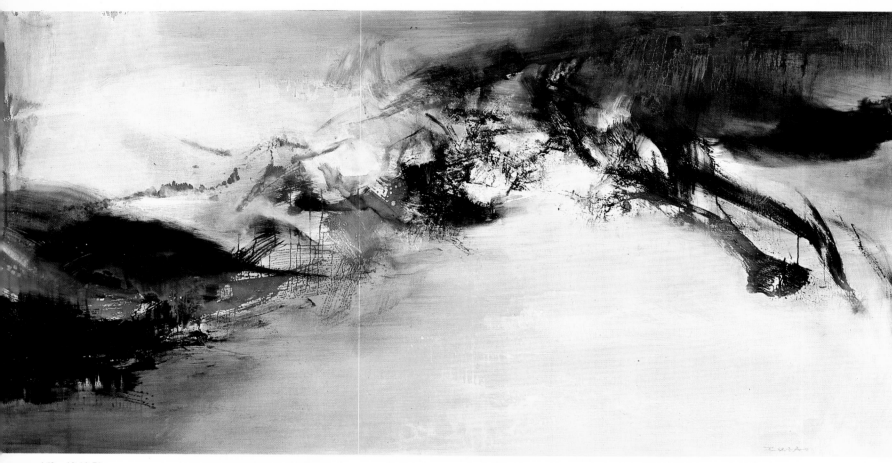

169. 18-10-71.
Oil on canvas, 97 × 195 cm.
Mr and Mrs Chi-Ming Cha Collection, Los Altos Hills, California.

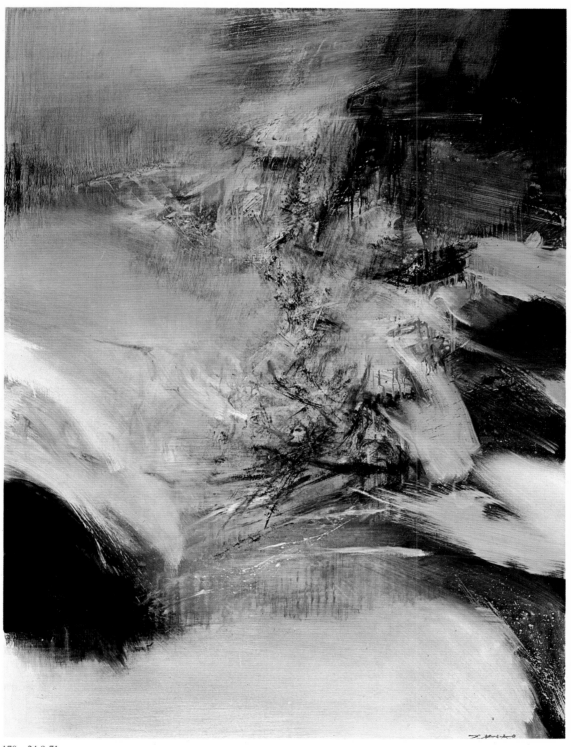

170. 24-9-71.
Oil on canvas, 130 × 97 cm.
Private collection, Luxemburg.

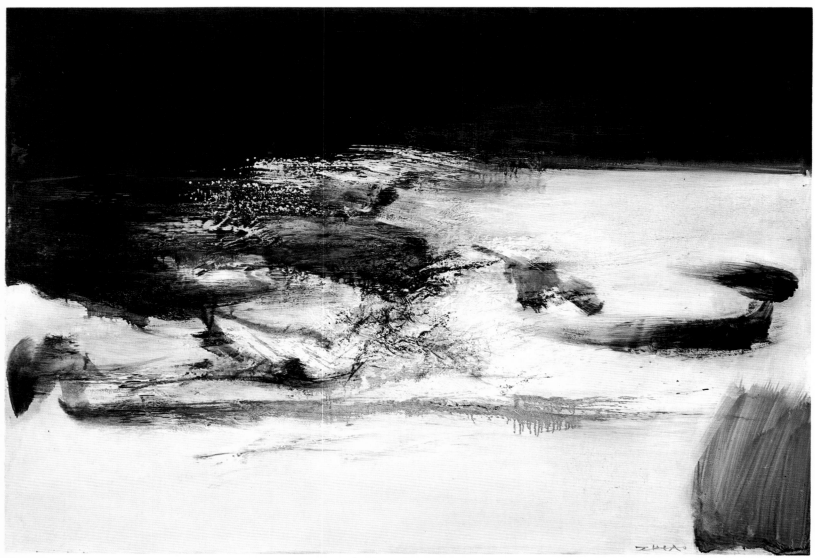

171. 23-5-62/7-1-71.
Oil on canvas, 114 × 162 cm.
Private collection, Paris.

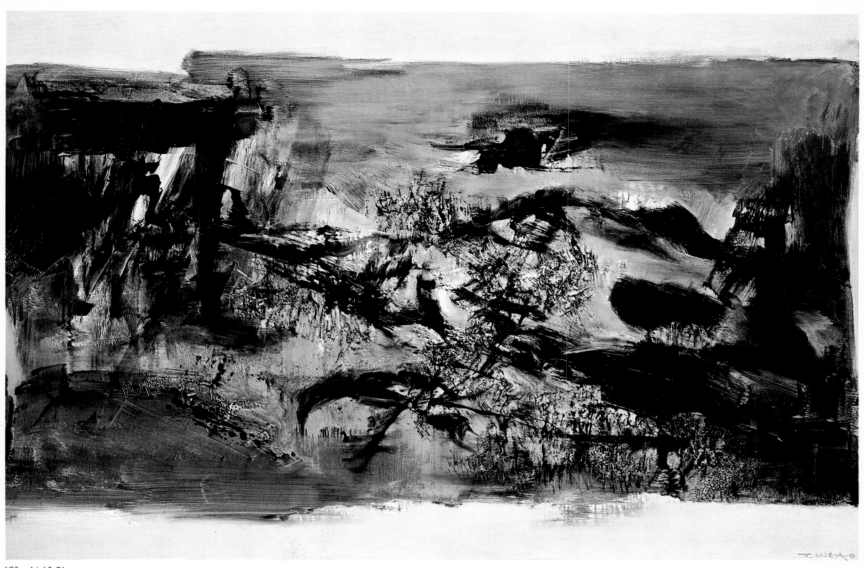

172. 14-12-71.
Oil on canvas, 130 × 195 cm.
Galerie de France, Paris.

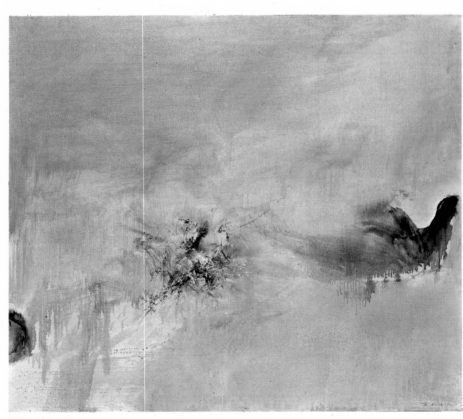

173. 12-10-71.
Oil on canvas, 95 × 105 cm.
Galerie de France, Paris.

174. 9-5-59/8-1-71.
Oil on canvas, 200 × 162 cm.
Tamayo Museum of Contemporary Art, Mexico.

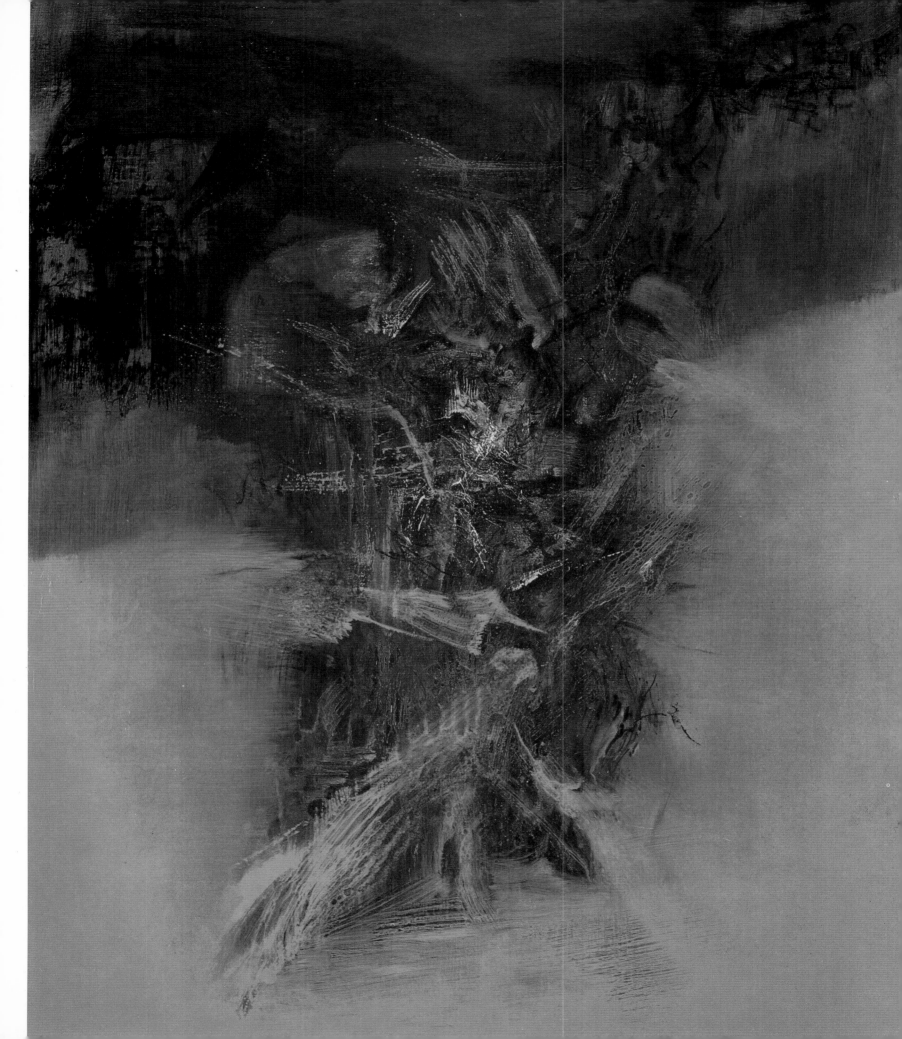

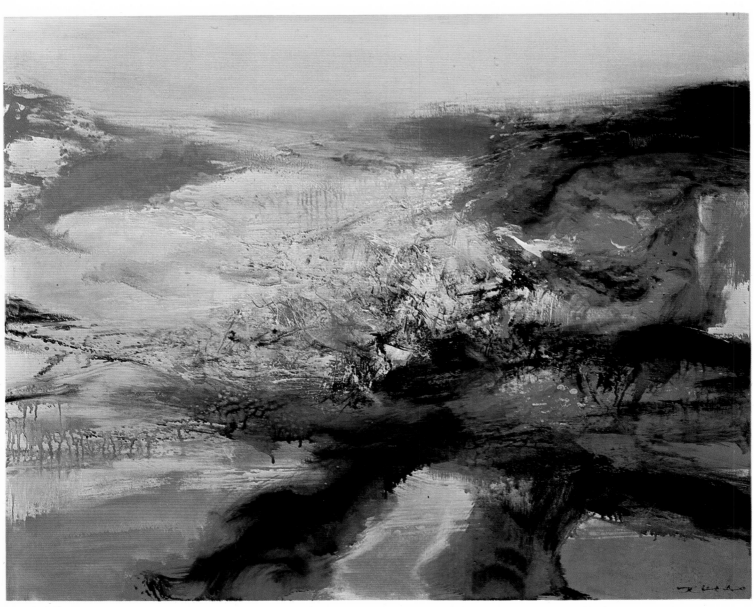

175. 21-2-72.
Oil on canvas, 81 × 100 cm.
Dr. R. Cherchère Collection, Paris.

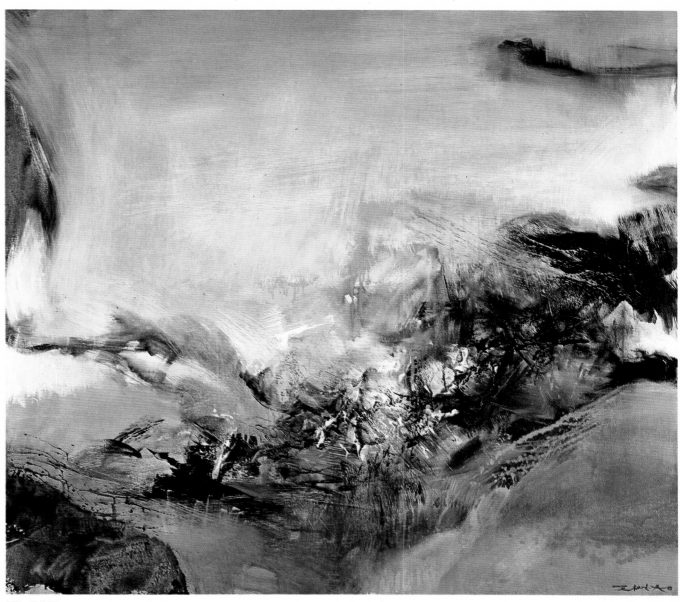

176. 2-8-72.
1972. Oil on canvas, 95 × 105 cm.
Private collection, Toulouse.

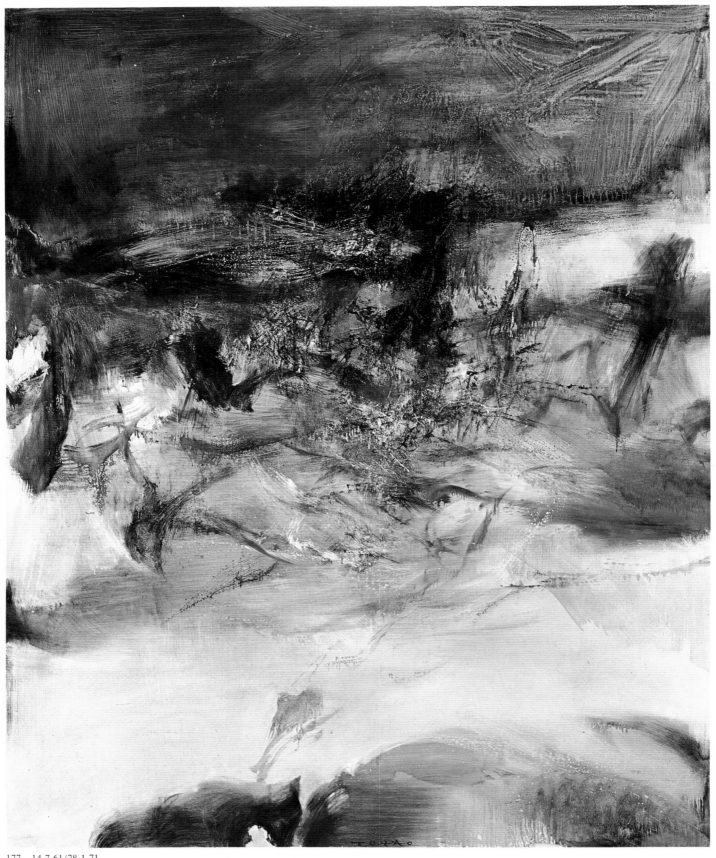

177. 14-7-61/28-1-71.
Oil on canvas, 200 × 162 cm.

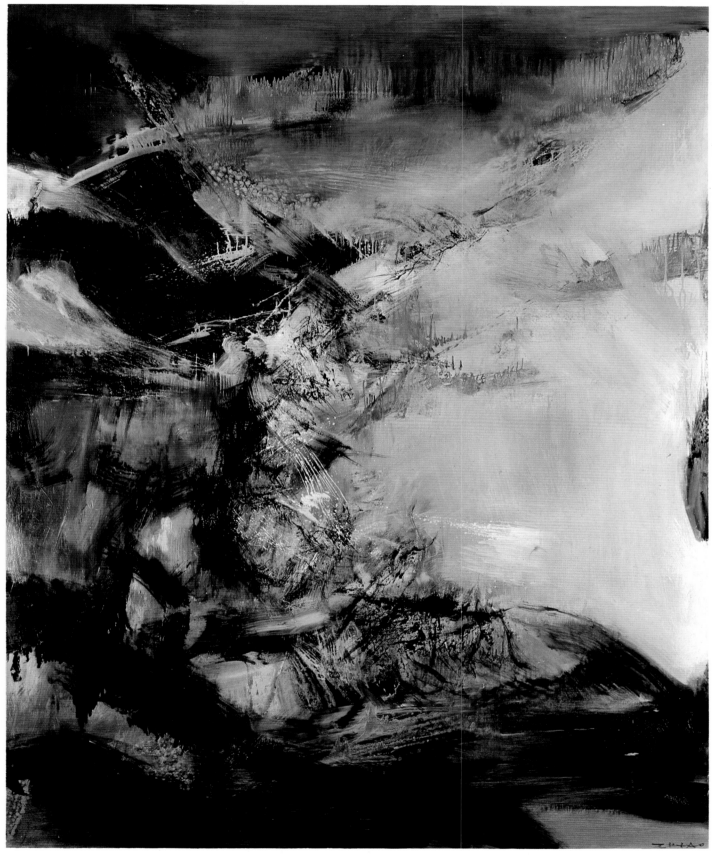

178. 19-11-71.
Oil on canvas, 200 × 162 cm.
Consulate General of France, Hong Kong (on loan from the National Fund of
Contemporary Art, Paris).

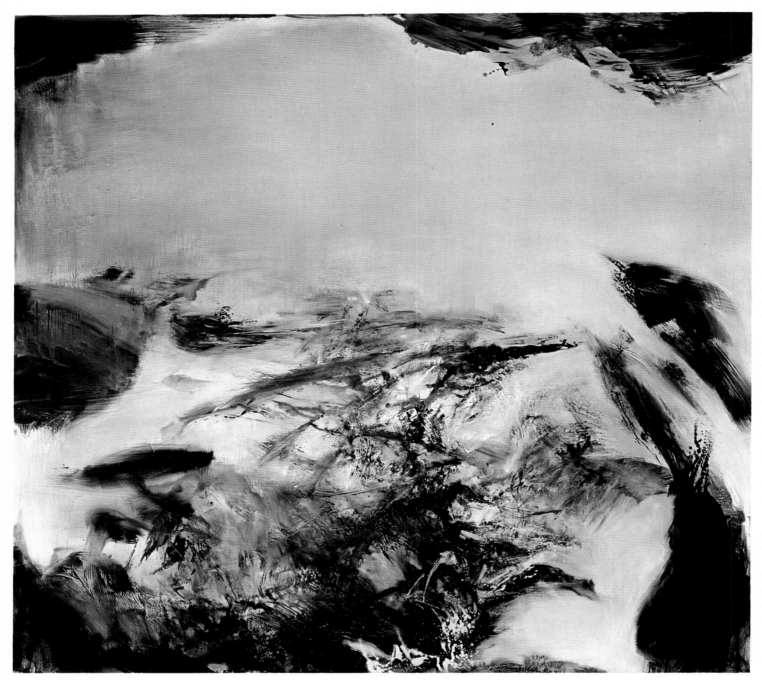

179. 10-10-72.
Oil on canvas, 150 × 162 cm.
Galerie de France, Paris.

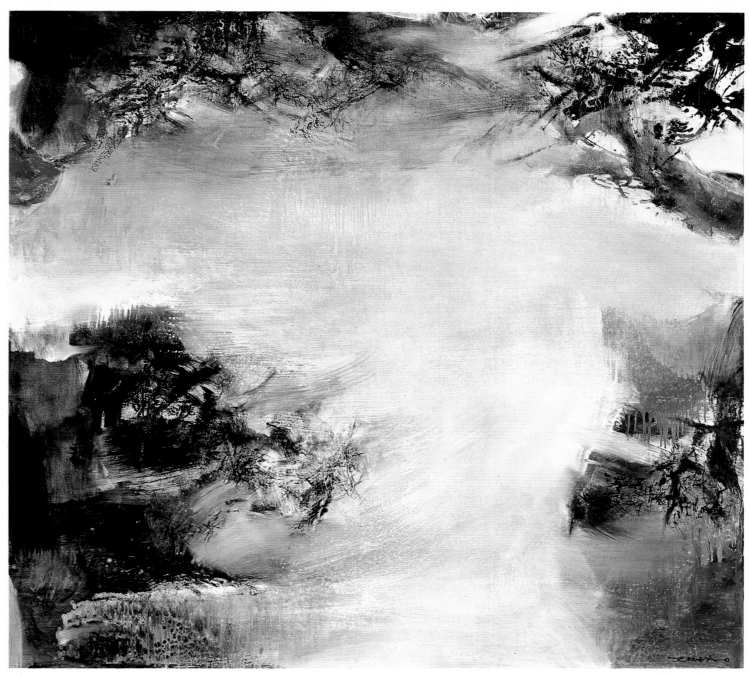

180. 8-2-72.
 Oil on canvas, 150 × 162 cm.

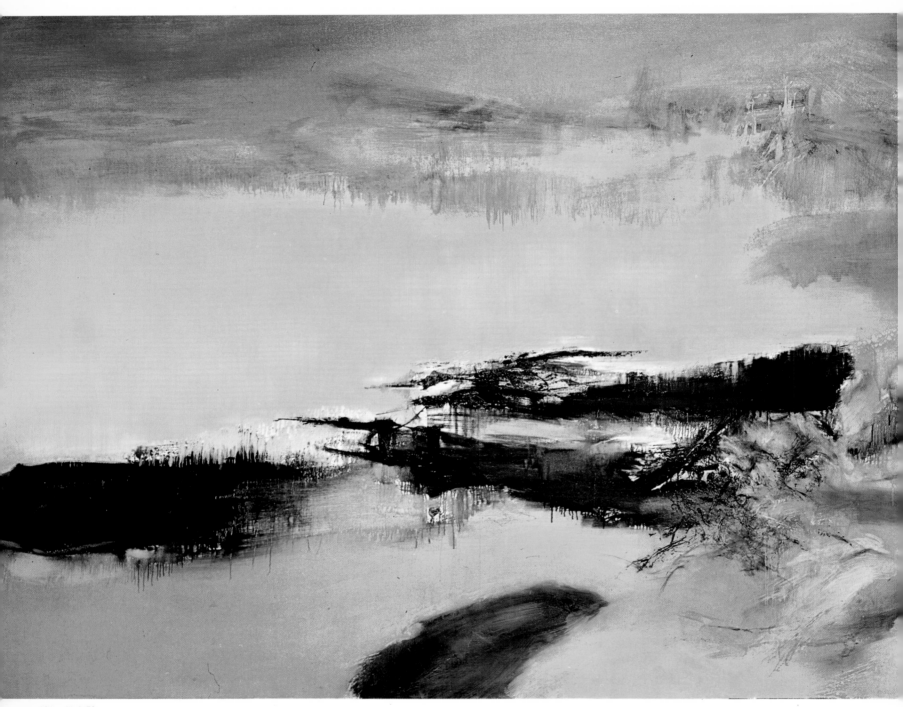

181. 10-9-72.
In memory of May. (14-11- 30/10-3-72).
Oil on canvas, 200 × 525 cm.
Centre Georges Pompidou,
National Museum of Modern Art, Paris.

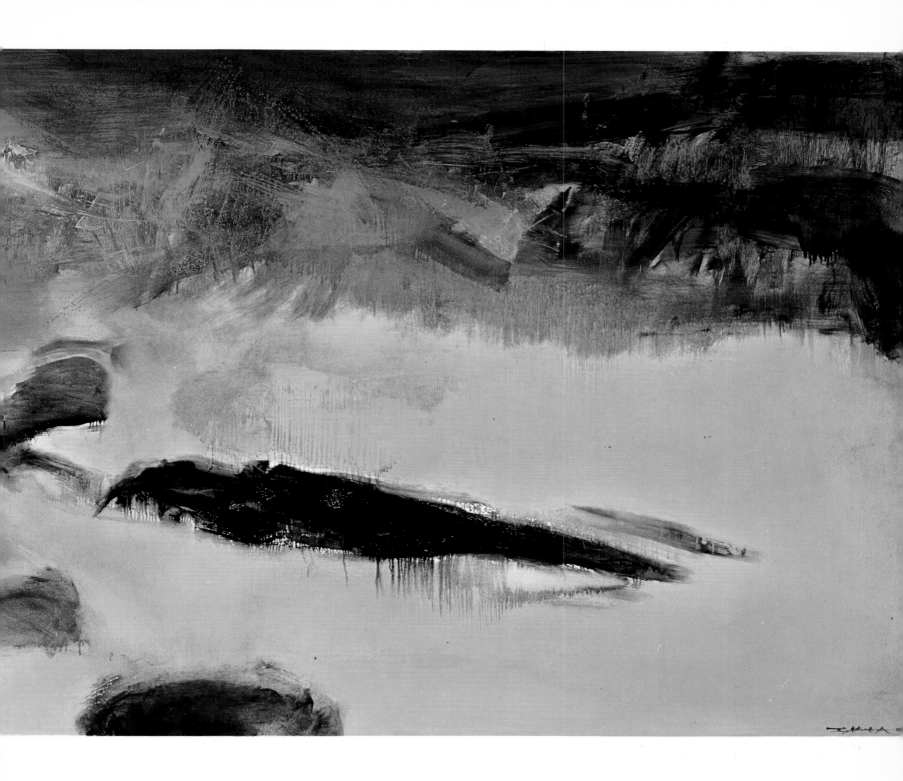

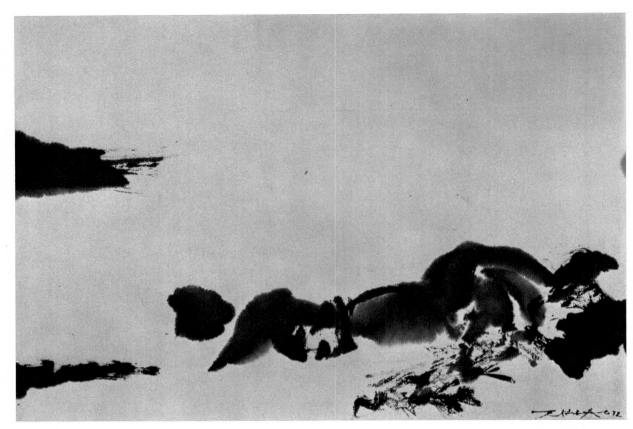

182. 1972.
India ink on Chinese paper, 22.7 × 33.3 cm.
M. et Mme Gaëtan Picon Collection, Paris.

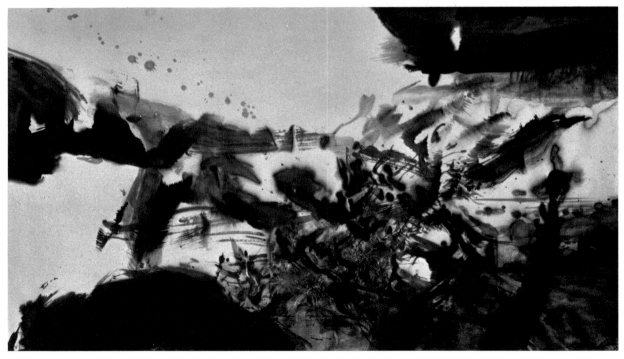

183. 1972.
India ink on Chinese paper, 69 × 119 cm.
Private collection, Paris.

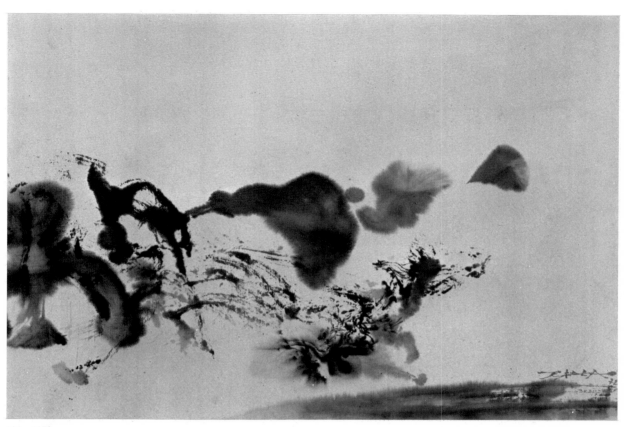

184. 1972.
 India Ink on Chinese paper, 22.2 × 33.3 cm.
 Private collection, Paris.

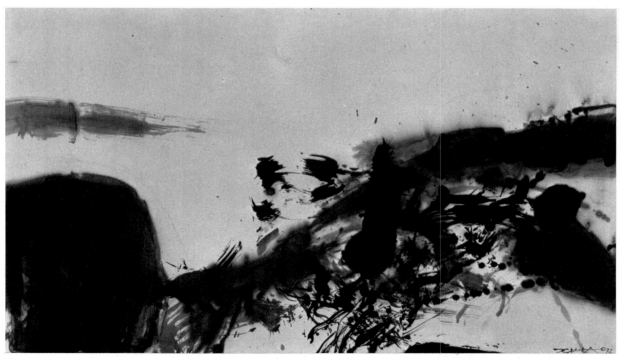

185. 1972.
 India ink on Chinese paper, 69 × 119 cm.
 Private collection, Paris.

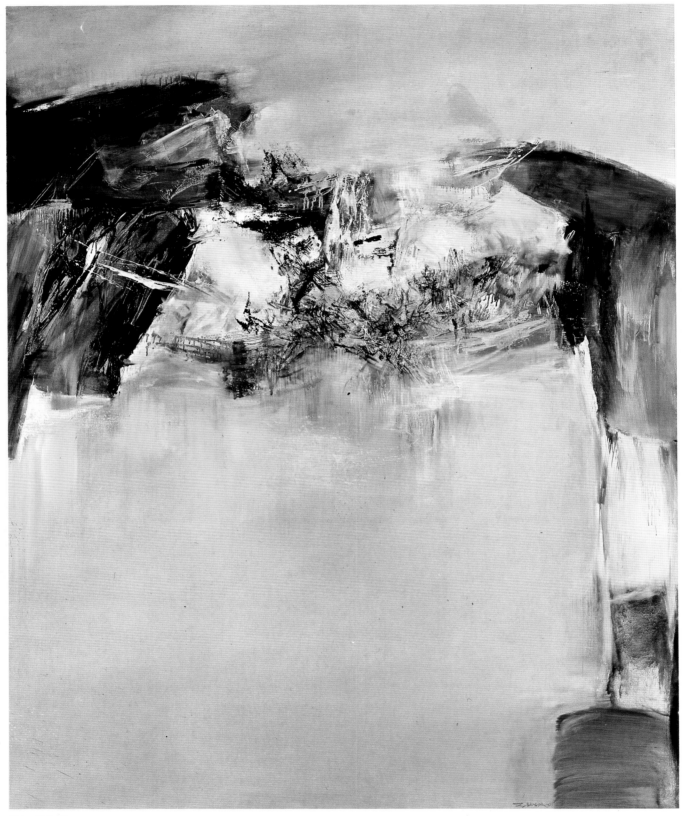

186. 10-9-73.
Oil on canvas, 200 × 162 cm.

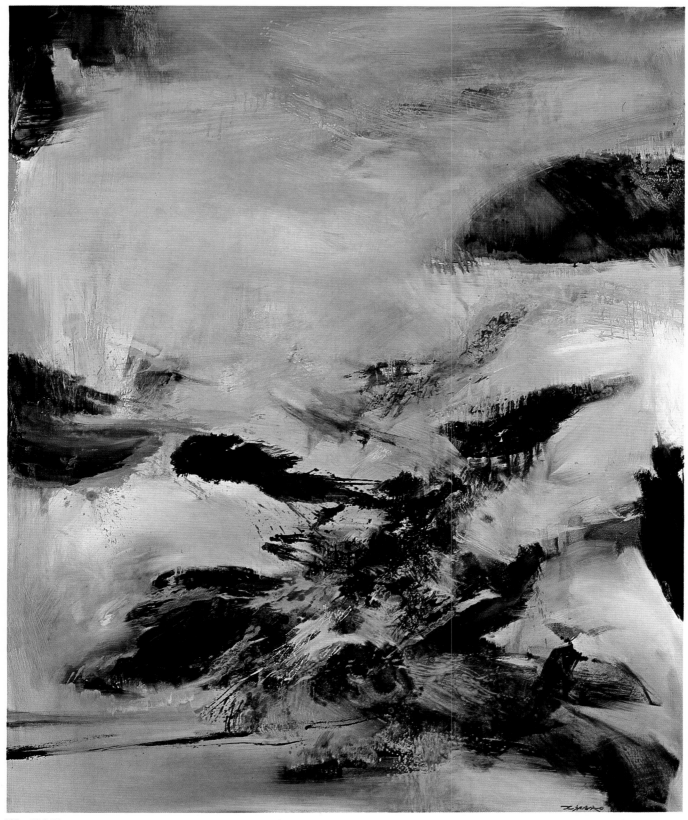

187. 13-9-73.
Oil on canvas, 200 × 162 cm.

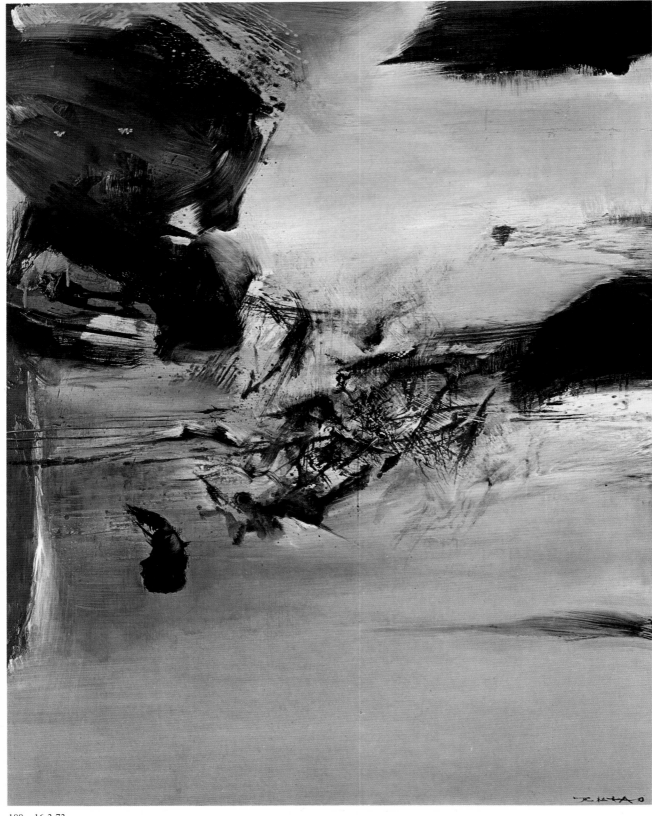

188. 16-3-73.
Oil on canvas, 146 × 114 cm.
Private collection, France.

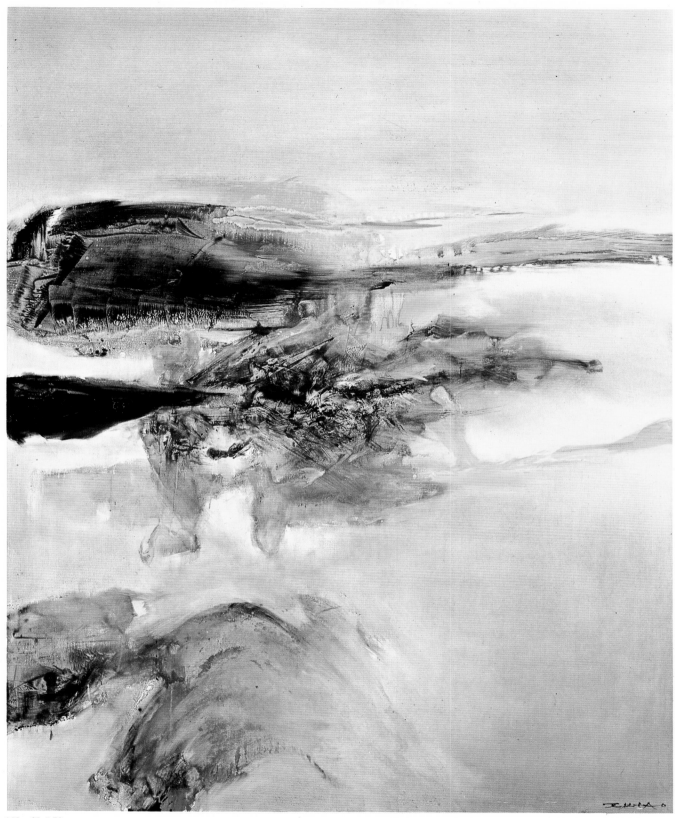

189. 28-5-73.
Oil on canvas, 162 × 130 cm.
Galerie de France, Paris.

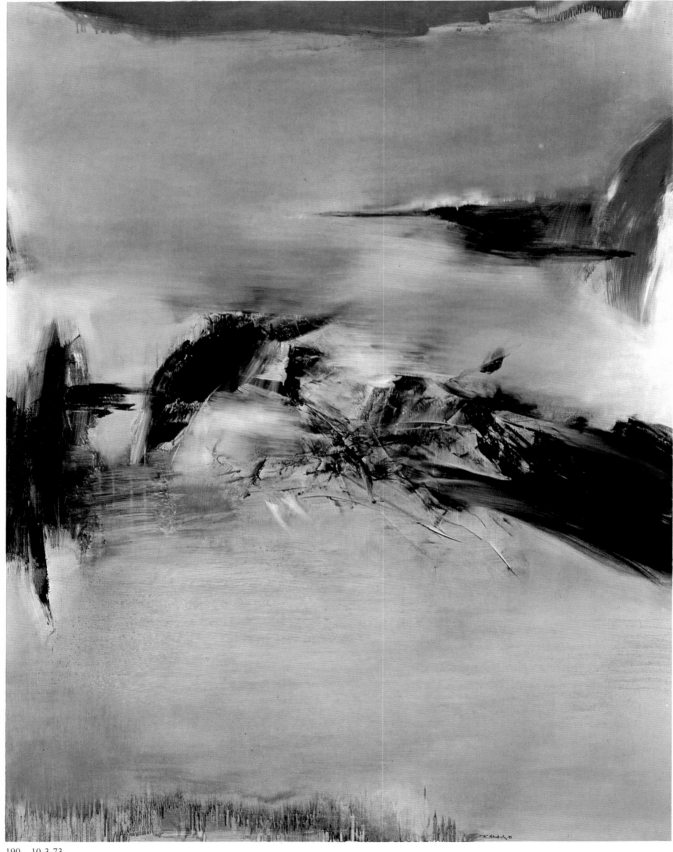

190. 10-3-73.
 Oil on canvas, 260 × 200 cm.

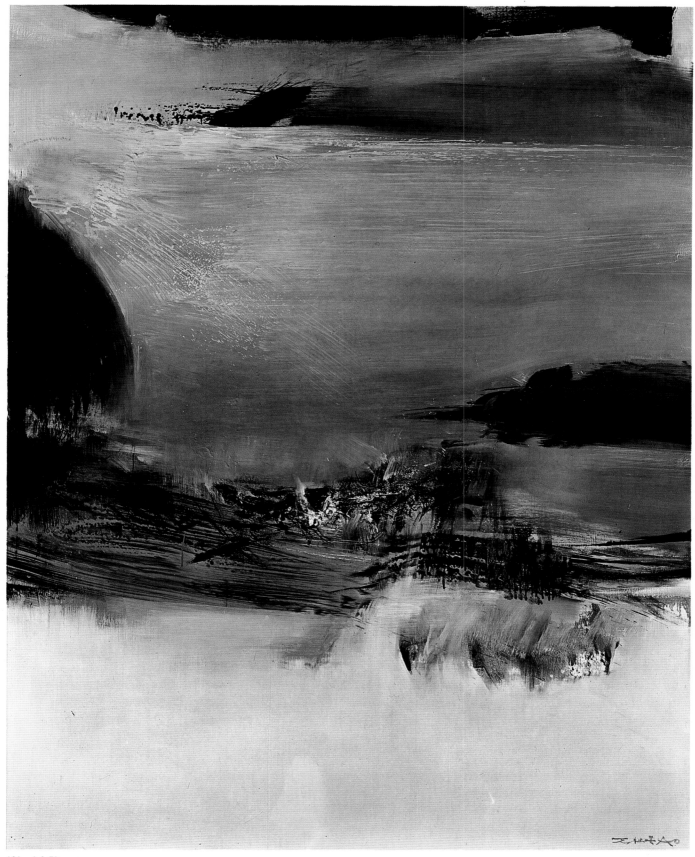

191. 3-2-73.
Oil on canvas, 146 × 114 cm.

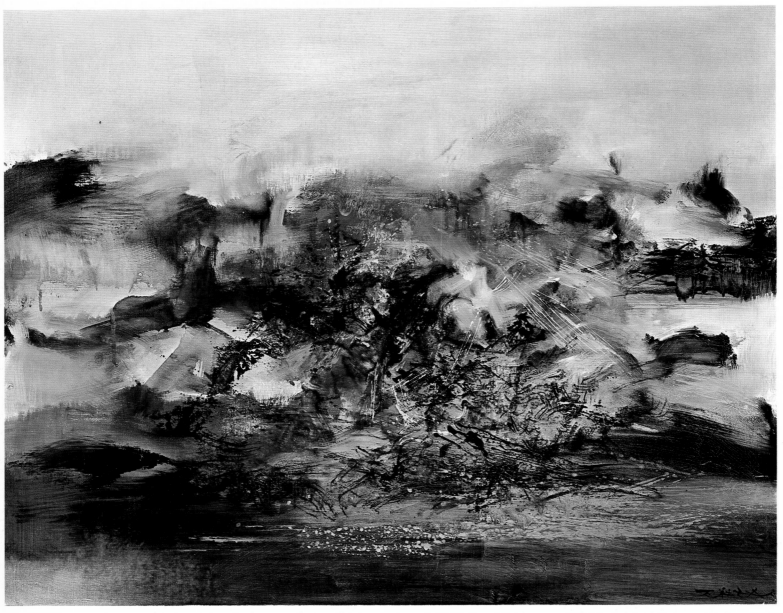

192. 6-2-74.
Oil on canvas, 65 × 81 cm.
Private collection, Paris.

193. 1-10-73.
Oil on canvas, 260 × 200 cm.

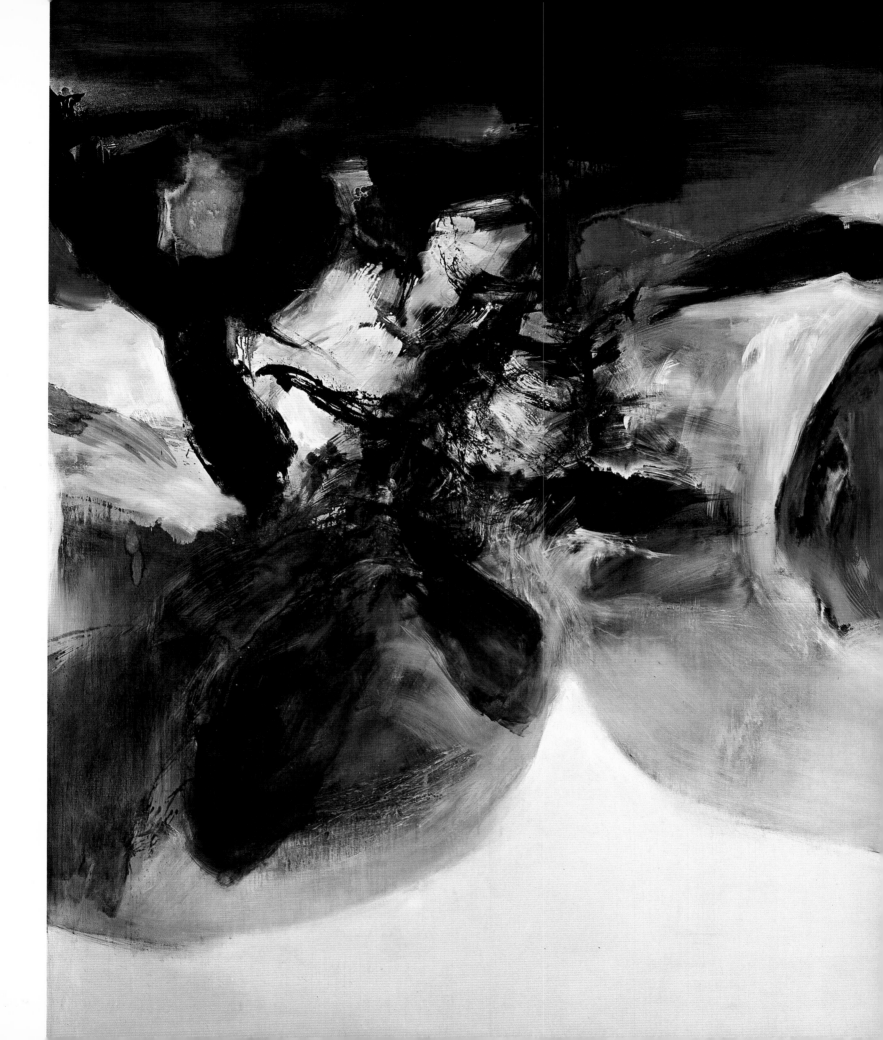

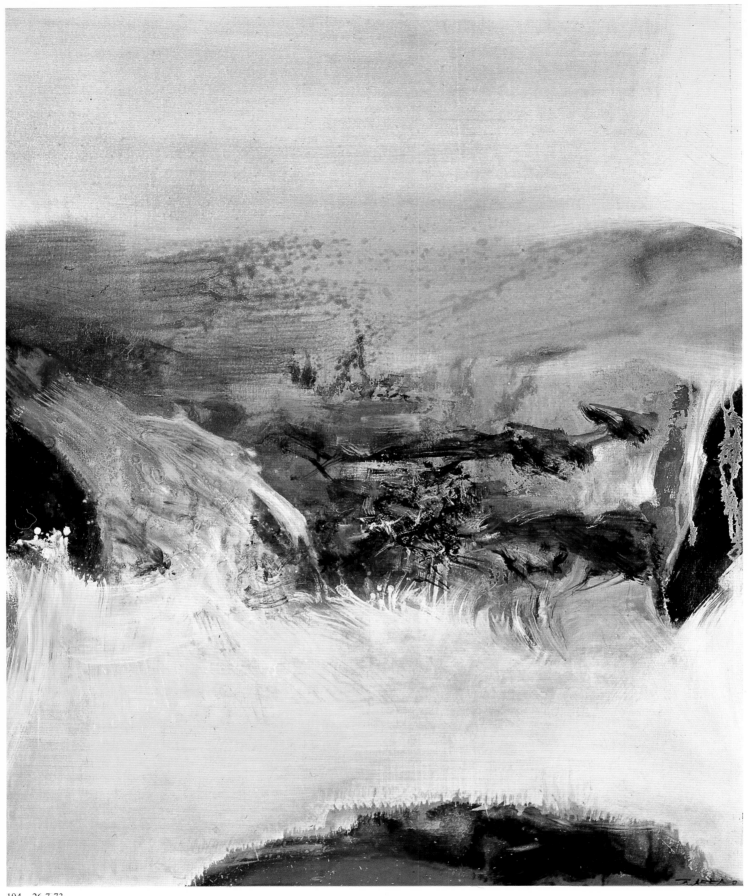

194. 26-7-73.
Oil on canvas, 73 × 60 cm.
Private collection, Paris.

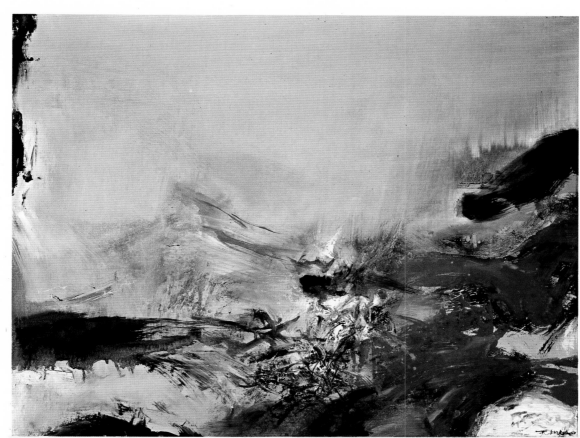

195. 27-10-73.
 Oil on canvas, 50 × 65 cm.
 Private collection, Paris.

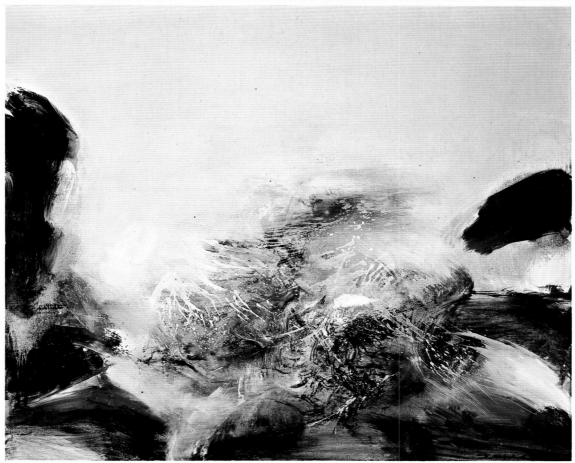

196. Homage to René Char.
 10-1-73 × 5-4-73.
 Oil on canvas, 54 × 65 cm.
 René Char Collection.
 L'Isle-sur-la-Sorgue, France.

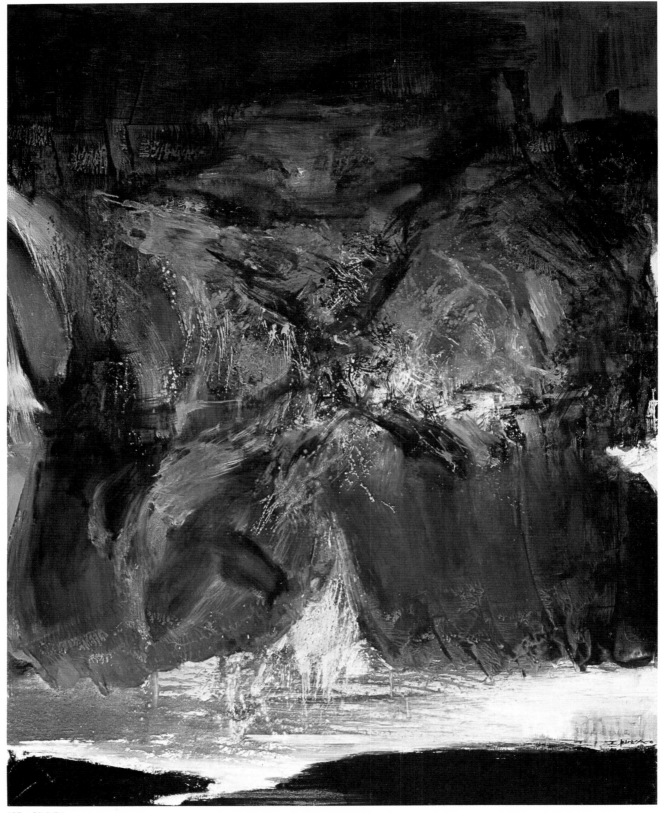

197. 28-8-74.
Oil on canvas, 92 × 73 cm.

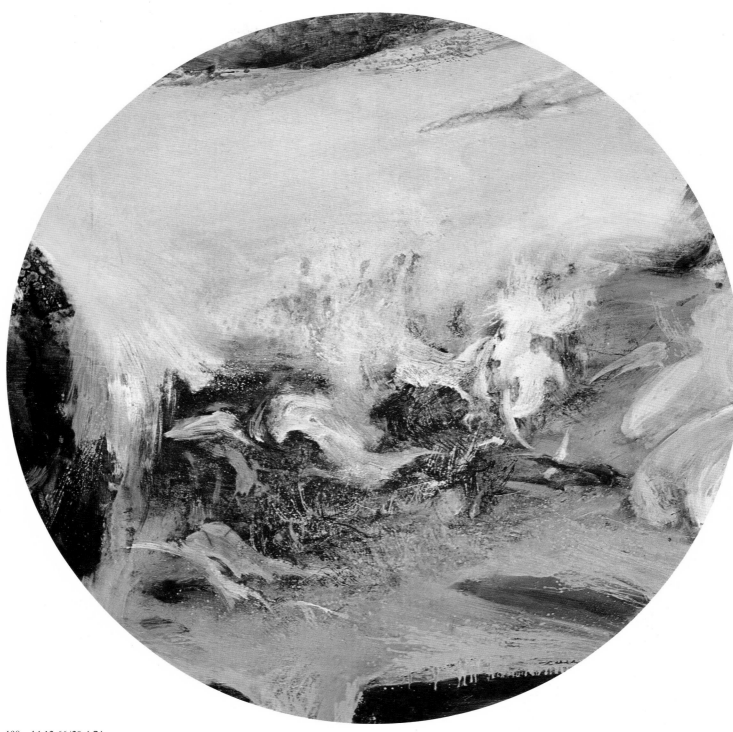

198. 14-12-66/20-4-74.
Oil on canvas, ∅ 100 cm.
Sin-May Zao Collection, Paris.

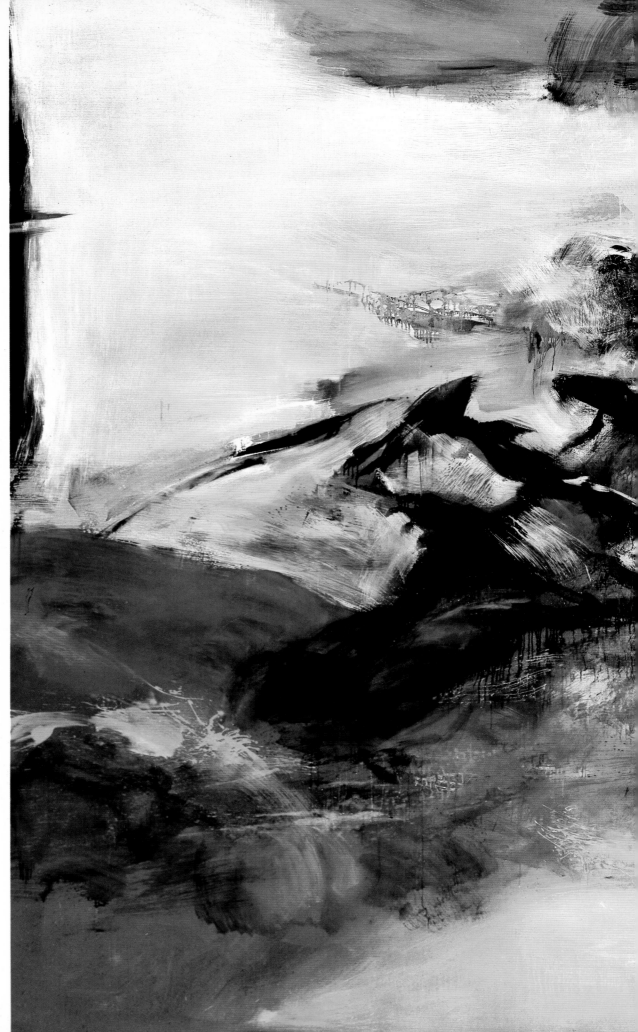

199. 10-3-74. We two again.
 Oil on canvas, 280 × 400 cm.
 Property of the artist.

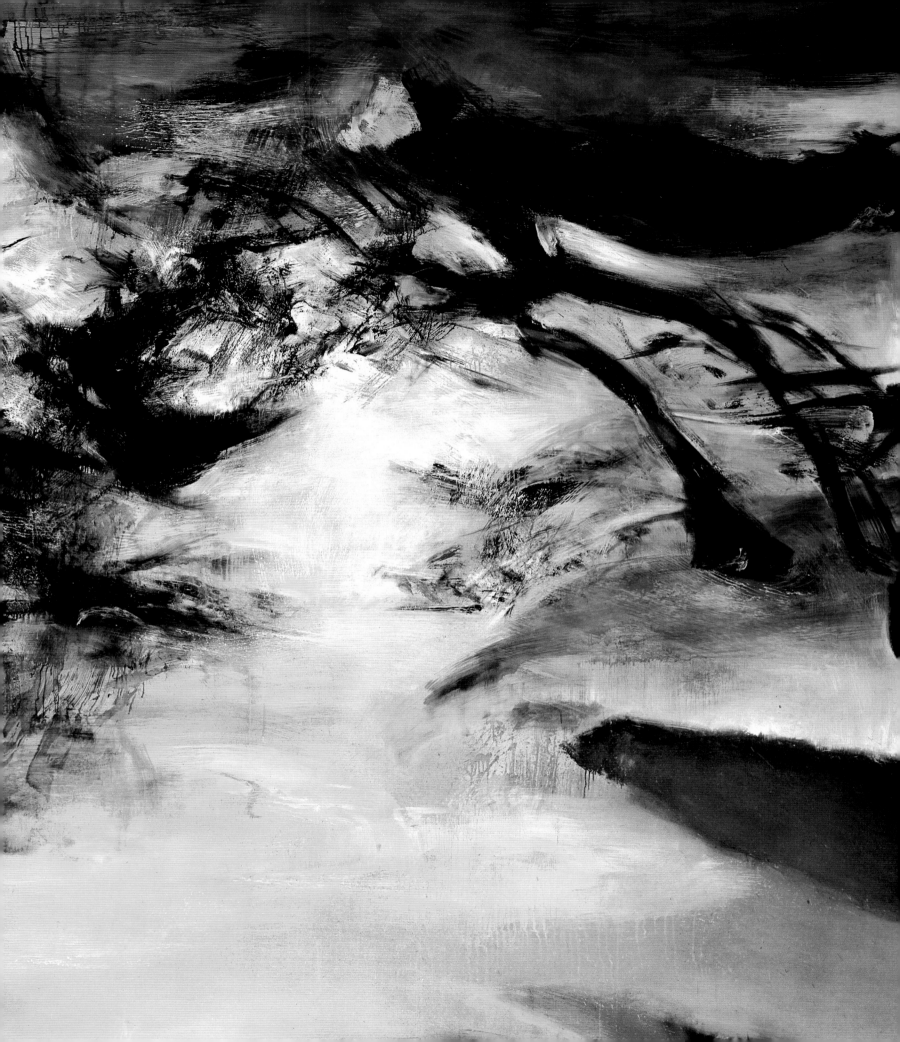

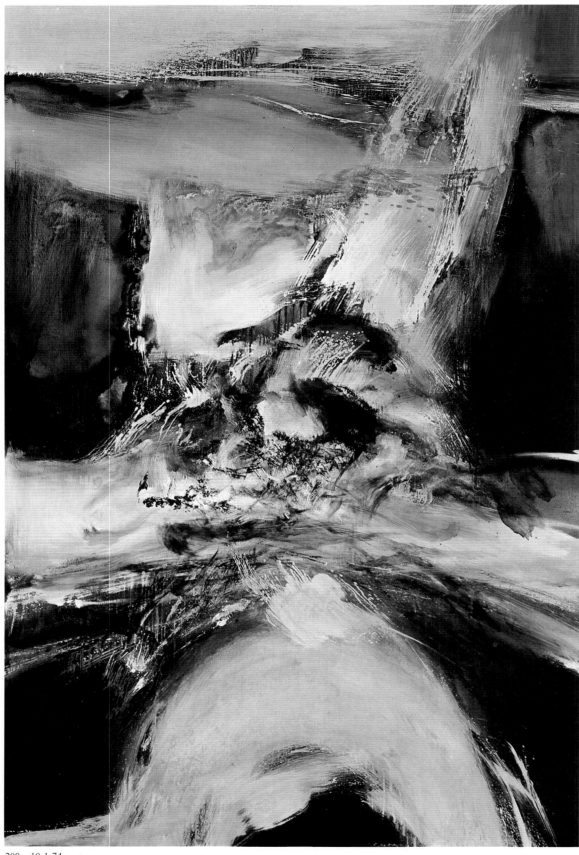

200. 10-1-74.
 Oil on canvas, 195 × 130 cm.

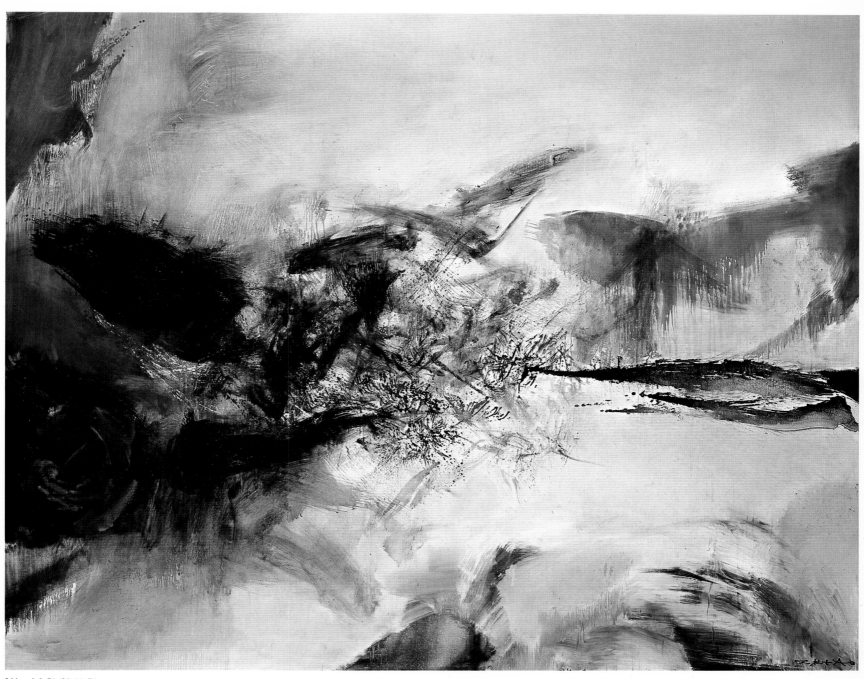

201. 5-3-71/28-11-74.
 Oil on canvas, 162 × 200 cm.

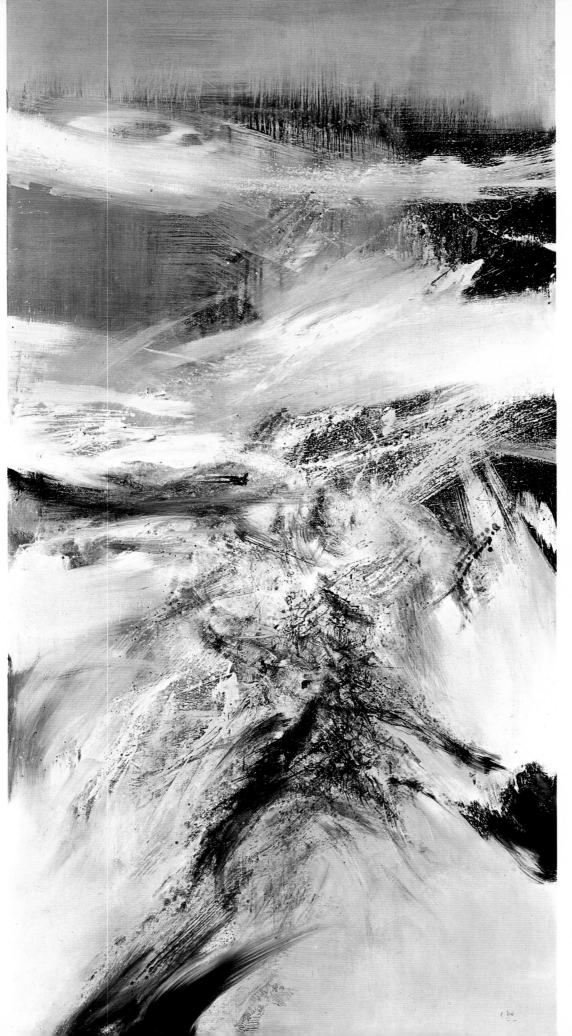

202. 1-2-73/5-12-74.
Oil on canvas, 195 × 97 cm.
J. M. D. Cha Collection, Los Altos Hills,
California.

203. 2-3-74.
Oil on canvas, 162 × 130 cm.
Property of the artist.

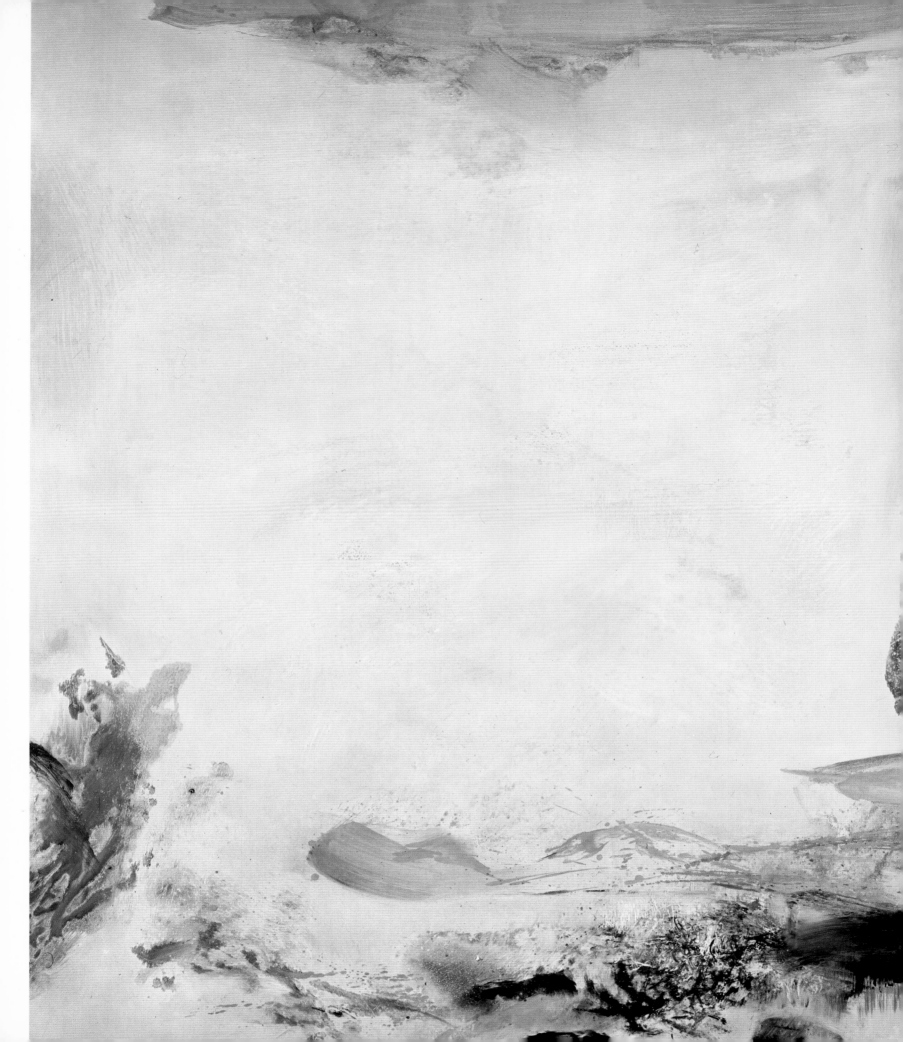

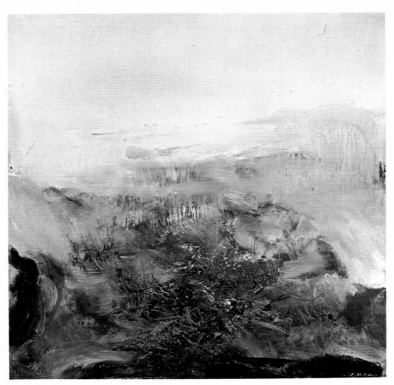

204. 6-11-75.
 Oil on canvas, 55 × 55 cm.
 Private collection, Geneva.

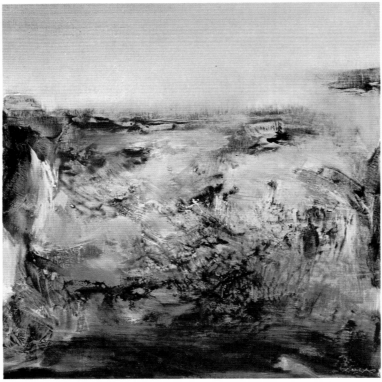

205. 1-2-76.
 Oil on canvas, 55 × 55 cm.
 Private collection, New York.

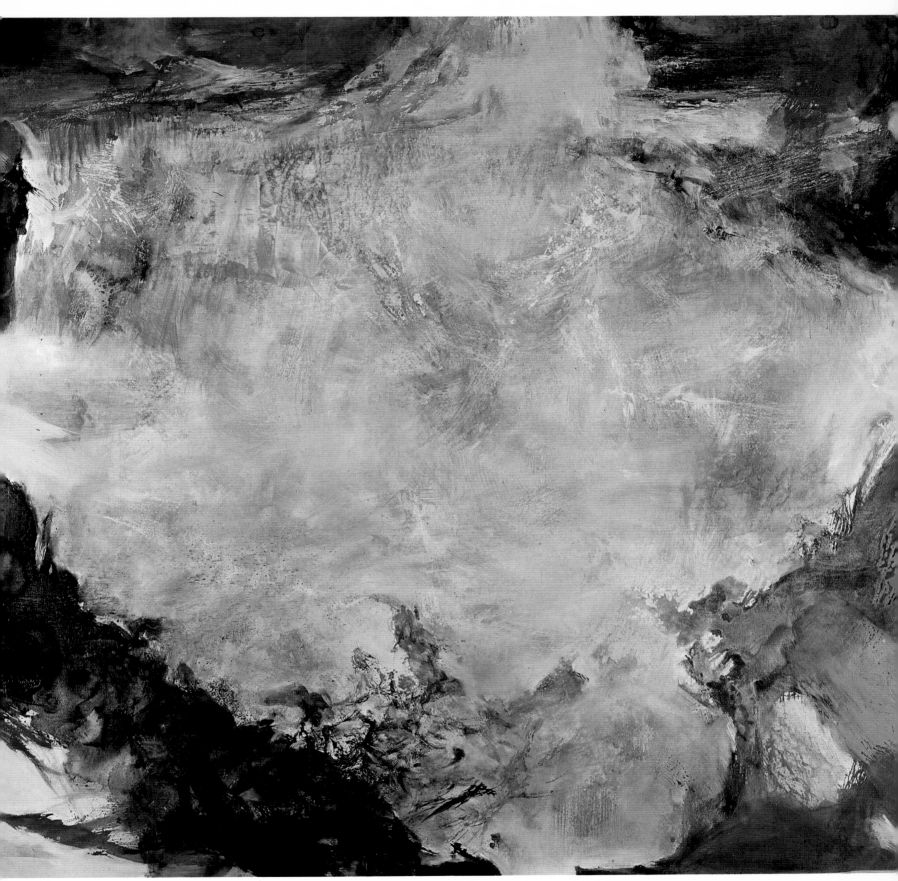

206. 3-12-74.
Oil on canvas, 250 × 260 cm.
National Fund of Contemporary Art, Paris.

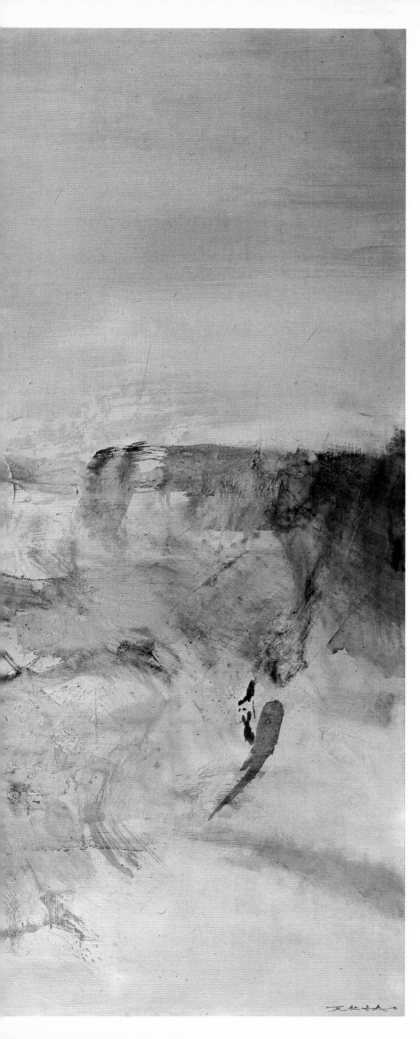

207. 1-12-75.
Oil on canvas, 114 × 146 cm.
Thyssen-Bornemisza Collection, Castagnola.

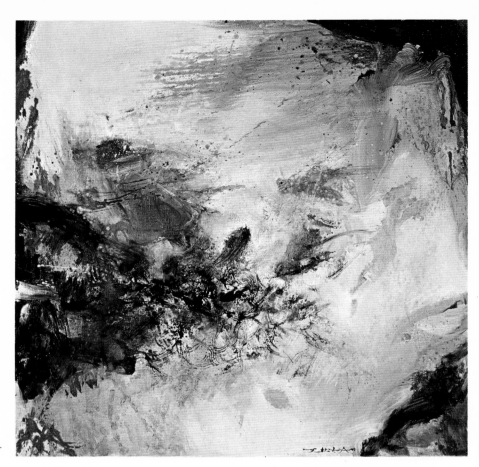

208. 5-2-75.
 Oil on canvas, 55 × 55 cm.
 Private collection, Paris.

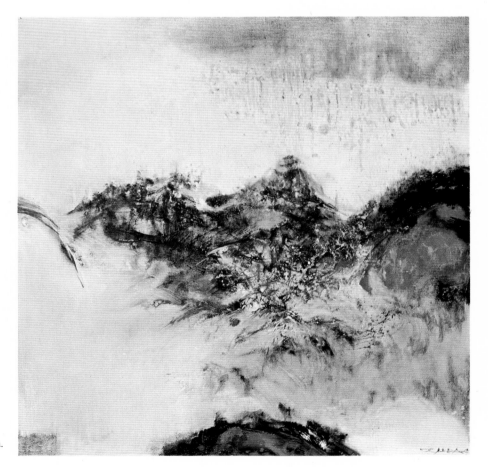

209. 3-3-75.
 Oil on canvas, 55 × 55 cm.
 Private collection, Paris.

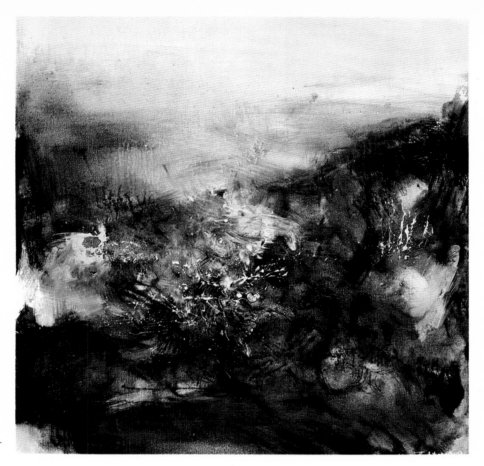

210. 8-4-75.
 Oil on canvas, 55 × 55 cm.
 Private collection, U.S.A.

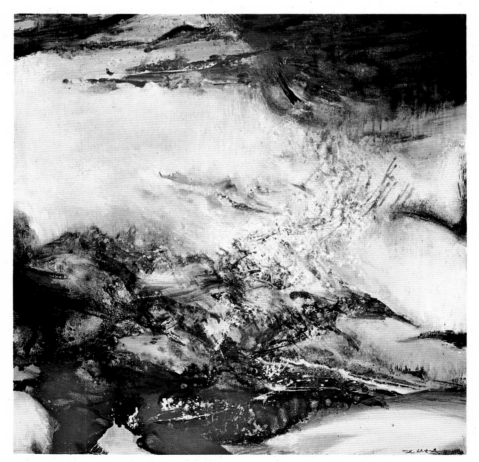

211. 24-1-75.
 Oil on canvas, 55 × 55 cm.
 Private collection, Sèvres, France.

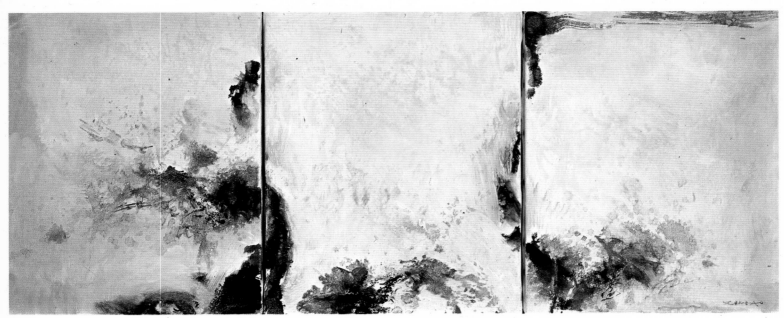

212. 11-10-75.
Triptych. Oil on canvas, 27 × 60 cm.
Daniel Abadie Collection, Paris.

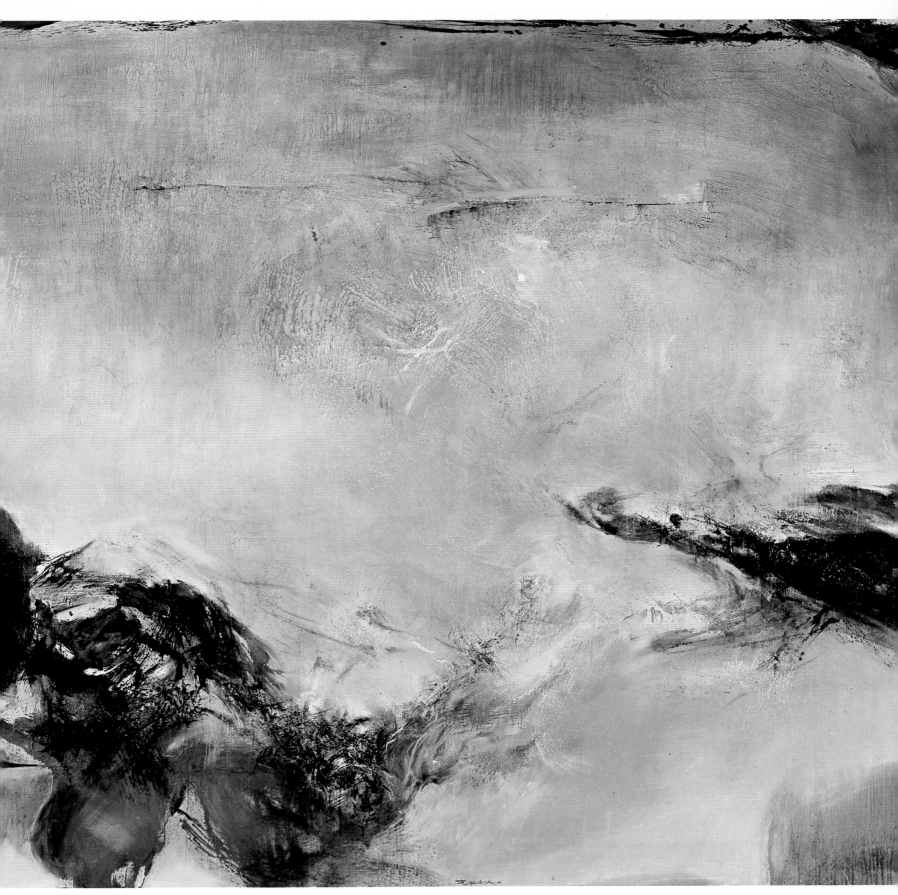

213. 5-3-75. In memory of my mother.
Oil on canvas, 250 × 260 cm.

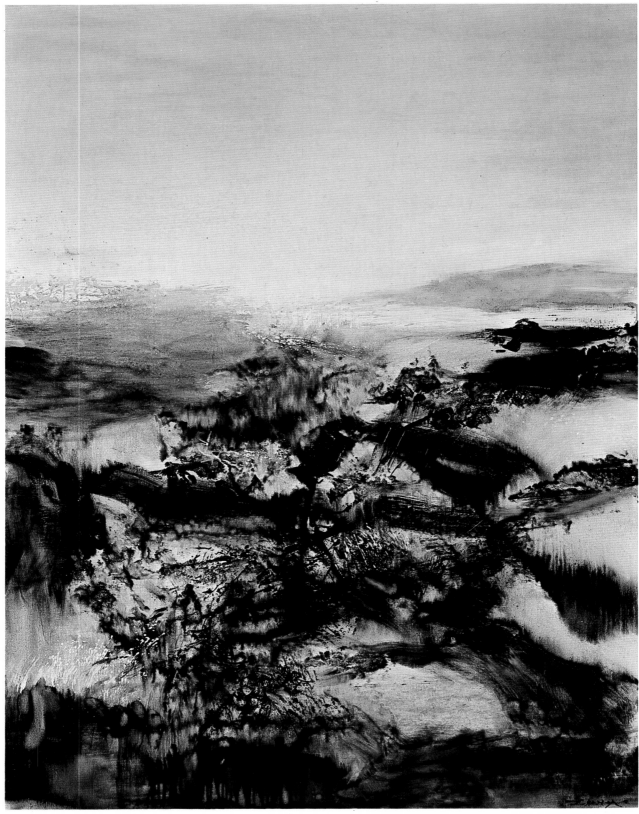

214. 20-8-75.
Oil on canvas, 116 × 89 cm.
Françoise Marquet Collection, Paris.

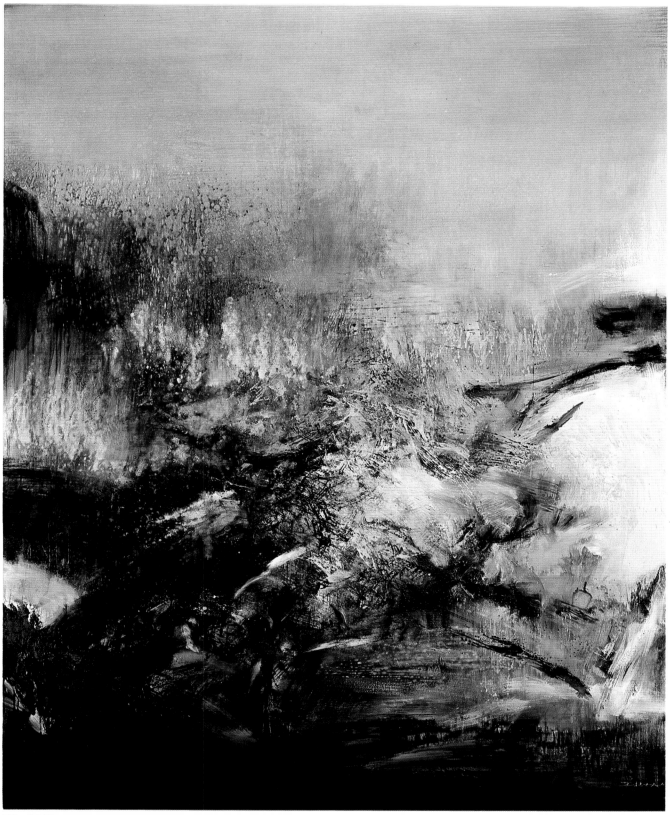

215. 1-2-75.
Oil on canvas, 162 × 130 cm.
Galerie de France, Paris.

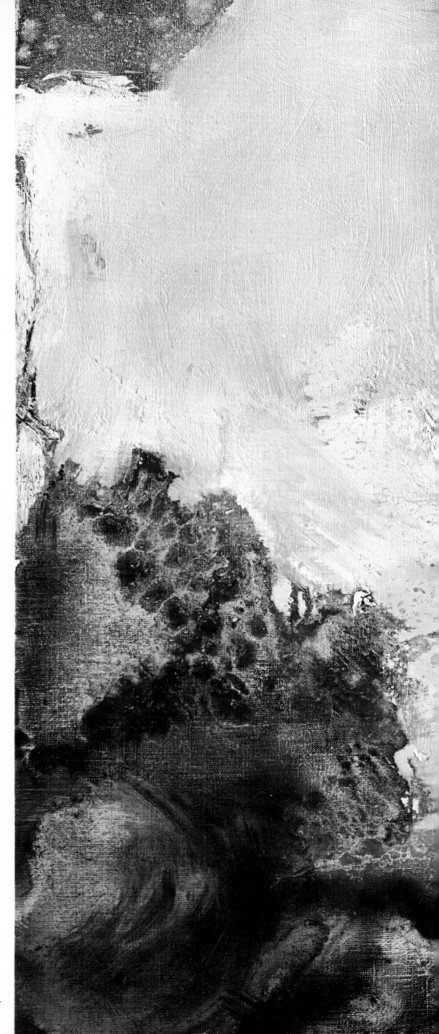

216. 14-11-74.
Oil on canvas, 55 × 55 cm.
Manuel de Muga Collection, Barcelona.

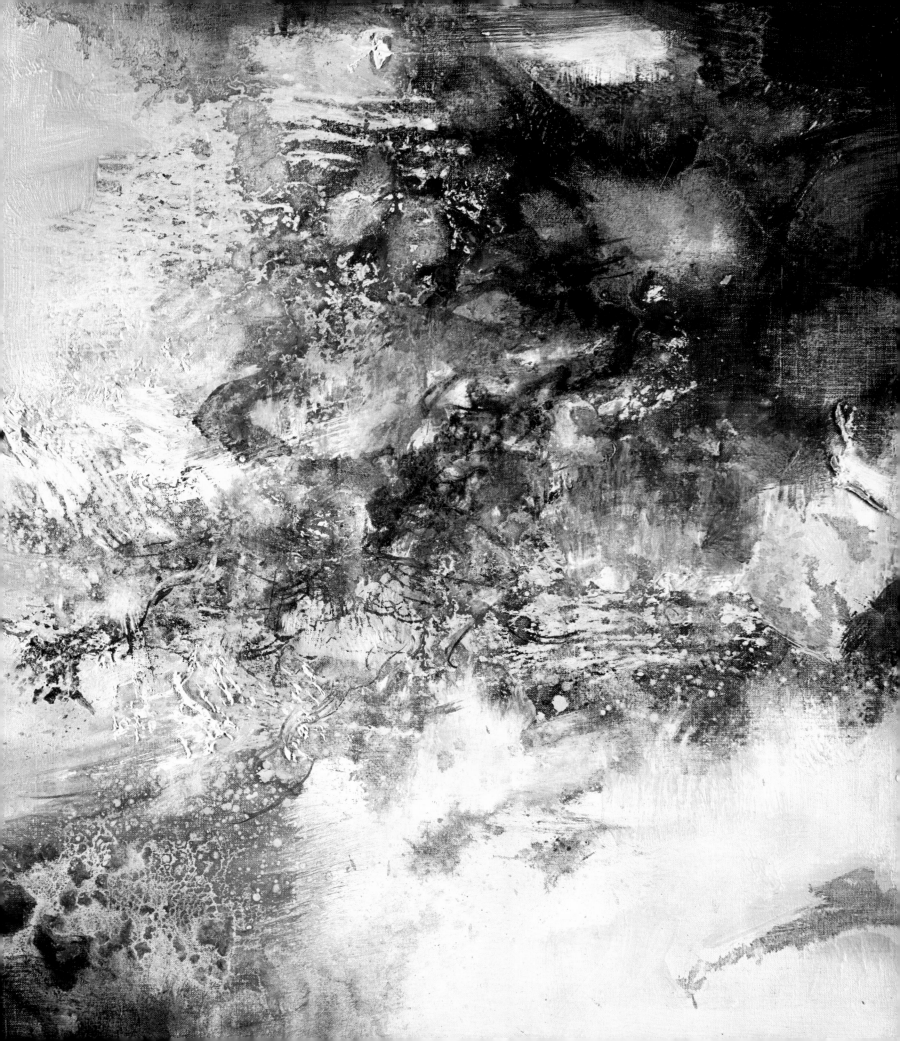

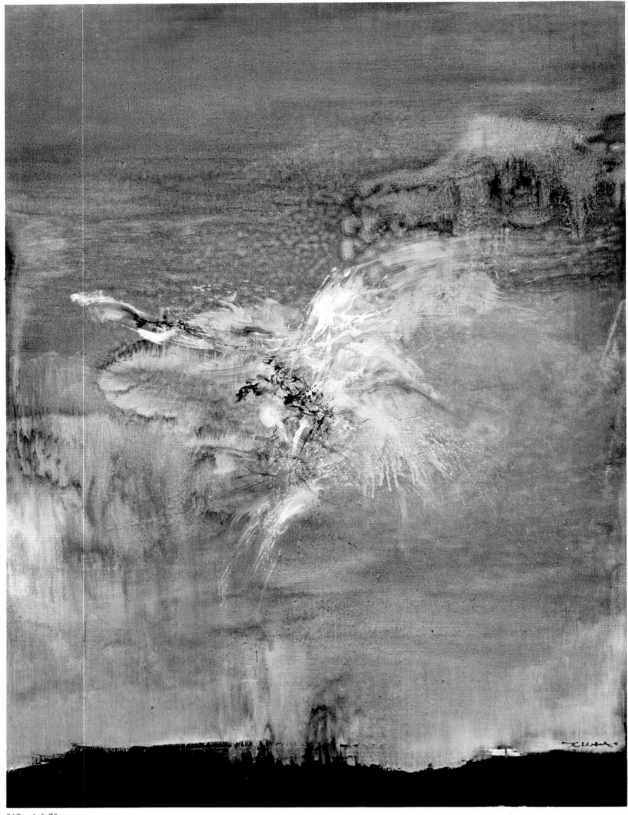

217. 1-5-75.
 Oil on canvas, 130 × 97 cm.
 M. et Mme Gildo Caputo Collection, Paris.

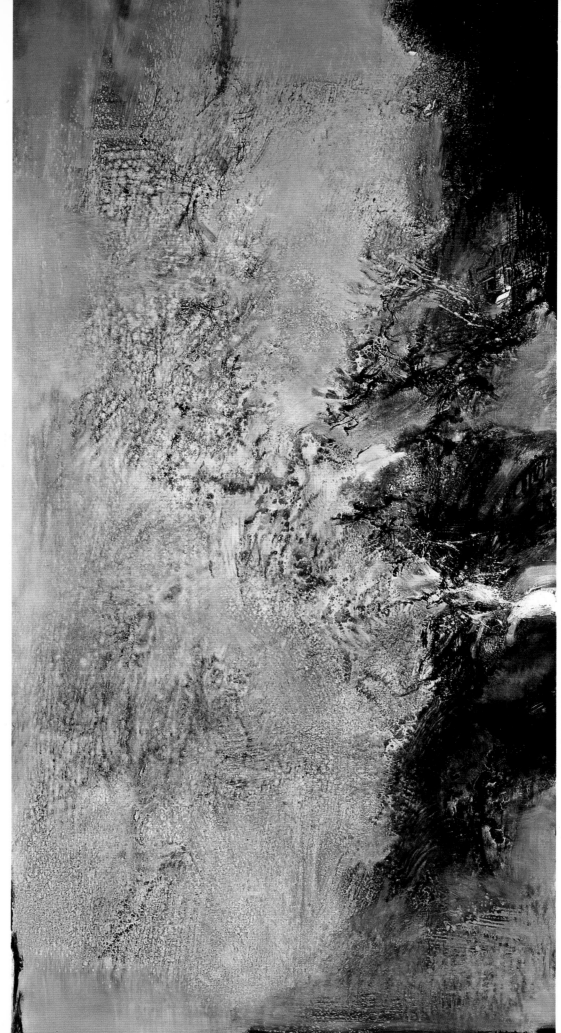

218. 10-3-76.
Oil on canvas, 195 × 97 cm.
Mr and Mrs Kanichiro
Ishibashi Collection, Tokyo.

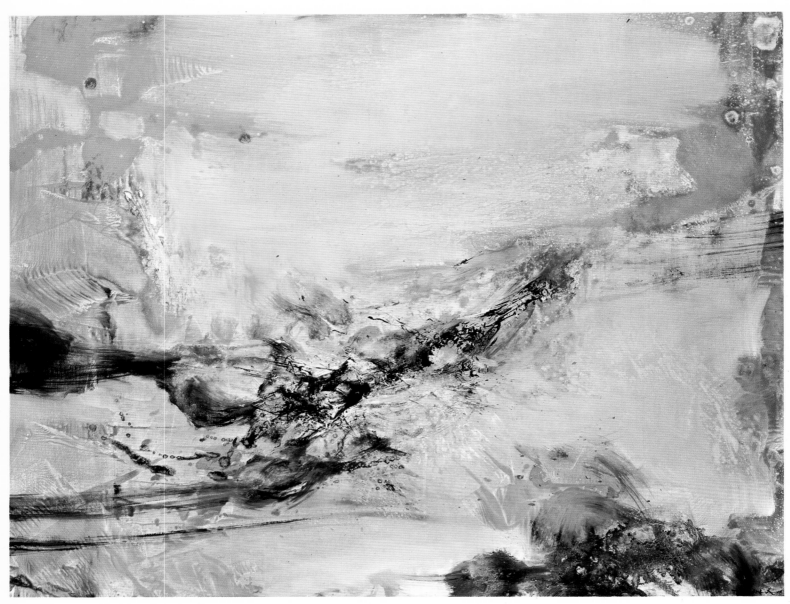

219. 21-1-76.
Oil on canvas, 73 × 92 cm.
Private collection, Paris.

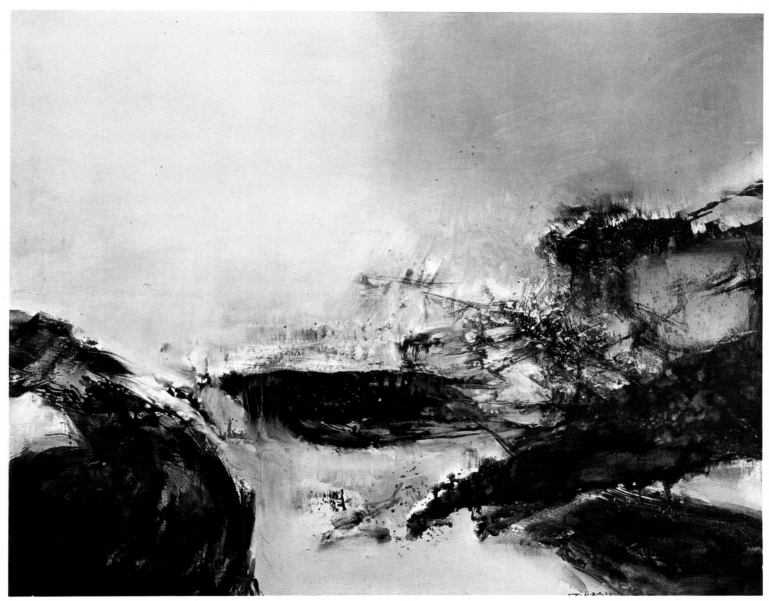

220. 10-2-76.
Oil on canvas, 81 × 100 cm.
Birch Gallery, Copenhagen.

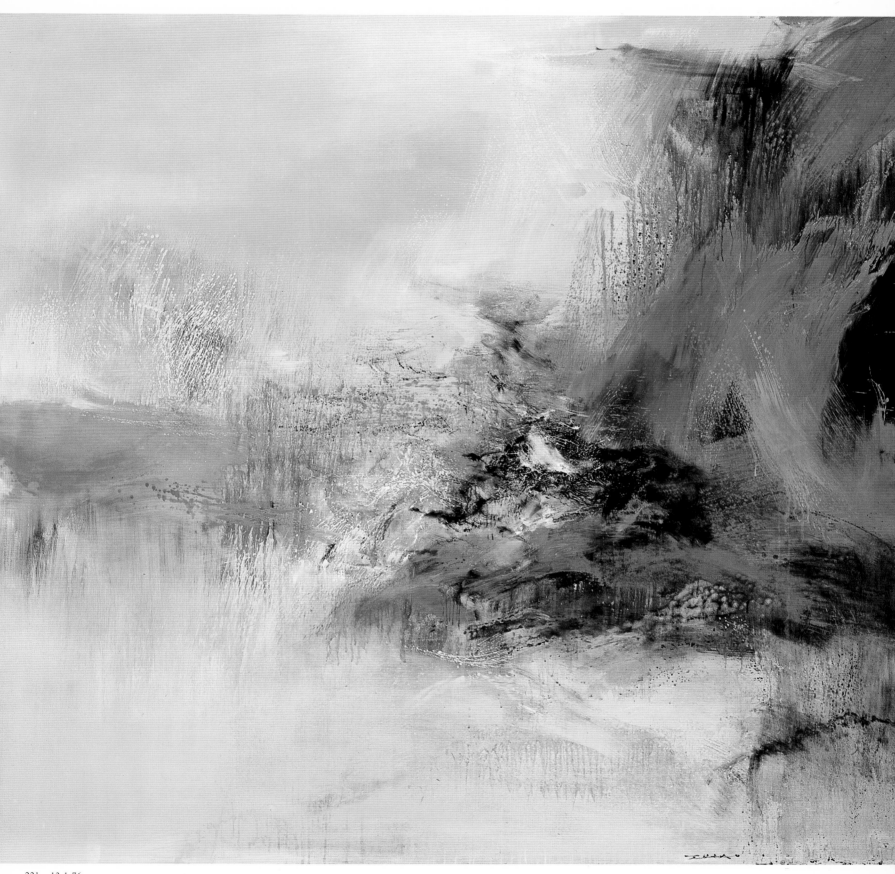

221. 13-1-76.
Oil on canvas, 150 × 162 cm.

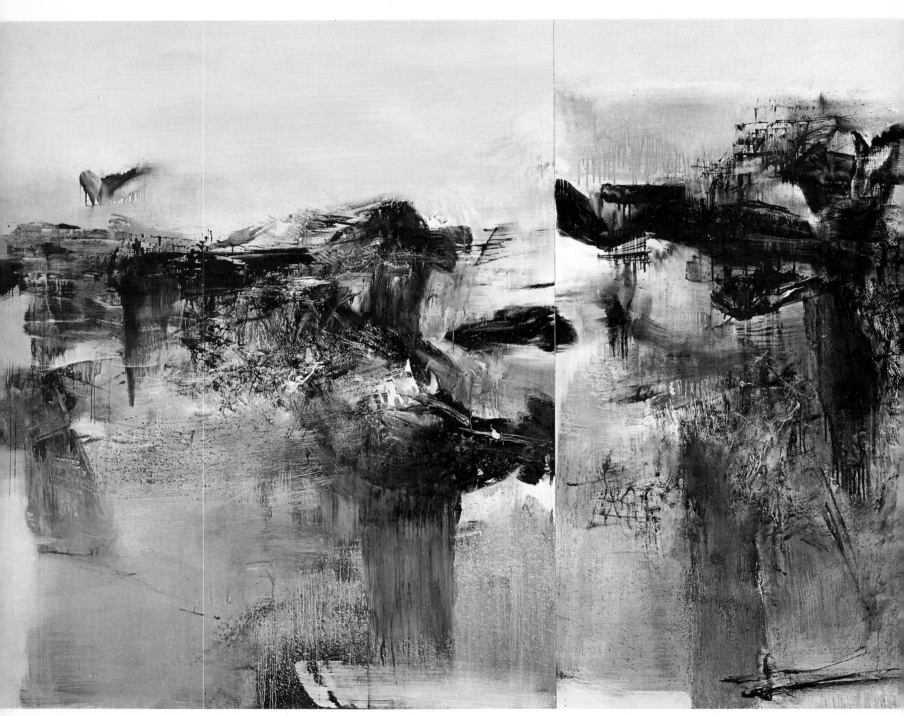

222. 1-4-76. Triptych. Homage to André Malraux.
Oil on canvas, 200 × 524 cm.
Fuji Telecasting Co. Ltd., Tokyo.

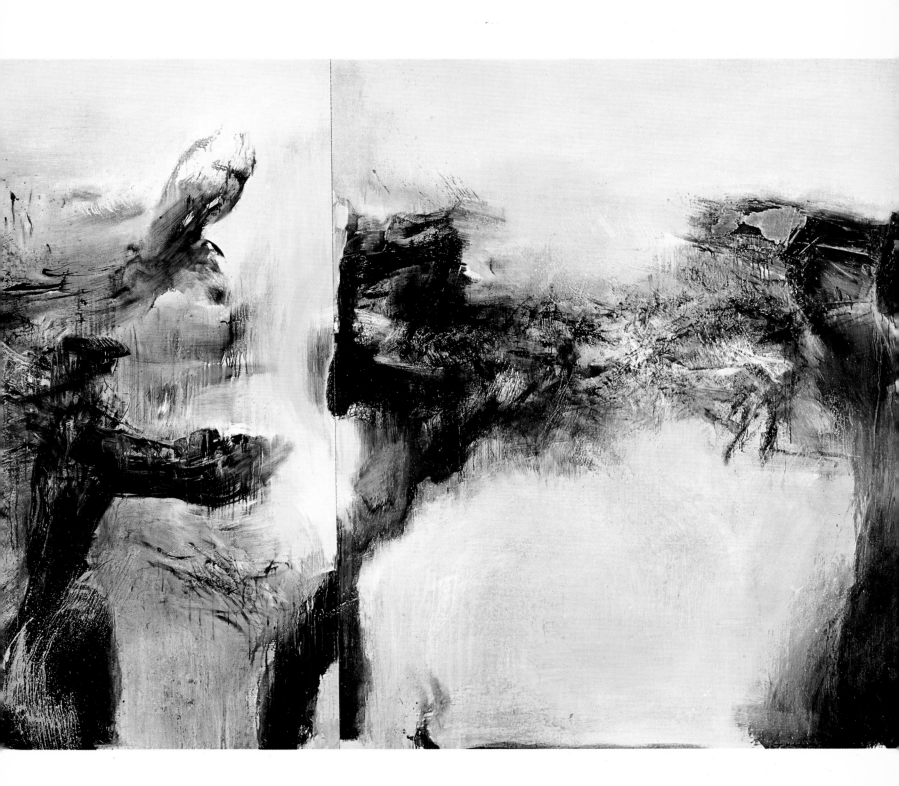

223. 1950.
Oil on canvas, 46 × 55 cm.
Private collection, New York.

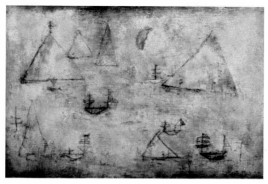

226. 1950.
Oil on canvas, 65 × 92 cm.
Private collection, Paris.

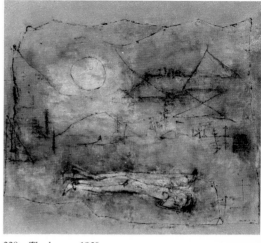

229. The lovers. 1950.
Oil on canvas, 116 × 132 cm.
The Aldrich Museum of Contemporary Art,
Ridgefield, U.S.A.

224. Stag. 1950.
Oil on canvas, 33 × 44 cm.
G. Cramer Collection, Geneva.

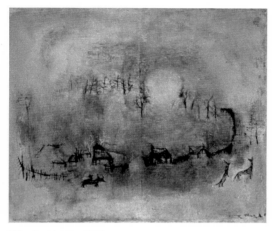

227. Landscape. 1950.
Oil on canvas, 38 × 46 cm.
National Museum of Modern Art, Paris.

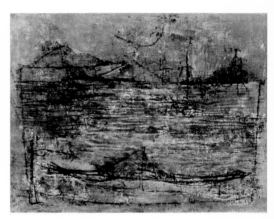

230. Lake Geneva. 1950.
Oil on canvas, 33 × 44 cm.
Property of the artist.

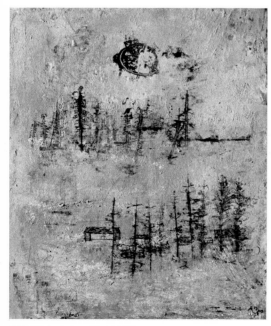

225. Pink-green village. 1950.
Oil on canvas, 41 × 33 cm.
Private collection, U.S.A.

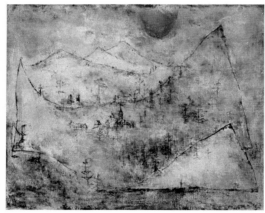

228. Grey and yellow mountain. 1951.
Oil on canvas, 81 × 100 cm.
Galerie Pierre, Paris.

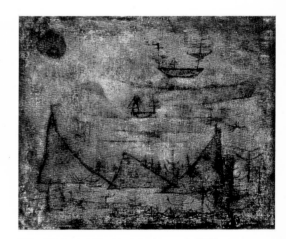

231. Boats against a black background. 1950.
Oil on canvas, 38 × 46 cm.
Private collection, U.S.A.

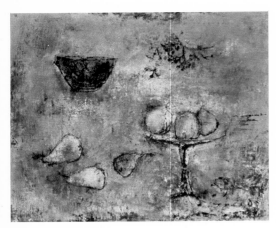

232. Still life. 1951.
Oil on canvas, 46 × 55 cm.
The Aldrich Museum of Contemporary Art,
Ridgefield, U.S.A.

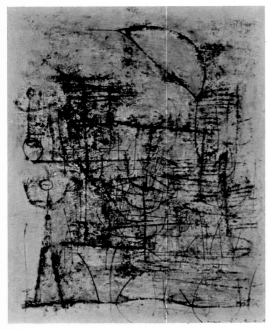

233. Landscape with characters. 1951.
Oil on cardboard, 42.5 × 34 cm.
The Aldrich Museum of Contemporary Art,
Ridgefield, U.S.A.

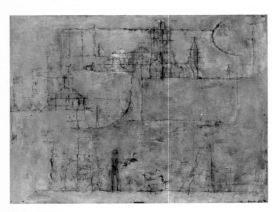

234. 1951.
Oil on canvas, 114 × 146 cm.
Private collection, Paris.

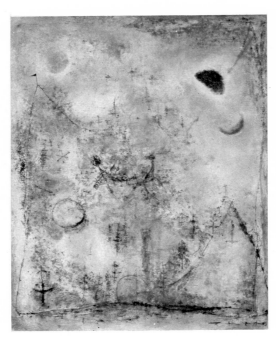

235. Birds. 1951.
Oil on canvas, 162 × 130 cm.
Private collection, New York.

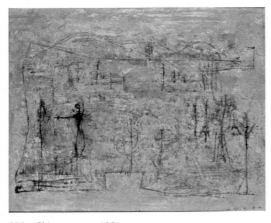

236. Chinese scene. 1951.
Oil on canvas, 38 × 41 cm.
San Francisco Museum of Modern Art, U.S.A.

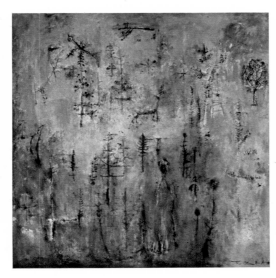

237. Emerald green. 1951.
Oil on canvas, 155 × 150 cm.
Private collection, U.S.A.

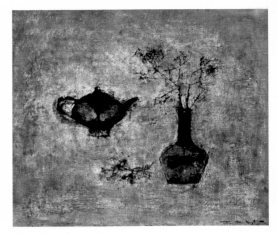

238. The teapot. 1951.
Oil on canvas, 65 × 81 cm.
Harry N. Abrams Collection, New York.

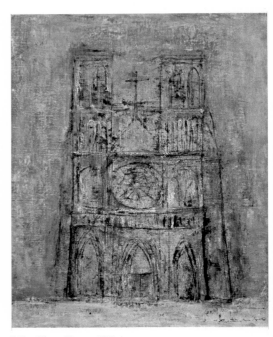

239. Notre-Dame. 1951.
Oil on canvas, 41 × 33 cm.
Private collection, Paris.

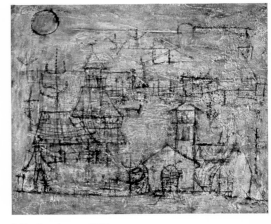

240. Landscape. 1951.
Oil on wood, 40 × 34 cm.
Galerie Pierre, Paris.

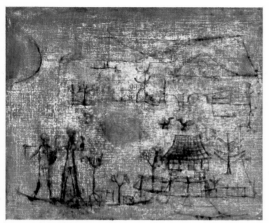

241. Red landscape. 1951.
Oil on canvas, 46 × 55 cm.
Galerie Pierre, Paris.

244. The garden. 1952.
Oil on canvas, 50 × 61 cm.
The High Museum of Art, Atlanta, Georgia.

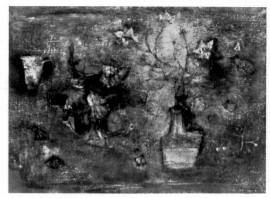

247. Flowers. 1953.
Oil on canvas, 65 × 81 cm.
The Aldrich Museum of Contemporary Art,
Ridgefield, U.S.A.

242. Landscape. 1950-1951.
Oil on canvas, 100 × 81 cm.
Private collection, Paris.

245. Town. 1952.
Oil on canvas, 46 × 55 cm.
The Aldrich Museum of Contemporary Art,
Ridgefield, U.S.A.

248. Five fishes. 1954.
Oil on canvas, 46 × 55 cm.
Private collection, Paris.

243. Bullfighting. 1952-1953.
Oil on canvas, 89 × 116 cm.
Private collection, Paris.

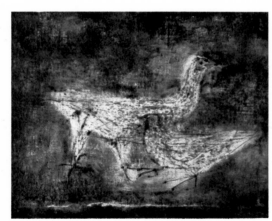

246. We two. 1953.
Oil on canvas, 38 × 46 cm.
M. et Mme Raymond Haas Collection, Paris.

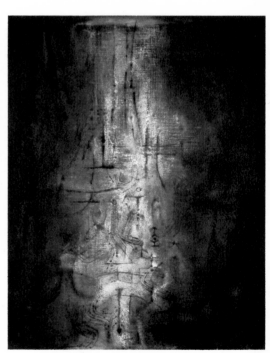

249. Rain. 1954.
Oil on canvas, 81 × 54 cm.
Private collection, Geneva.

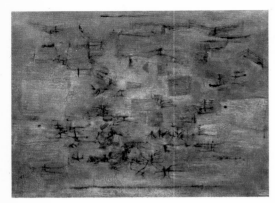

250. Yellow village. 1954.
Oil on canvas, 54 × 73 cm.
Private collection, Paris.

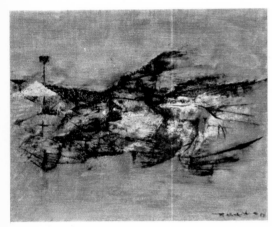

251. Fire birds. 1954.
Oil on canvas, 38 × 46 cm.
Private collection, U.S.A.

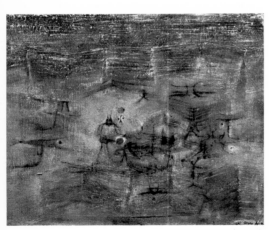

252. Circus resting. 1954.
Oil on canvas, 54 × 65 cm.
Private collection, New York.

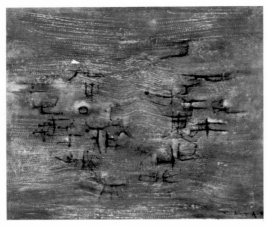

253. Innocent signs. 1954.
Oil on canvas, 38 × 46 cm.
Private collection, Paris.

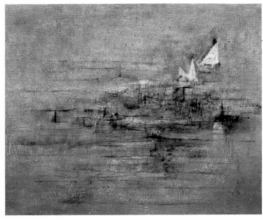

254. Far from the sea. 1954.
Oil on canvas, 60 × 73 cm.
Private collection, Paris.

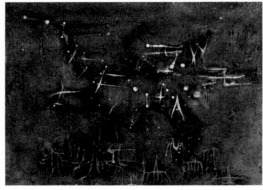

255. Riders with stars. 1954.
Oil on canvas, 30 × 45 cm.
Private collection, Paris.

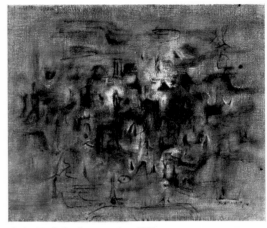

256. Enchained mountains. 1954.
Oil on canvas, 46 × 55 cm.
Private collection, U.S.A.

257. They're beginning to go faster. 1954.
Oil on canvas, 24 × 33 cm.
Private collection, Paris.

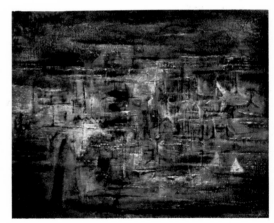

258. Engulfed city. 1954.
Oil on canvas, 60 × 73 cm.
Private collection, U.S.A.

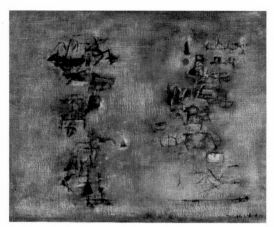

259. We two. 1955.
Oil on canvas, 38 × 46 cm.
Museum of Fine Arts, Le Havre.

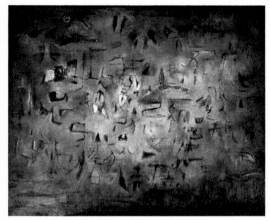

260. Roman ruins. 1955.
Oil on canvas, 46 × 65 cm.
Private collection, Paris.

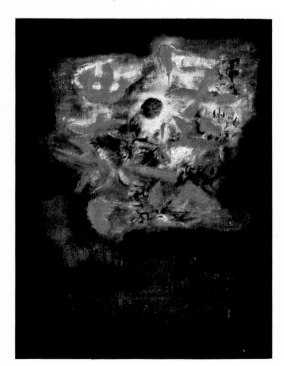

261. Cloud. 1955.
Oil on canvas, 130 × 97 cm.
Property of the artist.

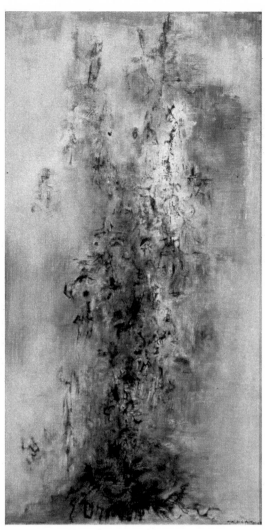

262. Pursuit. 1955-1957.
Oil on canvas, 195 × 97 cm.
Private collection, Switzerland.

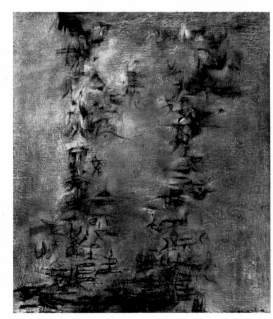

263. Untitled. 1955.
Oil on canvas, 92 × 73 cm.
Private collection, Paris.

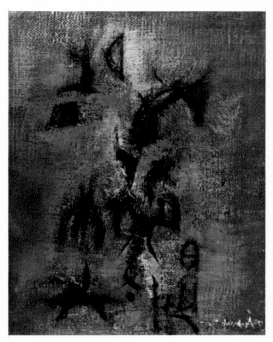

264. Christmas tree. 1955.
Oil on canvas, 18 × 14 cm.
M. et Mme Raymond Haas Collection, Paris.

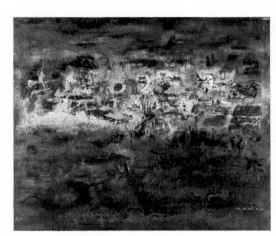

265. Growth. 1956.
Oil on canvas, 54 × 65 cm.
Museum of Fine Arts, Le Havre.

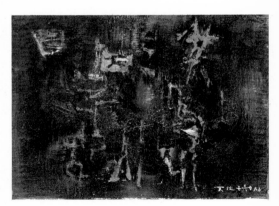

266. 1956.
Oil on canvas, 14 × 18 cm.
Private collection, Rio de Janeiro.

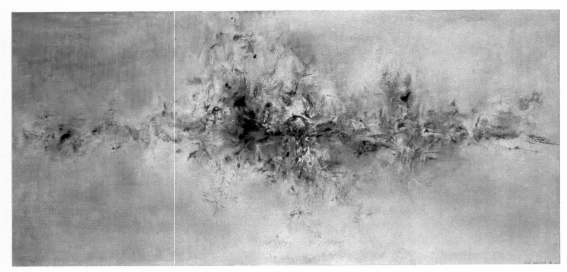

267. Crossing of appearances. 1956.
Oil on canvas, 97 × 195 cm.
Private collection, Paris.

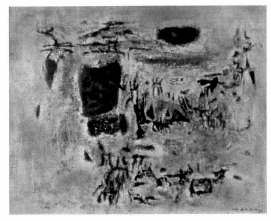

270. 1957.
Oil on canvas, 54 × 65 cm.
Dr R. Cherchère Collection, Paris.

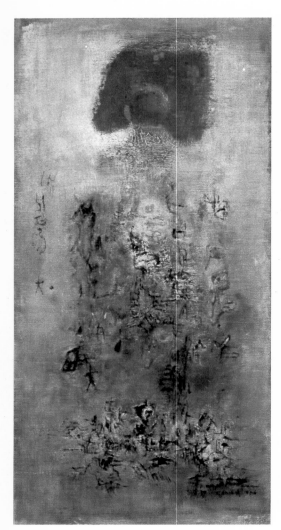

268. 1956.
Oil on canvas, 100 × 50 cm.
Private collection, Geneva.

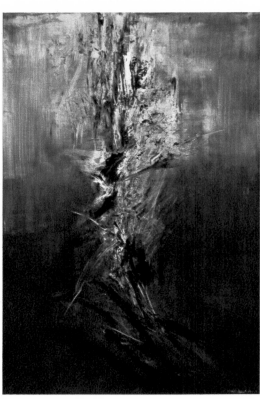

269. 8-1-56. Composition.
Oil on canvas, 162 × 114 cm.
Owned by Neil J. McKinnon, Toronto.

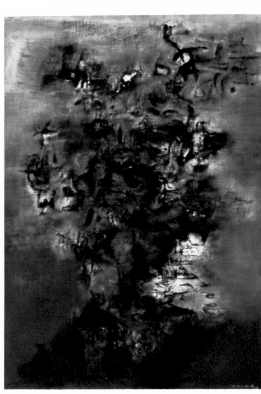

271. Homage to Tu-Fu. 1956.
Oil on canvas, 195 × 130 cm.
Galerie de France, Paris.

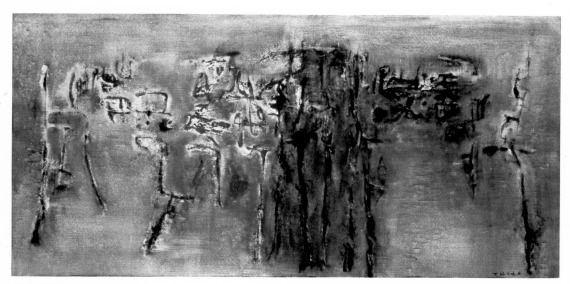

272. 1956.
Oil on canvas, 54 × 81 cm.

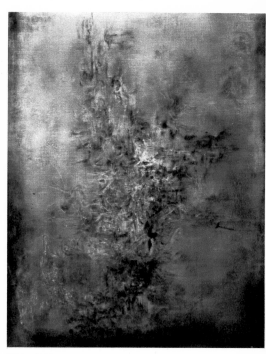

277. 1958.
Oil on canvas, 130 × 97 cm.
Mrs S. I. Rosenman Collection, New York.

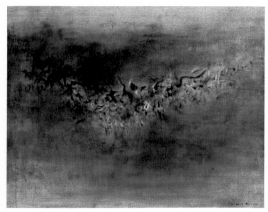

273. Start of the mistral. 1957.
Oil on canvas, 73 × 92 cm.
Galerie de France, Paris.

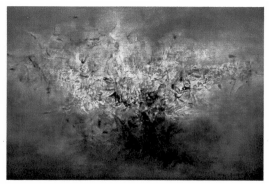

275. 1958.
Oil on canvas, 65 × 92 cm.
Private collection, U.S.A.

278. Painting. 1958.
Oil on canvas, 114 × 162 cm.
Kootz Gallery, New York.

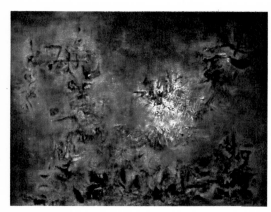

274. 1958.
Oil on canvas, 114 × 146 cm.
Private collection, New York.

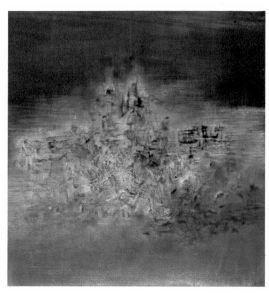

276. No. W. 4. 1958.
Oil on canvas, 81 × 75 cm.
Galerie de France, Paris.

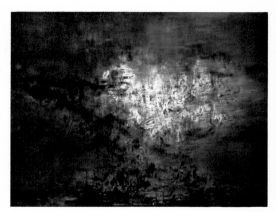

279. 4-4-59.
Oil on canvas, 89 × 116 cm.
Dr Richard Frank Collection, U.S.A.

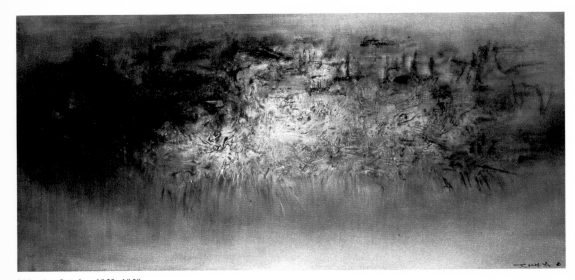

280. 1st October 1953. 1959.
Oil on canvas, 100 × 198 cm.
The Upjohn Company, Kalamazoo, Michigan, U.S.A.

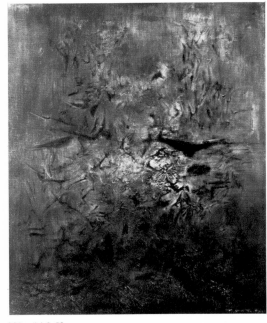

283. 14-3-59.
Oil on canvas, 162 × 130 cm.
Galerie de France, Paris.

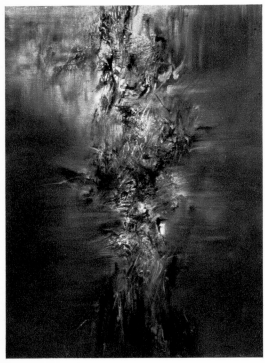

281. Painting. 1959.
Oil on canvas, 162 × 130 cm.
Galerie de France, Paris.

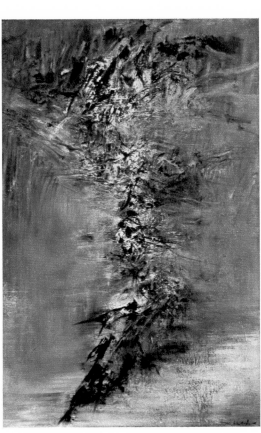

282. Painting. 1959.
Oil on canvas, 162 × 100 cm.
Private collection, Switzerland.

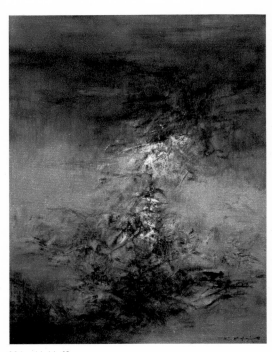

284. 11-11-60.
Oil on canvas, 116 × 89 cm.
Kootz Gallery, New York.

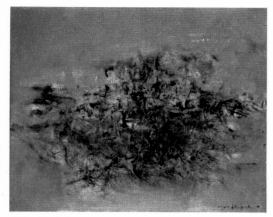

285. 22-10-60.
Oil on canvas, 54 × 65 cm.
Kootz Gallery, New York.

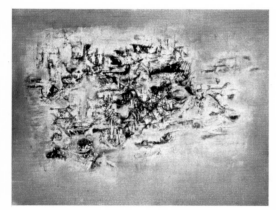

286. 9-2-60.
Oil on canvas, 73 × 92 cm.
Private collection, New York.

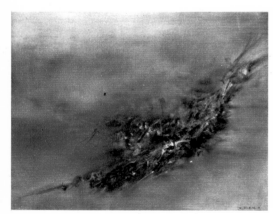

287. 15-3-60.
Oil on canvas, 89 × 116 cm.
Private collection, New York.

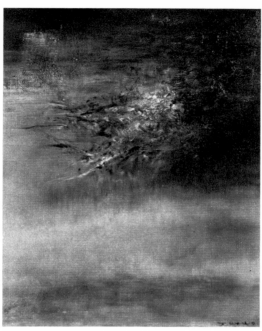

288. 16-2-60.
Oil on canvas, 146 × 114 cm.
Private collection, Paris.

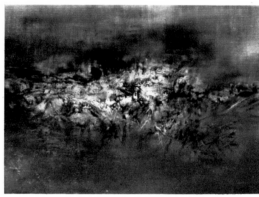

289. 26-1-60.
Oil on canvas, 97 × 130 cm.
Private collection, Paris.

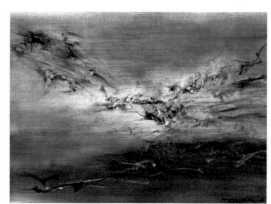

290. 27-1-60.
Oil on canvas, 60 × 81 cm.
Private collection, New York.

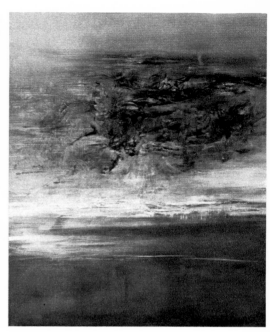

291. Composition in blue. 1960.
Oil on canvas, 162 × 130 cm.
Owned by Neil J. McKinnon, Toronto.

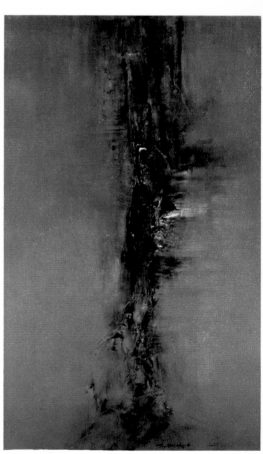

292. 18-10-1960.
Oil on canvas, 195 × 114 cm.
Mr and Mrs Al Aydelott Collection, Washington.

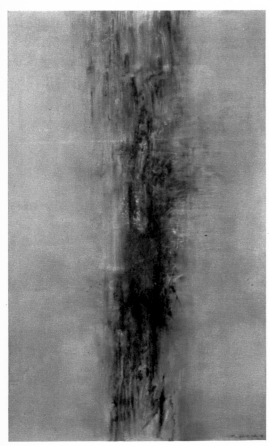

293. 25-5-60.
Oil on canvas, 195 × 130 cm.
Galerie de France, Paris.

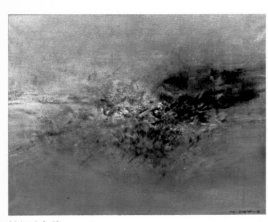

294. 9-2-60.
Oil on canvas, 117 × 146 cm.
The Upjohn Company Collection,
Kalamazoo, Michigan.

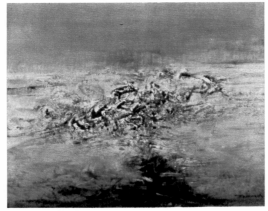

295. 8-11-61.
Oil on canvas, 73 × 92 cm.
Private collection, Paris.

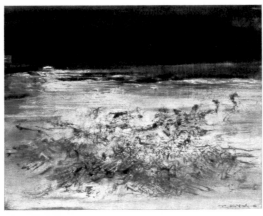

296. 21-6-61.
Oil on canvas, 60 × 73 cm.
Jean Seberg Collection, U.S.A.

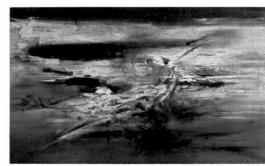

297. 4-12-61.
Oil on canvas, 81 × 130 cm.
Private collection, Paris.

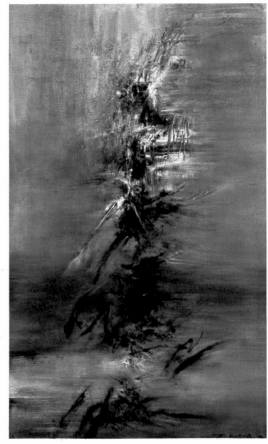

298. 7-4-61.
Oil on canvas, 195 × 114 cm.
Mr and Mrs H. M. Austin Collection, U.S.A.

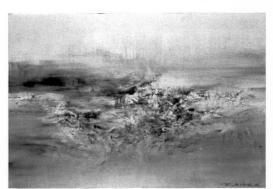

299. 20-6-61.
Oil on canvas, 81 × 116 cm.
Mrs Richard Rodgers Collection, U.S.A.

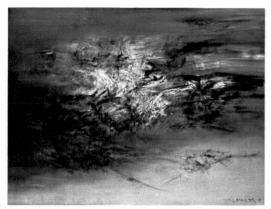

300. 22-3-61.
Oil on canvas, 114 × 146 cm.
Private collection, Princeton, New Jersey, U.S.A.

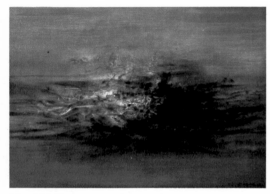

301. 15-1-61.
Oil on canvas, 54 × 73 cm.
Bridgestone Museum of Art, Tokyo.

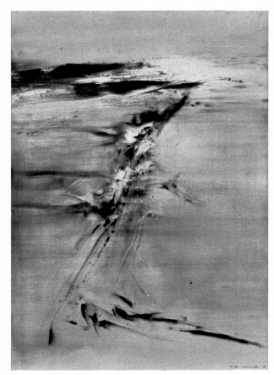

302. 60 P. 10-5-62.
Oil on canvas, 130 × 89 cm.
Property of the artist.

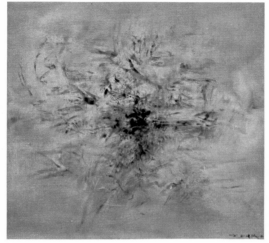

303. 12-12-62.
Oil on canvas, 150 × 162 cm.
Dr Duy Genon-Catalot Collection, Paris.

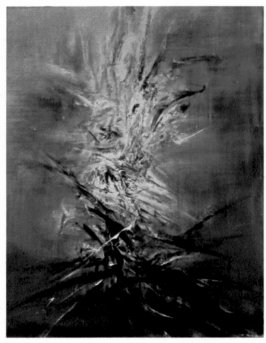

304. 14-12-62.
Oil on canvas, 130 × 97 cm.
Private collection, U.S.A.

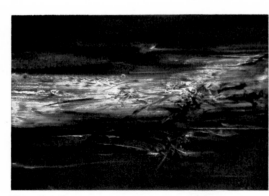

305. 10-6-62.
Oil on canvas, 60 × 81 cm.
M. et Mme Raymond Haas Collection, Paris.

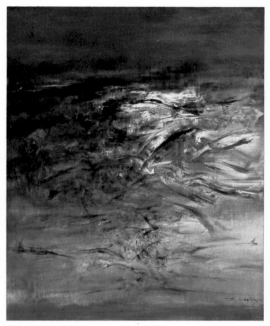

306. 12-12-62.
Oil on canvas, 162 × 130 cm.
Private collection, Paris.

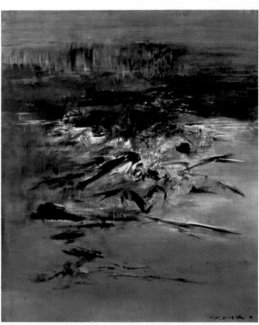

307. 25-5-62.
Oil on canvas, 200 × 162 cm.
Mr and Mrs Lynn Q. Fayman Collection, New York.

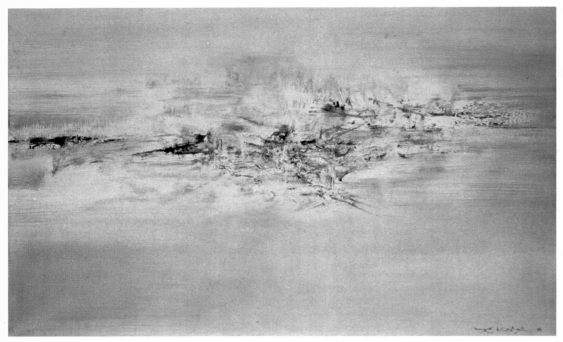

308. 10-4-62.
Oil on canvas, 73 × 116 cm.
Galerie de France, Paris.

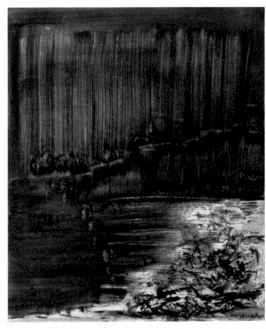

313. 30 F. 1963.
Oil on canvas, 92 × 73 cm.
Nesto Jacometti Collection, Zürich.

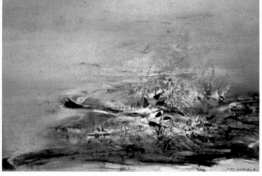

309. 24-3-63.
Oil on canvas, 81 × 116 cm.
M. et Mme H. Boileau Collection, Paris.

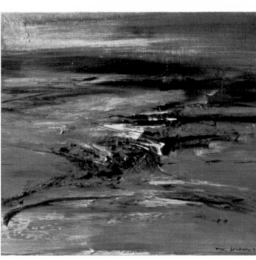

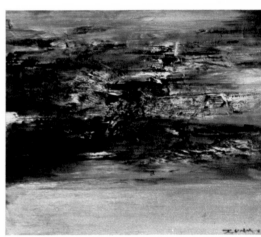

314. 2-4-63.
Oil on canvas, 50 × 55 cm.
Private collection, Paris.

311. 31-3-63.
Oil on canvas, 46 × 50 cm.
Private collection, Paris.

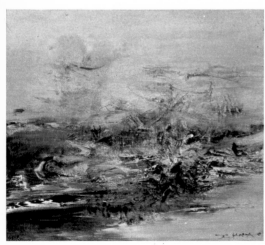

310. 5-4-63.
Oil on canvas, 46 × 50 cm.
Mr and Mrs Knott Collection, New York.

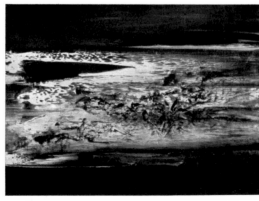

312. 18-3-63.
Oil on canvas, 60 × 81 cm.
Redfern Gallery, London.

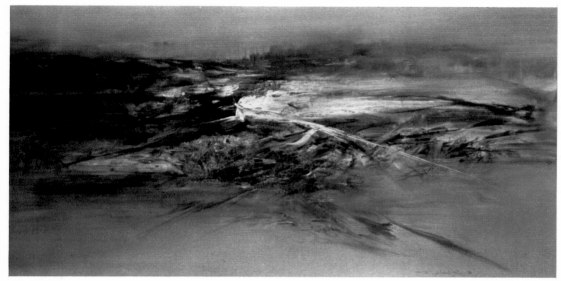

315. 26-4-62.
Oil on canvas, 97 × 195 cm.
Owned by Neil J. McKinnon, Toronto.

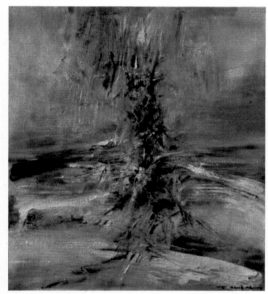

316. 1-4-63.
Oil on canvas, 55 × 50 cm.
Private collection, Paris.

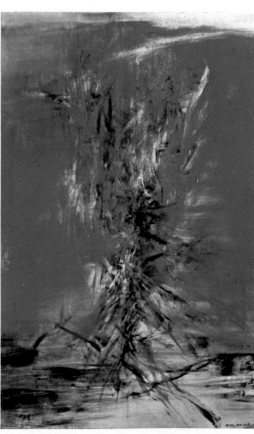

317. 22-6-63.
Oil on canvas, 146 × 89 cm.
Mr and Mrs Walter R. Berdsley Collection, U.S.A.

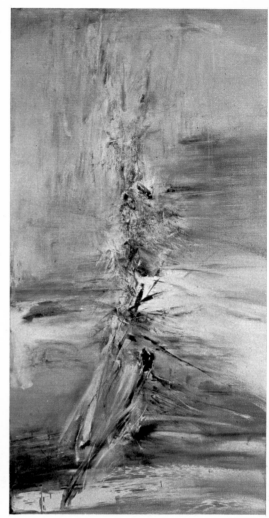

318. 18-4-63.
Oil on canvas, 195 × 97 cm.
Private collection, Paris.

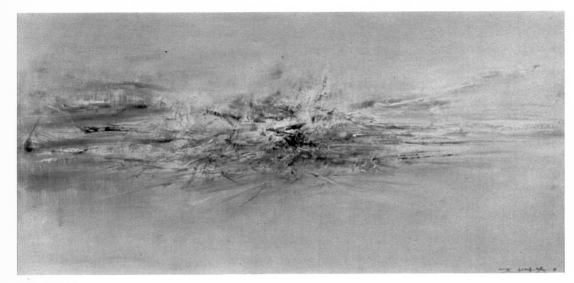

319. 21-3-63.
Oil on canvas, 97 × 195 cm.
Galerie de France, Paris.

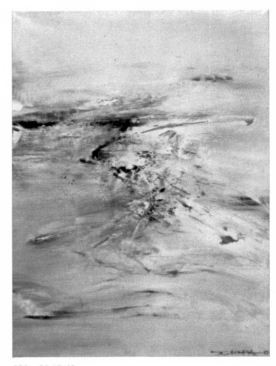

323. 25-10-63.
Oil on canvas, 100 × 73 cm.
International Minerals and Chemicals Corporation,
Stanford, California.

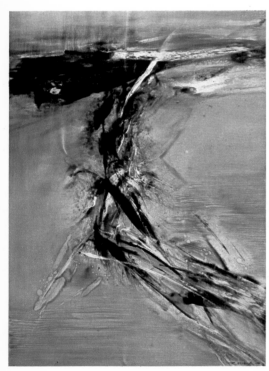

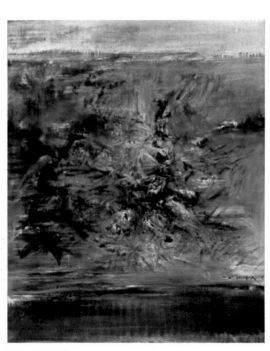

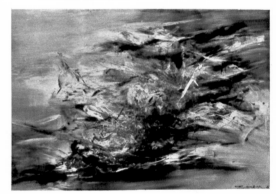

324. 17-4-64.
Oil on canvas, 114 × 162 cm.
Private collection, Paris.

320. 22-11-63.
Homage to John F. Kennedy.
Oil on canvas, 116 × 81 cm.
Galerie de France, Paris.

321. 29-1-63.
Oil on canvas, 116 × 89 cm.
Dr R. Cherchère Collection, Paris.

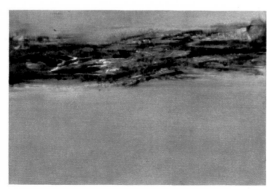

322. 30-10-64.
Oil on canvas, 114 × 162 cm.

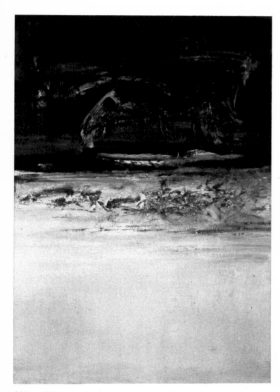

325. 1964.
 Oil on canvas, 130 × 89 cm.
 M. et Mme V. Elisseeff Collection, Paris.

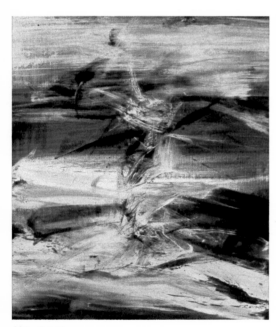

326. 7-5-63.
 Oil on canvas, 65 × 54 cm.
 Private collection, Paris.

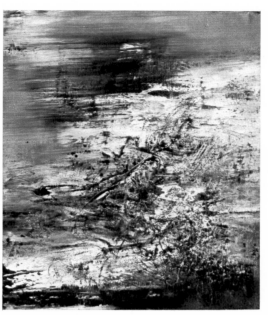

327. 9-5-64.
 Oil on canvas, 55 × 46 cm.
 Mr T. Hirano Collection, Tokyo.

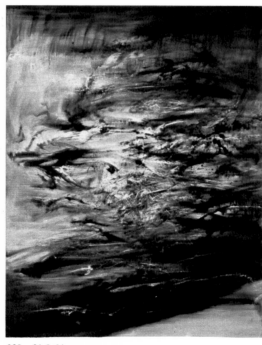

328. 21-9-64.
 Oil on canvas, 260 × 200 cm.
 Property of the artist.

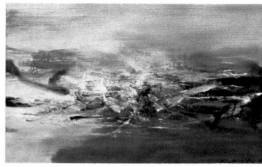

329. 8-2-64.
 Oil on canvas, 65 × 100 cm.
 Private collection, Ivory Coast.

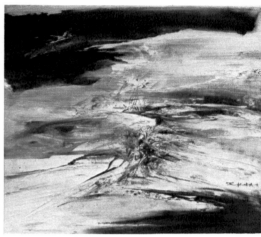

330. 20-1-64.
 Oil on canvas, 46 × 50 cm.
 Private collection, Lisbon.

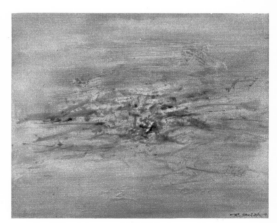

331. 2-6-64.
 Oil on canvas, 65 × 81 cm.
 Private collection, Paris.

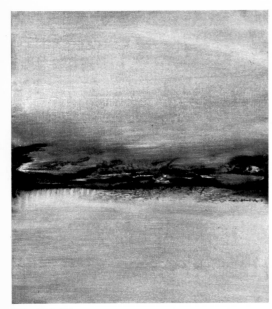

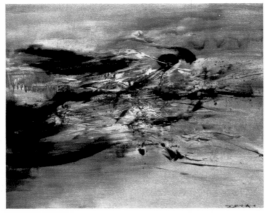

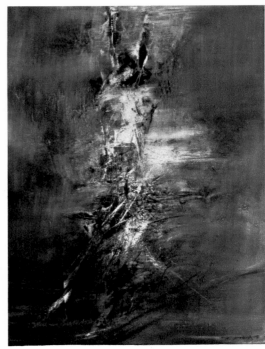

332. 23-9-64.
Oil on canvas, 55 × 46 cm.
Property of the artist.

334. 22-7-64.
Oil on canvas, 162 × 200 cm.
Dr Guy Genon-Catalot Collection, Paris.

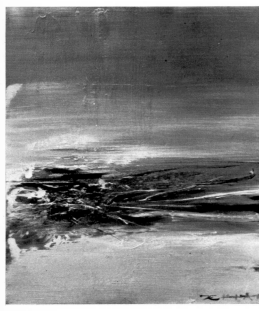

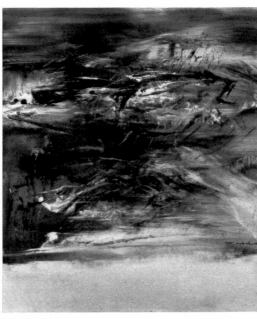

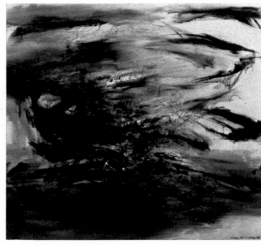

337. 11-6-64.
Oil on canvas, 130 × 97 cm.
Private collection, Paris.

333. 4-7-64.
Oil on canvas, 46 × 38 cm.
Private collection, Paris.

335. 23-5-64.
Oil on canvas, 200 × 162 cm.
Kootz Gallery, New York.

338. 30-7-64.
Oil on canvas, 150 × 162 cm.
J. F. Jaeger Collection, Paris.

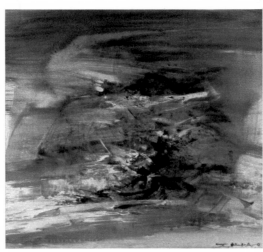

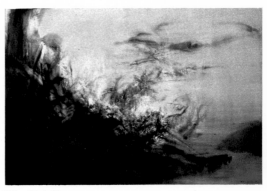

336. 24-5-64.
Oil on canvas, 46 × 50 cm.
Private collection, Paris.

339. 11-6-65.
Oil on canvas, 114 × 162 cm.
Mr and Mrs William Block Collection, U.S.A.

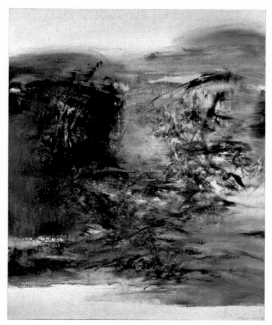

340. 30-7-65.
Oil on canvas, 200 × 162 cm.
Galerie de France, Paris.

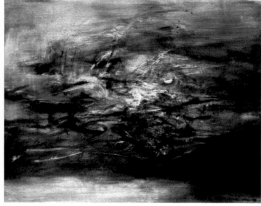

341. 2-1-65.
Oil on canvas, 162 × 200 cm.
Dr Guy Genon-Catalot Collection, Paris.

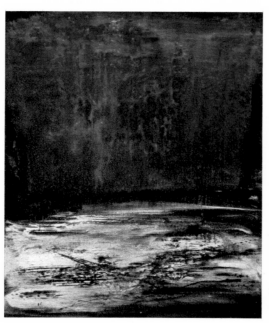

342. 8-3-65.
Oil on canvas, 73 × 60 cm.
Guy Marester Collection, Paris.

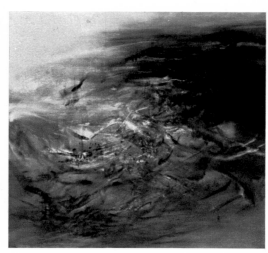

343. 30-9-65.
Oil on canvas, 150 × 162 cm.
Galerie de France, Paris.

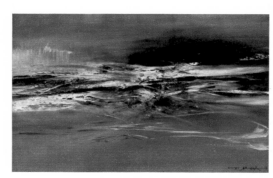

344. 1-3-65.
Oil on canvas, 81 × 130 cm.
Yale University Art Gallery, New Haven,
Connecticut. Gift of Susan Morse Hilles.

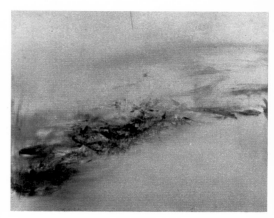

345. 26-2-65.
Oil on canvas, 73 × 92 cm.
Middle South Services Inc. Collection, U.S.A.

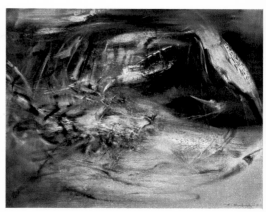

346. 9-3-65.
Oil on canvas, 130 × 162 cm.
Mrs Neil J. McKinnon Collection, Toronto.

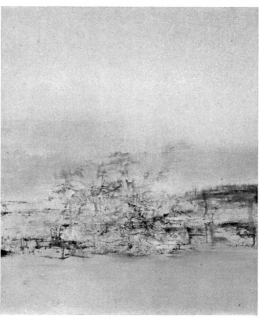

347. 2-10-66.
Oil on canvas, 73 × 60 cm.
Private collection, France.

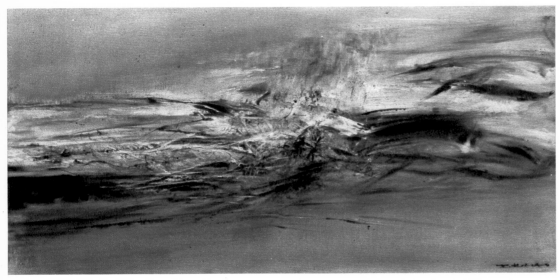

348. 15-2-65.
Oil on canvas, 97 × 165 cm.
Kootz Gallery, New York.

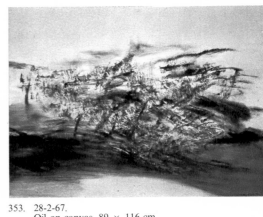

353. 28-2-67.
Oil on canvas, 89 × 116 cm.
Private collection, Paris.

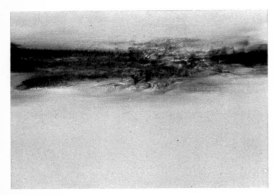

349. 28-5-65.
Oil on canvas, 65 × 92 cm.
Kootz Gallery, New York.

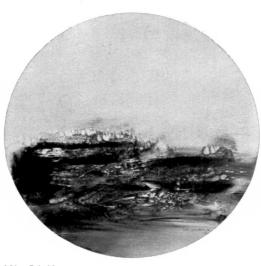

351. 7-1-66.
Oil on canvas, ⌀ 55 cm.
Private collection, Paris.

354. 10-8-67.
Oil on canvas, 65 × 54 cm.
Private collection, Paris.

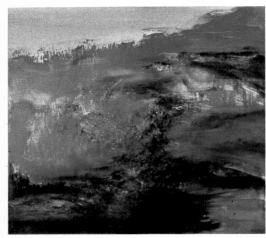

350. 13-2-66.
Oil on canvas, 95 × 105 cm.
Private collection, New York.

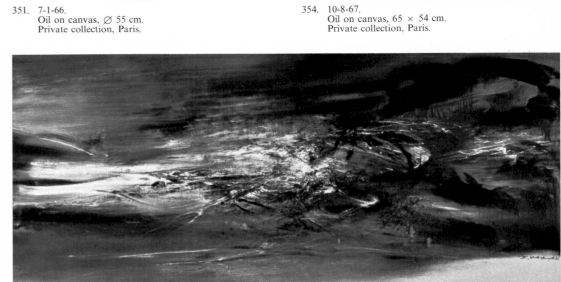

352. 18-11-66.
Oil on canvas, 97 × 195 cm.

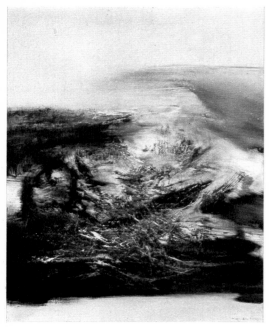

355. 5-1-67.
Oil on canvas, 81 × 65 cm.
Private collection, Paris.

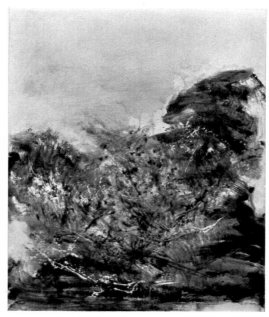

358. 12-12-67.
Oil on canvas, 73 × 60 cm.
Private collection, New York.

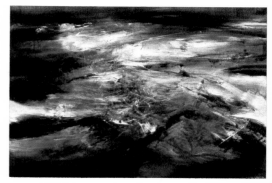

361. 12-6-67.
Oil on canvas, 130 × 95 cm.

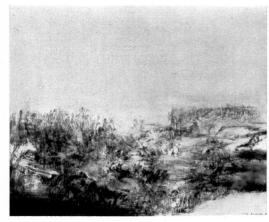

356. 4-2-67.
Oil on canvas, 54 × 65 cm.
Private collection, France.

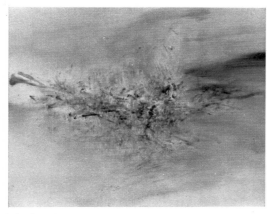

359. 15-1-67.
Oil on canvas, 114 × 146 cm.
Galerie de France, Paris.

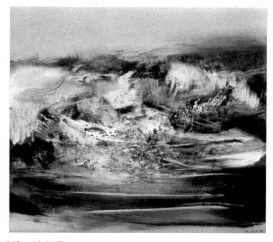

362. 18-8-67.
Oil on canvas, 95 × 105 cm.
Private collection, Paris.

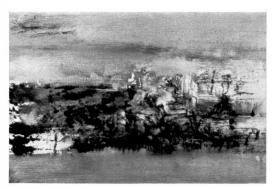

357. 25-1-67.
Oil on canvas, 22 × 33 cm.
G. Cramer Collection, Geneva.

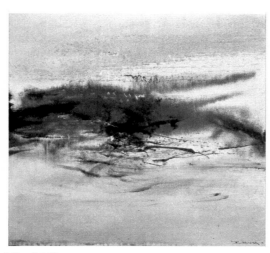

360. 5-7-67.
Oil on canvas, 46 × 50 cm.
Frank Perls Gallery, Los Angeles.

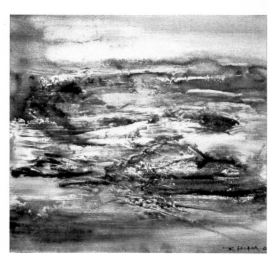

363. 8-1-67.
Oil on canvas, 50 × 55 cm.
Private collection, Paris.

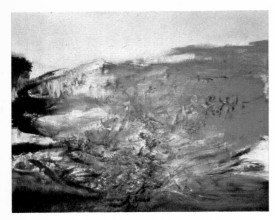

364. 1-8-67.
Oil on canvas, 65 × 81 cm.
Private collection, Paris.

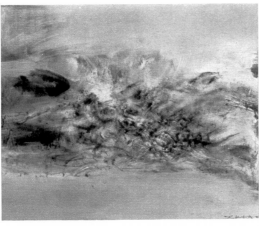

367. 28-6-67.
Oil on canvas, 60 × 73 cm.
Galerie de France, Paris.

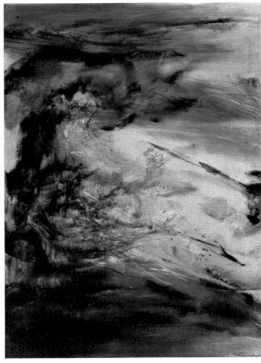

370. 1-12-68.
Oil on canvas, 162 × 114 cm.
Property of the artist.

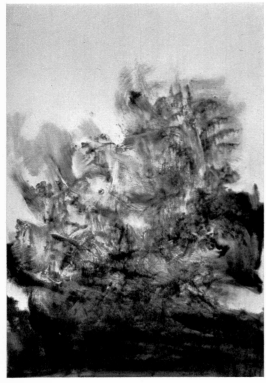

365. 25-7-67.
Oil on canvas, 92 × 60 cm.
Private collection, Paris.

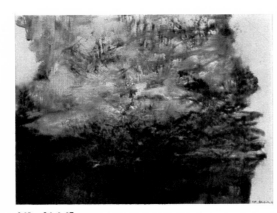

368. 24-6-67.
Oil on canvas, 54 × 73 cm.

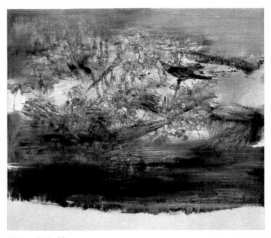

371. 6-10-68.
Oil on canvas, 95 × 105 cm.
Private collection, Lisbon.

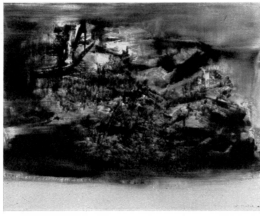

369. 14-1-67.
Oil on canvas, 73 × 92 cm.
Bert Leefmans Collection, New York.

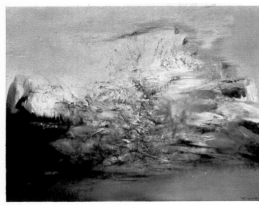

366. 28-8-67.
Oil on canvas, 89 × 116 cm.
Galerie de France, Paris.

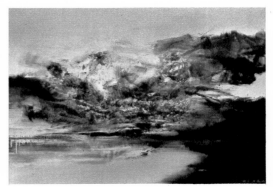

372. 23-3-68.
Oil on canvas, 89 × 130 cm.
Private collection, Tokyo.

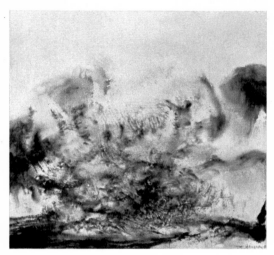

373. 4-12-68.
Oil on canvas, 46 × 50 cm.
Kunst Forum Schelderode, Belgium.

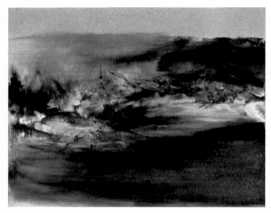

374. 31-7-68.
Oil on canvas, 73 × 92 cm.
Galerie Protée, Toulouse.

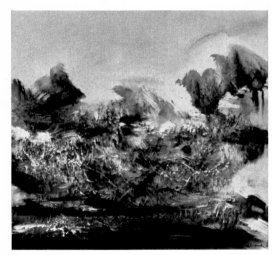

375. 10-2-68.
Oil on canvas, 46 × 50 cm.
Galerie de France, Paris.

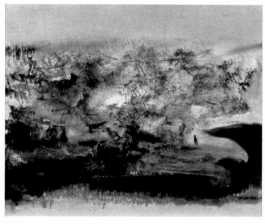

376. 308 - 27-10-68.
Oil on canvas, 54 × 65 cm.
Private collection, Avignon.

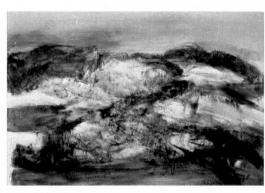

377. 24-10-68.
Oil on canvas, 130 × 162 cm.
Galerie de France, Paris.

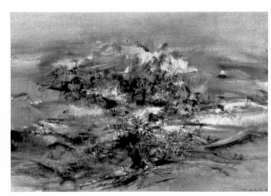

378. 10-1-68.
Oil on canvas, 81 × 116 cm.
Private collection, U.S.A.

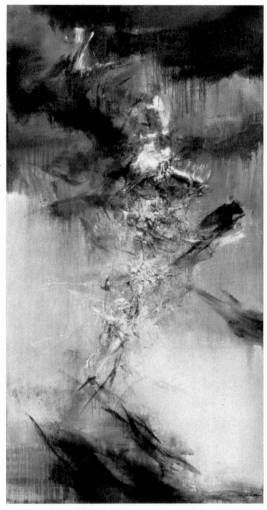

379. 15-12-69.
Oil on canvas, 195 × 97 cm.

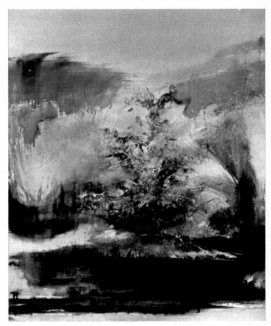

380. 29-7-69.
Oil on canvas, 92 × 73 cm.
Dr Guy Genon-Catalot Collection, Paris.

296

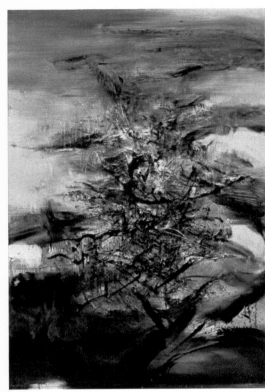

381. 25-9-69.
Oil on canvas, 146 × 97 cm.
Mr and Mrs Orlins Collection, New York.

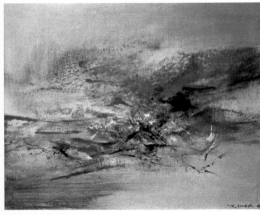

382. 14-2-69.
Oil on canvas, 46 × 55 cm.
Private collection, Antwerp.

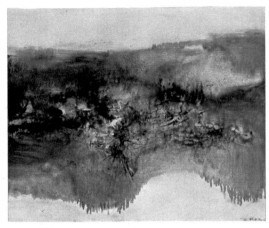

383. 27-4-69.
Oil on canvas, 46 × 55 cm.
Galerie Ducastel, Avignon.

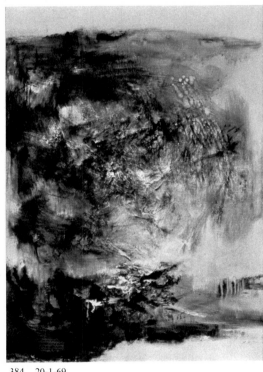

384. 20-1-69.
Oil on canvas, 116 × 81 cm.
Private collection, Essen.

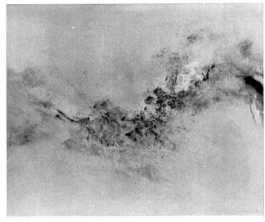

385. 10-2-69.
Oil on canvas, 60 × 73 cm.
Private collection, Paris.

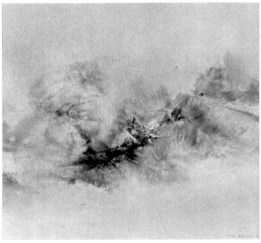

386. 16-1-69.
Oil on canvas, 46 × 50 cm.
Private collection, Paris.

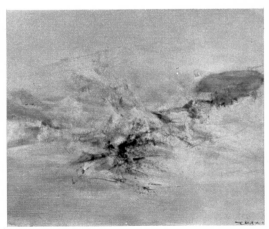

387. 16-5-69.
Oil on canvas, 46 × 55 cm.
Private collection, Le Havre.

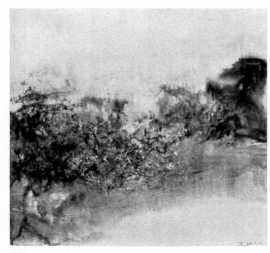

388. 22-4-69.
Oil on canvas, 46 × 50 cm.
Kunst Handlung Gryerboldgne.

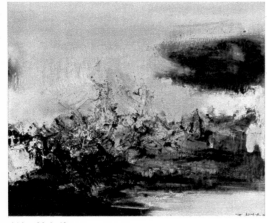

389. 22-9-69.
Oil on canvas, 46 × 55 cm.
Private collection, Paris.

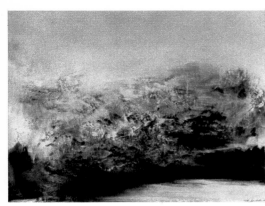

390. 2-8-69.
Oil on canvas, 64 × 73 cm.
Private collection, Paris.

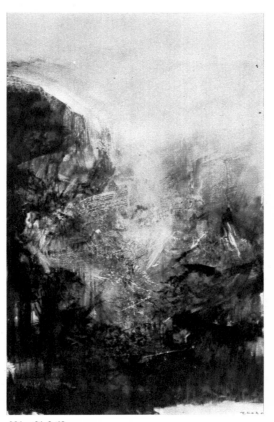

391. 21-3-69.
Oil on canvas, 130 × 81 cm.
Galerie de France, Paris.

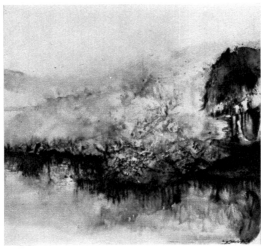

392. 30-5-69.
Oil on canvas, 46 × 50 cm.
Private collection, Toulouse.

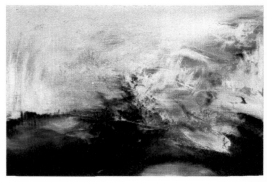

393. 12-6-69/20-12-69.
Oil on canvas, 130 × 195 cm.
Galerie de France, Paris.

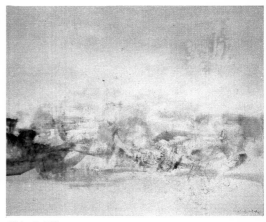

394. 3-6-70.
Oil on canvas, 46 × 55 cm.
Property of the artist.

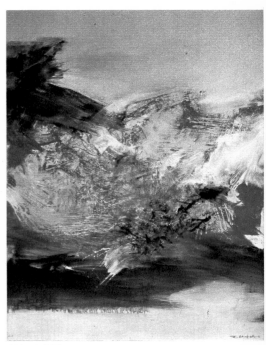

395. 8-4-70.
Oil on canvas, 116 × 89 cm.
Kunst Forum Schelderode, Belgium.

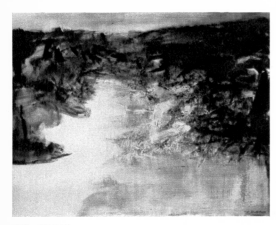

396. 24-2-70.
Oil on canvas, 130 × 162 cm.
Bridgestone Museum of Art, Tokyo.

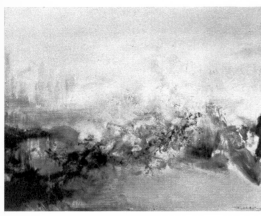

397. 6-10-70.
Oil on canvas, 60 × 73 cm.
Private collection, Lisbon.

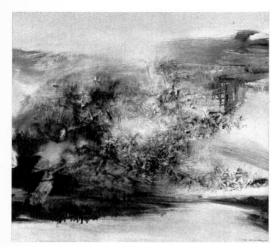

398. 30-1-70.
Oil on canvas, 95 × 65 cm.
Bruno Genon-Catalot Collection, Paris.

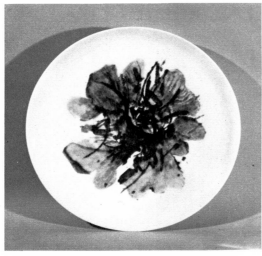

399. Plate produced by the Manufacture nationale
de Sèvres. 1970.
Ø 26 cm. Edition of 52 copies.

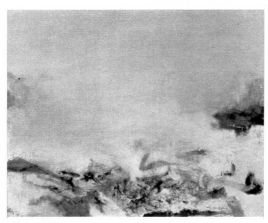

400. 7-10-70.
Oil on canvas, 54 × 65 cm.
Private collection, Stuttgart.

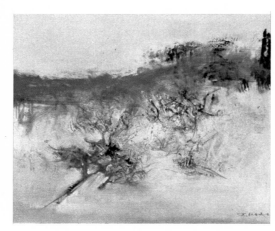

401. 23-9-70.
Oil on canvas, 46 × 55 cm.
Private collection, Paris.

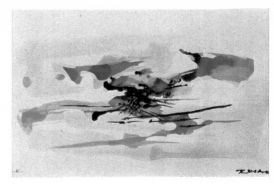

402. 1970.
Tapestry, 385 × 485 cm.
Manufacture nationale des Gobelins, Paris.

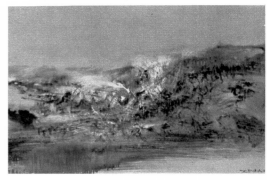

403. 1-5-70.
Oil on canvas, 65 × 100 cm.
Private collection, Paris.

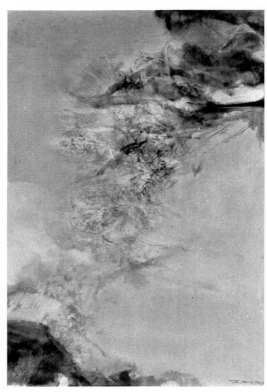

404. 22-1-71.
Oil on canvas, 81 × 54 cm.
Private collection, Stuttgart.

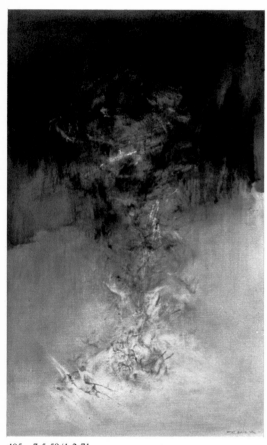

405. 7-5-59/1-2-71.
Oil on canvas, 162 × 114 cm.
Galerie de France, Paris.

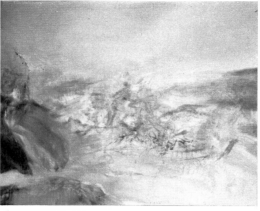

407. 2-11-71.
Oil on canvas, 130 × 162 cm.
Private collection, Le Havre.

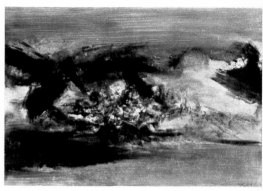

410. 21-7-72.
Oil on canvas, 65 × 92 cm. Heimshoff Galerie, Essen.

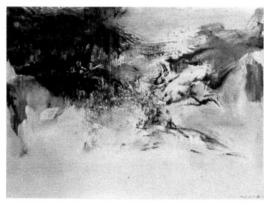

408. 12-6-59/20-1-71.
Oil on canvas, 97 × 130 cm.
Private collection, Paris.

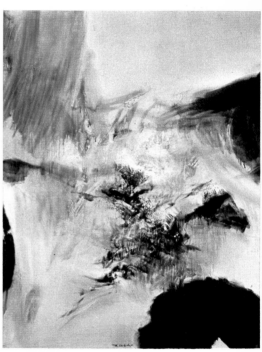

411. 18-9-72.
Oil on canvas, 130 × 97 cm.
Galerie de France, Paris.

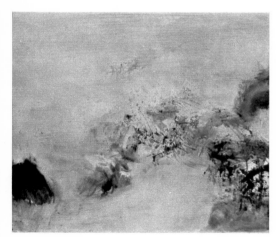

406. 1-7-71.
Oil on canvas, 46 × 55 cm.
M. et Mme Jacques Lassaigne Collection, Paris.

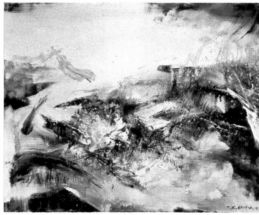

409. 28-9-72.
Oil on canvas, 46 × 55 cm.
Property of the artist.

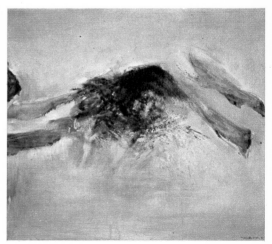

412. 6-11-72.
Oil on canvas, 95 × 105 cm.
Private collection, Paris.

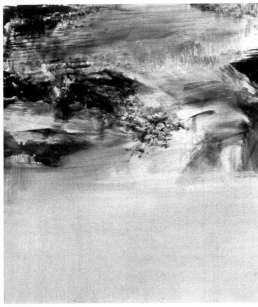

413. 1-10-72.
Oil on canvas, 55 × 46 cm.
Private collection, Paris.

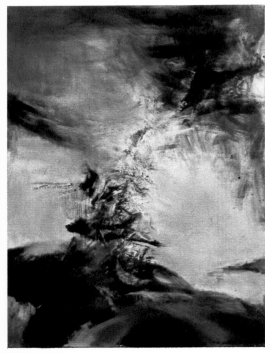

414. 30-6-72.
Oil on canvas, 130 × 97 cm.
Galerie Sapone, Nice.

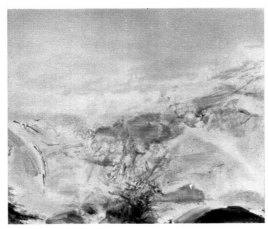

415. 5-10-73.
Oil on canvas, 55 × 64 cm.
Galerie de France, Paris.

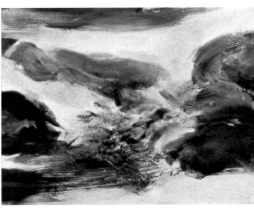

416. 25-10-73.
Oil on canvas, 89 × 116 cm.
Heimshoff Galerie, Essen.

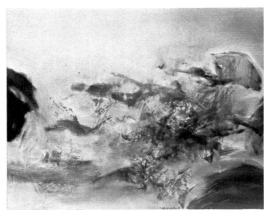

417. 20-1-73.
Oil on canvas, 73 × 92 cm.
Private collection, Courbevoie.

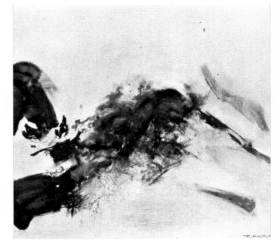

418. 12-7-73.
Oil on canvas, 95 × 105 cm.
Private collection, Paris.

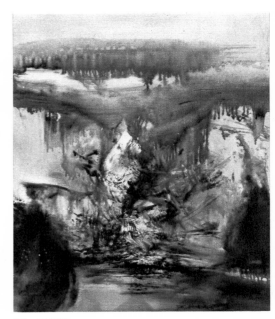

419. 21-3-73.
Oil on canvas, 55 × 46 cm.
Private collection, Paris.

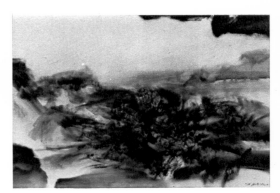

420. 3-6-73.
Oil on canvas, 60 × 92 cm.
Mr and Mrs Orlins Collection, New York.

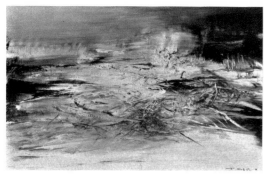

421. 24-1-64.
 Oil on canvas, 130 × 195 cm.
 Mr and Mrs Samuel M. Kootz Collection, New York.

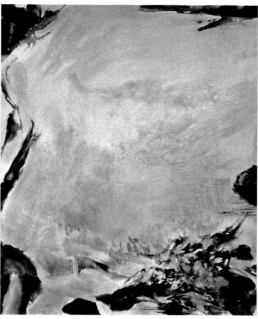

424. 9-7-73.
 Oil on canvas, 100 × 81 cm.
 Galerie de France, Paris.

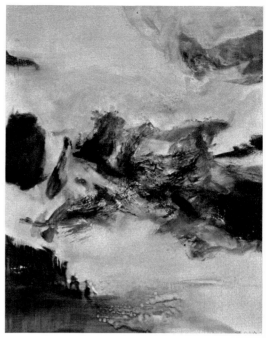

427. 6-4-73.
 Oil on canvas, 130 × 97 cm.
 Heimshoff Galerie, Essen.

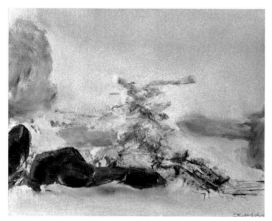

422. 9-1-73.
 Oil on canvas, 46 × 55 cm.
 Private collection, Paris.

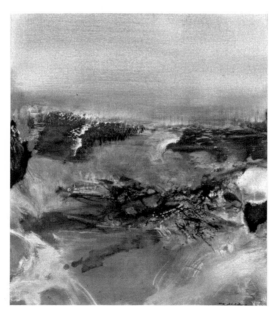

425. 24-9-73.
 Oil on canvas, 55 × 46 cm.
 Private collection, Essen.

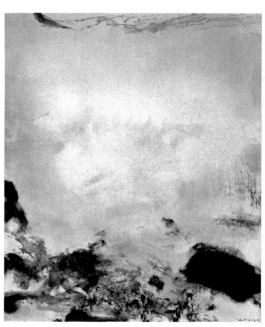

428. 4-9-74.
 Oil on canvas, 81 × 65 cm.
 Galerie de France, Paris.

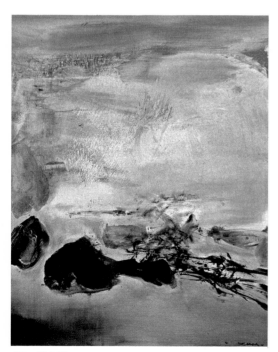

423. 28-3-73.
 Oil on canvas, 116 × 89 cm.
 Galerie de France, Paris.

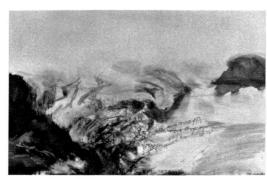

426. 28-10-72/15-1-73.
 Oil on canvas, 60 × 92 cm.
 E. Goldschmidt Collection, Brussels.

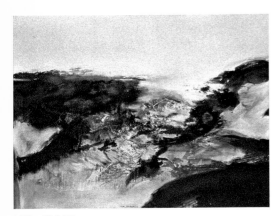

429. 18-3-74.
Oil on canvas, 89 × 116 cm.

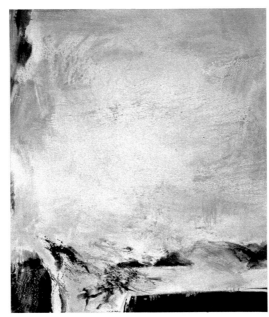

432. 22-4-74.
Oil on canvas, 100 × 81 cm.
Joan Mitchell Collection, Vétheuil, France.

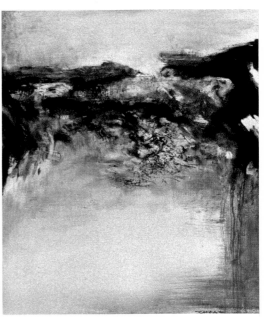

435. 19-8-74.
Oil on canvas, 73 × 60 cm.
Private collection, Paris.

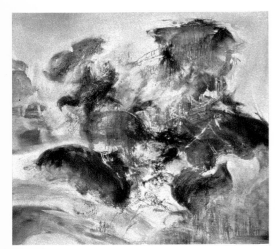

430. 10-8-74.
Oil on canvas, 150 × 162 cm.
Galerie de France, Paris.

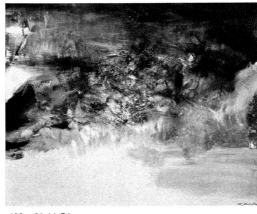

433. 30-11-74.
Oil on canvas, 60 × 73 cm.
Galerie de France, Paris.

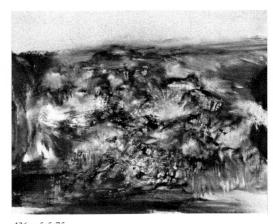

436. 5-5-75.
Oil on canvas, 60 × 73 cm.
Galerie Protée, Toulouse.

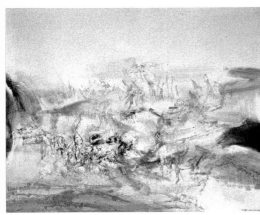

431. 14-4-74.
Oil on canvas, 60 × 73 cm.
Private collection, Essen.

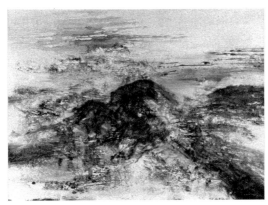

434. 25-8-74.
Oil on canvas, 60 × 81 cm.
Private collection, Brussels.

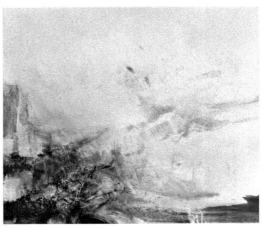

437. 19-8-75.
Oil on canvas, 60 × 73 cm.
Private collection, Paris.

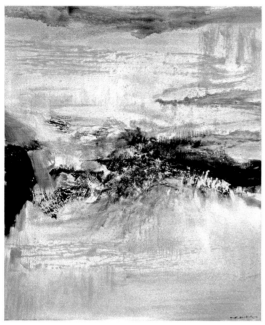

438. 1-7-75.
Oil on canvas, 92 × 73 cm.
Private collection, Rueil-Malmaison.

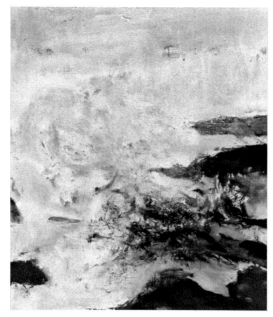

440. 10-1-75.
Oil on canvas, 73 × 60 cm.
Private collection, Paris.

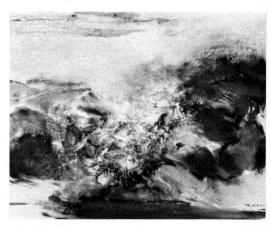

442. 10-6-75.
Oil on canvas, 65 × 81 cm.
Galerie de France, Paris.

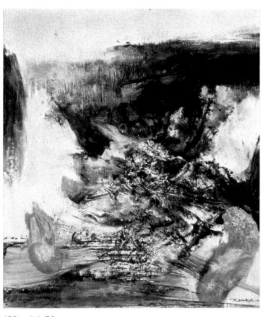

439. 6-1-75.
Oil on canvas, 55 × 46 cm.
Private collection, Paris.

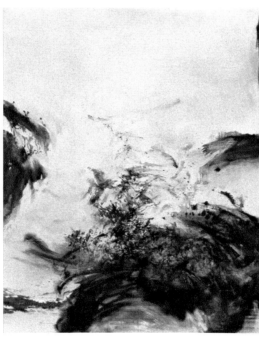

441. 28-4-75.
Oil on canvas, 46 × 89 cm.
Galerie de France, Paris.

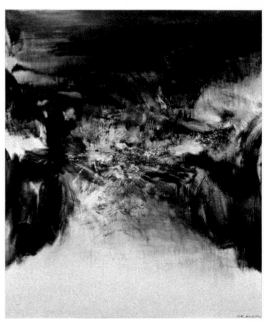

443. 25-4-75.
Oil on canvas, 100 × 81 cm.
Private collection, U.S.A.

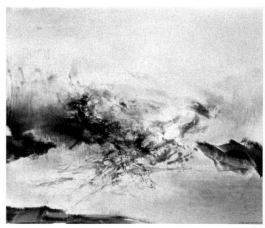

444. 27-8-75.
Oil on canvas, 54 × 65 cm.
Private collection, Paris.

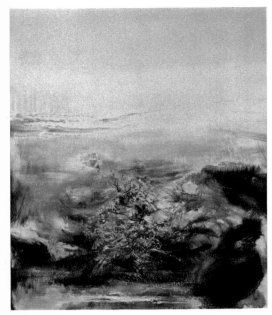

445. 10-9-75.
Oil on canvas, 65 × 54 cm.
Private collection, France.

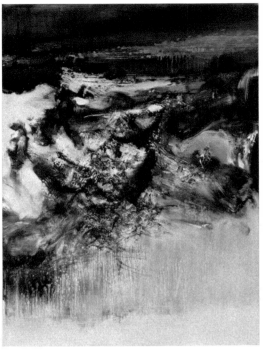

448. 10-12-75.
Oil on canvas, 130 × 97 cm.
Mr Nabutaka Shikanai Collection, Tokyo.

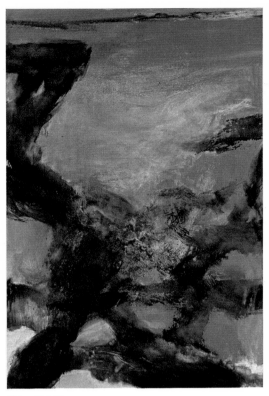

450. 21-5-76.
Oil on canvas, 195 × 130 cm.

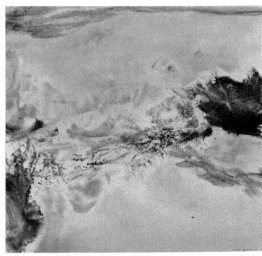

446. 4-6-75.
Oil on canvas, 55 × 55 cm.
Private collection, Paris.

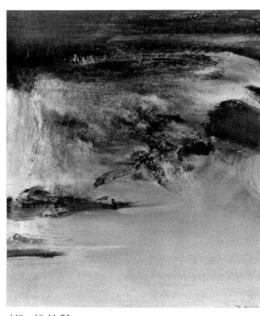

449. 18-11-75.
Oil on canvas, 65 × 54 cm.
Galerie de France, Paris.

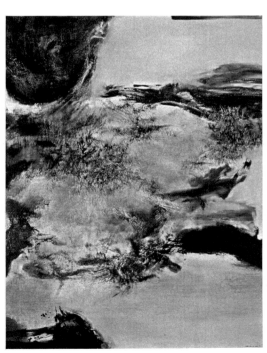

451. 14-11-76.
Oil on canvas, 260 × 200 cm.

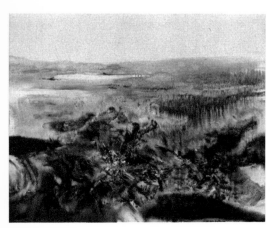

447. 24-11-75.
Oil on canvas, 60 × 73 cm.
Private collection, Paris.

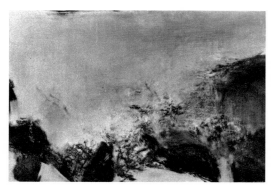

452. 5-3-76.
Oil on canvas, 130 × 195 cm.

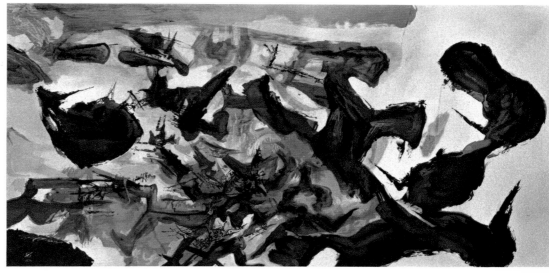

455. 1976.
Tapestry, 300 × 600 cm.
Manufacture nationale des Gobelins, Paris.

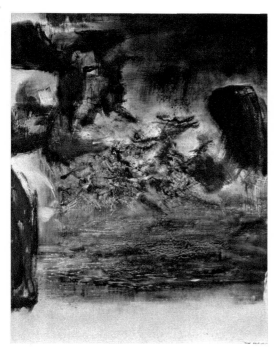

453. 10-5-76.
Oil on canvas, 116 × 89 cm.
Dr R. Cherchère Collection, Paris.

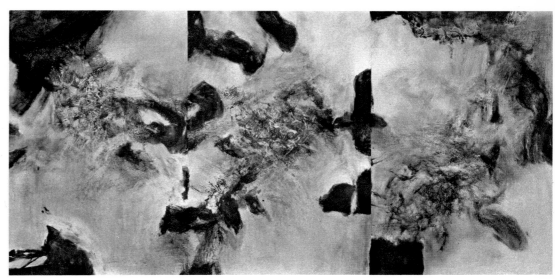

456. 15-12-76.
Triptych. Oil on canvas, 195 × 390 cm.

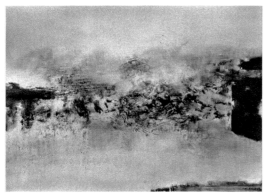

454. 17-2-71/12-5-76.
Oil on canvas, 73 × 100 cm.
Private collection, Paris.

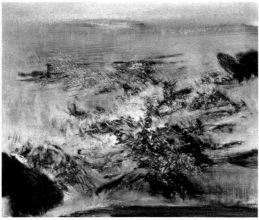

457. 5-11-76.
Oil on canvas, 55 × 66 cm.
Private collection, Paris.

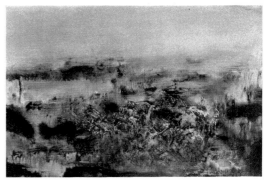

458. 27-12-76.
Oil on canvas.
Mr and Mrs Kanichiro Ishibashi, Tokyo.

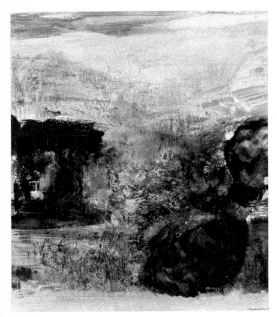

459. 25-11-76.
Oil on canvas, 85 × 70 cm.

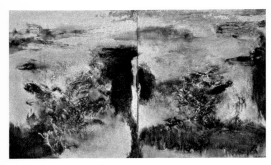

460. 23-9-76. Diptych.
Oil on canvas, 50 × 84 cm.
Sr. i Sra. Joan de Muga Collection, Barcelona.

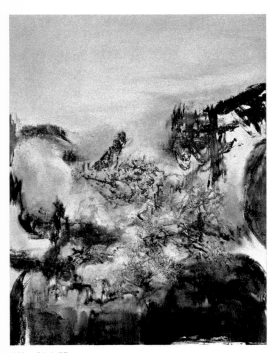

461. 21-1-77.
Oil on canvas, 130 × 97 cm.

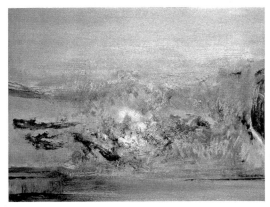

462. 10-2-77.
Oil on canvas, 116 × 89 cm.

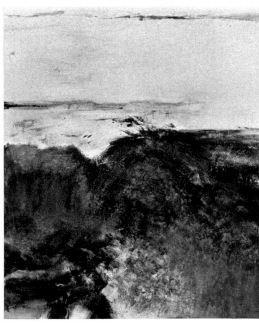

463. 17-2-77.
Oil on canvas, 200 × 162 cm.

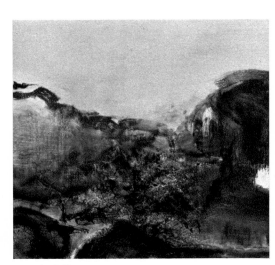

464. 15-5-77.
Oil on canvas, 150 × 162 cm.

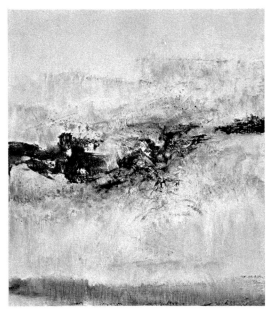

465. 2-3-77.
Oil on canvas, 65 × 54 cm.
Fuji Television Gallery Collection. Tokyo.

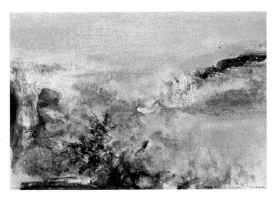

466. 7-3-77.
Oil on canvas, 54 × 73 cm.

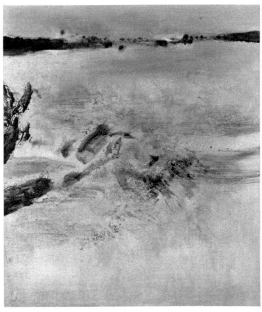

467. 15-4-77.
Oil on canvas, 200 × 162 cm.

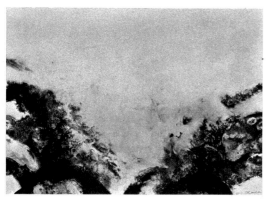

468. 28-4-77.
Oil on canvas, 73 × 54 cm.

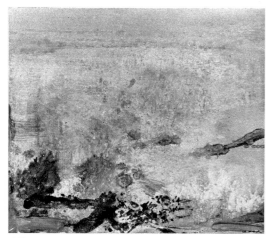

469. 15-6-77.
Oil on canvas, 55 × 50 cm.
Christian du Manoir Collection. Paris.

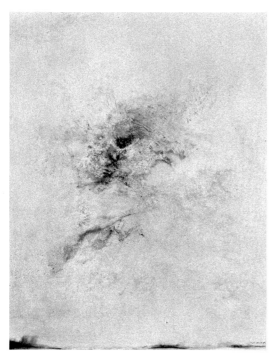

470. 1-7-77.
Oil on canvas, 130 × 97 cm.

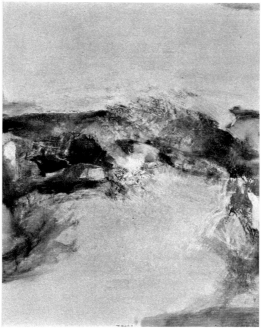

471. 12-7-77.
Oil on canvas, 146 × 114 cm.
Private collection, Châteauroux.

472. 1977.
Carpet, 400 × 400 cm.
Manufacture nationale de la Savonnerie, Paris.

473. 13-2-78.
Oil on canvas, 41 × 99 cm.

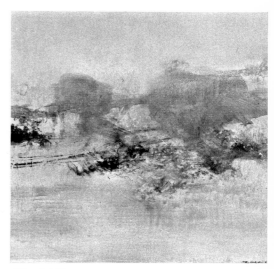

474. 5-3-78.
Oil on canvas, 55 × 55 cm.

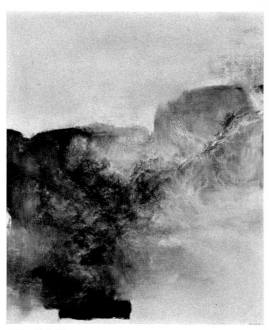

475. 10-3-78.
Oil on canvas, 200 × 162 cm.

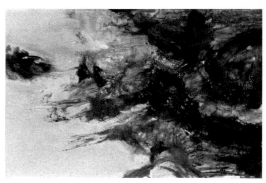

476. 6-5-78.
Oil on canvas, 130 × 195 cm.

BIOGRAPHY

1921. Zao Wou-Ki was born in Peking in 1921. Six months later his father, a banker, had to move to Nantung, a little town to the north of Shanghai. It was there that Zao Wou-Ki went to primary school and also spent the first three years of his secondary schooling. Meanwhile his family was increased by six more children. One of his brothers later went to live in the United States, but all the others remained in China. They were all destined to be intellectuals.

The T'chao family is a very ancient one, with a family tree that goes back to the Sung dynasty (10th-13th centuries A.D.); their ancestor was the Emperor's brother, who was known as King Swallow and Nightingale. Every year, on this forefather's birthday, all the brothers and sisters were assembled and were shown the great family treasure, which consisted of two paintings: one by Mi-Fei (1051-1107), and the other by Chao Meng-Fu (1254-1322), who was chiefly celebrated for his paintings on paper and on silk representing horses. It was Mi-Fei that Zao Wou-Ki preferred; in fact he still admires him and regards him as one of the greatest Chinese painters. Mi Fu, he says, was above all "a painter who looked at things in a different way and a great calligrapher".

1931. At school Zao Wou-Ki showed a great interest in literature, and in Chinese and world history, and his teachers considered him to be a gifted child, who worked hard at anything that caught his fancy. He drew and painted from the age of ten, and what he produced even then was far from conventional. He was sometimes reproached for this, but his urge to paint was never thwarted. He was also encouraged by his father, who was happy to have a son who did not want to be a banker. (He himself, in younger days, had won a prize for painting in the amateur section of an international art exhibition in Panama.) His mother, rather less enthusiastic, was furious one day when her son daubed paint over the plates of her 17th-century dinner service, and she certainly did not want him to become a painter.

Zao Wou-Ki thinks today that he would undoubtedly never have been a painter if he had not been strongly predisposed to such a career by his family environment. He quite readily admits, indeed, that had he been a better student of mathematics he would have become a doctor. Painting was always very highly regarded in his family, both by his father and by his uncle, who used to bring home reproductions of pictures in postcard format from his visits to Paris. So the boy's desire to be a painter took shape in a family of intellectuals, for whom painting was an object of curiosity and interest. His father took the trouble to explain to his children the reasons for which a calligraphy is considered good or bad, whether from the aesthetic or the technical point of view. And when Zao Wou-Ki was learning the Chinese characters, his grandfather used to draw a sketch of the object designated on the back of each ideogram. Thus he learnt that a calligraphic sign is artistic as long as it is alive, that is to say as long as it transmits an emotion to whoever looks at it. The opposite of a craftsman painter — i.e. a painter obedient to his technique — is the magic painter, who has the power through his work of touching our hearts, of moving us. This was the sort of teaching that Zao Wou-Ki received from his family.

1935. At the age of fourteen Zao Wou-Ki was enrolled in the Fine Arts School of Hangchow, after passing the entrance examination, which consisted in drawing a Greek statue from the plaster cast. He remained there for six years. The training at this school was as follows: three years were devoted to the study of drawing from plaster casts, and then two to the study of drawing from a model, while in the final year the pupils were introduced to oil painting. This teaching was supplemented by that of traditional Chinese painting by copying, and also by the theory of calligraphy and of western perspective.

Zao Wou-Ki, however, did not wait for this sixth year before beginning to practise oil painting. Only a year after entering the School, indeed, he painted landscapes at home for his own satisfaction and did some portraits of his little sister.

When the teachers at the Fine Arts School of Hangchow were Chinese, they taught the traditional painting of Ming Ts'ing; when they were foreign, they taught after the style of the Académie Royale in Brussels, where they had been trained themselves. But if they had been pupils of the École des Beaux-arts in Paris (while Besnard was director there), then it was the visions of Lucien Simon, Meissonier and Puvis de Chavannes that guided their teaching. While these painters took pains to represent with great precision the detailing of the corner of an eye or a mouth, Zao Wou-Ki sought to capture the overall effect of the lines formed by the portrait, what he thought to be essential in that moving form. He wished, as he says himself, "to rediscover the objective unity, beyond mere anecdote". To Zao Wou-Ki this painting, usually known as academic, seemed very far removed from reality or life. It evoked, he says, "false tragedies", more often than not black and grey.

Brought up, on the one hand, in a family whose traditions had formed his character and from which he had taken his desire to paint, and instructed, on the other hand, in an academic training which he rejected, he experienced (as did several of his fellow-students, who were prevented from going to Europe by lack of means) the urge to look elsewhere for a training that would satisfy him and permit him to develop further the necessity to feel closer to reality, to represent a more authentic universe.

1941. When he had finished his studies in Hangchow (or, to be more exact, in Chungking, the wartime capital of China), Zao Wou-Ki was appointed to the post of lecturer at the same school at which he had been trained. It was also in 1941 that he held his first exhibition, in Chungking. As he had to run into debt over the

expenses for this show, his father purchased the first picture sold, which enabled his son to repay the money he had had to borrow from him. Of these first exhibited works Zao Wou-Ki says today: "To tell the truth, the pictures I showed were strongly influenced by Matisse and Picasso; my harlequins recalled the blue period, my statue-women the Greek period." It was in Cézanne, Matisse and Picasso, indeed, that Zao Wou-Ki was to find the vision he considered to be closest to nature.

In his collection of postcards reproducing French paintings, which his uncle brought him from his trips to Paris, and of full-page illustrations (Renoir, Modigliani, Cézanne, Matisse, Picasso) from the American magazines one could buy in China then, such as *Life, Harper's Bazaar* and *Vogue,* Zao Wou-Ki found what he calls his "models". He considered, indeed, that the solutions to the problems he set himself were to be found neither in traditional Chinese painting nor in academic art, but rather in Cézanne and Matisse. He developed his way of looking at things from these two painters, who are, he says, the closest to his temperament.

1946. This was a crucial year for China. The Japanese evacuated the country, which thus regained its freedom. In 1946, too, the Fine Arts School, which had moved from Hangchow to Chungking in 1938, returned to its former premises. With it went Zao Wou-Ki.

In Chungking he organized an exhibition at the National Museum of Natural History, at which he presented works by Ling Feng-Mien (his principal at the Fine Arts School), Wu Ta-Yu, Kuang Leang, Ting Yin-Yong and Lin Tchong-Sue, as well as some of his own. Well received by a public of intellectuals and young painters, this exhibition was the first attempt to show the work of living artists who wanted to break away from tradition.

1947. Before leaving China he organized a one-man show in Shanghai.

On reaching the age of twenty-seven, he decided to come to Paris, with his father's approval; all he had done up to then, he says, was only his "apprenticeship".

1948. With his wife, Lan-lan, Zao Wou-Ki sailed from Shanghai on February 26th and landed at Marseilles after a voyage of thirty-six days. He arrived in Paris on the morning of April 1st and spent the afternoon of the same day in the Louvre. He stayed provisionally at first in a series of hotels in Montparnasse, but then settled definitively into a little studio in the Rue du Moulin-Vert, near that of Alberto Giacometti. He went to the Alliance Française for French lessons and also attended the Académie de la Grande-Chaumière, where his nude studies were corrected by Emile Othon-Friesz. He wanted to see everything and visit everything, whether in Paris or in the provinces. It was there — in France, in Paris — that he believes he found his true personality. He could not have done so elsewhere, and yet he is quite prepared to admit that it was also a discovery made by

chance. When he arrived from China, however, it was in Paris that he chose to settle — because, he says, of Impressionism, for which he has always had a great tenderness. When Zao Wou-Ki speaks today of that moment in his life, it is with enthusiasm and gaiety, as he recalls the friends he made, gradually realizing that he was participating in something important that was going on then and finding in it the echo of his own research. Everyone, he says, arrived in Paris between 1946 and 1948. Sam Francis and Norman Blum came from New York and Jean Riopelle from Canada; Pierre Soulages came up from Rodez; Hans Hartung and Nicolas de Staël, already very well-known, as well as Vieira da Silva, also belonged to this world. The Galerie Nina Dausset, in the Rue du Dragon, was one of the places where they all used to gather.

1949. In February 1949 he was awarded the first prize in a drawing competition, the judges of which were Lhôte and Gromaire. At that time he still did not understand French perfectly, and it was the man sitting next to him who made him stand up and go forward to receive his prize, which consisted of a series of histories of western painting published by Albert Skira.

It was about this time, too, that he first came into contact with the Desjobert printing-house, where he discovered and learnt the technique of lithography, which fascinated him. While he was a teacher in Chungking, Zao Wou-Ki had met Vadime Elisseeff, now chief curator of the Musée Cernuschi, but at that time a cultural attaché. He had seen the young artist's work and had encouraged him very strongly to come to Paris. Vadime Elisseeff was so enthusiastic, indeed, that when he returned to France he brought with him some twenty of his friend's oil paintings, which he exhibited at the Musée Cernuschi in 1946. And when Zao Wou-Ki had his first Parisian exhibition, at the Galerie Creuze in May 1949, it was Vadime Elisseeff who arranged to have the preface to the catalogue written by Bernard Dorival, curator of the Musée National d'Art Moderne. One of the notable phrases from this preface reads: "Chinese in their essence, modern and French in some of their aspects, the pictures of Zao Wou-Ki succeed in creating a most enjoyable synthesis."

1950. On January 4th 1950, Henri Michaux brought Pierre Loeb to visit the painter at his studio. Loeb went away without saying anything, but returned three months later to buy twelve canvases from him and to offer him a contract. Zao Wou-Ki was to work with Pierre Loeb from 1950 till 1957.

Carried out in 1949 at the Desjobert printing-house, the first eight lithographs done by Zao Wou-Ki were exhibited at the Galerie La Hune in Paris in 1950. Published by Robert J. Godet, who had shown them to Henri Michaux when they came off the press, they were presented, accompanied by eight poems by Henri Michaux, in a volume entitled *Lecture de huit lithographies de Zao Wou-Ki*. Another album, of six litho-

graphs, was published at the same time to illustrate a text by Harry Roskolenko, *Paris-Poems.*

From that time on, Zao Wou-Ki and Henri Michaux were to be linked by an uninterrupted friendship.

In 1950 Zao Wou-Ki also participated for the first time in the Salon de Mai, at which he was to show regularly every year after that.

1951. In 1951 the Swiss publisher Nesto Jacometti organized an exhibition of engravings at two galleries, in Bern and Geneva. On this occasion Zao Wou-Ki visited Switzerland for the first time and in the museums there discovered the paintings of Paul Klee, which he hardly knew. This was an important moment in his evolution as a painter. In the work of this artist he found an intimate, inner world that came close to his own sensibility. He declares now that he followed a very similar path. Paul Klee, influenced by Chinese art and its use of signs, led Zao Wou-Ki to enter the universe of western painting. Through Paul Klee he found the way to express what he had already felt within him in China, when he was so attracted by the drawings of his little sister. Thus Zao Wou-Ki learnt to know western painting through an artist who had himself chosen to follow the path of Chinese painting.

1952. In the course of the two years 1951 and 1952, Zao Wou-Ki painted comparatively little, because he was travelling extensively. He says that for him travelling, which is at once a break and an opening, means a reconciliation with himself in which he finds a balance. In June 1951 he discovered Italy; he did not go there simply to taste the joys of life, but to see the paintings in the Italian galleries. First he went to Tuscany, then to Rome, Pompeii, Naples and Ischia. On these journeys he saw a space in which the perspectives changed before the viewer's eyes, as they do in Chinese painting.

The following year he visited Spain. From 1952 on, Zao Wou-Ki's work was exhibited in Paris regularly, at the Galerie Pierre in the Rue des Beaux-Arts. He also held exhibitions in the United States (Washington, Chicago and New York), in Switzerland (Basel and Lausanne) and in London. Henri Michaux wrote the preface for the catalogue of his first exhibition at the Cadby-Birch Gallery in New York: "To display while concealing, to break the direct line and make it tremble, to trace in idleness the twists and turns of a walk and the doodlings of a dreaming spirit, that is what Zao Wou-Ki loves; and then, suddenly, with the same air of festivity that enlivens the Chinese countryside and villages, the picture appears, quivering joyously and rather amusing in a garden of signs."

1953. In 1953 Zao Wou-Ki did a setting for Roland Petit's Ballets de Paris (*La Perle,* a ballet in one act: story by Louise de Vilmorin, choreography by Victor Gsovsky, music by Claude Pascal). They must have asked him to do it, he says, because his "Far Eastern" origins evoked an exotic world.

But what made the years 1953 and 1954 remarkable was the change that took place in his painting. "My painting," he said in 1976, speaking of his earlier days, "became illegible. Still lifes and flowers were no longer there. I was tending towards an imaginary, indecipherable writing." It is the work itself one must question if one wishes to understand this passage. His dealer, Pierre Loeb, sold none of his work for a year and a half; the collectors seemed to have lost all interest in it.

1954. This year Zao Wou-Ki visited several places, among them Switzerland and Brittany. On November 22nd the Museum of Cincinnati presented a retrospective exhibition of his engraved work, of which Nesto Jacometti was to publish a *catalogue raisonné* early in the following year. Alain Jouffroy wrote, in "Arts": "The work of Zao Wou-Ki shows us clearly how the Chinese vision of the universe, in which the blurred and far-off reflects the spirit of contemplation rather than the thing contemplated, has become a modern, universal vision. And men as different as Paul Klee, Mark Tobey or Henri Michaux have likewise had recourse to it."

1955. In 1955 he made the acquaintance of Edgar Varèse and the two men became close friends. A year before Varèse's death, in 1964, Zao Wou-Ki was to paint a canvas in homage to his friend.

1957. The years 1957 and part of 1958 were years of travelling for Zao Wou-Ki. As a result of personal difficulties he decided to leave Paris for an indefinite period. He went to the United States, to New York first of all. There he stayed with his brother, who had been living in America from the age of seventeen. He made the acquaintance of the art dealer Samuel Kootz and also visited several artists who became friends of his: Franz Kline, Conrad Marca-Relli, Guston, Philip, Gottlieb, Baziotes, Steinberg, J. Brooks and Hans Hoffman. American painting, particularly that of the New York School, seemed to him to be more instinctive and spontaneous than European painting. He found a great freshness in it.

After his stay in New York he set out, with his friends Pierre and Colette Soulages, for Washington, Chicago and San Francisco, where he visited the museums and was astonished to find so many French paintings. After staying for ten days on an island near Hawaii, he went on to Japan, where he spent three weeks in Tokyo, Kyoto and Nara.

1958. While he stayed on in Hong Kong for about six months, for there he had met Chan May-Kan, who was to become his second wife, Pierre and Colette Soulages continued their travels in the East. Though Zao Wou-Ki was still in Hong Kong, the American dealer Samuel Kootz came to Paris and visited his studio, accompanied by Gildo Caputo and Myriam Prévot. In 1957 the painter was under contract to Kootz, and he exhibited regularly at the latter's New York gallery until 1967 (when it closed its doors). When he returned from his

travels, he was also under contract to the Galerie de France.

Gildo Caputo and Myriam Prévot, whom Zao Wou-Ki had met at the Galerie La Hune in 1950, had become friends of his. In 1955, when he was still with the Galerie Pierre, they invited him to work with them, and Zao Wou-Ki accepted the offer. In 1957, after coming to an agreement with Pierre Loeb, Zao Wou-Ki was to be under contract exclusively to the Galerie de France. Recognizing his great talent, Gildo Caputo and Myriam Prévot saw in Zao Wou-Ki an artist who contributed to the cause of what they were championing (a choice that had already been made by the Galerie Drouin, and later by the Galerie Bulliet-Caputo): lyrical abstraction. Nourished to by diversified — and, indeed, different — talents, this movement in painting constituted a unity in which Zao Wou-Ki might be one of the directions. He returned from Hong Kong in August with his new wife, May, after some detours on the way back to visit Thailand, Greece and Italy, and to Brussels to hear a performance of Varèse's music.

1959. He visited New York again for the opening of an exhibition of his works at the Kootz Gallery. He went there almost every year after that, until 1965. On his return to Paris at the end of 1959, he started looking around for a new studio, since the one he had in the Rue du Moulin-Vert was really too small for him. In the Rue Jonquoy he found a warehouse, which was converted into a studio and home for him by the architect Georges Johannet (who had already designed a studio for Vieira da Silva and was later to do one for Hadju).

1960. Consisting as it does of two separate buildings (only one of them giving on to the street), which are linked by the garden between them, Zao Wou-Ki's house gives no hint from the outside that it is an artist's working-place. On the street side one is confronted by a blank concrete façade, and it is only after walking through the first building that the visitor finds himself, to his surprise, in a garden with trees, a pool and statues, before entering the part reserved for living quarters. A large, bare room, without any windows on to the street (though there is one, heavily curtained, on to the garden), the studio was designed as a place of isolation without any opening on to the outside world; the light comes from above, as in all natural spaces, and it is a place of meditation where no whisper of life outside can penetrate or disturb. The finished canvases are all placed facing the wall. The studio is a place where Zao Wou-Ki paints alone, for he cannot bear to have anybody looking on until the work is finished.

1962. In 1962, when André Malraux was Minister for Culture, Zao Wou-Ki was commissioned by a publisher to illustrate *La Tentation de l'Occident* with ten lithographs. On this occasion Zao Wou-Ki made the acquaintance of the writer himself and, thanks to his support, was granted French citizenship in 1964. The

painter continued his work in engraving in 1965, 1966, 1967, 1971, 1974 and 1975, with illustrations accompanying poetic texts like those of Arthur Rimbaud and Saint-John Perse, René Char, Jean Lescure, Jean Laude and Roger Caillois. His fame as a painter grew steadily as he went on working in the solitude of his studio, seeing mostly the same old friends, to whom he was very faithful. But as from 1963 or 1964 Zao Wou-Ki had to postpone his journeys of discovery, as his work was taking up more and more of his time. Besides, May was ill, and Zao Wou-Ki's life began to be regulated by the ups and downs of his wife's health, so that painting sometimes offered him a release.

1964. In 1964 Zao Wou-Ki painted a very large picture as an act of homage to his friend Edgar Varèse, who died the following year. He also visited Amsterdam this year, for there was an important exhibition there of works by Vermeer and Rembrandt which he wished to see again; then he went on to Vienna for an exhibition of paintings by Brueghel. And he visited New York again, where he had many meetings with a Chinese friend of his, the architect I. M. Pei.

In 1965 Jean-Michel Meurice made a film about Zao Wou-Ki and the two men became very friendly. Meurice showed him his own paintings and Zao Wou-Ki suggested that they should exchange some works, as he used to do with all his other painter friends. In Dublin in 1967 he met Annelee and Barnett Newman, with whom he also formed a close friendship. 1969 was a year of travelling: to Montreal, to Quebec, to the United States (San Francisco, Los Angeles and New York). And Zao Wou-Ki also visited Mexico, where he stayed with his friend Tamayo, whom he had first met in 1950. He was greatly impressed by the Mexican archaeological sites.

1970. In 1970 Zao Wou-Ki was invited to teach at Salzburg, during the Festival, in a municipal seminar founded by Kokoschka. He put a great deal of energy into these activities as a teacher and decided not to repeat the experience.

The first biography of Zao Wou-Ki, written by his friend Claude Roy and originally published in 1957, was republished in 1970 in "Le Musée de Poche", with a foreword by Henri Michaux. In 1950 Claude Roy had been the first collector of Zao Wou-Ki's works, before he even knew the painter; by now he was an old friend and in 1967 he had collaborated with the artist in publishing a book devoted to Han "stampings" (209 B.C. to 200 A.D.). These "stampings" were prints carried out directly on stone, and their subject-matter consisted of anecdotes from the lives of the persons buried beneath them. Zao Wou-Ki considers that in the Chinese tradition, after the bronzes and jades of the archaic period, these stones are the best expression of a truly Chinese civilization.

In 1971 Zao Wou-Ki did some work in India ink, a technique he rarely uses because, he says, it is far too facile. May was now very ill and he could not paint.

1972. May died at the beginning of May 1972 and Zao Wou-Ki left for China on the 25th of the same month. He wished to see once again the family he had left there in 1948.

On his return, in July, "L'Express" published a long interview with Zao Wou-Ki, in the course of which he spoke of his country, of how China had changed since he had first left it and of the other impressions he had had on this visit. He was to visit China again in 1974 and 1975. In 1975, thanks to the help of the Chinese embassy in Paris and the French embassy in Peking, he brought back some paintings done by peasants in the region of Huxian; they were exhibited at the Paris Biennale, at which they occupied the whole of the Palais Galliéra. In these works he found a style that went beyond the conventions of social realism, and he thought it was important to show them in Europe.

In November 1972 the Galerie de France presented an exhibition of sculpture by May, together with colour-washes and drawings in India ink by Zao Wou-Ki. May's memory was evoked in a catalogue that contained tributes from some of their dearest friends.

1973. It was not until the end of 1973 that Zao Wou-Ki began to work again. He started to use very large formats once more. His 1975 exhibition at the Galerie de France was to bear witness to this moment when Zao Wou-Ki started painting again, after interrupting his work for a year and a half.

1975. The exhibition at the Galerie de France presented the fruits of all this hard work: oil paintings, some of them very large indeed. The preface to the catalogue was written by René Char.

This year Zao Wou-Ki returned to China again, this time to see his mother, who was very ill. He stayed there for about a fortnight, surrounded by his family. 1975 and 1976 were to be years of intensive output. He painted mostly very large-scale works; one of the most important, *Homage to André Malraux* (200×525 cm), was to be exhibited at the Fuji Television Gallery in Tokyo.

The publishing company "Arts et Métiers graphiques" published the catalogue of his graphic works, which now numbered three hundred. The preface, in the form of a stele, was written by Roger Caillois. Simultaneously with this the same company published *Randonnée* by Roger Caillois, illustrated by five engravings by Zao Wou-Ki.

1976. Before its move from the Palais de Tokyo to the Centre d'Art et de Culture Georges Pompidou, the Musée National d'Art Moderne presented an exhibition that grouped together the works in its collection by one and the same artist. Under the title *Accrochage III* a whole room was devoted to Zao Wou-Ki, showing nine paintings done between 1950 and 1975.

In this year, too, Ediciones Polígrafa of Barcelona published a text by Roger Caillois entitled *A la gloire de l'image,* accompanying fifteen lithographs by Zao Wou-Ki.

1977. Fourteen pictures, most of them on a very large scale, were exhibited at the Fuji Television Gallery in Tokyo. The exhibition was dedicated to the memory of Myriam Prévot, one of the directors of the Galerie de France, who had died suddenly in the month of July. A catalogue was published with a preface by Henri Michaux and Tamon Miki, curator of the Tokyo Museum of Modern Art. Before going to the opening of this show, Zao Wou-Ki paid a visit to New York with his wife, Françoise Marquet. They spent a lot of time there with their old friends I. M. and Eileen Pei, and Sam and Joyce Kootz. Soon after their return to Paris they set out again, this time for Rome, on the invitation of their friend Jean Leymarie, principal of the Villa Medici (the French Academy in Rome). A very beautiful exhibition of works by Nicolas Poussin was on there at the time, and Zao Wou-Ki spent many hours in front of the pictures.

1978. In February of this year Zao Wou-Ki made the acquaintance of the Baron and Baroness Thyssen-Bornemisza, on the occasion of their visit to Paris for the exhibition of their collection at the Musée d'Art Moderne de la ville de Paris.

In March the municipality of Châteauroux, the home town of Zao Wou-Ki's wife, organized an exhibition of engravings at the Town Hall and the Municipal Library. This exhibition, though apparently a modest one, was important because of the interest it aroused among the public and the critics alike.

During the month of May, Zao Wou-Ki went to Madrid, to attend the opening of the exhibition entitled "Homage to Joan Miró" organized by the local Museum of Contemporary Art and the National Library. He went there to see Miró himself, a great friend, and also to meet two other friends of long standing, Tàpies and Chillida.

Zao Wou-Ki also went to Washington, for the opening of the new East Wing in the National Gallery, designed by his friend I. M. Pei.

After this he spent some time in Amsterdam with Pierre Descargues, in order to prepare a two-hour television programme on Rembrandt for France-Culture. In Paris he made a donation to the National Library which regrouped his engraved work and completed the collection of his prints in the Cabinet des Estampes. An exhibition presenting this collection in the Salon d'Honneur is planned to open early in 1979.

At the 1978 FIAC, Zao Wou-Ki exhibited for the Galerie de France and for the Atelier Lacourière et Frélaut.

INDEX OF ILLUSTRATIONS

57. And the earth was without form. 1957. Oil on canvas, 200 × 162 cm. Private collection, Switzerland.

58. Composition. 1957. Oil on canvas, 200 × 300 cm. Nagaoka Museum of Contemporary Art, Nagaoka, Japan.

59. Mistral. 1957. Oil on canvas, 130 × 195. Solomon R. Guggenheim Museum, New York.

60. Red, blue and black. 1957. Oil on canvas, 75 × 80 cm. Mr and Mrs Benjamin Hertzberg Collection, New York.

61. We two. 1957. Oil on canvas, 162 × 200 cm. Fogg Art Museum, Harvard University, Massachusetts. Gift of Mr and Mrs John Cowles, New York.

62. Near the Loire. 1957. Oil on canvas, 114 × 146 cm. Wadsworth Atheneum Collection, Hartford, Connecticut.

63. Wind and dust. 1957. Oil on canvas, 200 × 162 cm. Fogg Art Museum, Harvard University, Massachusetts

64. Painting. 1957. Oil on canvas, 97 × 221 cm. Detroit Institute of Art, Detroit. Gift of Dr Wu-Wai Chao.

65. Painting. 1958. Oil on canvas, 73 × 92 cm. Property of the artist.

66. Painting. 1958. Oil on canvas, 114 × 97 cm. Mrs S. I. Rosenman Collection, New York.

67. Painting. 1958. Oil on canvas, 73 × 100 cm. Mrs Lester Dana Collection, Boston.

68. Painting. 1958. Oil on canvas, 200 × 162 cm. Mr and Mrs Paul Tishman Collection, New York.

69. Painting. 1958. Oil on canvas, 162 × 130 cm. Hirshhorn Museum and Sculpture Garden, Smithsonian Institution, Washington, D.C.

70. Composition. 1958. Oil on canvas, 130 × 162 cm. Mery and Leigh B. Block Foundation. The Art Institute of Chicago.

71. 13-10-59. Oil on canvas, 114 × 146 cm. Private collection, Paris.

72. Painting. 1959. Oil on canvas, 130 × 97 cm. Ateneumin Taidemusee, Helsinki.

73. 15-1-59. Oil on canvas, 130 × 97 cm. Galerie de France, Paris.

74. 21-4-59. Oil on canvas, 130 × 162 cm. Private collection, Paris.

75. 19-11-59. Oil on canvas, 114 × 146 cm. Upjohn Company Collection, Kalamazoo, Michigan.

76. 2-4-59. Oil on canvas, 97 × 130 cm. Private collection, London.

77. 2-11-59. Oil on canvas, 130 × 97 cm. Private collection, New York.

78. 6-1-60. Oil on canvas, 130 × 195 cm. Private collection, Paris.

79. 10-12-60. Oil on canvas, 200 × 162 cm. Upjohn Company Collection, Kalamazoo, Michigan.

80. 1-3-60. Oil on canvas, 162 × 200 cm. Galerie de France, Paris.

81. 14-3-60. Oil on canvas, 89 × 116 cm. Jean Seberg Collection, U.S.A.

82. 17-12-60. Oil on canvas, 162 × 130 cm. Mrs Iola Haverstick Collection, New York.

83. 25-8-60. Oil on canvas, 24 × 33 cm. Jean Leymarie Collection, Paris.

84. 4-9-60. Oil on canvas, 65 × 81 cm. Private collection, Toronto.

85. 14-10-60. Oil on canvas, 162 × 130 cm. Mrs and Mrs John Q. Powers Collection, New York.

86. 14-6-61. Oil on canvas, 81 × 65 cm. Mr and Mrs John Cowles Collection, New York.

87. 30-10-61. Oil on canvas, 130 × 195 cm. Mr and Mrs Abraham M. Lindenbaum Collection, Brooklyn, New York.

88. 27-5-61. Oil on canvas, 100 × 73 cm. Private collection, U.S.A.

89. 19-7-61. Oil on canvas, 162 × 150 cm. Galerie de France, Paris.

90. 15-12-61. Oil on canvas, 200 × 180 cm. Centre Georges Pompidou, National Gallery of Modern Art, Paris.

91. 1961. Oil on canvas, 130 × 195 cm. Private collection, Tokyo.

92. 14-11-61. Oil on canvas, 130 × 162 cm. Property of the artist.

93. 23-5-62. Oil on canvas, 195 × 130 cm. Mrs William R. Thompson Collection, New York.

94. 24-6-61. Oil on canvas, 146 × 97 cm. Galerie de France, Paris.

95. 14-4-62. Oil on canvas, 81 × 130 cm. Galerie de France, Paris.

96. Painting. 1962. Oil on canvas, 114 × 195 cm. Private collection, Paris.

97. 4-3-62. Oil on canvas, 65 × 54 cm. Private collection, Geneva.

98. 21-6-62. Oil on canvas, 146 × 97 cm. Lord Clark Collection, London.

99. 17-3-63. Oil on canvas, 130 × 97 cm. Private collection, Le Vésinet.

100. 14-11-63. Oil on canvas, 130 × 195 cm. Marsteller Inc. Collection, Chicago.

101. 28-3-63. Oil on canvas, 50 × 46 cm. Private collection, Paris.

102. Homage to Henri Michaux, 18-1-63. Oil on canvas, 60 × 92 cm. Henri Michaux Collection, Paris.

103. 7-6-63. Oil on canvas, 130 × 195 cm. Private collection, Paris.

104. 31-1-63. Oil on canvas, 162 × 200 cm. Folkwang Museum, Essen.

105. 18-2-63. Oil on canvas, 89 × 130 cm. Private collection, Paris.

106. 4-6-63. Oil on canvas, 146 × 114 cm. Mr and Mrs Donald Benjamin Collection, Long Island, New York.

107. 2-3-64. Oil on canvas, 135 × 145 cm. René Char Collection, L'Isle-sur-la-Sorgue, France.

108. 5-9-64. Oil on canvas, 150 × 162 cm. Lefebvre-Foinet Collection, Paris.

109. 16-6-64. Oil on canvas, 146 × 114 cm. Cuyahoya Saving Association Collection, Cleveland, Ohio.

110. 29-1-64. Oil on canvas, 260 × 200 cm. Private collection, Paris.

111. Homage to Edgar Varèse. 25-10-64. Oil on canvas, 255 × 345 cm. Private collection, Paris.

112. 1964. Oil on canvas, 65 × 81 cm. Cuyahoya Saving Association Collection, Cleveland, Ohio.

113. 4-5-64. Oil on canvas, 200 × 260 cm. Centre Georges Pompidou, National Museum of Modern Art, Paris.

114. 9-7-64. Oil on canvas, 260 × 200 cm. Mrs Ruth Roskaner Smith Collection, New York.

115. 1-2-64. Oil on canvas, 150 × 162 cm. Jean-Paul Riopelle Collection, Vétheuil, France.

116. 29-9-64. Oil on canvas, 255 × 345 cm. Private collection, Meudon, France.

117. 16-5-66. Oil on canvas, 195 × 130 cm. Private collection, Geneva.

118. 1-4-66. Triptych. Oil on canvas, 195 × 358 cm. Private collection, Paris.

119. 21-10-66. Oil on canvas, ∅ 100 cm. Private collection, U.S.A.

120. 19-12-66. Oil on canvas, 195 × 97 cm. Private collection, Paris.

121. 5-6-65. Oil on canvas, 100 × 81 cm. Private collection, Paris.

122. 29-9-65. Oil on canvas, 73 × 116 cm. Private collection, Paris.

123. 20-1-67. Oil on canvas, 150 × 162 cm. Property of the artist.

124. 8-3-66. Oil on canvas, 150 × 162 cm. Mrs Neil J. McKinnon Collection, Toronto.

125. 24-5-65. Oil on canvas, 162 × 150 cm. Stanford University, Stanford, California (on loan from H. Harvard Arnason).

126. 13-2-67. Oil on canvas, 200 × 300 cm. Private collection, Paris.

127. 24-1-66. Oil on canvas, 162 × 200 cm. Arthur Goldberg Collection, New York.

128. 9-6-67. Oil on canvas, 114 × 162 cm. Private collection, London.

129. 3-11-68. Oil on canvas, 195 × 130 cm. Galerie de France, Paris.

130. 26-2-66. Oil on canvas, 130 × 162 cm. National Fund of Contemporary Art, Paris.

131. 9-7-67. Oil on canvas, 150 × 162 cm. Private collection, Paris.

132. 1-4-68. Oil on canvas, 195 × 130 cm. Property of the artist.

133. 6-1-68. Oil on canvas, 260 × 200 cm. City of Paris Museum of Modern Art.

134. 12-8-69. Oil on canvas, 200 × 300 cm. Property of the artist.

135. 22-10-68. Oil on canvas, 46 × 50 cm. Private collection, Paris.

136. 7-11-68. Oil on canvas, 46 × 55 cm. Bert Leefmans Collection, New York.

137. 16-1-69. Oil on canvas, 46 × 55 cm. Private collection, Le Havre.

138. 25-2-69. Oil on canvas, 54 × 65 cm. Private collection, Essen.

139. 31-8-68. Oil on canvas, 146 × 89 cm. Galerie de France, Paris.

140. 5-9-69. Oil on canvas, 195 × 130 cm.

141. 18-3-68. Oil on canvas, 95 × 105 cm. Private collection, Los Angeles.

142. 21-12-68. Oil on canvas, 97 × 195 cm. Mr and Mrs Chi-Ming Cha Collection, Los Altos Hills, California.

143. 18-1-68. Oil on canvas, 150 × 162 cm.

144. 18-12-69. Oil on canvas, 116 × 89 cm. Property of the artist.

145. 3-4-60/1-2-69. Oil on canvas, 195 × 130 cm. Galerie de France, Paris.

146. 31-3-59/1-3-69. Oil on canvas, 60 × 73 cm. Private collection, Paris.

147. 8-1-69. Oil on canvas, 114 × 146 cm. Private collection, Paris.

148. 23-1-67/27-1-69. Oil on canvas, 135 × 145 cm. Private collection, Paris.

149. 15-4-69. Oil on canvas, 130 × 162 cm. Private collection, Paris.

150. 1-10-70. Oil on canvas, 162 × 200 cm.

151. 30-12-68/30-10-70. Oil on canvas, 200 × 162 cm. Galerie de France, Paris.

152. 29-1-70. Oil on canvas, 200 × 525 cm. Private collection, Paris.

153. 6-10-71. Oil on canvas, 195 × 130 cm.

154. 27-3-70. Oil on canvas, 130 × 195 cm. Mr and Mrs I. M. Pei Collection, New York.

155. 30-3-71. Oil on canvas, 105 × 95 cm. Private collection, Paris.

156. 15-4-70. Oil on canvas, 97 × 130 cm. Private collection, Lisbon.

157. 12-10-70. Oil on canvas, 130 × 162 cm. Private collection, Paris.

158. 26-10-70. Oil on canvas, 81 × 100 cm. Private collection, Huy, Belgium.

159. 15-6-69/26-12-70. Oil on canvas, 89 × 116 cm. Private collection, Antony, France.

160. 10-11-58/30-12-70. Oil on canvas, 130 × 195 cm. Private collection, Mexico.

161. 25-5-70. Oil on canvas, 150 × 162 cm. Private collection, Lisbon.

162. No. 30. 1971. India ink on Chinese paper, 34 × 34 cm. Private collection, Amsterdam.

163. No. 16. 1971. India ink on Chinese paper, 21.5 × 21.5 cm. Sin-May Zao Collection, Paris.

164. No. 9. 1971. India ink on Chinese paper, 34 × 33.5 cm. Private collection, Paris.

165. No. 39. 1971. India ink on Chinese paper, 34 × 34 cm. Private collection, New York.

166. 14-7-71. Oil on canvas, 150 × 162 cm.

167. 1-12-61/27-1-71. Oil on canvas, 130 × 89 cm. Private collection, Paris.

168. 2-10-66/8-2-71. Oil on canvas, ∅ 55 cm. Private collection, Paris.

169. 18-10-71. Oil on canvas, 97 × 195 cm. Mr and Mrs Chi-Ming Cha Collection, Los Altos Hills, California.

170. 24-9-71. Oil on canvas, 130 × 97 cm. Private collection, Luxemburg.

171. 23-5-62/7-1-71. Oil on canvas, 114 × 162 cm. Private collection, Paris.

172. 14-12-71. Oil on canvas, 130 × 195 cm. Galerie de France, Paris.

173. 12-10-71. Oil on canvas, 95 × 105 cm. Galerie de France, Paris.

174. 9-5-59/8-1-71. Oil on canvas, 200 × 162 cm. Tamayo Museum of Contemporary Art, Mexico.

175. 21-2-72. Oil on canvas, 81 × 100 cm. Dr R. Cherchère Collection, Paris.

176. 2-8-72. 1972. Oil on canvas, 95 × 105 cm. Private collection, Toulouse.

177. 14-7-61/28-1-71. Oil on canvas, 200 × 162 cm.

178. 19-11-71. Oil on canvas, 200 × 162 cm. Consulate General of France, Hong Kong (on loan from the National Fund of Contemporary Art, Paris).

179. 10-10-72. Oil on canvas, 150 × 162 cm. Galerie de France, Paris.

180. 8-2-72. Oil on canvas, 150 × 162 cm.

181. 10-9-72. In memory of May. (14-11-30/10-3-72). Oil on canvas, 200 × 525 cm. Centre Georges Pompidou, National Museum of Modern Art, Paris.

182. 1972. India ink on Chinese paper, 22.7 × 33.3 cm. M. et Mme Gaëtan Picon Collection, Paris.

183. 1972. India ink on Chinese paper, 69 × 119 cm. Private collection, Paris.

184. 1972. India Ink on Chinese paper, 22.2 × 33.3 cm. Private collection, Paris.

185. 1972. India ink on Chinese paper, 69 × 119 cm. Private collection, Paris.

186. 10-9-73. Oil on canvas, 200 × 162 cm.

187. 13-9-73. Oil on canvas, 200 × 162 cm.

188. 16-3-73. Oil on canvas, 146 × 114 cm. Private collection, France.

189. 28-5-73. Oil on canvas, 162 × 130 cm. Galerie de France, Paris.

190. 10-3-73. Oil on canvas, 260 × 200 cm.

191. 3-2-73. Oil on canvas, 146 × 114 cm.

192. 6-2-74. Oil on canvas, 65 × 81 cm. Private collection, Paris.

193. 1-10-73. Oil on canvas, 260 × 200 cm.

194. 26-7-73. Oil on canvas, 73 × 60 cm. Private collection, Paris.

195. 27-10-73. Oil on canvas, 50 × 65 cm. Private collection, Paris.

196. Homage to René Char. 10-1-73/5-4-73. Oil on canvas, 54 × 65 cm. René Char Collection, L'Isle-sur-la-Sorgue, France.

197. 28-8-74. Oil on canvas, 92 × 73 cm.

198. 14-12-66/20-4-74. Oil on canvas, ⌀ 100 cm. Sin-May Zao Collection, Paris.

199. 10-3-74. We two again. Oil on canvas, 280 × 400 cm. Property of the artist.

200. 10-1-74. Oil on canvas, 195 × 130 cm.

201. 5-3-71/28-11-74. Oil on canvas, 162 × 200 cm.

202. 1-2-73/5-12-74. Oil on canvas, 195 × 97 cm. J. M. D. Cha Collection, Los Altos Hills, California.

203. 2-3-74. Oil on canvas, 162 × 130 cm. Property of the artist.

204. 6-11-75. Oil on canvas, 55 × 55 cm. Private collection, Geneva.

205. 1-2-76. Oil on canvas, 55 × 55 cm. Private collection, New York.

206. 3-12-74. Oil on canvas, 250 × 260 cm. National Fund of Contemporary Art, Paris.

207. 1-12-75. Oil on canvas, 114 × 146 cm. Thyssen-Bornemisza Collection, Castagnola.

208. 5-2-75. Oil on canvas, 55 × 55 cm. Private collection, Paris.

209. 3-3-75. Oil on canvas, 55 × 55 cm. Private collection, Paris.

210. 8-4-75. Oil on canvas, 55 × 55 cm. Private collection, U.S.A.

211. 24-1-75. Oil on canvas, 55 × 55 cm. Private collection, Sèvres, France.

212. 11-10-75. Triptych. Oil on canvas, 27 × 60 cm. Daniel Abadie Collection, Paris.

213. 5-3-75. In memory of my mother. Oil on canvas, 250 × 260 cm.

214. 20-8-75. Oil on canvas, 116 × 89 cm. Françoise Marquet Collection, Paris.

215. 1-2-75. Oil on canvas, 162 × 130 cm. Galerie de France, Paris.

216. 14-11-74. Oil on canvas, 55 × 55 cm. Manuel de Muga Collection, Barcelona.

217. 1-5-75. Oil on canvas, 130 × 97 cm. M. et Mme Gildo Caputo Collection, Paris.

218. 10-3-76. Oil on canvas, 195 × 97 cm. Mr and Mrs Kanichiro Ishibashi Collection, Tokyo.

219. 21-1-76. Oil on canvas, 73 × 92 cm. Private collection, Paris.

220. 10-2-76. Oil on canvas, 81 × 100 cm. Birch Gallery, Copenhagen.

221. 13-1-76. Oil on canvas, 150 × 162 cm.

222. 1-4-76. Triptych. Homage to André Malraux. Oil on canvas, 200 × 524 cm. Fuji Telecasting Co. Ltd., Tokyo.

223. 1950. Oil on canvas, 46 × 55 cm. Private collection, New York.

224. Stag. 1950. Oil on canvas, 33 × 44 cm. G. Cramer Collection, Geneva.

225. Pink-green village. 1950. Oil on canvas, 41 × 33 cm. Private collection, U.S.A.

226. 1950. Oil on canvas, 65 × 92 cm. Private collection, Paris.

227. Landscape. 1950. Oil on canvas, 38 × 46 cm. National Museum of Modern Art, Paris.

228. Grey and yellow mountain. 1951. Oil on canvas, 81 × 100 cm. Galerie Pierre, Paris.

229. The lovers. 1950. Oil on canvas, 116 × 132 cm. The Aldrich Museum of Contemporary Art, Ridgefield, U.S.A.

230. Lake Geneva. 1950. Oil on canvas, 33 × 44 cm. Property of the artist.

231. Boats against a black background. 1950. Oil on canvas, 38 × 46 cm. Private collection, U.S.A.

232. Still life. 1951. Oil on canvas, 46 × 55 cm. The Aldrich Museum of Contemporary Art, Ridgefield, U.S.A.

233. Landscape with characters. 1951. Oil on cardboard, 42.5 × 34 cm. The Aldrich Museum of Contemporary Art, Ridgefield, U.S.A.

234. 1951. Oil on canvas, 114 × 146 cm. Private collection, Paris.

235. Birds. 1951. Oil on canvas, 162 × 130 cm. Private collection, New York.

236. Chinese scene. 1951. Oil on canvas, 38 × 41 cm. San Francisco Museum of Modern Art, U.S.A.

237. Emerald green. 1951. Oil on canvas, 155 × 150 cm. Private collection, U.S.A.

238. The teapot. 1951. Oil on canvas, 65 × 81 cm. Harry N. Abrams Collection, New York.

239. Notre-Dame. 1951. Oil on canvas, 41 × 33 cm. Private collection, Paris.

240. Landscape. 1951. Oil on wood, 40 × 34 cm. Galerie Pierre, Paris.

241. Red landscape. 1951. Oil on canvas, 46 × 55 cm. Galerie Pierre, Paris.

242. Landscape. 1950-1951. Oil on canvas, 100 × 81 cm. Private collection, Paris.

243. Bullfighting. 1952-1953. Oil on canvas, 89 × 116 cm. Private collection, Paris.

244. The garden. 1952. Oil on canvas, 50 × 61 cm. The High Museum of Art, Atlanta, Georgia.

245. Town. 1952. Oil on canvas, 46 × 55 cm. The Aldrich Museum of Contemporary Art, Ridgefield, U.S.A.

246. We two. 1953. Oil on canvas, 38 × 46 cm. M. et Mme Raymond Haas Collection, Paris.

247. Flowers. 1953. .Oil on canvas, 65 × 81 cm. The Aldrich Museum of Contemporary Art, Ridgefield, U.S.A.

248. Five fishes. 1954. Oil on canvas, 46 × 55 cm. Private collection, Paris.

249. Rain. 1954. Oil on canvas, 81 × 54 cm. Private collection, Geneva.

250. Yellow village. 1954. Oil on canvas, 54 × 73 cm. Private collection, Paris.

251. Fire birds. 1954. Oil on canvas, 38 × 46 cm. Private collection, U.S.A.

252. Circus resting. 1954. Oil on canvas, 54 × 65 cm. Private collection, New York.

253. Innocent signs. 1954. Oil on canvas, 38 × 46 cm. Private collection, Paris.

254. Far from the sea. 1954. Oil on canvas, 60 × 73 cm. Private collection. Paris.

255. Riders with stars. 1954. Oil on canvas, 30 × 45 cm. Private collection, Paris.

256. Enchained mountains. 1954. Oil on canvas, 46 × 55 cm. Private collection, U.S.A.

257. They're beginning to go faster. 1954. Oil on canvas, 24 × 33 cm. Private collection, Paris.

258. Engulfed city. 1954. Oil on canvas, 60 × 73 cm. Private collection, U.S.A.

259. We two. 1955. Oil on canvas, 38 × 46 cm. Museum of Fine Arts, Le Havre.

260. Roman ruins. 1955. Oil on canvas, 46 × 65 cm. Private collection, Paris.

261. Cloud. 1955. Oil on canvas, 130 × 97 cm. Property of the artist.

262. Pursuit. 1955-1957. Oil on canvas, 195 × 97 cm. Private collection, Switzerland.

263. Untitled. 1955. Oil on canvas, 92 × 73 cm. Private collection, Paris.

264. Christmas tree. 1955. Oil on canvas, 18 × 14 cm. M. et Mme Raymond Haas Collection, Paris.

265. Growth. 1956. Oil on canvas, 54 × 65 cm. Museum of Fine Arts, Le Havre.

266. 1956. Oil on canvas, 14 × 18 cm. Private collection, Rio de Janeiro.

267. Crossing of appearances. 1956. Oil on canvas, 97 × 195 cm. Private collection, Paris.

268. 1956. Oil on canvas, 100 × 50 cm. Private collection, Geneva.

269. 8-1-56. Composition. Oil on canvas, 162 × 114 cm. Owned by Neil J. McKinnon, Toronto.

270. 1957. Oil on canvas, 54 × 65 cm. Dr R. Cherchère Collection, Paris.

271. Homage to Tu-Fu. 1956. Oil on canvas, 195 × 130 cm. Galerie de France, Paris.

272. 1956. Oil on canvas, 54 × 81 cm.

273. Start of the mistral. 1957. Oil on canvas, 73 × 92 cm. Galerie de France, Paris.

274. 1958. Oil on canvas, 114 × 146 cm. Private collection, New York.

275. 1958. Oil on canvas, 65 × 92 cm. Private collection, U.S.A.

276. No. W. 4. 1958. Oil on canvas, 81 × 75 cm. Galerie de France, Paris.

277. 1958. Oil on canvas, 130 × 97 cm. Mrs S. I. Rosenman Collection, New York.

278. Painting. 1958. Oil on canvas, 114 × 162 cm. Kootz Gallery, New York.

279. 4-4-59. Oil on canvas, 89 × 116 cm. Dr Richard Frank Collection, U.S.A.

280. 1st October 1953. 1959. Oil on canvas, 100 × 198 cm. The Upjohn Company, Kalamazoo, Michigan, U.S.A.

281. Painting. 1959. Oil on canvas, 162 × 130 cm. Galerie de France, Paris.

282. Painting. 1959. Oil on canvas, 162 × 100 cm. Private collection, Switzerland.

283. 14-3-59. Oil on canvas, 162 × 130 cm. Galerie de France, Paris.

284. 11-11-60. Oil on canvas, 116 × 89 cm. Kootz Gallery, New York.

285. 22-10-60. Oil on canvas, 54 × 65 cm. Kootz Gallery, New York.

286. 9-2-60. Oil on canvas, 73 × 92 cm. Private collection, New York.

287. 15-3-60. Oil on canvas, 89 × 116 cm. Private collection, New York.

288. 16-2-60. Oil on canvas, 146 × 114 cm. Private collection, Paris.

289. 26-1-60. Oil on canvas, 97 × 130. Private collection, Paris.

290. 27-1-60. Oil on canvas, 60 × 81 cm. Private collection, New York.

291. Composition in blue. 1960. Oil on canvas, 162 × 130 cm. Owned by Neil J. McKinnon, Toronto.

292. 18-10-1960. Oil on canvas, 195 × 114 cm. Mr and Mrs Al Aydelott Collection, Washington.

293. 25-5-60. Oil on canvas, 195 × 130 cm. Galerie de France, Paris.

294. 9-2-60. Oil on canvas, 117 × 146 cm. The Upjohn Company Collection, Kalamazoo, Michigan.

295. 8-11-61. Oil on canvas, 73 × 92 cm. Private collection, Paris.

296. 21-6-61. Oil on canvas, 60 × 73 cm. Jean Seberg Collection, U.S.A.

297. 4-12-61. Oil on canvas, 81 × 130 cm. Private collection, Paris.

298. 7-4-61. Oil on canvas, 195 × 114 cm. Mr and Mrs H. M. Austin Collection, U.S.A.

299. 20-6-61. Oil on canvas, 81 × 116 cm. Mrs Richard Rodgers Collection, U.S.A.

300. 22-3-61. Oil on canvas, 114 × 146 cm. Private collection, Princeton, New Jersey, U.S.A.

301. 15-1-61. Oil on canvas, 54 × 73 cm. Bridgestone Museum of Art, Tokyo.

302. 60 P. 10-5-62. Oil on canvas, 130 × 89 cm. Property of the artist.

303. 12-12-62. Oil on canvas, 150 × 162 cm. Dr Guy Genon-Catalot Collection, Paris.

304. 14-12-62. Oil on canvas, 130 × 97 cm. Private collection, U.S.A.

305. 10-6-62. Oil on canvas, 60 × 81 cm. M. et Mme Raymond Haas Collection, Paris.

306. 12-12-62. Oil on canvas, 162 × 130 cm. Private collection, Paris.

307. 25-5-62. Oil on canvas, 200 × 162 cm. Mr and Mrs Lynn Q. Fayman Collection, New York.

308. 10-4-62. Oil on canvas, 73 × 116 cm. Galerie de France, Paris.

309. 24-3-63. Oil on canvas, 81 × 116 cm. M. et Mme H. Boileau Collection, Paris.

310. 5-4-63. Oil on canvas, 46 × 50 cm. Mr and Mrs Knott Collection, New York.

311. 31-3-63. Oil on canvas, 46 × 50 cm. Private collection, Paris.

312. 18-3-63. Oil on canvas, 60 × 81 cm. Redfern Gallery, London.

313. 30 F. 1963. Oil on canvas, 92 × 73 cm. Nesto Jacometti Collection, Zürich.

314. 2-4-63. Oil on canvas, 50 × 55 cm. Private collection, Paris.

315. 26-4-62. Oil on canvas, 97 × 195 cm. Owned by Neil J. McKinnon, Toronto.

316. 1-4-63. Oil on canvas, 55 × 50 cm. Private collection, Paris.

317. 22-6-63. Oil on canvas, 146 × 89 cm. Mr and Mrs Walter R. Beardsley Collection, U.S.A.

318. 18-4-63. Oil on canvas, 195 × 97 cm. Private collection, Paris.

319. 21-3-63. Oil on canvas, 97 × 195 cm. Galerie de France, Paris.

320. 22-11-63. Homage to John F. Kennedy. Oil on canvas, 116 × 81 cm. Galerie de France, Paris.

321. 29-1-63. Oil on canvas, 116 × 89 cm. Dr R. Cherchère Collection, Paris.

322. 30-10-64. Oil on canvas, 114 × 162 cm.

323. 25-10-63. Oil on canvas, 100 × 73 cm. International Minerals and Chemicals Corporation, Stanford, California.

324. 17-4-64. Oil on canvas, 114 × 162 cm. Private collection, Paris.

325. 1964. Oil on canvas, 130 × 89 cm. M. et Mme V. Elisseeff Collection, Paris.

326. 7-5-63. Oil on canvas, 65 × 54 cm. Private collection, Paris.

327. 9-5-64. Oil on canvas, 55 × 46 cm. Mr T. Hirano Collection, Tokyo.

328. 21-9-64. Oil on canvas, 260 × 200 cm. Property of the artist.

329. 8-2-64. Oil on canvas, 65 × 100 cm. Private collection, Ivory Coast.

330. 20-1-64. Oil on canvas, 46 × 50 cm. Private collection, Lisbon.

331. 2-6-64. Oil on canvas, 65 × 81 cm. Private collection, Paris.

332. 23-9-64. Oil on canvas, 55 × 46 cm. Property of the artist.

333. 4-7-64. Oil on canvas, 46 × 38 cm. Private collection, Paris.

334. 22-7-64. Oil on canvas, 162 × 200 cm. Dr Guy Genon-Catalot Collection, Paris.

335. 23-5-64. Oil on canvas, 200 × 162 cm. Kootz Gallery, New York.

336. 24-5-64. Oil on canvas, 46 × 50 cm. Private collection, Paris.

337. 11-6-64. Oil on canvas, 130 × 97 cm. Private collection, Paris.

338. 30-7-64. Oil on canvas, 150 × 162 cm. J. F. Jaeger Collection, Paris.

339. 11-6-65. Oil on canvas, 114 × 162 cm. Mr and Mrs William Block Collection, U.S.A.

340. 30-7-65. Oil on canvas, 200 × 162 cm. Galerie de France, Paris.

341. 2-1-65. Oil on canvas, 162 × 200 cm. Dr Guy Genon-Catalot Collection, Paris.

342. 8-3-65. Oil on canvas, 73 × 60 cm. Guy Marester Collection, Paris.

343. 30-9-65. Oil on canvas, 150 × 162 cm. Galerie de France, Paris.

344. 1-3-65. Oil on canvas, 81 × 130 cm. Yale University Art Gallery, New Haven, Connecticut. Gift of Susan Morse Hilles.

345. 26-2-65. Oil on canvas, 73 × 92 cm. Middle South Services Inc. Collection, U.S.A.

346. 9-3-65. Oil on canvas, 130 × 162 cm. Mrs. Neil J. McKinnon Collection, Toronto.

347. 2-10-66. Oil on canvas, 73 × 60 cm. Private collection, France.

348. 15-2-65. Oil on canvas, 97 × 165 cm. Kootz Gallery, New York.

349. 28-5-65. Oil on canvas, 65 × 92 cm. Kootz Gallery, New York.

350. 13-2-66. Oil on canvas, 95 × 105 cm. Private collection, New York.

351. 7-1-66. Oil on canvas, ⌀ 55 cm. Private collection, Paris.

352. 18-11-66. Oil on canvas, 97 × 195 cm.

353. 28-2-67. Oil on canvas, 89 × 116 cm. Private collection, Paris.

354. 10-8-67. Oil on canvas, 65 × 54 cm. Private collection, Paris.

355. 5-1-67. Oil on canvas, 81 × 65 cm. Private collection, Paris.

356. 4-2-67. Oil on canvas, 54 × 65 cm. Private collection. France.

357. 25-1-67. Oil on canvas, 22 × 33 cm. G. Cramer Collection, Geneva.

358. 12-12-67. Oil on canvas, 73 × 60 cm. Private collection, New York.

359. 15-1-67. Oil on canvas, 114 × 146 cm. Galerie de France, Paris.

360. 5-7-67. Oil on canvas, 46 × 50 cm. Frank Perls Gallery, Los Angeles.

361. 12-6-67. Oil on canvas, 130 × 95 cm.

362. 18-8-67. Oil on canvas, 95 × 105 cm. Private collection, Paris.

363. 8-1-67. Oil on canvas, 50 × 55 cm. Private collection, Paris.

364. 1-8-67. Oil on canvas, 65 × 81 cm. Private collection, Paris.

365. 25-7-67. Oil on canvas, 92 × 60 cm. Private collection. Paris.

366. 28-8-67. Oil on canvas, 89 × 116 cm. Galerie de France, Paris.

367. 28-6-67. Oil on canvas, 60 × 73 cm. Galerie de France, Paris.

368. 24-6-67. Oil on canvas, 54 × 73 cm.

369. 14-1-67. Oil on canvas, 73 × 92 cm. Bert Leefmans Collection, New York.

370. 1-12-68. Oil on canvas, 162 × 114 cm. Property of the artist.

371. 6-10-68. Oil on canvas, 95 × 105 cm. Private collection, Lisbon.

372. 23-3-68. Oil on canvas, 89 × 130 cm. Private collection, Tokyo.

373. 4-12-68. Oil on canvas, 46 × 50 cm. Kunst Forum Schelderode, Belgium.

374. 31-7-68. Oil on canvas, 73 × 92 cm. Galerie Protée, Toulouse.

375. 10-2-68. Oil on canvas, 46 × 50 cm. Galerie de France, Paris.

376. 308-27-10-68. Oil on canvas, 54 × 65 cm. Private collection, Avignon.

377. 24-10-68. Oil on canvas, 130 × 162 cm. Galerie de France, Paris.

378. 10-1-68. Oil on canvas, 81 × 116 cm. Private collection, U.S.A.

379. 15-12-69. Oil on canvas, 195 × 97 cm.

380. 29-7-69. Oil on canvas, 92 × 73 cm. Dr Guy Genon-Catalot Collection, Paris.

381. 25-9-69. Oil on canvas, 146 × 97 cm. Mr and Mrs Orlins Collection, New York.

382. 14-2-69. Oil on canvas, 46 × 55 cm. Private collection, Antwerp.

383. 27-4-69. Oil on canvas, 46 × 55 cm. Galerie Ducastel, Avignon.

384. 20-1-69. Oil on canvas, 116 × 81 cm. Private collection, Essen.

385. 10-2-69. Oil on canvas, 60 × 73 cm. Private collection, Paris.

386. 16-1-69. Oil on canvas, 46 × 50 cm. Private collection, Paris.

387. 16-5-69. Oil on canvas, 46 × 55 cm. Private collection, Le Havre.

388. 22-4-69. Oil on canvas, 46 × 50 cm. Kunst Handlung Gryerboldgne.

389. 22-9-69. Oil on canvas, 46 × 55 cm. Private collection, Paris.

390. 2-8-69. Oil on canvas, 64 × 73 cm. Private collection, Paris.

391. 21-3-69. Oil on canvas, 130 × 81 cm. Galerie de France, Paris.

392. 30-5-69. Oil on canvas, 46 × 50 cm. Private collection, Toulouse.

393. 12-6-69/20-12-69. Oil on canvas, 130 × 195 cm. Galerie de France, Paris.

394. 3-6-70. Oil on canvas, 46 × 55 cm. Property of the artist.

395. 8-4-70. Oil on canvas, 116 × 89 cm. Kunst Forum Schelderode, Belgium.

396. 24-2-70. Oil on canvas, 130 × 162 cm. Bridgestone Museum of Art, Tokyo.

397. 6-10-70. Oil on canvas, 60 × 73 cm. Private collection, Lisbon.

398. 30-1-70. Oil on canvas, 95 × 65 cm. Bruno Genon-Catalot Collection, Paris.

399. Plate produced by the Manufacture nationale de Sèvres. 1970. ⌀ 26 cm. Edition of 52 copies.

400. 7-10-70. Oil on canvas, 54 × 65 cm. Private collection, Stuttgart.

401. 23-9-70. Oil on canvas, 46 × 55 cm. Private collection, Paris.

402. 1970. Tapestry, 385 × 485 cm. Manufacture nationale des Gobelins, Paris.

403. 1-5-70. Oil on canvas, 65 × 100 cm. Private collection, Paris.

404. 22-1-71. Oil on canvas, 81 × 54 cm. Private collection, Stuttgart.

405. 7-5-59/1-2-71. Oil on canvas, 162 × 114 cm. Galerie de France, Paris.

406. 1-7-71. Oil on canvas, 46 × 55 cm. M. et Mme Jacques Lassaigne Collection, Paris.

407. 2-11-71. Oil on canvas, 130 × 162 cm. Private collection, Le Havre.

408. 12-6-59/20-1-71. Oil on canvas, 97 × 130 cm. Private collection, Paris.

409. 28-9-72. Oil on canvas, 46 × 55 cm. Property of the artist.

410. 21-7-72. Oil on canvas, 65 × 92 cm. Heimshoff Galerie, Essen.

411. 18-9-72. Oil on canvas, 130 × 97 cm. Galerie de France, Paris.

412. 6-11-72. Oil on canvas, 95 × 105 cm. Private collection, Paris.

413. 1-10-72. Oil on canvas, 55 × 46 cm. Private collection, Paris.

414. 30-6-72. Oil on canvas, 130 × 97 cm. Galerie Sapone, Nice.

415. 5-10-73. Oil on canvas, 55 × 64 cm. Galerie de France, Paris.

416. 25-10-73. Oil on canvas, 89 × 116 cm. Heimshoff Galerie, Essen.

417. 20-1-73. Oil on canvas, 73 × 92 cm. Private collection, Courbevoie.

418. 12-7-73. Oil on canvas, 95 × 105 cm. Private collection, Paris.

419. 21-3-73. Oil on canvas, 55 × 46 cm. Private collection, Paris.

420. 3-6-73. Oil on canvas, 60 × 92 cm. Mr and Mrs Orlins Collection, New York.

421. 24-1-64. Oil on canvas, 130 × 195 cm. Mr and Mrs Samuel M. Kootz Collection, New York.

422. 9-1-73. Oil on canvas, 46 × 55 cm. Private collection, Paris.

423. 28-3-73. Oil on canvas, 116 × 89 cm. Galerie de France, Paris.

424. 9-7-73. Oil on canvas, 100 × 81 cm. Galerie de France, Paris.

425. 24-9-73. Oil on canvas, 55 × 46 cm. Private collection. Essen.

426. 28-10-72/15-1-73. Oil on canvas, 60 × 92 cm. E. Goldschmidt Collection, Brussels.

427. 6-4-73. Oil on canvas, 130 × 97 cm. Heimshoff Galerie, Essen.

428. 4-9-74. Oil on canvas, 81 × 65 cm. Galerie de France, Paris.

429. 18-3-74. Oil on canvas, 89 × 116 cm.

430. 10-8-74. Oil on canvas, 150 × 162 cm. Galerie de France, Paris.

431. 14-4-74. Oil on canvas, 60 × 73 cm. Private collection, Essen.

432. 22-4-74. Oil on canvas, 100 × 81 cm. Joan Mitchell Collection, Vetheuil, France.

433. 30-11-74. Oil on canvas, 60 × 73 cm. Galerie de France, Paris.

434. 25-8-74. Oil on canvas, 60 × 81 cm. Private collection, Brussels.

435. 19-8-74. Oil on canvas, 73 × 60 cm. Private collection, Paris.

436. 5-5-75. Oil on canvas, 60 × 73 cm. Galerie Protée, Toulouse.

437. 19-8-75. Oil on canvas, 60 × 73 cm. Private collection, Paris.

438. 1-7-75. Oil on canvas, 92 × 73 cm. Private collection, Rueil-Malmaison.

439. 6-1-75. Oil on canvas, 55 × 46 cm. Private collection, Paris.

440. 10-1-75. Oil on canvas, 73 × 60 cm. Private collection, Paris.

441. 28-4-75. Oil on canvas, 46 × 89 cm. Galerie de France, Paris.

442. 10-6-75. Oil on canvas, 65 × 81 cm. Galerie de France, Paris.

443. 25-4-75. Oil on canvas, 100 × 81 cm. Private collection, U.S.A.

444. 27-8-75. Oil on canvas, 54 × 65 cm. Private collection, Paris.

445. 10-9-75. Oil on canvas, 65 × 54 cm. Private collection, France.

446. 4-6-75. Oil on canvas, 55 × 55 cm. Private collection, Paris.

447. 24-11-75. Oil on canvas, 60 × 73 cm. Private collection, Paris.

448. 10-12-75. Oil on canvas, 130 × 97 cm. Mr Nabutaka Shikanai Collection, Tokyo.

449. 18-11-75. Oil on canvas, 65 × 54 cm. Galerie de France, Paris.

450. 21-5-76. Oil on canvas, 195 × 130 cm.

451. 14-11-76. Oil on canvas, 260 × 200 cm.

452. 5-3-76. Oil on canvas, 130 × 195 cm.

453. 10-5-76. Oil on canvas, 116 × 89 cm. Dr R. Cherchère Collection, Paris.

454. 17-2-71/12-5-76. Oil on canvas, 73 × 100 cm. Private collection, Paris.

455. 1976. Tapestry, 300 × 600 cm. Manufacture nationale des Gobelins, Paris.

456. 15-12-76. Triptych. Oil on canvas, 195 × 390 cm.

457. 5-11-76. Oil on canvas, 55 × 66 cm. Private collection, Paris.

458. 27-12-76. Oil on canvas. Mr and Mrs Kanichiro Ishibashi, Tokyo.

459. 25-11-76. Oil on canvas, 85 × 70 cm.

460. 23-9-76. Diptych. Oil on canvas, 50 × 84 cm. Sr. i Sra. Joan de Muga Collection, Barcelona.

461. 21-1-77. Oil on canvas. 130 × 97 cm.

462. 10-2-77. Oil on canvas, 116 × 89 cm.

463. 17-2-77. Oil on canvas, 200 × 162 cm.

464. 15-5-77. Oil on canvas, 150 × 162 cm.

465. 2-3-77. Oil on canvas, 65 × 54 cm. Fuji Television Gallery Collection, Tokyo.

466. 7-3-77. Oil on canvas, 54 × 73 cm.

467. 15-4-77. Oil on canvas, 200 × 162 cm.

468. 28-4-77. Oil on canvas, 73 × 54 cm.

469. 15-6-77. Oil on canvas, 55 × 50 cm. Christian du Manoir Collection, Paris.

470. 1-7-77. Oil on canvas, 130 × 97 cm.

471. 12-7-77. Oil on canvas, 146 × 114 cm. Private collection, Châteauroux.

472. 1977. Carpet, 400 × 400 cm. Manufacture nationale de la Savonnerie, Paris.

473. 13-2-78. Oil on canvas, 41 × 99 cm.

474. 5-3-78. Oil on canvas, 55 × 55 cm.

475. 10-3-78. Oil on canvas, 200 × 162 cm.

476. 6-5-78. Oil on canvas, 130 × 195 cm.

ONE-MAN SHOWS

1941. Sino-Sovietic Society, Chungking.

1947. Ta-Hsin Department Store, Shanghai.

1949. Galerie Creuze, Paris. Catalogue with a preface by Bernard Dorival.

1951. Galerie Klipstein, Bern: Paintings.
Galerie Pierre, Paris: Paintings.
Galerie La Hune, Paris: Drawings and engravings; presentation of *Lecture par Henri Michaux de huit lithographies de Zao Wou-Ki.*
Galerie Laya, Geneva.

1952. Galerie Feigel, Basel: Paintings.
Mainstreet Gallery, Chicago: Paintings and watercolours.
Hanover Gallery, London: Paintings. Catalogue with a preface by Henri Michaux, translated by Sylvia Beach.
Cadby-Birch Gallery, New York: Paintings. Catalogue with a preface by Henri Michaux, translated by Sylvia Beach.
Galerie Pierre, Paris: Paintings.
Galerie de la Vieille Fontaine, Lausanne.
White Gallery, Washington.

1953. Galerie La Hune, Paris: Watercolours and lithographs.
Galerie Klipstein, Bern: Lithographs.
Galleria dell'Obelisco, Rome: Paintings.
Galerie Gerald Cramer, Geneva: Engravings.
Galerie Otto Stangl, Munich: Watercolours.

1954. Cadby-Birch Gallery, New York: Paintings.
Galerie Otto Stangl, Munich: Watercolours.
Galleria del Sole, Milan: Paintings.

1955. Museum of Fine Arts, Cincinnati: Lithographs and engravings.
Galerie Pierre, Paris: Paintings.

1956. Kleemann Gallery, New York: Paintings and watercolours.
Galerie Lucien Blanc, Aix-en-Provence.
Galerie La Hune, Paris: Watercolours.
Galerie du Capitole, Lausanne: Paintings.

1957. Galerie de France, Paris: Paintings.
Galerie Müller, Bern.
Galerie Henning, Halle.

1958. Kootz Gallery, New York.

1959. Kootz Gallery, New York.

1960. Gallery Ketterer. Stuttgart.
Galerie de France, Paris.
Galerie Mala, Ljubljana: Retrospective show of engravings.

1961. Kootz Gallery, New York.
Tokyo Gallery, Tokyo.
Galerie d'Art O. Landwerlin, Strasbourg: Engravings.

1962. Exhibition Rooms of the Ateneo, Madrid: Paintings, watercolours and lithographs.
Galería Liceo, Cordova: Same exhibition.
Galerie La Hune, Paris: Recent gouaches. The opening of this exhibition included the presentation of André Malraux's *La Tentation de l'Occident,* published by Les Bibliophiles Comtois and illustrated with lithographs by Zao Wou-Ki.
Galleria Tornabuoni, Florence: Engravings.

1963. Galerie de France, Paris.
Redfern Gallery, London.
Galerie Parti-Pris, Grenoble: Oils, drawings, watercolours and engravings.

1964. Galerie La Pochade, Paris: "Ten years of engravings".
Kootz Gallery, New York: Recent paintings.
Hayden Gallery, Massachusetts Institute of Technology, Cambridge, Massachusetts: Retrospective.
Galerie de France, Paris.

1965. Folkwang Museum, Essen: Retrospective.
Graphische Sammlung Albertina, Vienna: Watercolours and engravings.
Forum Stadtpark, Graz: Watercolours and engravings.
Kootz Gallery, New York.

1966. Maison de la Culture, Caen: Paintings.
Galleria La Bussola, Turin: Paintings, engravings and lithographs.
Galerie Géo-Michel, Brussels: Engravings and lithographs.

1967. Galerie Holst Halvorsen, Oslo: Drawings and watercolours.
Christiansands Kunstforening, Christiansand, Norway.
Stavanger Kunstforening, Stavanger, Norway.
Galerie de France, Paris: Paintings and watercolours.

1968. Frank Perls Gallery, Los Angeles: Paintings and engravings.
Museum of Art, San Francisco: Paintings, engravings and lithographs.

1969. Galerie de l'Angle aigu, Brussels: Watercolours and lithographs.
Galerie Saint-Michel, Bordeaux.
Galerie de Montreal, Montreal.
Musée d'Art contemporain, Montreal: Retrospective.
Musée du Québec, Québec: Retrospective.

1970. Galerie Gerald Cramer, Geneva: Watercolours, illustrated books and engravings.
Galerie Argos, Nantes: Paintings and watercolours.
Internationale Sommerakademie für Bildende Kunst, Salzburg.
Galerie de France, Paris.
Palais des Beaux-Arts, Charleroi: Retrospective.
Galerie At Home, Toulouse.

1971. Galerie Philippe Ducastel, Avignon: Paintings, watercolours and lithographs.
Galerie Candillac, Bordeaux: Paintings, watercolours and lithographs.
Galerie Pierre Hautot, Paris: Engravings and lithographs.
Galerie Municipale, Esch-sur-Alzette (Luxemburg): Paintings, watercolours and prints.

1972. Galerie Maurel, Nîmes: Paintings and engravings.
Kunst Forum, Schelderode: Paintings.
Galerie de France, Paris: Drawings in India ink, with sculptures by May Zao.

1973. Galerie Protée, Toulouse: Paintings and drawings in India ink.
Musée d'Art et d'Histoire, Neuchâtel.
Galerie Melisa, Lausanne.
Observatoire de Genève, Sauverny: Lithographs and engravings.
Chapelle du Parage, Les Arcs.
Galeria Carl Van der Voort, Ibiza: Watercolours and drawings.
Galerie Synthèse, Antwerp: Prints and wash drawings.
Galerie Ducastel, Avignon: Prints and wash drawings.

1974. Galeria Diprove, Lisbon: Paintings, prints and wash drawings.
Galeria Diprove, Oporto: Same exhibition.
Maison des Arts et Lettres, Sochaux: Paintings and wash drawings.
Galerie Kutter, Luxemburg: Paintings and watercolours, wash drawings and lithographs.
Heimshoff Galerie, Essen: Paintings, watercolours and engravings.
Galerie Nicolas, Amsterdam: Paintings, watercolours and wash drawings.
Galerie Bruck, Luxemburg: Prints.

1975. Salon des Beaux-arts, Centre Culturel de Creil: "Homage to Zao Wou-Ki" (15 paintings).
Galerie de l'Ours, Bourges: Watercolours and prints.
Galerie Art et Matière, Grenoble: Watercolours and prints.
Galerie 31, Strasbourg: Prints.
Fondation Veranneman, Kruishoutem (Belgium): Large formats; also four sculptures by May Zao.
Galerie de France, Paris: "1971-1975". Catalogue with a preface by René Char.

Galerie ABCD, Paris: Prints.
Delta International Art Center, Beirut. Catalogue with a preface by Marwann Hoss.
Galerie ACB, Geneva: Illustrated books, watercolours and prints.
Maison de la Culture, Saint-Étienne: 20 paintings, watercolours and prints, with sculptures by May Zao. Catalogue with a preface by Maurice Allemand.
Galerie Nieuwe Weg, Doorn: Prints.
Galerie Nouvelles Images, Lombreuil: Drawings and prints.

1976. Galerie Ducastel, Avignon.
Galerie Pro Arte, Mulhouse.
Librairie Fontaine, Paris: Recent prints.

Galerie Protée. Toulouse: Paintings, watercolours and wash drawings.
Galerie Jivo, Vanesborg (Sweden): Prints by Zao Wou-Ki and Soulages.

1977. Fuji Television Gallery, Tokyo: Catalogue with prefaces by Tamon Miki and Henri Michaux.

1978. Town Hall, Châteauroux: 40 prints. Municipal Library, Châteauroux: *A la gloire de l'image,* by Roger Caillois, illustrated by Zao Wou-Ki.
Gallery Huset, Copenhagen: "Zao Wou-Ki Poetisk-Grafik"
Galeria Joan Prats, Barcelona: "About gesture", with a preface by Dora Vallier
Paris, F.I.A.C. 1978: Atelier Lacourière et Frélaut; Galerie de France.

COLLECTIVE EXHIBITIONS

1946. "Contemporary Chinese Painting", Musée Cernuschi (private room), Paris.
"Contemporary Chinese Painting", National Museum of Natural History, Chungking.

1948. "Four Chinese painters", Chinese Government Information Office, Paris.

1950. "Lecture d'Henri Michaux", Galerie La Hune, Paris.
Since 1950 Zao Wou-Ki has shown regularly at the Salon de Mai.

1951. Galerie Nina Dausset, Paris.

1952. "Young painters of the School of Paris", an exhibition organized in various English museums by the British Arts Council.

1954. "Painters of today", Turin Biennale.
Galerie Ariel, Paris.
Cabinet des Estampes, Geneva.
Rotterdamse Kunstkring, Rotterdam: Engravings.

1955. "Pittsburgh International", Carnegie Institute, Pittsburgh.
3rd São Paulo Biennale.
"Art 55", Museum of Fine Arts, Rouen.

1956. Galerie Lucien Blanc, Aix-en-Provence.
"Ten years of French art", Museum of Grenoble.
"Art lovers", Nantes.

1957. "Abstract painting", Galerie Creuze, Paris.
"The School of Paris", Galerie Charpentier, Paris.
"Painters of today", Museum of Turin.
Premio Lissone Exhibition, Carrara.
Galleria dell'Ariete, Milan.
Museum of Fine Arts, Tokyo.
Museum of Modern Art, Pittsburgh.

1958. "The School of Paris", Galerie Charpentier, Paris.
Kootz Gallery, New York.
"Exhibition of contemporary art", Museum of Nantes.
"Pittsburgh International", Carnegie Institute, Pittsburgh.
French Pavilion, International Exhibition, Brussels.
"Contemporary French painting", in various towns in Yugoslavia.
"East-West", Musée Cernuschi, Paris.
Print rooms, Vonderbank, Frankfurt: Engravings.

1959. "The School of Paris", Galerie Charpentier, Paris.
"Drawings by artists of the School of Paris", Galerie Creuzevault, Paris.
"Paintings of today", Museum of Grenoble.
Salon des Tuileries, Nice.
"East-West", Musée Cernuschi, Paris.
Galerie Birch, Copenhagen.
Redfern Gallery, London.
"School of Paris, the Internationals", Walker Art Center, Minneapolis.
"From Gauguin to our day", in various towns in Poland.
"Exhibition of French painting", Dortmund, Vienna and later several towns in Poland.
"Painters of today", Museum of Turin.
Kootz Gallery, New York.
Walker Art Gallery, Liverpool.

1960. "Antagonisms", Museum of Decorative Arts, Paris.
"Art and youth", Brest.
"French painting", Venice Biennale.
Parwood Investments, Los Angeles.
"Contemporary French art", Göteborg.
"Modern Graphic Art", Kunsthaus, Glarus (Switzerland).
2nd Tokyo International Biennale.
Galerie de France, Paris.

1961. Exhibition at the UNESCO Centre, Paris, organized by the Philips Company.

Galerie Argos, Nantes.
"Painters of today", Museum of Turin.
"Pittsburgh International", Carnegie Institute, Pittsburgh.

1962. "Salon des Surindépendants", Paris.
"Diptychs and triptychs by contemporary artists", Galerie Creuzevault, Paris.
Galerie Spinazzola, Aix-en-Provence.
International Exhibition, Museum of Modern Art, Tokyo.
Presentation of the Salon de Mai in Tokyo.
Exhibition of French drawings in Poland.
Redfern Gallery, London.
"Kootz Gallery", John and Mabel Ringling Museum of Art, Sarasota (U.S.A.); Municipal Gallery, Esch-sur-Alzette (Luxemburg).
"Eight painters of the School of Paris", Molton Gallery, London.
"International Prints", Cincinnati Art Museum, Cincinnati.
"21 Artists from Klee to Fontana", Minami Gallery, Tokyo.

1963. "Exhibition of contemporary French art", Yugoslavia.
"French Painting", Rhodes National Gallery, Salisbury (Rhodesia).
"School of Paris", American Federation of Art, New York: Watercolours.
"Soulages, Sugaï, Zao Wou-Ki", Kootz Gallery, New York; Galleria La Bussola, Turin.
Redfern Gallery, London.
Galerie 8, Athens: Engravings and watercolours.
Galerie am Griechenbeisl, Vienna.
"Contemporary French art", Canada.
Galerie Valérie Schmidt, Paris.
"International Meeting of Artists", Rabat.

1964. Galerie Mourgue, Paris.
"Selected works from 1900 to our day", Galerie Kaganovitch, Paris.
"Beyond dimensions", American Center, Paris.
"School of Paris", 1964 (with Hans Hartung, Manessier, Soulages, Singier, Poliakoff, Alechinsky, González, Robert Muller), Galerie de France, Paris.
Galerie L'Armitière, Rouen.
"The painters of the Galerie de France", Maison de la Culture, Caen.
"Lourdes 64", Lourdes.
Galerie Horn, Esch-sur-Alzette (Luxemburg).
Eugenio Mendoza Foundation, Caracas (Venezuela).
Galerie Handschin, Basel.
"Drawing International", Darmstadt.
"Pittsburgh International", Carnegie Institute, Pittsburgh.

1964-1965. "Graphics 65". University of Kentucky, Lexington.
Stedelijk Museum, Schiedam.

1965. La Pochade, Paris: Etchings and lithographs.
"Promises kept", Musée Galliera, Paris.
"Under the sign of Pausias", Galerie XXᵉ Siècle, Paris.
1st Festival organized by the AGEM under the aegis of the "Centre National de Diffusion Culturelle", Le Mans; Museum of Art and Industry, Saint-Étienne; Musée Fabre, Montpellier.
"Art Collection of the Grand Duchy of Luxemburg", Museum of Verviers.
Municipal Gallery, Esch-sur-Alzette (Luxemburg): Engravings.
Redfern Gallery, London.
Presentation of the Salon de Mai in Poland.
"Works in Progress", Kootz Gallery, New York.
"Art International", Museum of Skopje.
"Contemporary graphic art in France", travelling exhibition: Berlin, Magdeburg, Halle, Leipzig.
"International 65", Hudson Gallery, Detroit.
"Contemporary French art", travelling exhibition in South America organized by Bernard Dorival and Michel Hoog: Rio de Janeiro, Buenos Aires, Montevideo, Santiago de Chile, Lima.
"Contemporary Chinese artists", Museum of Brussels.

1966. "Panorama 1886-1966", Imprimerie Draeger, Paris.
"Painters of today", Galeries Lafayette, Paris.
"The art lover's print room", Galerie Dalléas, Bordeaux.
"Contemporary graphic art in France", travelling exhibition in Czechoslovakia: Prague, Bratislava, Cheb, Litomerice, Usti, Ziline.
Presentation of the Salon de Mai in Yugoslavia.

1967. "The four elements. Earth", Galerie Cimaise Bonaparte, Paris.
"Contemporary trends", T.E.P., Paris.
Museum of Saint-Maur: Lithographs.
Galerie Harmonies, Grenoble: Engravings.
"Ten years of living art 1955-1965", Maeght Foundation, Saint-Paul-de-Vence.
Museum of Art and History, Saint-Denis.
"Trends in contemporary French painting", travelling exhibition in Germany: Berlin and Hamburg.
"Rosc International 1967", Royal Dublin Society, Dublin.
7th International Engraving Biennale, Ljubljana.
French Pavilion, International Exhibition, Montreal.
Municipal Gallery, Esch-sur-Alzette (Luxemburg): Engravings.
Exhibition of engravings organized by the Club Méditerranée on the liner Louis-Lumière, in the course of a South American cruise.
"Pittsburgh International", Carnegie Institute, Pittsburgh.
"From Cézanne to Picasso", Musée de l'Athénée, Geneva.
"Vancouver Print International", Vancouver.
"Jazz 67", Musée Galliera, Paris.

1968. "From the landscape", Galerie Kaganovitch, Paris.
Exhibition organized on the occasion of the presentation of Michel Ragon's book, *La peau des choses,* Galerie Arnaud, Paris.
"Living painting", Maison de la Culture, Nanterre.
"Expression at present", Centre Culturel, Gennevilliers.
"Living art 1965-1968", Maeght Foundation, Saint-Paul-de-Vence.
Mentone Biennale.
"Painting in France 1900-1967", travelling exhibition: National Gallery, Washington; Metropolitan Museum, New York; Museum of Fine Arts, Boston; Art Institute, Chicago; Museum of the Legion of Honor, San Francisco; Detroit Institute of Arts, Detroit; Museum of Contemporary Art, Montreal; Museum of Quebec.
"International Print Biennale", City Art Gallery and Museum of Bradford.
"French graphic art from 1930 to today", Baukunst, Cologne.
"International Drawing Biennale", Moderna Galerija, Rijeka, Yugoslavia.
"Masters from here and there", Galerie de Montreal.
"The poster, art's support in the opposition", Galerie Nicaise, Paris.
Galerie Argos, Nantes.

1968-1969. "Black and White", Town Hall, Vitry.
"Asian paintings in Paris", Maison de l'Iran, Paris.
Exhibition to mark the publication of Michel Ragon's book, *La peau des choses,* Galerie Arnaud, Paris.
Same exhibition, Municipal Museum, Les-Sables-d'Olonne.
"Homage to René Char", Museum of Modern Art, Céret.
"Graphic Arts of the 20th Century", Palais de l'Europe, Mentone.
"Illustrator painters. The modern illustrated book since Manet", Maeght Foundation, Saint-Paul-de-Vence.
International Exhibition of Contemporary Modern Art, "L'Oeil écoute", Avignon Festival, Avignon.
"Contemporary art", Palace Hotel, Gstaad.
"Contemporary French painting", travelling exhibition in Central America: Guatemala, Nicaragua, Panama, Honduras, San Salvador, Costa Rica.
"Contemporary art, a dialogue between East and West", National Museum of Modern Art, Tokyo.
"French Painting since 1900", Royal Academy of Arts, London.

1970. "Contemporary tapestries and ceramics", Centre Social Culturel, Hérouville-Saint-Clair.
"Prints, contemporary tapestries", National Museum of Modern Art, Seoul.
Mentone Biennale.
"Salon des peintres de Paris", Gentofte Radhaus, Gentofte.
"From Bonnard to our day", Museum of Fine Arts, Nancy.
Municipal Art Gallery, Esch-sur-Alzette (Luxemburg): Engravings.
"The figure in painting today", Lamalou-les-Bains.
"Second International Drawing Biennale", Moderna Galerija, Rijeka, Yugoslavia.

1970-1971. "Contemporary French painting", travelling exhibition: Korea, Malaysia, Ceylon, India, Pakistan.

1971. "Potential Forms", Mercedes-Benz Foundation, Paris.
Galerie Christine Leurent, Lille: Prints.
"Prix de la Critique 1968-69/1969-70", Palais des Beaux-arts, Charleroi.
"Five lyrical abstracts", Congress Hall, Royan Festival, Royan.
"Nature, man's source", Institut National de l'Éducation Populaire, Marly-le-Roi; Centre Culturel du Prieuré, Vivonins.
"Light of the hand", Maison des Jeunes et de la Culture, Caen; City Museum, Bayeux.
"Painters of Paris since 1950", Gulbenkian Foundation, Lisbon.
"Salon des Réalités Nouvelles", Paris.
"The great contemporary engravers", Galerie du Club Français du Livre, Paris.
"The museum in the street", Rue du Faubourg-Saint-Honoré, Paris.
Galerie du Soleil, Nice: Lithographs and engravings.
"René Char", Maeght Foundation, Saint-Paul-de-Vence; City of Paris Museum of Modern Art.
"Rosc 71", Waterford (Ireland): Prints and multiples.
Galerie Delsol, La Rochelle: Prints.
"Contemporary non-figurative artists", Théâtre-Maison de la Culture, Caen.
"The gallery in the street", Quartier Colbert and Cathedral, Tours.
"10th year", Galerie Argos, Nantes.
The Taiwan Art Center, Formosa.

1971-1972. "25 years of painting in France", travelling exhibition in India and Korea: Kyngbok Palace, Seoul; Lalit Kala Gallery, Hyderabad; Egmore Museum, Madras; Hejangir Gallery, Bombay.
"Panorama of contemporary French art", travelling exhibition organized by Jacques Lassaigne and the Association Française d'Action Artistique in the following centres: Iran Bastan Museum, Tehran; Gallery of the Semiramis Hotel, Cairo; Soutzo Museum, Athens; National Museum, Damascus; New Bab Rouah Gallery, Rabat; Town Hall, Algiers; Yahia Gallery, Tunis.

1972. Galerie Images, Gargilesse.
"Aspects of contemporary art", Maison des Jeunes et de la Culture, Drancy.
Galerie Sapone, Nice.
Painting Biennale, Le Cannet-Rocheville.
"Civilizations of the world and modern art", exhibition organized within the framework of the 20th Olympic Games, Munich.
"Paris and contemporary painting over the last half-century", travelling exhibition organized by Jacques Lassaigne and the Association Française d'Action Artistique in South America: National Museum of Plastic Arts, Montevideo; Museum of Fine Arts, Buenos Aires; Museum of Fine Arts, Santiago de Chile; Institute of Contemporary Art, Lima; Museum of Modern Art, Bogotá; Museum of the Central Bank, Quito; Ateneo, Caracas; Museum of Modern Art, Mexico.
Exhibition organized by the French Institute during the "Kunsttage Köln", Cologne.
Exhibition on print techniques, Collège d'échanges contemporains, Old Royal Convent, Saint-Maximin.
"Exhibition of Contemporary Prints by Chinese Printmakers", City Museum and Art Gallery, Hong Kong.
"Aspects of current art", Galerie de la Halle-au-blé, Alençon.
"Modern productions of the Sèvres National Factory", Antwerp (exhibition organized as part of the French Fortnight).

1973. Galerie Gilles Corbeil, Montreal.
"About Monet", exhibition held on the occasion of the publication of the book *Monet, Nymphéas ou les miroirs du temps,* by Denis Rouart and Jean-Dominique Rey (Librairie J.-P. Ollivier, Paris).
Centre culturel et social, Limoges: Prints.
"André Malraux", Maeght Foundation, Saint-Paul-de-Vence.
"Aspects of contemporary art", travelling exhibition in South Africa: South African National Gallery, Cape Town; Johannesburg Art Gallery, Johannesburg; Pretoria Art Gallery, Pretoria.
"Lyrical space from 1950 to our day", Abbey of Beaulieu-en-Rouergue; Maison des Jeunes et de la Culture, La Croix-des-Oiseaux, Avignon.
"International exhibition of original drawings", Skopje (Yugoslavia).
"Permanence of French art", Royal Scottish Academy, Edinburgh.

"Contemporary French prints", at Drisket the decorator's shop, Liège.
"French painting in France from 1900 to 1960", travelling exhibition in Yugoslavia: Belgrade, Skopje, Sarajevo, Zagreb, Ljubljana.
"Aspects of contemporary art", Musée Léon Dierx, Saint-Denis-de-la-Réunion (continuation of the exhibition presented in South Africa).
"Homage to Germaine Richier", Galerie Odermatt, Paris.
"The painters of the Galerie Protée", Galerie Protée, Toulouse.
Galerie L. Tragin, Brussels: Lithographs.

1973-1974. Travelling exhibition organized by the French Institute of Heidelberg: Kunstverein, Mannheim; French Institute, Mainz; Danube Commercial Centre, Ratisbon.
Galerie Christine Leurent, Lille: Prints published by La Hune, Paris.

1974. "Black and White", Galerie ABCD, Paris: Prints.
"Abstracts", Galerie R. Mischkind, Lille.
Atelier Hilbur, Karlsruhe: Prints.
European Engraving Biennale, Mulhouse.
Mentone Biennale.
"Views of G.-E. Clancier", Museum of Modern Art, Céret.
"10th International Art Biennale 1974", Palais de l'Europe, Mentone.
Royal Factory, Copenhagen: Ceramics, drawings, gouaches, engravings.
"4th Painting Biennale", Le Cannet-Rocheville: Paintings, watercolours and tapestries.
Museum of Agen: Tapestries.
Municipal Gallery, Esch-sur-Alzette (Luxemburg): Exhibition of engravings and lithographs.
Palais des Arts et de la Culture, Brest.
"The ceramic artists of the Sèvres National Factory", Amos Anderson Museum, Helsinki.

1975. "New Images", Galerie de la Défense, Paris.
Salon de Mai, Paris.
Hôtel du Lion, Mulhouse.
"Lithographs by Zao Wou-Ki, Soulages, Hartung and Manessier", Galerie Irène Huisse, Rouen.
"Prints from Bonnard to our day", Museum of Chartres.
"The abstracts", Galerie Olivier, Lille.
"Today's great and young", Salle de la nouvelle mairie, La Baule.
Galerie Nicole Fourrier, Lyon.
"12 masters of abstraction", Museum of Tourcoing.
Galerie Sapone, Nice.
"The universe of Roger Caillois", Municipal Library, Vichy.
"Weber Selection": Galerie Médicis, Ostend; Galerie Huisse, Rouen; Galerie Joan D. Galtung, Oslo.
"Manessier, Soulages, Zao Wou-Ki", Galerie Modulo, Oporto: Prints.
"Estève, Hartung, Manessier, Miró, Poliakoff, Soulages, Zao Wou-Ki: "Abstract prints", Art Conseil, Paris.
"Selection of prints", Librería Central Bogotá (Colombia).
"Prints 1973-1975", Centre Culturel and Galerie Guénaud, Limoges.
"San Lazzaro and his friends", City of Paris Museum of Modern Art.
"Weber Selection 2", Galerie de France, Paris.
1st International Art Exhibition, International Art Centre, Tehran.
"Etchings and Line Engravings", Atelier aux Abbesses (with the cooperation of the Atelier Lacourière), Paris.
"60 years of abstract art", Maison de la Culture André Malraux, Rheims.
Galerie Convergence, Nantes: Prints.
"Weber Selection", 5th Fine Arts Exhibition, Centre Culturel de la Ville, Creil.
Galerie ACB, Geneva: Illustrated books, watercolours, wash drawings.

1976. "Contemporary prints", Maison des Livres et de la Culture Marengo, Angoulême.
"Contemporary Art 3", Centre Georges Pompidou, National Museum of Modern Art (one room), Paris.
J.-C. Sörensen Graphic Centre, Hjorring.
"Weber Selection 1", Municipal Gallery, Esch-sur-Alzette (Luxemburg).

"From Impressionism to our day", Cultural Foundation, Brazil; Museum of Modern Art, Rio de Janeiro; Museum of Modern Art, São Paulo.
"The painters in Paris in the fifties", Galerie Melki, Basel.
21st Salon de Montrouge.
International Print Biennale (gold medal), Fredrikstad.
"Tours, multiples-76", Galerie Comparaison, Tours.
Saman Gallery, Tehran.
Galerie Ulysse, Vienna.
"L'atelier Lacourière et Frélaut", Galerie de France, Paris.
"Prints 1973-1975", Centre Culturel, Montmorillon.
"New works", Galerie de France, Paris: Hanging.
"Prints 1973-1975", Le Moulin du Verger, Puy-Moyen (Charente).
Pittsburgh Corporations Collect, Heinz Galleries, Carnegie Institute, Pittsburgh.
5th Biennale, Le Cannet-Rocheville.
"A century of painting in Paris. From Impressionism to our day", 21st Salon, Montrouge.
"Innovation and tradition", 55th Exhibition of the Society of French Engraver Painters, National Library, Paris.
"Actuelles 1", Galerie de France, Paris.
"Works on paper", exhibition organized by the Municipality and the French Cultural Centre of Salzburg: Pavillon and Bastion im Mirabellgarten Museums, Salzburg.
Landes Galerie, Klagenfurt.
"Magic of the image", Weber Selection 1, Galerie Claudine Planque, Lausanne.
Gabinete de Artes Gráficas, São Paulo.
Galerie de France, Paris: Paintings.
Galerie de France, Paris: Watercolours.

1977. "Works on paper", Neue Galerie, Graz.
"26 French artists", Kunstforening, Aarhus (Denmark).
"Works on paper" (Hartung, Manessier, Musie, Poliakoff, Soulages, Zao Wou-Ki), Landesmuseum, Innsbruck.
"Abstract lyricism and landscape 1945-1975", Musée Cantini, Marseilles.
Centre Georges Pompidou, Paris: Prints.
Nordjyllands Kunstmuseum, Aalborg (Denmark).
Kunstpavillon, Esbjerg (Denmark).
Kunstforening, Svendborg (Denmark).
"Homage to Julien Alvard", Château d'Ancy-le-Franc (Yonne).
National Library, Paris, "The book and the artist". Cat. 54.103.
Galerie Pesch Atrium, Cologne.
"The book and the artist", National Library, Paris.
"Abstraction II", Maison des Arts et Loisirs, Montbéliard.
"Colour", Galerie Protée, Toulouse (Manessier, Poliakoff and Zao Wou-Ki).

1978. "Malraux, encounter with history", Association mulhousienne pour la culture, Mulhouse.
"Malraux, encounter with history", Municipal Library, Strasbourg.
"Malraux, encounter with history", Municipal Library, Colmar.
Salon de Mai, Paris.
"Paris, the fifties", Galerie Ariel, Paris.
"Salon de Mai" in Japan (5 museums).
"Interior landscape, Realistic landscape", Château de Sainte Suzanne.
"Interior landscape today about Max-Pol Fouchet", Château Vesvres, Rouy.
"Paris, home of painters", Forum des Halles, Paris.
"Landmarks 1956-1975", Museums of Milan, Naples, Florence, Poland, Barcelona and Madrid.
"20 ans de peinture", Eymoutiers Town Hall.
"Ecole de Paris", Palazzo Reale, Milan.
"Les amis de Jean Lescure", Centre Culturel de Paris.
"Les estampes aujourd'hui 77-78" and "Hommage à Léopold Sédar Senghor", Bibliothèque Nationale, Paris.
"Les Elégies majeures de Léopold Sédar Senghor" with Vieira da Silva, Hadju, Hartung, Manessier, Soulages and Zao Wou-Ki, Galerie de France, Paris.

BIBLIOGRAPHY

A.E.D.: *Zao Wou-Ki.* "Nouvelle Gazette", 28 November 1969.

A.K.: *Zao Wou-Ki à la galerie du Capitole.* "Gazette de Lausanne", 4 April 1956.

Allemand, Maurice: Preface to the catalogue of the exhibition in the Maison de la culture et des loisirs, Saint-Étienne.

Arnason, H.H.: *History of Modern Art.* Pages 574, 583. Harry H. Abrams Editions, New York.

Bardiot, Jean: *Un aristocrate de la peinture.* "Valeurs actuelles", 20 April 1967.

Baron, Jeanine: *Zao Wou-Ki et May Zao, deux styles et une même espérance.* "La Croix", 8 January 1973.

Barotte, René: *Zao Wou-Ki. Des arbres comme des systèmes nerveux ensanglantés.* "Paris-Presse", 18 April 1967.
Zao Wou-Ki et May Zao qui travaillaient si bien l'un près de l'autre. "L'Aurore", 20 December 1972.
Zao Wou-Ki. "Sud-Ouest" (Bordeaux), 28 September 1975.

Batlle-Vallmajó, M.: *Zao Wou-Ki l'enchanteur.* "Sud-Ouest" (Bordeaux), 2 April 1970.

Bell, Eleanor: *Chinese Artist Speaks from Paris.* "The Cincinnati Post", 27 November 1954.

Béraud, Jeanne: *Zao Wou-Ki.* "La Nouvelle Revue Française", August 1957.

Bobot, M. T.: *L'Art Chinois.* Ed. Desclée de Brouwer, Brussels, 1974.

Boissieu, Jean: *Orientale Avignon.* "Le Provençal-Dimanche" (Marseilles), 4 November 1973.

Bonnefoi, Geneviève: *Loin de la photographie* and *Lecture de Zao Wou-Ki par Henri Michaux.* "Le Nouvel-Observateur", 19 April 1967.

Boudaille, Georges: *Une semaine à Paris.* "Les Lettres Françaises", 13 April 1967.

Bouret, Jean: *Zao Wou-Ki.* "Arts", 22 June 1951.

Bourniquel, C.: *Zao Wou-Ki.* "Esprit", January 1971.

Brière, Valérie: *Estampes de Zao Wou-Ki.* "Critique", October 1975.

Cabanne, P.: *Aux antipodes de l'objet.* "Arts", 12 April 1967.
Voici la réalité poétique, la vraie. "Arts et Loisirs", 12-18 April 1967.
La nature parle d'elle-même. "Combat", 23 November 1970.
Focus. Ed. Bordas, Paris. 1971. Pp. 140 & 486.
Les deux Zao. "Combat", 18 December 1972.
De Corot à Zao Wou-Ki. "Elle", 6-12 June 1975.
Les Arts. Ed. Bordas, Paris, 1976. P. 1426.

Caillois, Roger: *Stèle pour honorer un peintre,* and Marchesseau, Daniel: *Zao Wou-Ki.* "Cimaise", No. 138-139, Cover and pages 9-20.

Cardoso, J. R.: *O Pintor Zao Wou-Ki.* "Jornal de Comercio" (Oporto), 14 February 1970.
Zao Wou-Ki. "Gazeta do Sud" (Montijo), October 1970.
Zao Wou-Ki. "Republica" (Lisbon), 6 March 1970.

Carvalho, Renée: *Zao Wou-Ki.* "Vision sur les Arts" (Béziers), No. 29, 1963.

C.B.: *Zao Wou-Ki.* "Les Lettres Françaises", November 1970.

C.F.: *Un peintre magicien.* "Presse Nouvelle", 21 April 1967.

Chapon, F.: *Chronique sur Zao Wou-Ki et Roger Caillois,* Bulletin du Bibliophile, No. 4, 1977.

Chaput, Christian: *May Zao: sculptures - Zao Wou-Ki: encres de Chine.* "Esprit", January 1973.

Char, René: *Zao Wou-Ki 1971-1975.* Preface to the catalogue of the exhibition at the Galerie de France. Published by Galerie de France and Arts et Métiers Graphiques, Paris, 1975.

Charbonnier, Georges: *Le monologue du peintre.* Ed. Julliard, Paris, 1960. Vol. 2, pp. 181-188.

Cheng-Kan Hoo: *Zao Wou-Ki.* "Artist" (Taiwan), No. 31, December 1977. Pp. 60-71 and cover.

Chevalier, Denys: *May Zao et Zao Wou-Ki.* "Les Nouvelles Littéraires", 11-17 December 1972.

Coates, Robert M.: *West is East.* "The New Yorker", 27 October 1956.

Cogniat, Raymond: *Lecture par Henri Michaux de 8 lithographies de Zao Wou-Ki.* "Beaux-Arts", 14 July 1950.
Le geste et l'espace. "Le Figaro", 6 May 1967.

Conlan, Barnett D.: *Chinese Art in French Style.* "Daily Mail", 14 May 1949.
Zao Wou-Ki Begins a Page of History. "Daily Mail", 24 June 1951.
In *Pictures on Exhibit,* May 1967.

Darriulat, Jacques: *Vent d'Est, vent d'Ouest.* "Le Point", 1 January 1973.

D.C.: *Zao Wou-Ki.* "Art d'Aujourd'hui", 1960.

Defoy, Lucien: *Zao Wou-Ki à Charleroi.* "Le Rappel" (Charleroi), 28 November 1969.

Demoriane, Hélène: *Zao Wou-Ki.* "Le Point", 14 July 1975.

Dittiere, Monique: *Zao Wou-Ki.* "L'Aurore", 17 September 1975.

Dorival, Bernard: *Signovert et Zao Wou-Ki.* "La Table Ronde", December 1953.
Les peintres du XXe siècle. Ed. Tisné, Paris, 1957. Pp. 132-133, note 172.
The World of Abstract Art. G. Wittenborn, New York, 1957. P. 64.

D.S.: *Zao Wou-Ki.* "Le Courrier Français", 18 October 1969.

Dubrulle, P.: *Aux confins de l'Orient et de l'Occident.* "Journal de Charleroi", 9 December 1969.

Elgar, Frank: *La Chine à Paris.* "Carrefour", 29 May 1957.
Un Chinois à Paris. "Carrefour", 3 July 1975.

Faure, Jean: *Chez Ducastel, le retour du grand Zao Wou-Ki.* "Le Dauphiné Libéré" (Grenoble), 7 July 1976.

Fermigier, André: *Encres de Chine.* "Le Nouvel-Observateur", 18 December 1972.

F.F.: *Zao Wou-Ki et Jacques Villon.* "Tribune", 12 May 1953.

Fourcaud, Dr Gibert: *Le portrait du temps.* "Violon d'Ingres et Caducée", No. 66, 1976. Pp. 22-27.

Galy-Carle, Henry: *Zao Wou-Ki ou l'espace envahi par le rêve.* "Arts", 1 May 1963.
Zao Wou-Ki, une synthèse Orient-Occident. "Les Lettres Françaises", 23 December 1970.

G.B.: *Zao Wou-Ki.* "L'Est Republicain", 14 May 1953.

Gibson, M.: *Zao Wou-Ki.* "Herald Tribune", 5 July 1975.

Gindertael, R. V.: *A la Galerie de France, Zao Wou-Ki.* "Beaux-Arts", 24 May 1957.

Giralt-Miracle, Daniel: *Zao Wou-Ki, un pintor entre l'Orient i l'Occident.* "Avui", 20 October 1978.

Goern, Dr H.: *Zao Wou-Ki, ein Chinese in Paris.* "Neue Zeit", 19 February 1957.
Zao Wou-Ki. "Sansai", No. 92, 10 May 1957. Pp. 18-21.

Goldaine, Louis & Astier, Pierre: *Ces peintres vous parlent.* Published by L'Oeil du Temps, Paris, 1964. PP. 172-173.

Grand, P.-M.: *Œuvres récentes de Zao Wou-Ki.* "Le Monde", 14 april 1967.
Zao Wou-Ki à la Galerie de France. "Le Monde", 2 December 1970.

Granville, Léone de la: *Hommage à May.* "Plaisir de France", 12 December 1972.

Grenier, Jean: *Zao Wou-Ki.* "Preuves", May 1959.

Gutiérrez, Fernando: *Zao Wou-ki en la Galería Joan Prats.* "La Vanguardia", 21 October 1978.

Hagen, Yvonne: *East Meets West.* "New York Herald Tribune", 3 December 1958.

H.C.: *Zao Wou-Ki.* "Arts News", March 1960.

Heyligers, Claude: *Zao Wou-Ki ou l'alliance de l'Occident et de l'Extrême-Orient.* "Racing", September 1975.

Huser, France: *Un Oriental à Paris.* "Le Nouvel Observateur", 5 May 1975.

Iglesias del Marquet, Josep: *La Caligrafía ejemplar de Zao Wou-Ki.* "Diario de Barcelona", 15 October 1978.

Jackson, John E.: *En marge d'une exposition Zao Wou-Ki.* "Journal de Genève" (Samedi Littéraire), 15 November 1975.
Zao Wou-Ki: Quand je commence à peindre, je ne sais pas où je vais. Le tableau se structure à mesure. "Gazette de Lausanne", 15 November 1975.

Jacometti, Nesto: *Zao Wou-Ki.* "Documents" (Geneva), April 1951.
L'oeuvre gravé 1949-1954 de Zao Wou-Ki. Published by Gutekunst et Klipstein, Bern, 1955.
Booklet published by the Galerie Mala, Ljubljana, 1960.

J.A.F.: *Zao Wou-Ki.* "Aujourd'hui", January 1963.

Joly, Pierre & Cardot, Véra: *La maison du peintre Zao Wou-Ki.* "Maison Française", No. 205, March 1967.

Jouffroy, Alain: *Zao Wou-Ki.* "Arts", 1 June 1955.
Portrait d'un artiste: Zao Wou-Ki. "Arts", 5 September 1956.

J.P.: *Zao Wou-Ki.* "La Libre Belgique", 8 December 1969.

Kiehl, Roger: *Zao Wou-Ki.* "Les derniéres nouvelles d'Alsace", 23 April 1975.

Lambert, Jean-Clarence: *De la peinture officielle chinoise à Zao Wou-Ki.* "France-Observateur", 5 February 1959.

Lassaigne, Jacques: Preface to the catalogue of the exhibitions at the Musée d'Art contemporain, Montreal and the Musée du Québec, Québec, 1969.
Painting's sculptures. "Montreal Star", 9 June 1969.
La pittura sognante di Zao Wou-Ki. "Documento Arte", Rome, Year I, No. 2, October-November 1976. Pp. 29-39.

Laude, Jean: *Zao Wou-Ki.* Published by La Connaissance, Brussels, 1974.
Le merveilleux travail du pinceau. "L'Oeil", January 1975.
Zao Wou-Ki. Published by La Connaissance ("Depuis 45" Collection), Brussels, 1975.

L.B.: *Zao Wou-Ki.* "Tribune de Lausanne", 29 March 1956.

Lefebvre, Monique: *Le peintre Zao Wou-Ki.* "Télérama", 6 April 1974.

Lévêque, Jean-Jacques: *Dictionnaire des artistes contemporains.* Published by Les Libraires Associés, Paris, 1964. Pp. 172-173.
Promenez-vous dans le jardin de Zao Wou-Ki. "Arts", 5 April 1967.
Le monde de May Zao. "Le Nouveau Journal", 23 December 1972.
Zao Wou-Ki. "La Galerie", December 1972.
Airs de Fête. "Les Nouvelles Littéraires", 14 July 1975.
Poliakoff et Zao Wou-Ki. "Le Nouveau Journal", 5 July 1975.

Leymarie, Jean: *Zao Wou-Ki.* Published by Ediciones Polígrafa, S.A., Barcelona; Editions Hier et Demain, Paris; Rizzoli Editions, New York. Documentation by Françoise Marquet.

L.H.: *Zao Wou-Ki, un éparpillement.* "Arts", 15 May 1957.

Maillard, Robert: *Dictionnaire universel de la peinture.* Published by Le Robert, Paris, 1976. Pp. 494 & 495.

M.A.L.: *Zao Wou-Ki.* "Cimaise", January 1964.

Marester, Guy: *Zao Wou-Ki à la Galerie Pierre.* "Combat", 30 June 1952.

Marquet, Françoise: *Zao Wou-Ki, Les estampes 1937-1974* (75 first copies, accompanied by an etching). Published by Arts et Métiers Graphiques and Yves Rivière, Paris, 1975. Preface by Roger Caillois.

Masson, R. M.: *La signature du Dragon.* "Tribune de Genève", 27 May 1970.

Mazars, Pierre: *Zao Wou-Ki: le charme d'un peintre d'Extrême-Orient.* "Le Figaro", 6 April 1974.
Zao Wou-Ki et Rimbaud. "Le Figaro", 10 June 1975.

Mégret, Fréderic: *Zao Wou-Ki.* "Le Figaro Littéraire", 14 December 1970.

M.G: In "Les Nouvelles Littéraires", 9 April 1964.

Michaux, Henri: In "L'Herne", No. 8, 1968. P. 386.
Trajet Zao Wou-Ki. "XXe siècle", No. 36, 1971.
Trajet Zao Wou-Ki. Catalogue of the exhibition at the Fuji Television Gallery, Tokyo, 1977.

Michaux, Henri, Prévot, Myriam & Gali, Christian: *Parti-pris pour Zao Wou-Ki.* "Revue Parler", autumn and winter 1975.

Michel, Jacques: *Le voyage en Chine de Zao Wou-Ki. Propos recueillis par Jacques Michel.* "Le Monde", 8 December 1972.
Les territoires intérieurs de Zao Wou-Ki. "Le Monde", 3 July 1975.

Miki, Tamon: *Zao Wou-Ki and Space.* Catalogue of the exhibition at the Fuji Television Gallery, Tokyo.

Minamikawa, S.: *Zao Wou-Ki.* "The Geijutsu-Shincho", December 1975.

Moimant, Françoise: *Catalogue des estampes de Zao Wou-Ki.* "Nouvelles de l'Estampe", No. 23, 1975. P. 45.

Mosellan, Jean: *Zao Wou-Ki. Galerie Creuze.* "Opéra", 18 May 1949.

Muller, Joseph-Émile: *Encyclopédie de l'art au XXe siècle.* Published by Larousse, Paris, 1967. P. 286.

Neret, Gilles: *Zao Wou-Ki, retour de Chine.* "L'Oeil", January 1975.

Paret, Pierre: *Zao Wou-Ki à la Galerie Condillac.* "Sud-Ouest" (Bordeaux), 1971.

P.C.: *Zao Wou-Ki.* "Le Soir" (Brussels), 20 March 1968.

P.D.: *Zao Wou-Ki: à l'écart des formules.* "Tribune de Lausanne", 9 April 1967.

Peillex, Georges: *Les peintures de Zao Wou-Ki.* "Tribune de Lausanne", 29 May 1952.

Pierre, José: *L'Abécédaire. Appel à Zao Wou-Ki. 79 peintres et quelques sculpteurs.* Published by Éric Losfeld, Paris, 1971.

Plazy, Gilles: *Zao Wou-Ki: L'important, c'est la peinture.* "Le Quotidien de Paris", 19 June 1975.

Pluchart, F.: *Zao Wou-Ki nouveau.* "Combat", 11 June 1963.

Pradel, J. L.: *Zao Wou-Ki.* "La Quinzaine Littéraire", 16 December 1972.

Preston, Stuart: *Zao Wou-Ki.* "The New York Times", 1 May 1956.

Prévot-Douatte, Myriam: *Mon ami Zao Wou-Ki.* Booklet published by the Galerie de France, Paris, 1960.

Prévot-Douatte, Myriam; Lassaigne, Jacques; Ragon, Michel; Roy, Claude; Schneider, Pierre: *Zao Wou-Ki.* "Terre d'Europe", No. 53, September-October 1977.

P.S.: *Zao Wou-Ki; retour à la tradition.* "L'Express", 11 December 1972.

Ragon, Michel: *Zao Wou-Ki.* "Cimaise", No. 57, 1962 (preface to a booklet published by "Cuadernos de Arte del Ateneo", Madrid).
Zao Wou-Ki. "Arts", June 1963 (booklet published by the Redfern Gallery, London).
25 ans d'art vivant. Published by Casterman, París, 1969. Pp. 156-158.
Peinture contemporaine. Published by Casterman, Paris, 1974. P. 225 (reproduction on back cover).

Ragon, Michel & Seuphor, Michel: *L'Art abstrait.* Published by Maeght, Paris, 1971-1974. Pp. 37, 222, 265, 170, 171, 284.

Rey, J.D.: *Zao Wou-Ki.* "Le Monde", 7 December 1962.
Zao Wou-Ki. "Jardin des Arts", 1967.

Rey, Stéphane: *Zao Wou-Ki.* "L'Écho de la Bourse" (Brussels), 4 April 1975.

Rheims, Maurice: *Catalogue Bolaffi.* Published by F. Hazan, Paris, 1966. Pp. 401, 411, 470.

Rheinwald, Albert: *La vision de Zao Wou-Ki.* "Journal de Genève", 28 April 1951.

Rigaud, Jacques: *La culture pour vivre.* Published by Gallimard, Paris, 1975.

R.M.U.: *Zao Wou-Ki. Recherches colorées.* "Arts", 25 March 1964.

Roy, Claude: *Zao Wou-Ki*. Published by Georges Fall, Paris, 1957.

 Zao Wou-Ki. Published by Grove Press, New York, 1960.

 Iz likovenega Sveta, Pek in Pariz Mala gelerija. "Dnewnir" (Yugoslavia), 18 March 1960.

 Article in Bernard Dorival's *Les peintres célèbres*, published by I. Mazenod, Paris, 1964. Pp. 156-159.

 Un pays nommé Zao Wou-Ki. "Galerie des Arts", May 1967.

 Zao Wou-Ki. New edition, revised and corrected, with a preface by Henri Michaux. Published by Jacques Goldschmidt, Paris ("Le Musée de Poche" Collection), 1970.

 Depuis 45, Vol. I. Published by La Connaissance, Brussels, 1970. Pp. 79, 81, 92, 96.

 Zao Wou-Ki. "Art International", No. 7, 1971.

 Zao Wou-Ki. "Le Club Français de la Médaille", No. 54, 1977. Pp. 24-25.

Roy, Claude & Moimant, Françoise: *Zao Wou-Ki vu par Claude Roy* and *Dossier Zao Wou-Ki*. "Nouvelles de l'Estampe", No. 42, 1978. Cover and pages 43-50.

R.V.G.: *Une nouvelle expérience picturale de l'univers*. "Les Beaux-Arts" (Brussels), June 1960.

Santos Torroella, Rafael: *Zao Wou-Ki*. "El Noticiero Universal", 24 October 1978.

Sasaki, Mieco: *Zao Wou-Ki Exhibition*. "The Daily Yomiuri", Tokyo, 11 November 1977.

Schneider, Pierre: *Zao Wou-Ki*. "L'Express", June 1963.

 Au Louvre avec Zao Wou-Ki. "Preuves", No. 158, April 1964.

 Preface to a booklet published by the Albertina Museum, Vienna, 1965.

 Preface to the catalogue of the exhibition at the Galerie de France, Paris, 1967.

 Preface to the catalogue of the exhibitions in Los Angeles and San Francisco, 1968.

 Le retour d'un Chinois en Chine. "L'Express", 24 July 1972.

 Les dialogues du Louvre. Published by Denoël, Paris, 1972 (11 artists, notably Zao Wou-Ki, Soulages, Chagall, Miró; American edition published by the New York Atheneum).

 Les encres de Zao Wou-Ki. "Connaissance des arts", December 1972.

Schneider, Pierre & Manessier, Alfred: Preface to a booklet published by the Folkwang Museum, Essen.

Schneider-Arnspergel, Klaus: *Long Distance Interview. Artists in Paris Quizzed*. "Cincinnati Time-Star", 5 November 1954.

Seuphor, Michel: *Dictionnaire de la peinture abstraite*. Published by F. Hazan, Paris, 1957. P. 293.

 La peinture abstraite. Published by Flammarion, Paris, 1962. Pp. 166, 233.

Siblik, Jiri: *La Gravure contemporaine*. Published by Cercle d'Art, Paris, 1971. Pp. 102 & 103.

Socias, Jaume: *La magia oriental de Zao Wou-Ki*. "Destino", 25 October 1978.

Solier, René de: *Signes d'éléments*. In the catalogue of the exhibition at the Galerie de France, Paris, 1957.

Spielmann, Heinz: In "Das Kunstwerk", November 1961. Pp. 17-19.

S.T.: *Zao Wou-Ki*. "Arts", March 1960.

Sullivan, Michael: *Chinese Art in the 20th Century*. Published by Faber & Faber, London, 1959. Pp. 56, 57, 60, 75; plates 51, 52, 54, 60.

Surazu: *Lumière, vibration, espace dans la peinture hors de la pesanteur de Zao Wou-Ki*. "La Dépêche, la Liberté", Saint-Étienne, 20 December 1975.

Taillandier, Yvon: *Zao Wou-Ki*. "Connaissance des Arts", No. 63, 1957.

Tasset, Jean-Marie: *Zao Wou-Ki (deux expositions à Paris) a fait une découverte au nord-ouest de Pékin. Ces étonnants Chinois, peintres et paysans*. "Le Figaro", 3 June 1975.

Thoren, Barbara: *Zao Wou-Ki*. "The Japan Times", Tokyo, 11 November 1977.

Troche, Michel: *Zao Wou-Ki*. "Les Lettres Françaises", 12 June 1963.

Turpin, Georges: *Zao Wou-Ki*. "La Revue moderne des arts et de la vie", July 1949.

Vallier, Dora: *Zao Wou-Ki, autour du geste*. Preface to the catalogue of Galeria Joan Prats, Barcelona.

Vree, Freddy de: *Zao Wou-Ki*. Published by Kunstforum, Schelderode, Belgium (Kunstpocket Collection, in Flemish), 1977.

Vrinat, Robert: *Zao Wou-Ki*. "Jeune Afrique", 12 February 1967.

 In "Vision sur les Arts" (Béziers), No. 78, 1973.

Yonekera: *United Beauty of East and West*. "Asahi Shimbun", 7 November 1977.

Zervos, Christian: In "Cahiers d'Art", 1953. P. 309.

BIBLIOGRAPHY II (Unsigned articles, etc., in chronological order)

Art Bargains in Color Lithographs. "Life", 14 July 1952.

Zao Wou-Ki. "Aus Sudwest Deutschland", 29 October 1952.

Artist from East is a Hill in West. "Life", 22 February 1954. Pp. 102-104, 4 reproductions in colour.

Neue Kunst nach 1945. Published by Will Grobmann, Berlin, 1958. P. 50, plate 27.

Soulages et Zao Wou-Ki, calligraphie et peinture. "Bokubi", No. 76, May 1958.

Pariski Kitazec. "Delo" (Yugoslavia), 18 March 1960.

Zao Wou-Ki le contemplatif. "Chefs-d'oeuvre de l'art", 29 May 1963.

Le piéton de Paris: Art barbare et art civilisé. "France-Observateur", 13 June 1963.

Zao Wou-Ki. "Tageblatt", Esch-sur-Alzette (Luxemburg), 18 April 1964.

Métro 1964. Published by Métro, Milan, 1964. Pp. 396 & 397.

Zao Wou-Ki aux confins de l'Orient et de l'Occident. "Sud-Ouest" (Bordeaux), 22 October 1969.

Zao Wou-Ki. "Vie des Arts", Montreal, November 1969.

Zao Wou-Ki. "Plaisir de France", November 1970.

Traité des techniques. Published by Princeps, Paris, 1971. Pp. 1-105.

Catalogue of the exhibition "Homage to René Char", organized by the Maeght Foundation, Saint-Paul-de-Vence and the City of Paris Museum of Modern Art, Nos. 259, 708, 709.

Où en est l'art chinois contemporain. "Les Nouvelles Littéraires", 7 May 1973.

Premier Chinois naturalisé Français, le peintre Zao Wou-Ki a fait un nouveau séjour en Chine. "L'Express", 28 October 1974.

Zao Wou-Ki. "Les Muses", No. 258, 1974. Pp. 5148-5150.

Art Actuel Annuel. Published by Skira, Geneva, 1976. P. 83.

Petit Larousse. 1976

Petit Larousse illustré. 1977.

Zao Wou-Ki. "Gallery", Vol. 7, Tokyo, October 1976. Pp. 21-24.

In oriental pursuit of life. "Komei shimbun", 1 November 1977.

Oriental Mysterious space. "Sankei Shimbu", 14 November 1977.

Oriental Line, Similarity to Chinese Black and White Painting. "Shin-Bijutsu shimbu", No. 139, 1 October 1977.

Contemporary Artists. St Martins Press, Inc. Editions, New York, 1977.

INTERVIEW

1978. "Un homme, une ville. Rembrandt à Amsterdam", Radio programme by Pierre Descargues, with Zao Wou-Ki. France-Culture (two hours).

 "Visite d'Atelier" Emission by François Le Targat. France-Culture (30 minutes).

APPLIED ARTS

1953. Décor and costumes for Roland Petit's ballet *La Perle*, based on a libretto by Louise de Vilmorin, with choreography by Victor Gsovsky and music by Claude Pascal.

1970. Decorative panel for a Boeing 747 of the Air France fleet.
Tapestry for the Gobelins National Factory, Paris, 385 × 485 cm.

1972. Decorative panel for a Boeing 747 of the Air Fance fleet.

1973. Tapestry for the Gobelins National Factory, Paris, 300 × 600 cm.
Carpet for the Savonnerie Factory, Paris, 400 × 400 cm.

1974-1975. Décor and costumbres for Béla Bartók's *The Wonderful Mandarin* and *The Wooden Prince;* choreography by Milko Sparemblak and Peter Van Dyk (Rhine Opera: Mulhouse, Colmar, Strasbourg). Production by Alain Lombard.

FILMS IN COLOUR

1960. *Ateliers en France: Zao Wou-Ki.* Director: Pierre Neurisse. Commentary by Claude Roy.

1964. *Zao Wou-Ki*, in the "Art Vivant" series. Director: Jean-Michel Meurice. Film in colour, 16 mm., 26 minutes. Produced by Deroclès, Paris.

1969. *Zao Wou-Ki*, in the "Champ Visuel" series. Director: Pierre Schneider. Film in colour. Produced by the O.R.T.F. 2nd channel.

1972. *Le défi de la grandeur.* Director: Herbert Kline. Worldview Production, Los Angeles. Commentary read by Orson Welles.

1974. *Personnage de la vie.* Directors: Claude-Jean Philippe and Monique Lefebvre. Film in colour, 16 mm., 52 minutes, shown on 7 April 1974. Produced by the O.R.T.F. 2nd channel.

1975. *Ombre et lumière.* Director: Daniel Le Comte.
France Panorama: Zao Wou-Ki. Director: Angeliki Haas, for the Ministry of Foreign Affairs. Produced by Gaumont Cinéma.

1976. *Chronique de la France: Zao Wou-Ki.* Director: Max Gérard, for the Ministry of Foreign Affairs, Cultural Exchange Service. Produced by Pathé Cinéma.

1977. *L'Aventure de l'Art Moderne.* Director: Carlos Vilardebó. Produced by Pathé Cinéma.
Sur Zao Wou-Ki. Interviews by Yusuke Nakahara and Michiyo Yokoyama. Video: 30 mm. Directed and produced by T.V.-Museum, Tokyo.

1978. *Potrait d'artiste: Zao Wou-Ki.* Director: Jacques Navadic. Presented by Liliane Thorn. Produced by Téle-Luxembourg; 30 minutes.

TEXTS BY ZAO WOU-KI

1967. *Estampages Han.* Preface by Zao Wou-Ki and Claude Roy. Published by Le Club Français du Livre.

BOOKS ILLUSTRATED BY ZAO WOU-KI

1950. Michaux, Henri: *Lecture par Henri Michaux de 8 lithographies de Zao Wou-Ki.* Euros & Robert Godet, Paris.

1950. Roskolenko, Harry: *Paris Poems.* Editions Euros, Paris.
Louis Broder, Paris.

1962. Malraux, André: *La Tentation de l'Occident,* 10 lithographs in colour. Les Bibliophiles Comtois, Paris.
Juin, Hubert: *Les terrasses de jade,* 4 engravings in colour. La Source, Paris.

1965. Saint-John Perse: *Oeuvre poétique.* 8 watercolours reproduced in colour. Rombaldi, Paris.

1966. Rimbaud, Arthur: *Les illuminations.* 8 watercolours reproduced in colour. Le Club Français du Livre, Paris.

1967. Rimbaud, Arthur: *Les Illuminations.* 8 original engravings in colour. Le Club Français du Livre, Paris.

1971. Lescure, Jean: *L'étang.* 8 engravings in colour. Galanis, Paris (selected in 1973 by the Committee for Book Exhibitions and French Graphic Arts as one of the "50 beautiful books of the year 1972").
Pound, Ezra: *Cantos Pisan.* Pierre Belfond, Paris.
François, Jocelyne: *Feu de Roue.* 1 lithograph in colour. Fata Morgana, Montpellier.
Kobler, Arnold: *Gerald Cramer, Trente ans d'activité.* Prints by: Arp, Braque, Calder, Chadwick, Chagall, Dunoyer de Segonzac, Max Ernst, Marino Marini, Henri Matisse, André Masson, Joan Miró, Henry Moore, Picasso, Siqueiros, Jacques Villon and Zao Wou-Ki. Gerald Cramer, Geneva.

1974. Laude, Jean: *En attendant un jour de fête.* 1 etching. Fata Morgana, Montpellier.
Laporte, Roger: *Une migration.* Letter-preface by René Char, frontispiece by Zao Wou-Ki, 1 original etching. Fata Morgana, Montpellier.
Char, René: *Le monde de l'art n'est pas le monde du pardon.* 6 lithographs in colour: Miró, Lam, Szènes, Vieira da Silva, Charbonnier, Zao Wou-Ki. Maeght, Paris.

1975. Caillois, Roger: *Randonnée.* 5 etchings in colour accompanying a text by Roger Caillois. Yves Rivière, Paris.
Cadieu, Martine: *La mémoire amoureuse.* Letter-preface by René Char, frontispiece by Zao Wou-Ki, 1 original etching. Rougerie, Limoges.
San Lazzaro et ses amis. 9 lithographs in colour: Max Bill, Calder, Chagall, Max Ernst, Hartung, Miró, Sutherland and Zao Wou-Ki. XXe Siècle, Paris.

1976. Gali, Christian: *Bocage pour les allusions à Brève.* With 1 engraving in black and white. St-Germain-des-Près, Paris.
Caillois, Roger: *À la gloire de l'image.* With 15 lithographs in colour. La Polígrafa, S.A., Barcelona.
Boudaille, Georges; Lescure, Jean; Parmelin, Hélène: *Hommage à Federico Fellini.* (Illustrations by) Corneille, Kijno, Labisse, Lindström, Messagier, Pignon, Prassinos, Singier, Zao Wou-Ki. Grégory, Rome.

1977. *Hommages aux prix Nobel.* Portfolio with works by 33 artists. Galerie Börjeson, Malmö.

1978. Senghor, Léopold Sédar: *Élégie pour Jean-Marie.* With 4 lithographs in colour. Regard, Geneva.

PUBLIC MUSEUMS AND COLLECTIONS POSSESSING WORKS BY ZAO WOU-KI

AUSTRIA
Albertina Museum, Vienna.

BELGIUM
Royal Library of Belgium, Brussels.
Museum of Fine Arts, Brussels.

BRAZIL
Museum of Modern Art, Rio de Janeiro.

CANADA
Canadian Imperial Bank of Commerce, Toronto.
Museum of Fine Arts, Montreal.

FINLAND
Kunstmuseum Athenaeum, Helsinki.

FRANCE
Le Havre Museum, Le Havre.
National Museum of Modern Art, Paris.
City of Paris Museum of Modern Art.
National Fund of Contemporary Art, Paris.
National Library, Paris.
Gobelins National Factory.
Savonnerie National Factory, Paris.
Sèvres National Factory, Paris.

GERMANY
Folkwang Museum, Essen.

GREAT BRITAIN
Tate Gallery, London.
Victoria and Albert Museum, London.

HONG KONG
French Consulate General (on loan from the CNAC).

INDONESIA
Museum of Djakarta.

ISRAEL
Museum of Tel-Aviv.

ITALY
Civic Gallery of Modern Art, Genoa.
Civic Gallery of Modern Art, Milan.
Museum of Fine Arts, Milan.

JAPAN
Nagaoka Contemporary Art Museum, Nagaoka, Tokyo.
Bridgestone Museum of Art.
The Fuji Telecasting Co. Ltd. Collection.
Kanichiro Ishibashi Collection
Nobutaka Shikanai Collection.
H. Imasato Collection.
The Hakone Open-Air Museum

JAVA
Museum of Djakarta.

LUXEMBURG
Museum of History and Art.

MEXICO
Museum of Contemporary Art, Mexico.
Museum of Modern Art, Mexico.

PORTUGAL
National Museum of Fine Arts, Oporto.

SWITZERLAND
"Gerald Cramer Foundation" Museum of Art and History, Geneva.
Thyssen-Bornemisza Collection, Castagnola.

U.S.A.
Aldrich "Old 100" Collection, Ridgefield.
Art Institute of Chicago, Chicago.
Atlanta Art Center, Atlanta.
Atlanta University, Atlanta.
Berkeley University, Los Angeles.
Carnegie Institute, Pittsburgh.
Cuyahoya Savings Association. Cleveland.
Cincinnati Art Museum, Cincinnati.
Coldby Museum of Art, Maine.
Detroit Institute of Art, Detroit.
Finch Art College Museum, New York.
Fogg Art Museum, Harvard University, Cambridge (Massachusetts).
Herbert F. Johnson Museum of Art, Ithaca (New York).
Hirshhorn Museum, Washington, D.C.
International Minerals and Chemicals Corporation, Stanford (California).
Medical Research Center, Los Angeles.
Museum of Fine Arts, Houston (Texas).
Museum of Modern Art, San Francisco.
Rose Museum, Brandeis University.
San Francisco Museum, San Francisco.
Solomon R. Guggenheim Museum, New York.
Stanford University, Stanford (California).
Upjohn Company Collection, Kalamazoo (Michigan).
Virgin Island Museum, St. Thomas (Virgin Islands).
Virginia Museum of Fine Arts, Richmond (Kentucky).
University of Virginia Art Museum, Richmond.
Wadsworth Atheneum, Hartford (Connecticut).
White Art Museum, Cornell University, Ithaca (New York).
Walker Art Center, Minneapolis.
Yale University Art Gallery, New Haven.
High Museum of Art, Atlanta (Georgia).
Middle South Service Inc.

YUGOSLAVIA
Museum of Contemporary Art, Skopje.

Printed in Spain by La Polígrafa, S. A. - Balmes, 54 - Barcelona-7 - Spain - Dep. Legal: B. 24.006 - 1979

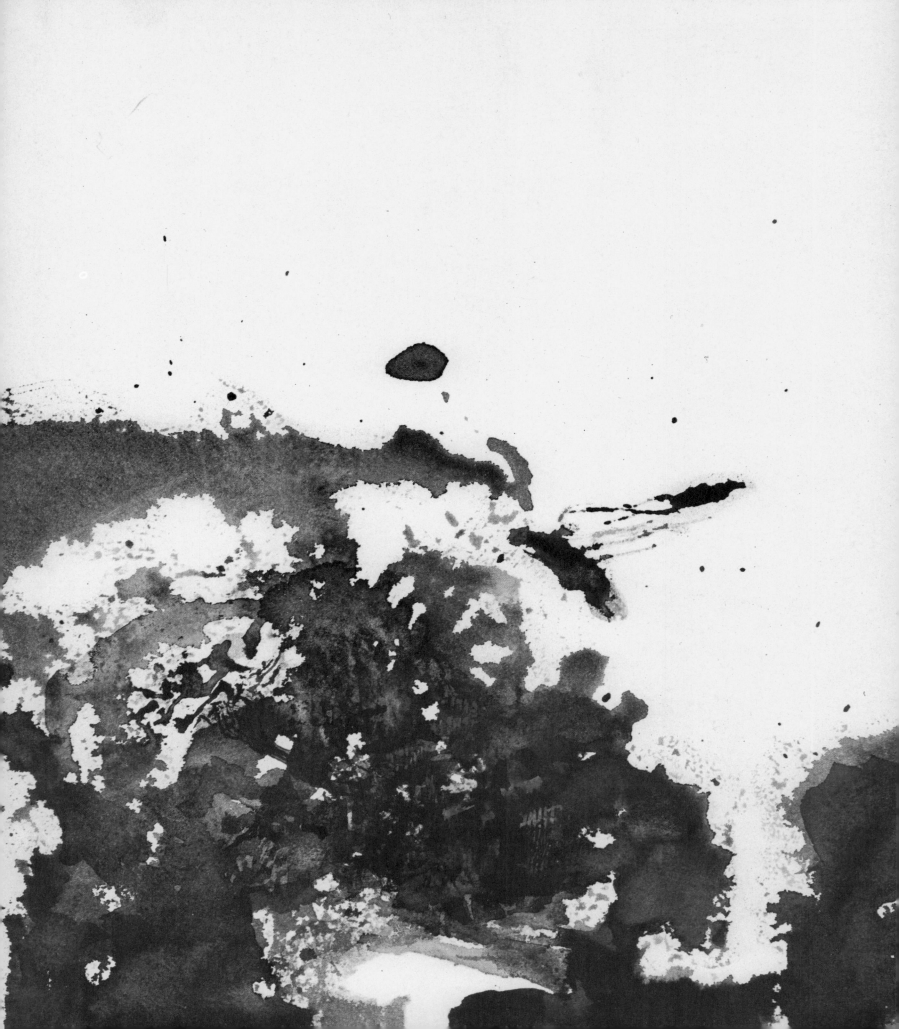